Studies of the Russian Institute *Columbia University*

Russian Realist Art

THE STATE AND SOCIETY:
The Peredvizhniki and Their Tradition

by
ELIZABETH VALKENIER

ARDIS / ANN ARBOR

Published by Ardis, 2901 Heatherway,
Ann Arbor, Michigan 48104.
ISBN 0-88233-264-3

In memoriam

MANFRED KRIDL
(1882-1957)

CONTENTS

Introduction xi

I. The Institutional and Social Background 3
II. Free Art and Professional Autonomy 33
III. The Making of a National School 52
IV. The Peredvizhnik Themes and Their Appeal 76
V. The Decline of an Ethos 115
VI. The Peredvizhnik and Revolution 137
VII. The Native Roots of Socialist Realism 165

Notes 196
Appendices
 The Founding Members of the Artel 224
 The Association of Traveling Art Exhibits 226
 Draft Statutes of the Association of Traveling Exhibit 227
 Works Displayed at the First Peredvizhnik Exhibit in
 St. Petersburg 229
Bibliography 231
Name and Subject Index 243

ILLUSTRATIONS

p. 24, top — The Imperial Academy of Arts, built in 1765-84 according to the architectural plans of Alexander Kokorinov and J. B. Vallin de la Mothe.

p. 24, bottom — The Second Antique Plaster Cast Gallery at the Academy. Painting by G. K. Mikhailov (1814-67).

p. 25, top — A. Ivanov, "Life-Drawing Class at the Academy of Arts" (around 1840).

p. 25, bottom — An artist's studio at the Academy. (A 1913 photo, but this is what individual studios looked like after the Academy was remodeled in 1859.)

p. 26 — Meeting of the Academic Council in Catherine Hall (about 1850). It is here that the fourteen artists refused to paint on the set theme on November 9, 1863.

p. 27 — Vasili Shebuev (1777-1855), painter of historical scenes and Rector of the Academy (1832-55), in dress uniform.

p. 28, top — Main street in the village of Ostrogozhsk, Voronezh province, Kramskoy's birthplace.

p. 28, bottom — The provincial background: a view of the house in which Kramskoy was born.

p. 29 — Ilya Repin with his mother and younger brother, 1863.

p. 30 — N. Koshelev, "Kramskoy with His Wife," 1865.

p. 31 — V. Pukirev, "A Painter's Studio," 1865.

p. 32, top — Examples of political satire: N. V. Yevlev, "Visible signs of attachment to the officialdom." *Gudok,* no. 9 (1862).

p. 32, bottom — "For how long will this man be crossed out?" This picture of the poet M. I. Mikhailov behind prison bars never appeared in *Gudok* because of censorship. (May 1, 1862).

p. 49 — N. Dmitriev-Orenburgsky's sketch in celebration of A. Korzukhin's birthday at the Artel, 1865.

p. 50, top — N. Dmitriev-Orenburgsky's sketch of a Thursday evening at the Artel, 1865.

p. 50, bottom — The fourteen protesters (13 painters and 1 sculptor).

p. 51, top — N. Petrov, "Two Hungry Ones," 1867.

p. 51, bottom — A. Korzukhin, "Funeral Meal at the Cemetery," 1865.

p. 74 — V. V. Stasov in his study, around 1890.

p. 75 — P. M. Tretiakov, 1878.

p. 98, top — V. Perov, "Last Tavern at the City Gates," 1868.

p. 98, bottom — A. Savrasov, "Rural Scene," 1867.

p. 99 — A. Savrasov, "The Rooks Have Come," 1871.

p. 100 — V. Perov, "Fedor M. Dostoevsky," 1872.

p. 101 — I. Kramskoy, "Nekrasov at the Time of His Last Poems," 1877-78.

p. 102 — I. Repin, "Protodiakon," 1877.

p. 103 — V. Shvarts, "Patriarch Nikon at the New Jerusalem Monastery," 1867.

pp. 104-105 — V. Surikov, "Boyarinia Morozova," 1887.

p. 106, top — V. Vasnetsov, "From One Apartment to Another," 1876.

p. 106, bottom — V. Vasnetsov, "Battle between Russians and Scythians," 1881.

p. 107, top — I. Kramskoy, "Forester," 1874.

p. 107, bottom — I. Repin, "Peasant with an Evil Eye," 1877.

p. 108 — V. Maksimov, "Family Division," 1876.

p. 109 — G. Miasoedov, "Zemstvo at Lunch," 1872.

p. 110, top — V. Makovsky, "A Rendezvous," 1883.

p. 110, bottom — Possible model for "They Did Not Await Him." From Repin's collection of photographs of political prisoners.

p. 111, top — I. Repin's 1883 study for the figure of the returning exile.

p. 111, bottom — Detail of the 1888 version of "They Did Not Await Him."

p. 112 — I. Repin, "Refusal of Confession," 1875-85.

p. 113 — I. Kramskoy, "Christ in the Desert," 1872.

p. 114, top — V. Makovsky, "An Evening Gathering," 1875-97.

p. 114, bottom — V. Maksimov, "All in the Past," 1889.

p. 135 — The Association in the mid-1880s; Repin third from the left, Kramskoy in the middle.

p. 136 — Mounting an exhibit.

p. 160 — Cover of the catalogue to the 1890 Academic exhibit.

p. 161, top — Grand Duchess Maria Pavlovna at the Academy, 1910.

p. 161, bottom — David Shterenberg presides over the Fine Arts Department, 1918.

p. 162 — David Shterenberg at the Free Art Studios, 1919.

p. 163 — E. Cheptsov, "Meeting of the Rural Communist Cell," 1925.

p. 164, top — G. Riazhsky, "The Delegate," 1927.

p. 164, bottom — Isaak Brodsky with Ilya Repin at Penaty, 1926.

p. 194 — K. Petrov-Vodkin, "Alarm," 1938.

p. 195 — K. Petrov-Vodkin, "Death of a Commissar," 1928.

This book is about the Russian realist painters known as the Peredvizh-niki. Their movement was born of protest in 1863 and died of senility in 1923. Ten years later it was resurrected for political reasons, to become the basis for Socialist Realism. And until recently, this style flourished in the Soviet Union.

In telling the story of Russian realist painting from its origins in the mid-nineteenth century to its evolution into the obligatory style under Stalin, I have concentrated on the interrelationship of pictorial expression, the public's response, and state policy. The nexus between society, politics and art—rather than esthetic evaluation—interests me as a historian: it is at the crux of what is unique about the Russian art scene, under both tsars and commissars. What realism signified, and how it related to society when it first was an antagonist and eventually an ally of the regime, is very much a Russian story, an experience that was not repeated elsewhere in Europe.

The distinguishing traits of Russian realism are associated with the Peredvizhniki. Strictly speaking, the name Peredvizhnik applies only to members of the Association of Traveling Art Exhibits (*Tovarishchestvo peredvizhnykh khudozhestvennykh vystavok*).* It was set up in 1870 in defiance of bureaucratic controls by fifteen young painters who rejected academic neoclassicism and took their canvases, depicting Russian scenes and commenting on national issues, beyond the official and aristocratic patronage of St. Petersburg to the new middle-class clientele in Moscow and the provinces.

However, the naturalism of *Peredvizhnichestvo,* with its extra-painterly attributes, has become synonomous with Russian realism and has played a variety of roles, both as an active force and as a tradition, in its more than a century-long history. The initial, creative phase of *Peredvizhnichestvo,* when it liberated painting from stagnant traditions and gave Russian art a new identity, was nurtured on the spirit of the 1860s, a period of reform and renovation, and lasted roughly through the mid-1880s. It established the autonomy of artists in their role as the conscience of the nation and reflected the intelligentsia's efforts to unshackle individual thought and activity from the state's supervision. The other two principal periods in the long life of the movement

*I use the Russian word Peredvizhniki, derived from the verb *peredvigat'sia*—to travel, move about—since the common English translation, the Wanderers or Ambulants, is misleading with its connotation of aimlessness. *Peredvizhnichestvo* refers to the movement, or to its works considered as a style.

had little in common with the original ethos. Toward the end of Alexander III's reign the Peredvizhniki ran to seed and became the officially sponsored school of Russian painting. From the early 1890s until 1917 they acted as guardians of a new academism that mirrored the conservative nationalism of the Tsar and the ascendant bourgeosie. During the third period, 1932-56, the art of the Peredvizhniki experienced a spectacular resuscitation after years of neglect and discredit. It had been derided and scorned before World War I by the proponents of the new visual esthetics, and after the Revolution by the proponents of revolutionary art. In the Stalinist years a tendentious rehabilitation of Russian nineteenth-century realism was undertaken in order to legitimate the regime's direction of all creative endeavors. For this purpose, the critical social realism of the Peredvizhniki was refashioned into the prototype for the positive Socialist Realism imposed on Soviet painters and society by political dictates, institutional supervision and a falsified historiography.

My first two chapters and much of the fourth cover the meaning for the first-generation Peredvizhniki of their commitment to Russian society and its problems; the factors that instigated their secession from the Academy; and the significance, to them and to the intelligentsia, of their challenge to the ubiquitous authority of the state. This confirms a well-known pattern of Russian nineteenth-century cultural history, namely, the unceasing tug-of-war between a critically-disposed society (*obshchestvo*) and the oppressive regime. But my book does more than study the Peredvizhniki in their familiar role as painters of political and social commentary. The aim of Chapters 3 and 5, and parts of 4, is to determine why these artists, originally identified with dissent, became the academic painters of the cultural establishment. They probe the much less familiar story of the complex interplay between the painters' own personal and public aspirations, the populist and nationalist preoccupations of the 1870s that displaced the liberal Westernizing stance of the intelligentsia, and Alexander III's jingoist promotion of a national school of art. This evolution of the Peredvizhniki tarnishes their image as knights-errant of free art. It also uncovers another deep current in Russian cultural history: that of an elemental nationalism, fed by an ambiguous distrust of the West with its manifold quest for new experience and expression.

Chapter 6 traces the decline of the Peredvizhnik ethos and reputation during the three decades of cultural effervescence before World War I and after the Bolshevik Revolution. This coupling of the declining years of the Tsarist Empire with the early period of the Soviet regime may seem incongruous. Yet the unpopularity of the Peredvizhnik manner among many creative minds in both periods stemmed from similar sources: a rejection of the stale formula of fidelity to subject matter over style, the growing cultural pluralism, intellectual and political rapprochement with the West, the search for new forms, and the inability or unwillingness of the state to dictate artistic expression.

These conditions disappeared during the Stalinist years, and Chapter 7 deals with the depressing story of how Socialist Realism with its attributes of stylistic conformity, political regimentation and cultural autarchy was imposed on painters after 1932 with the aid of an officially revived cult of the Peredvizhnik tradition, re-interpreted as didactic art in the service of the "people" and the state. Conversely, the liberalization of the artistic scene since the late 1950s has been accompanied by an increasingly objective treatment of the historical role of the Peredvizhniki and recognition of the rich plurality in Russian art prior to and just after the Revolution.

There are several reasons for not limiting a book on the Peredvizhniki to their truly creative phase (when they contributed a distinctive chapter to the history of Russian art), and for including an account of their decline and the subsequent political manipulation of their legacy. As it happened, the post-1932 rehabilitation of Russian nineteenth-century realism as the model for official Soviet art soon deteriorated into formulae that had more in common with the later, conformist stage of *Peredvizhnichestvo* than with the original ethos of moral commitment and liberal dissent. It is an interesting historical parallel that the characteristics the movement acquired during its decline—intolerance toward innovative trends at home and abroad, together with loyal service to the political establishment—were the features revived by Stalin.

Furthermore, the extensive publication of primary sources and secondary works on Russian nineteenth-century realism has taken place mainly since 1932. These works, tendentious in their editorializing and assessments, have shaped not only the popular Soviet image of the Peredvizhniki and attitudes toward the function of art, but also Western views on the nature of Russian realism with its tradition of activism and social service. A better knowledge of the political background of this extensive historiography uncovers a truer picture of the original premises of *Peredvizhnichestvo* and rescues it from the Stalinist distortions devised to legitimate a narrowly political, didactic and nationalist cultural policy.

Finally, by covering the full range of *Peredvizhnichestvo* I hope to provide insights into some important problems of cultural continuities: the extent to which the alleged Russian attachment to a narrative pictorial language and utilitarian esthetics is deeply rooted in the national tradition, and how it has been shaped by deliberate political manipulation. What one encounters in the USSR today—the responsive crowds that view the Peredvizhnik canvases in the Tretiakov Gallery in Moscow or in the Russian Museum in Leningrad; the widespread conviction that the tenets of Socialist Realism are based on historical precedents and popular preferences—is the product of a variety of influences. These include a genuine attachment to the familiar scenes of their native land and its history, a lack of habituation to alternate ways of expression, as well as institutional controls that have fostered

one-sided views and preferences in art.

* * *

I have many people and institutions to thank for their help and support of my work. Foremost, I would like to acknowledge my debt to the late Michael Cherniavsky, who steered my interest toward the social aspects of art. Nora Beeson, John Bowlt, Ann Farkas, Sheila Fitzpatrick, Robert Maguire, Marc Raeff and Meyer Schapiro gave me much encouragement and useful advice. The same is true of my husband Rob, who read and commented on the manuscript in its several stages, and together with our daughter Lisa bore with varying degrees of patience my absences and neglect of them. I am deeply grateful to them all. Naturally, they are in no way responsible for my sins of omission or commission.

Financial aid from the International Research and Exchanges Board and from the Russian Institute of Columbia University enabled me to do an unencumbered year of research and writing in Moscow, Leningrad and New York. The excellent collections and the knowledgeable staff in the Fine Arts Library at Columbia and in the Slavonic Division at the New York Public Library made it possible to do much preliminary work before undertaking more detailed research in the Soviet Union.

Much pleasure and reward in working on this book came from the opportunities I had to consult with Soviet specialists and to use Soviet libraries and archives, both as a private visitor and as an exchange scholar. I owe special gratitude to I.A. Brodsky, S.N. Goldshtein, V.S. Kemenov, A.K. Lebedev, I.N. Punina, D.V. Sarabianov, A.N. Savinov, I.N. Shuvalova, G.Yu. Sternin, N. Yezerskaya, and N.Yu. Zograf for the interest they took in my work and for the invaluable guidance to sources they were most generous in providing me with. I received the same cooperation from the research staffs of the Tretiakov Gallery archives and library, the Lenin Public Library and its archives division, the Central State Historical Archive of Literature and Arts, and the Academy of Arts, all in Moscow; of the Saltykov-Shchedrin Public Library and its manuscript collection, the Central State Historical Archive, the Russian Museum archives and library, the Academy of Arts library and archives, in Leningrad; and the Repin Museum in Penaty. Time and again, the help I received from Soviet scholars went beyond the call of duty. They let me consult their manuscripts, shared rare archival material which I would have been unlikely to discover on my own, and provided me with illustrations. It is the cause of some distress to me that not all the judgments in this book coincide with the views of those Soviet scholars who were most generous with their time and resources. I hope that my judgments will be taken as an honest difference of opinion on a subject open to a range of interpretations. It is needless to add that although I am indebted to many Soviet specialists for refining my views, the final evaluation is my own—one that has

xiv

emerged from the sources themselves and my understanding of them and not from any preconceived notions or political attitudes.

* * *

My transliteration follows the standard Library of Congress system with some modifications, the most important of which are the use of "iya" and "iyu" instead of "iia" and "iiu"; the termination of last names with "sky" or "skoy" instead of "skii" and "skoi"; and the omission of the soft sign in first and last names in the text proper (though it is retained in the citations). All translations are mine, except where noted.

Abbreviations used in citing Archives are as follows:

BL, OR. Gosudarstvennaya biblioteka SSSR imeni V.I. Lenina, Otdel rukopisei.

BS, OR. Gosudarstvennaya publichnaya biblioteka imeni M.E. Saltykova-Shchedrina, Otdel rukopisei.

GRM, OR. Gosudarstvennyi Russkii muzei, Otdel rukopisei.

GTG, OR. Gosudarstvennaya Tret'iakovskaya galereya, Otdel rukopisei.

TsGALI. Tsentral'nyi gosudarstvennyi arkhiv literatury i iskusstva SSSR.

TsGIA. Tsentral'nyi gosudarstvennyi istoricheskii arkhiv SSSR.

RUSSIAN REALIST ART, THE STATE AND SOCIETY

The Peredvizhniki and Their Tradition

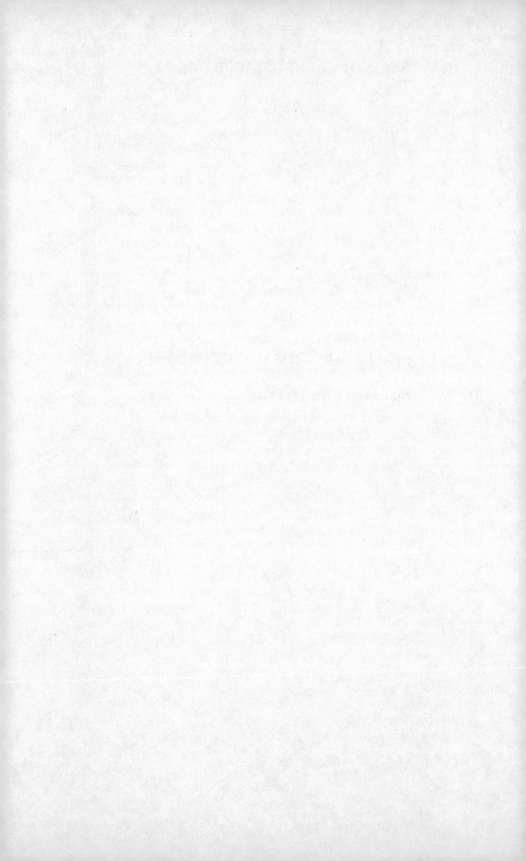

I THE INSTITUTIONAL AND SOCIAL BACKGROUND

The Imperial Academy of Arts

The massive, neo-classical building on the banks of the Neva housing the Academy of Arts embodies in its monumental solidity a persisting feature in the history of Russian art: its regimentation by the state. Although the high-minded inscription FOR THE FREE ARTS *(Svobodnym khudozhestvam)* is chiseled on its imposing portico, the Academy has been, by and large, the mainstay not of free but of official art.

Other academies in other countries have also prescribed canons of taste. But in Russia this function has persisted longer and has been far more restrictive than elsewhere in Europe. During the reign of Nicholas I it regimented artists as civil servants through minute regulations; under Alexander III and his successors it infused Russian art with a heightened nationalist ethos; and under Stalin it was the symbol of the extreme politicization of Soviet art, combining both the bureaucratic features of Nicholas' administration and the chauvinistic aims of Alexander. Furthermore, close institutional supervision over painters was as crucial to the emergence of Peredvizhnik realism in the nineteenth century as to the imposition of Socialist Realism after 1932. Hence a description of how the Russian Academy of Arts first acquired its restrictive character is a necessary setting for the story of Russian realism.

The libertarian motto gracing the entrance to the Academy expresses the aims of its founder, Catherine the Great, who tried to foster the cultural development of her adopted country by encouraging individual initiative among her subjects. The Statutes she promulgated in 1764[1] were patterned on those of the French Academy of Fine Arts, set up by Colbert for Louis XIV a hundred years earlier. But despite similarly detailed provisions on the election and duties of the Academy's personnel and on the strictly supervised training of its students, it was not the purpose of the Russian institution to put artists in the straitjacket of state service, as had been Colbert's aim. Quite the contrary, given the serf-owning and rigidly structured nature of Russian society, the St. Petersburg Academy was to help create a free and legally protected profession. The Statutes specified that the graduates were to work as independent artists free from military recruitment or any other compulsory state service. To make doubly sure that this status would not be violated, it was "most strictly" forbidden "to each and all" to enserf any graduate of the Academy or his progeny.

More important, Catherine wished to give Russia well-educated artists

3

who would practice their profession with due distinction. For this purpose a boarding school was affiliated with the Academy. Since the curriculum was similar to that of the exclusive schools for the upper classes, the Academy gave its graduates, most of whom came from a very modest social background, a well-rounded training that enabled them to gain entrance to the literary salons and become part of the cultural elite.

Neither under Catherine nor under her grandson, Alexander I, did the Academy exercise inordinate official interference. The extensive initiative it had to take in educating and training artists, in patronizing and promoting the fine arts, reflected less the predilections of an autocratic regime than the absence of a public school system and private clientele. In these conditions, the activities of the Academy served as a lever to raise cultural standards and spread what were considered to be the essential amenities of civilized life.

But during the reign of Nicholas I (1825-55) the Academy was transformed into an instrument that molded artists into servitors of the state, subordinated art to the needs and tastes of the Court, and controlled artistic life throughout the country. Because of these measures, the Academy came to be regarded as yet another oppressive Tsarist institution—a view that had important repercussions on the course of Russian art. As a result of this change in public opinion, any actions that challenged the Academy's dictates were regarded less as a matter of professional ethics or esthetic preferences and more as a protest against the crushing weight of autocracy. Thus the secession of the fourteen graduating students in 1863 and the formation of an independent exhibiting society in 1870, regardless of what the motivations of the painters might have been, were interpreted as semi-political acts. In the longer run, the authoritarian measures introduced by Nicholas were in part responsible for the civic-minded ethos that attended the birth of Russian realism.

Nicholas bureaucratized the Academy and brought it under his personal supervision. The new measures, like the rest of the Nicholaevian system, reflected the Emperor's conviction that men and institutions functioned best under tight administrative controls and the threat of due punishment. His policing of literature is better known.[2] But since his tastes in literary matters were not pronounced, his heavy hand was mostly felt in censorship and through other negative controls. In art, however—a field in which Nicholas fancied himself a connoisseur, in part because he was an accomplished draftsman through his training as an engineer—he created a system of prescriptive measures that imposed his own taste and preferences. Previously, Russia had had a state-supported art; from about 1830 on, an officially endorsed neoclassicism permeated taste and all practice.

The Tsar's personal interference in the life of the Academy and its pupils became legendary during his lifetime. His predecessors had left the actual administration in the hands of its President, the Conference Secretary and the governing Council. But Nicholas himself supervised almost everything per-

4

taining to the Academy. He would appoint the artists he favored as professors without going through the formality of having them elected by the Council. Others he would dismiss peremptorily either because he did not approve of their works or because he disliked their independent opinions. He closely followed the students' progress, frequently visiting classrooms and studios and generously admonishing the young men to work better and harder.

His treatment of the Academy's pensioners in Rome was telling and typical. When the Tsar visited that city in 1839, his first reaction after meeting a group of grantees was to surmise that they might be "loafing." And then to make sure that this was not the case, he went on an inspection tour of their studios. He treated the young men not as creative artists but as his employees whom he assigned tasks to and commanded at will—either to copy some Italian masterpiece required for an Imperial residence or to paint a nymph in a more modest attire so that he could purchase it without qualms. The refrain to all his remarks was: if you behave well and work hard, you can expect many commissions. Upon taking leave of the pensioners, the Tsar commended them on their "good conduct," for that to Nicholas was the most important attribute of an artist.[3]

The ethos of bureaucracy and discipline was introduced by two major amendments to the 1764 Statutes. (Together, these amendments were almost twice as long as Catherine's document.) Under the original Statutes there was the single title of Artist, which carried the lowest civil service rank (the 14th), to be granted to all students upon successful completion of their course. Having received it, they were entitled to work freely throughout the Empire at jobs and places of their own choosing. For mature and recognized artists, there was also one honorific title, that of Academician, which carried the 10th rank in the civil service. Nicholas replaced this simple scheme with an elaborate hierarchy of ranks and titles, each to be obtained by gradual promotion in due time and after proper examination.[4]

The amendment of 1840 set up three different grades to be awarded upon finishing the six-year program that consisted of three courses. It began with drawing from plaster casts of antique heads; proceeded to copying the entire figure, again from casts; and ended, only in the third course, with working from live models. Those students who finished the curriculum and, at examinations, won Gold Medals (which were, in turn, divided into first- and second-class varieties) would receive the title Class Artist *(Klassnyi khudozhnik)*, First Grade, and the 14th civil service rank. Those who managed to win Silver Medals, became Class Artists, Second Grade, and merely had the right to "claim" the 14th civil service rank after obtaining a position either in some government office or in a public school. And finally, those who passed their examinations without distinction would emerge as Non-class Artists *(Neklassnye khudozhniki)*. They could try to get on the bottom rung of the civil service ladder by submitting at some later date an example of their inde-

pendent work for consideration by the Academic Council.

Similarly, Catherine's single title of Academician was minutely broken down into Academician, Second and First Grade, and Professor, Third and Second Grade.[5] Each title could be gained only after a specified number of years had elapsed since the previous promotion and after submitting work to the Academic Council. The titles *per se* did not carry any financial rewards, nor did they bring a professional assignment. They merely placed Russia's painters, engravers, architects and sculptors somewhere on the civil service ladder and entitled them to climb further, as well as to demand the remuneration commensurate with the rank. The requisite ranking was necessary for obtaining a position or seeking promotion. For example, only those artists who already held the title of Professor could be appointed as full professors at the Academy. Those with the title of Academician could aspire only to the position of a classroom instructor at the Academy; whereas Artist of various gradations could only apply for such jobs as teachers of drawing in secondary schools.

As for discipline, strict regulations were rigorously enforced. In memoirs of their student days, painters invariably described the rigid, barracks-like atmosphere prevailing in the Academy.[6] Though (like other reminiscences of the Nicholaevian period) they tended to overemphasize the autocratic excesses of the monarch, one cannot discount their general veracity. Nicholas had amplified Catherine's benevolent Statutes with a section on discipline that specified various degrees of punishment, including that of commitment to military service (which in those days lasted about twenty-five years and was regarded as equivalent to penal servitude). To ensure compliance, another staff member was added—a policeman *(politsmeister)*, whose duty it was to enforce order among students and "strict military discipline" among the junior staff.

Consequently, a spirit of suspicion, of aggrieved watchfulness—not the sympathetic encouragement of talent—prevailed in relations between students and staff. Among the forms of arid regimentation that became particularly odious to mature students was the practice of making the competitors for the First Class (Big) Gold Medal, and the accompanying six-year fellowship for study abroad, paint on an assigned subject. The initial sketch on which they were judged had to be completed within twenty-four hours in closely supervised seclusion and, once the professors approved the sketches of the winners, they were not permitted to deviate in any detail during the year or two that it took to complete the painting. What rankled the young painters was not so much the subjects from antiquity or the observance of correct drawing as the spirit of dictation and utter disregard for the individual. Artists resented that the Academy, instead of nurturing talent, was training technicians who could fulfill Court commissions with skill and dispatch.

In addition to amending the Statutes, Nicholas put the Academy

directly under the control of the Court. With the appointment of Prince Maximilian of Leuchtenberg, the Tsar's son-in-law, to the Presidency of the Academy in 1843, the office passed from wealthy patrons or amateurs into the hands of members of the Imperial family, where it remained until the end of the Romanov dynasty. Upon the Prince's death in 1852, he was succeeded by his wife, Grand Duchess Maria, the Tsar's favorite daughter. Like her father Maria Nikolaevna did not confine her patronage to purchases and commissions. She participated in the meetings of the Academic Council, where her voice—given the timidity of other, less well-born members—was often decisive in the awarding of appointments, titles and prizes. When she inspected the studios of the competitors for the Big Gold Medal, her remarks were taken down in the Official Journal, and rare was the student who did not deem it wise to comply.[7]

In 1850 the administration of the Academy was transferred from the Ministry of Education to the Ministry of the Imperial Household *(Ministerstvo Dvora)*. This measure merely formalized what already was fact, for the absorption of the Academy into the personal domain of the Emperor had started some twenty years earlier. All administrative and financial matters of the Academy were now decided either by the Emperor or by the Minister responsible for the management of his lands and other possessions.

The reign of Nicholas also marked the extension of the Academy's control over the artistic life of the country. The few private art schools that had sprung up in the provinces at the beginning of the nineteenth century had no chance to flourish after 1832 when the Academy assumed supervision of art instruction in secondary schools and claimed the exclusive right to grant titles and medals. These private schools languished as the Academy gave preference to its own graduates over locally trained artists in staffing teaching posts. Concerned individuals periodically urged the founding of art schools in cities like Kiev and Tiflis, but their suggestions were invariably turned down, for Nicholas did not encourage the emergence of other centers in the far reaches of his Empire.[8]

The two organizations of some prominence that were established during the first half of the century, one in Moscow, the other in St. Petersburg, were absorbed into Nicholas' centralized system. The Moscow Art School, started in 1833 by the Moscow Art Society as informal art classes, obtained in 1843 permission to become a full-fledged School of Painting, Sculpture and Architecture.[9] But at the same time as its scope and curriculum were enlarged, the school came under closer official supervision, and an institution started and supported through private initiative became administratively part of the official system. The Ministry of the Imperial Household approved the School's Statutes and the appointment of its professors; the Governor-General of Moscow was *ex officio* head of the governing Council; and an annual government subsidy of 6,000 rubles was granted. Care was taken in St. Petersburg

that the Moscow School would remain in a subordinate position. During Nicholas' reign it never received permission to grant to its graduates any distinction other than the lowest title, that of *Neklassnyi khudozhnik*. Until 1865 Moscow students had to turn to the Academy to obtain medals and civil service ranks.[10]

A similar fate befell the Society for the Promotion of Artists in St. Petersburg. It had been founded in 1820 by three wealthy patrons to help young painters with fellowships, purchases, and commissions. From 1839 on it maintained a drawing school, which provided an important preparatory course for entrance into the Academy. It is indicative of the state of private partronage at the time that the Society managed to survive on contributions from members and private donors for only two years; the first government subsidy came in 1822. Five years later, the Society was granted the "privilege" of informing the Emperor about notable talents in need of support; in 1833 it was renamed the Imperial Society for the Promotion of Art; and after 1852 it was headed, like the Imperial Academy, by the same meddlesome Grand Duchess Maria.[11]

The Academy came to control all the other avenues to Parnassus. The minutes of the Academic Council's sessions show that it spent considerable time and effort on "promoting art." This had been one of Catherine's original aims, to which Nicholas' Academy applied itself diligently. It bought pictures from provincial painters to encourage them; it granted pensions and allotted studios to enable deserving artists outside the Academy to perfect their talent. But in all too many instances the "promotion of art" was limited to assigning ranks and titles. The extended ladder of professional advancement acquired overriding importance during this period, and only the Academy could confer the coveted titles and ranks. In consequence, countless amateur artists and architects submitted their works to the Council with the petition that they be granted this or that rank on the strength of their submission.[12] To be sure, paintings were painted and buildings built in Nicholas' Russia by men who did not hold official titles. But those artists who wanted recognition had no other recourse but to seek advancement through official channels and to exhibit at the annual shows of the Academy, which remained the most prestigious artistic event in the country until the advent of the Association of Traveling Art Exhibits in the 1870s.

The pervasiveness of the structure created by Nicholas was only intensified by the absence of private patronage outside the two capitals. In the vast expanses of rural Russia, those landowners who wanted to have family portraits painted or to decorate their mansions and village churches turned to their own serf artists, trained by the local ikon painter. They had no need for the services of free artists. It was only after the Emancipation in 1861 and in response to changed market conditions that art schools began to appear in provincial towns and painters sought to assert their professional independence. Until that happened, Russia's painters had to plan their careers and seek success

within the ambit of the official system.[13] Unlike well-known painters in Paris, they did not set up their own ateliers and take on pupils. That there were only three private art studios in St. Petersburg in 1860 is a good indication of the demand for working space by artists who proposed to paint "outside" the Academy, both in the physical and in the figurative sense.

Such, then, were the stifling controls that Nicholas had imposed on Russia's art and artists. Not surprisingly, his successor's decision to liberalize the country's institutions also included the Academy of Arts. The reform was entrusted to a new Conference Secretary, Fedor Lvov (1820-1895), an amateur painter who had studied in St. Petersburg and Dresden. His sojourn in Germany had opened Lvov's eyes to the changes that had occurred in art education in the West after the French Revolution, changes that replaced the rigid training of meticulous and accomplished craftsmen with methods designed to nurture creative talent.

But the spirit of greater freedom and individuality could not be reproduced in Russia. As his memoirs indicate, Lvov was very much aware of the need for a new student-teacher relationship, for a freer atmosphere to foster the development of art and for improving the status of artists in Russian society. Yet the reform of 1859, embodied in new Statutes, did not substantively improve matters. It proved impossible to dislodge the old professors and turn to less formal methods of training. The six-year course was still divided into three sections, with only the last devoted to drawing from life. Lvov was unable to introduce individual instruction in studios (that finally occurred during the next major reorganization in 1893) and all teaching was confined to classroom instruction. Students had little access to professors, clad in their official uniforms and ensconced in their spacious apartments, that together with servants' quarters were located right in the same building.[14]

Other aspects of free creativity and professional autonomy gained no greater recognition. The practice of assigning compulsory subjects for the Silver and Gold Medal competitions—something that came under much criticism in the liberal press after Nicholas' death—was but slightly modified. Only the candidates for the lesser medals were permitted to choose their own subjects, while the contenders for the Gold Medals were obliged to paint on subjects chosen by the Council and to observe the same strict rules on close adherence to the original sketch. Similarly, the Academy retained control over the careers of artists, for the complicated hierarchy of titles and honorific appellations, each with its appropriate civil service rating, remained almost unchanged.

The single reform that offered prospects for improving the professional and social status of artists was the re-introduction of general education courses, discontinued by Nicholas in 1840 when the boarding school was closed. From then on the Academy had admitted only day students after they passed a very general examination in draftsmanship and the three R's. Undertaken as an

9

economy measure, the step had, by all accounts, quite catastrophic results. The public school network was still very inadequate, and instead of well-prepared graduates of secondary schools the Academy acquired half-literate, raw youths from distant provinces who never managed to overcome their ignorance or to shed their crude manners.

Those who were concerned about the moribund state of Russian art, its isolation from the West and the bureaucratization of the profession blamed the situation not only on Nicholas' propensities but also on the lack of cultural sophistication that marked art students in the 1850s. Hence the liberal and the radical press greeted this section of the new Statutes with unqualified approbation. The reform-minded public had high expectations that painters, who under Nicholas had been reduced to the status of bureaucrats *(chinovniki)*, would be transformed by means of a well-rounded education into active participants in the renovation of national life and take their place alongside other free professions.[15]

For the rest, the 1859 reform failed either to alter the relationship of the Academy to the Court or to lessen official control over artistic activities in the country. The Academy remained under the jurisdiction of the Ministry of the Imperial Household and, as before, was entrusted with overseeing art instruction in schools and supervising other art centers.

But this program that failed to liberalize training and lessen bureaucratic management was to operate in an entirely new situation; an awakened critical public opinion was positing quite a different role for artists in national life. Instead of carrying out government commissions, they were to educate and transform society through their creative work. Neither the progressive journalism of the day nor the new generation of students wanted to put up any longer with the old ways, with the political and institutional restrictions of the official system. Because the Academic reform of 1859 was so paltry, tensions emerged, leading to the dramatic gesture of the fourteen Big Gold Medal contestants in 1863.

The Painters' Inferiorities

Much has been written about the dicta of Belinsky, Chernyshevsky and their followers—namely, the obligation in all creative endeavors to contribute to the solution of the pressing moral and civic problems of the day—as being responsible for the covert and open criticism of the existing order in Russian realism. Another aspect of the situation has hardly been examined: the lower-class background of the founders of the school. Their humble origins and

their position in Russian society accounts for much of the extra-painterly concerns in the Peredvizhnik works.

The simple, direct ascription of the critical spirit of Russian realism to the utilitarian esthetics of the time does not account for the social dimensions of this ethos. The legal, social and cultural obstacles that the first-generation Peredvizhniki had to overcome to win recognition for themselves and their art were so restrictive and pervasive that to surmount them was as much a motivation as what the radical democrats from Belinsky on had preached about the civic role of art. The young realists wanted to attain personal equality and professional recognition. In practical terms this meant not only escaping from the fetters of the Academy and its style, but also gaining social acceptance— becoming members of the intelligentsia, that glamorous elite of the mind and spirit which guided the rest of the nation, and from which painters were excluded well into the 1870s.

Though there are no reliable statistics on the social background of the artists, contemporary sources make it amply clear that most of them came from very humble families. According to Vladimir Stasov, who shepherded the realist school, "the overwhelming majority of the best Russian painters came from the lower estates of our people."[16] Of the fourteen artists who walked out of the Academy in 1863, only one came from the gentry; and among the rest, those from the lower middle class predominated. The social background of the fifteen founding members of the Association of Traveling Art Exhibits was more prepossessing—there were five members of the gentry. The tone of the movement, however, was set by the others: Ivan Kramskoy, its *spiritus rector*, came from the petty bourgeoisie; Vasili Perov, who popularized the style of public condemnation in the 1860s, was underprivileged because of his illegitimate birth; and Ilya Repin, who carried on the tradition for the next twenty years, was the son of a state peasant.

These bare facts about the painters' origins are pretty meaningless, taken by themselves. The full weight of the handicaps imposed by lowly birth can be fully appreciated only when seen in light of the existing legal barriers and social prejudices. The class system in mid-nineteenth century Russia was more rigid than elsewhere in Europe because the class and status differences were not only punctiliously observed in social relations but also carefully defined by law. The population was divided into five estates *(sosloviya)*: gentry *(dvorianstvo)*, clergy *(dukhovenstvo)*, distinguished or honorable citizens *(pochetnye grazhdane)*, petty bourgeoisie *(meshchane)*,and the peasants *(krest'iane)*. Only the last two groups paid a poll tax and served in the army. In addition, they were also liable to corporal punishment and subject to compulsory public labor during emergencies such as forest fires or railroad accidents. To make it easier for the government to exact these obligations, the peasants and the *meshchane* had to reside and be registered in a tax-paying, labor- and recruit-supplying community. This did not mean that petty traders and peasants did

11

not travel about or never changed their place of residence. They could and did. But to be away from their community for any extended period, they had to obtain a permit that specified the duration of their absence. This was easy enough to acquire, provided that the applicant had paid all his taxes (arrears, as well as in advance), that he was not liable to recruitment, and that enough money was left with the community to pay for any emergency public work he might be called upon to perform during his absence.

The gentry and those social groups which made up the estate of distinguished citizens, whether by birth, education or service rank—that is, factory owners, wealthy merchants, university graduates, civil servants in ranks 14 through 9, children of the clergy—were not liable to military service (until 1874) or to the poll tax (until the mid-1880s). Nor were they subject to physical punishment or obligatory public labor. Unlike the two lower estates, they could obtain permanent internal passports which entitled them to travel freely throughout the Empire and to reside where they wished.

Even though the estate structure was rigidly observed through the 1870s, it was never a closed system; despite all the rules and regulations, there was much social mobility. It was not impossible to improve one's station. Higher education most commonly provided the means for the lower orders to rise to the distinguished citizen level. It was relatively easy for someone from the lower middle class or from the peasantry (after 1861) to obtain a permit from his community to send his son away for schooling, so that he would graduate with a civil service rating. Technical schools granted the 14th rank to their graduates and the universities the 10th, both of which conferred membership in the distinguished citizen category, liberating the young man from all the burdens of second-class citizenship.[17]

Despite these opportunities for upward mobility, the legal complications attendant on rising from the lower depths were extensive. The haggling and the uncertainties in attaining full citizenship were often so humiliating that they compounded the feeling of inferiority which nagged the first generation of Peredvizhniki. Take the case of Vasili Maksimov (1844-1911), a painter of rural subjects and one of the founding members of the Association, who was born to a family of state peasants. After the Emancipation he was entitled to enter the Academy (from which serfs had been excluded), but he still faced myriad complications. Having passed the entrance exams in 1862, he could not be admitted as a regular, full-time student because he was unable to obtain proper documents from his rural commune that would free him from his obligations. Upon Lvov's advice, Maksimov enrolled as an auditor and worked hard to distinguish himself, sustained by the Conference Secretary's assurances that he would soon win a medal and thereby escape from the peasantry. Indeed, within two years, young Maksimov won a Gold Medal and the permanent release from his obligations, granted by the Ministry of Finance. Prior to that, tormented by his uncertain legal status, Maksimov had again pe-

12

titioned his commune for the temporary release. But the shrewd peasant elders wanted to realize a good profit and demanded a veritable ransom, which he refused to pay.[18]

In the case of Fedor Vasiliev (1850-73), one of the first realists to paint Russian landscape with feeling and verisimilitude, the legal complications assumed tragic proportions. Son of a minor postal clerk, Vasilev was studying with Kramskoy and Shishkin at the Art School run by the St. Petersburg Society for the Promotion of Art. In 1871, as he was about to leave St. Petersburg for the Crimea to nurse a case of tuberculosis, he was arrested to prevent his "evasion" from the forthcoming draft to which he was liable. (By then, military service had been reduced to sixteen years, but still, only members of the lower estates had to serve.) Friends and admirers of Vasilev quickly raised 1,000 rubles to obtain his release from prison, plus a postponement of his induction and an internal passport valid for one year. The only way for Vasilev to escape military service permanently was to shed his *meshchanin* status by way of artistic promotion, which only the Academy could grant. So he quickly enrolled at the Academy as an auditor and submitted several canvases for the title of Artist. The wheels of bureaucracy ground slowly. Despite Kramskoy's repeated visits to the Academy's office to press the matter—undertaken under a constant barrage of Vasilev's pleas, "For God's sake, hurry up"—the talented young painter was still awaiting the title when he died in the Crimea two years later.

In Vasilev's letters to Kramskoy, the artistic title loomed as the sole magic source of salvation. It would have freed him from the obtuse jurisdiction of his *meshchane* administration and allowed him to go abroad in search of a more effective cure. As he wrote on April 8, 1873, "If the Academy will not give me the title and the passport, it will take from me the chance to save my life."[19] To Kramskoy, likewise, the business of proper official papers was the core of the whole drama. The concluding sentence in a letter he wrote to Stasov just after receiving news of his young friend's death reads: "Vasilev died without a passport."[20]

Socially, the artists also faced an uphill struggle. The gulf that separated full-fledged citizens from the underprivileged was as wide in social relations as in legal provisions. As Repin wrote around 1890:

> Not long ago the estate system played an important role in relations between people.... When you attained the first rank [the 14th], the [familiar] "ty" was replaced by the [respectful] "vy," and a well-born hand would be extended to you at meetings. In all social relations there was this severe caste system.[21]

Lowly birth carried with it the stigma of ignorance and crude behavior—so much so that Lvov, the Academy's reforming Conference Secretary, intro-

duced, in addition to the courses in general education, special social evenings to raise the new generation of painters to acceptable standards. These soirées were supposed to be a "school of manners" where students could meet with better-educated and "well-brought-up" people on an equal basis and acquire more refined ways. Lvov invited high society, writers and journalists to some evenings, organized concerts, and staged theatricals at others, in the hope of "unteaching" the young men the "country tavern" habits they had acquired at home.[22]

Lvov's evenings of enforced exposure failed of their aim, and the persisting inferiority complex was quite pronounced among the first-generation Peredvizhniki. Their letters and memoirs frequently refer in amazement to the attire and deportment of the upper classes whom they would observe from a respectful distance in parks or at the theater. Unfamiliarity with the ways of the world was such that when the wealthy patron who gave Repin a stipend to attend the Academy extended his hand in greeting, the young man could only think of kissing it. And in the split second of his reflex Repin was astonished that a hand could be so delicately shaped and clean.[23]

On the scale of sensed inferiorities, intellectual inadequacy rankled the young artists even more than their social provenance. To an inordinate extent, it gnawed at them for the rest of their lives. The highly introspective Kramskoy (whose parents could not afford to send him to a gymnasium after he had finished the local primary school at the age of thirteen) confessed: "My story would not be complete unless I add that I have never envied anybody...so much as an educated person. Formerly, I even panicked like a lackey before every university student."[24] Similar feelings persisted with Repin much longer; in 1881, a successful and recognized painter, he seriously considered attending the University of Moscow.[25]

The added requirement in 1859 of courses in history, literature and esthetics failed to transform the Academy's graduates into adepts of sophistication and high culture. Some ten years later Kramskoy was still maintaining that painters "could not talk, could not behave [and] were insufficiently well educated," and attributing the poor quality of contemporary Russian art and the public's indifference to these factors.[26] Lvov blamed the lack of progress in raising the cultural level of his students on the old professors—he was unable to "pour new wine into old bottles." But one must note other obstacles: mainly, the simple fact that there were almost no Russian works on art history or esthetics, that foreign languages were not taught at the Academy, and that such basic sources as the lives by Vasari and the histories by Kugler and Waagen had not yet been translated into Russian.[27] It was only after the teaching of the new courses improved and the general educational level of art students rose that the marked contrast between graduates of the Academy and the University disappeared. And that happened only in the late 1870s. The writings of painters born around 1860 make no references to this prob-

lem that so vexed the first-generation realists.

The awesome respect the young artists had for those with a university training reveals another aspect of their drive to gain acceptance in Russian society. Legal equality was within their reach, provided they worked hard at the Academy to obtain the necessary titles and ranks bestowing full citizenship. But this was only a part, and the less difficult part, of their rise from a lower to a higher stratum. They also sought entry into the cultural elite, from which artists were still excluded. They wanted their paintings to be counted along with the written word as worthy contributions to national culture and the ongoing debates—a valuation that the routinized academic art, produced at the bidding of the Court, was not accorded by the critically inclined, educated public.

One might ask why formal education and membership in the intelligentsia were all that crucial for Russian artists in this period. Why, during the period of general liberation after the death of Nicholas I, did they not strike out on their own, assert their individual modes of seeing and feeling, instead of adopting the concerns and style of others, mainly those of the literary profession? Part of the explanation lies in the social origins of the artists who, given the very rigid class structure and equally strong social prejudices of Imperial Russia, lacked the necessary self-assurance and conviction to fashion for themselves their own values and attitudes.

Another part of the explanation lies in the fact that the artists matured at a time when formal education, learning or knowledge *(nauka)*, and a self-conscious intelligentsia assumed overriding importance. During the 1860s, when all aspects of public and private life were undergoing scrutiny, the premium placed on knowledge was higher than ever. Hallowed traditions were discredited; scientific analysis was expected to light the way ahead, to provide solutions in every field. Chernyshevsky and others argued that, to help create the new life, contemporary art had to be based on wide learning; merely to be able to wield a brush was not sufficient in itself to make one a good painter. In an article on Alexander Ivanov and the triumphal showing of his "Christ Before the People," Chernyshevsky quoted extensively from that artist's correspondence to make his point: before Ivanov would undertake another major canvas of current significance he considered it mandatory to deepen his own education.[28] The intellectually active and culturally prominent contemporaries of the first-generation Peredvizhniki believed that "art should not be ashamed [to state] that its goals are [like those of *nauka*] to understand and explain reality and then apply its findings for the use of humanity."[29]

Even though a well-defined stance characterized the members of the intelligentsia—a highly censorious attitude toward the political situation and social realities and a dedicated search for a better, more just life—still, what made one an *intelligent* was not the attitude but education. Birth was not im-

15

portant *per se*; in those days, however, one still had to be moderately well-born—not necessarily in the gentry but certainly in the non-taxable estate, as were most of the so-called *raznochintsy* writers and journalists—to have the opportunity to attend the university. The views and the leadership of the intelligentsia were accepted by others because they were based on formal training.[30]

Thus in their regard for higher education the artists simply reflected current notions. With this general faith in the power of trained minds and the obsession with renovating society and its institutions, there was little likelihood that the artists—saddled with a sense of social, cultural, and legal inferiority and emerging from their provincial narrowness onto an art scene that lacked tradition (except the discredited one of service to the Court)—would set off on a course of their own. Having renounced the official Academy, they took up service to society, the preoccupation of the intelligentsia. Being and feeling culturally suspect, they were not ready at this time of general emancipation to step forward and proclaim their own concepts based on sensibility, feelings, or visual perception. The first-generation Peredvizhniki managed only to establish the claim of artists to be a free profession and to be part of the cultural elite. Emancipated painters first had to go through a period of apprenticeship as members of the intelligentsia, with all the peculiar concerns of that group, before others would venture to pursue purely artistic goals. And that happened only toward the end of the century. In the tenor of the 1860s and 1870s, the first independent painters felt ill-prepared to speak up without the cachet of formal education and without the elaborate baggage of training in literature, history, and philosophy.

Kramskoy believed that what made Raphael truly great was his close connection with the academies and the intellectual world of Italy and never tired of preaching that learning would enable artists to express "eternal verities" and "humanity's ideals." As late as 1876 he wrote that his fellow painters were just beginning to attain the requisite level of culture:

> We, the Russian artists, are just about catching up to the point where we are not considered ignoramuses *(nevezhi)* in the eyes of the educated.... Talent is not enough.... An artist should be one of the most educated and developed persons of his time. He is obliged not only to know at what point the [intellectual] development of the day stands but also to have opinions on all problems agitating the best representatives of society, opinions that reach farther and deeper than those prevalent at the moment.[31]

It is customary in discussing the preoccupation of Russian realist painters with moral and social, not pictorial, problems to trace this predisposition to the influence of Chernyshevsky's theories that the arts not merely reflect

reality but comment and pass judgment upon it as well. In the case of the first-generation Peredvizhniki, however, what is significant is not just the intelligentsia's ideology of committed action but also the actual social context which assured it such a ready response among the painters. The fact that artists adopted the prevailing ideas partly out of insecurity might help to explain why these ideas fell on such fertile soil and their stranglehold for some thirty years. The influence of Chernyshevsky's materialist esthetics on Russian painters takes on a somewhat different perspective when seen against the background of an artistic proletariat seeking to overcome the social inequalities in the world of culture by assimilating the style of the dominant group.

The Spirit of the "Sixties"

Frequent reference to the founders of Russian realism as "men of the 'sixties' "—both by themselves and by others—has produced a misleading general impression about their political convictions. Chronologically, the first-generation Peredvizhniki were men of the "sixties" since most of them attended art school between 1857 and 1868, which coincides with the actual political span of the period of reform and renovation that swept the country after Nicholas' death (1855) and Russia's defeat in the Crimean War (1856). But placing them ideologically is not so easily done since several currents made up the spirit of the times. There was the radicalism of the young who wanted to overturn the nation's institutions; they issued proclamations calling for the establishment of a republic, and a few extremists went so far as to attempt to assassinate the Tsar. Far more widespread was the liberal impulse toward social initiative, individual liberation and the moral transformation of society. The older generation tried to achieve all this by broadening the scope of self-government and through other expressions of autonomous activity; the young, by leaving home, quitting government service and setting up communes.[32]

At first glance it would seem that the early Peredvizhniki should be classed with the political radicals, those who wanted to topple the outmoded institutions. Their bold gesture in walking out of the Academy, followed by the setting up of a cooperative workshop *(artel)*, seemed like the organization of a counter-Academy, an independent art center to rally the opposition. But when the activities of the secessionists are examined more closely in the light of what the leftists were demanding of art and artists in radical journals, the common assumption that the painters were motivated by political radicalism has to be discarded. The youthful protesters belonged with the other trend of

17

the "sixties," that of individual liberation and a diffuse dedication to the moral regeneration of society.

Another prevalent misconception about the fourteen secessionists is that their quarrel with the Academy was on the question of genre—realistic paintings of everyday scenes and contemporary subjects.[33] The Academy, it is asserted, tried to proscribe genre, while the independent-minded students were determined to promote it. More will be said later about why I believe that this issue was really secondary, but first it is germane to consider the official attitude toward genre painting at the time.

Like other Academies, the Russian *Akademiya* regarded mythological subjects and neo-classical style as the only ones fit to convey genuine beauty and other esthetic principles of High Art, a valuation it begrudged to realistic scenes of daily life. But aside from depreciating genre, the Academy did not actively suppress it within its walls or discourage it among painters at large, and during Nicholas' reign it granted fellowships and Academic titles to Fedotov and others for their scenes of bureaucratic foibles or domestic bliss. During the general change that marked the first years of Alexander II's reign, the Academy began to allow informal and contemporary subject matter more leeway. Lvov was instrumental in introducing genre classes and in letting advanced students paint scenes from everyday life. And, as mentioned above, the 1859 Statutes permitted the submission of freely chosen "popular scenes" *(narodnye stseny)*, though for the Silver Medal awards only.

But even this hold-over from the past that rated genre lower in the hierarchy of art values did not survive for long. In 1860, Perov was granted a Small Gold Medal for "A Petty Clerk's Son" *(Syn d'iachka),* a satirical depiction of a simple family watching their puffed-up son try on his first uniform, the symbol of having attained his first civil service rank. The following year Perov won the Big Gold Medal, plus a fellowship to study abroad, with "A Village Sermon" *(Propoved' na sele),* a scene in a village church where the sermon about the Kingdom of God being accessible to the poor and the downtrodden is preached to a peacefully snoring landowner, his flirtatious wife and a crowd of peasants in rags. Both subjects were Perov's own choice and contravened the 1859 Statutes. The rules became largely inoperative during 1860-63, as Gold Medals were being awarded both for pictures painted on assigned biblical or classical themes and on subjects chosen by the students themselves —such as "Broken Engagement" (A. Volkov), "Drunken Father" (A. Korzukhin), "Rest at Harvest Time" (A. Morozov), "Insane Musician" (P. Kosolap), "Engagement of a Bureaucrat with a Tailor's Daughter" (N. Petrov). As Kramskoy put it graphically, "peasant coats" *(sermiagi)* and "bast shoes" *(lapti)* made their appearance at the Academy.[34]

The new subject matter in the Academic exhibits attracted public attention. Initial comments in the liberal and radical press were sympathetic, though laconic. They welcomed the appearance of genre, "the style of paint-

18

ing to which our artists seem to be very much attracted," and noted the coolness of the public to subjects drawn from mythology and antiquity—"worlds which are quite foreign to our minds and arouse little feeling in modern society."[35] As increasingly more pictures on contemporary topics were shown at the Academic exhibits, a lively controversy developed. In the esthetic debate about the artistic merits of the realistically painted scenes from domestic and public life, conservative opinion bemoaned the disappearance of eternally beautiful forms and objected to the "photographic" rendition of streets or taverns with all their "trivial" and "ugly" details. The liberals applauded these paintings of the real Russian world, long dealt with by Russian writers, but expressed some apprehension that the new, Real Art might dislodge the old, Ideal Art altogether. They had cause to worry, for the impetuous Vladimir Stasov (whose long and vociferous career publicizing realist art started inauspiciously in 1856 with a philosophical justification of genre in an essay on Dutch painting) was from 1862 on unceremoniously consigning all preceding art—whether it was Raphael or Briullov—to the dustbin of history.[36]

Outspokenly radical demands on painters were first made abroad and not by Chernyshevsky, who is generally credited with having set the tone for the socially concerned art of the 1860s. *The Contemporary (Sovremennik),* which he had been editing since 1853, gave a perfunctory review of the 1858 Academic exhibit that displayed Perov's "The Arrival of the Rural Police Inspector" *(Priezd stanovogo na sledstvie).*[37] Depicting a tipsy official about to witness the flogging of a peasant, the picture has since been considered a landmark in the development of what is now called critical realism. Prior to that canvas, genre had been confined to social satire that poked gentle fun at the pompousness of lower officialdom or the pettiness of domestic life. But Perov's picture of the besotted official's power over a defenseless peasant could readily be taken as pointed commentary on serfdom, which by then was under general attack as an institution that affected and degraded all relationships, not only those between master and peasant. Perov's picture seemed to be painted according to Chernyshevsky's prescription, in his Master's essay on "The Esthetic Relations of Art to Reality" (1855), that art should pass moral judgment on the reality it represented.

Yet *The Contemporary* took no special notice of the canvas as the topic for didactic commentary, as soon became endemic. It would seem that political goals for art had not yet been formulated, and this, rather than timidity in the face of censorship, would explain the pallid reaction. For, within the year, *The Contemporary* was expounding a wide-ranging program of radical action for painters.

The first outright political comments on the position of artists and on the role art should assume came from Alexander Herzen and Nikolai Ogarev. Their *Free Russian Press*, printed in London and smuggled into Russia, started the radical proddings with which young artists were soon to be assailed by

university students and journals like *The Spark (Iskra)*, *The Contemporary*, *The Alarm Clock (Budil'nik)*, *Foundation (Osnova)*.

During 1858 Herzen's *The Bell (Kolokol)* began to include comments on art in its campaign to abolish serfdom in Russia. The power of the Academy and the lot of the artists were cited as yet two further examples of the absence of freedom. Herzen's obituary of Alexander Ivanov (1806-58) was, in effect, a programmatic statement in describing him as an artist who resented the servile position of painters as Court functionaries, who refused lucrative commissions in order to devote himself to his own creative work. The inference was clear: like Ivanov, who was at first inspired by religious faith but shortly before his death sought a new source in the democratic movement (Herzen claimed that Ivanov wanted to meet Mazzini), Russian artists should serve the cause of liberty.[38]

This implicit call to action was followed by Ogarev's much more explicit statement. Taking as his starting point Ivanov's tortuous search for inspiration, Ogarev spelled out in detail the goals and principles that should guide Russian artists. He called on young artists to "find the strength to curse" the evil institutions of the Empire. Painters should become actively involved in the problems of the day and "boldly bring out social sufferings." It was not enough to paint scenes from the life of the common people, the way the Dutch genrists did. Such art was acceptable and sufficient in a "free and happy" seventeeth-century Holland, but this was not "our lot." Because of the accumulated injustices and the massive inertia of their society, Russian painters had to paint "denunciatory"*(oblichitel'nye)* pictures. Ogarev placed "denunciatory" works of art on a veritable pedestal and argued their claim to approbation, even if they happened not to be of the highest quality, on the ground that such pictures were inspired by the noble aim of awakening and refashioning a moribund and unjust society.[39]

From 1859 on, probably more because of direct influence than by coincidence, radical criticism in Russia increasingly expressed the same demands as did Herzen and Ogarev.[40] With each passing year, the bell pealed more insistently that artists become committed to tearing down outmoded institutions. By 1863 the din was clamorous: young artists should break loose from Academic fetters and paint pictures that would depict "truth"[41] (which in the Aesopian language of the day meant "demand justice by exposing some malfunctioning of the Tsarist system") and make the public "think" (read "act").

The sharpest attack against the Academy appeared in *The Spark* on the eve of the walk-out by the fourteen. Written by I.I. Dmitriev (1840-67), a young literary critic and follower of Dobroliubov, it ridiculed the obligatory themes for the competitions (the character of which had not changed since Catherine's time) and the servile prospects for students (whose future was circumscribed by comfortable apartments and lucrative commissions provided

by the state) so savagely that any fledgling painter with a trace of self-respect must have flinched. Like other radical writers of the day, Dmitriev made the fact that students could not choose their own subjects a symbol of their enserfment.[42]

Dmitriev's article was the most forthright call for action to appear in print inside Russia. Without recourse to Aesopian language, without any reference to "thinking," i.e., critical, genre, he went straight to the point: paintings should evoke "energetic protest and dissatisfaction, . . . speak a language understandable to the people," and "transmit ideas and decide problems." The customary genre on sorrowful subjects, like drunken fathers or impoverished widows, was inadequate. Dmitriev called for bold canvases that would not dwell on incidentals but go instead to the heart of the matter. For example, instead of mocking the lower ranks of the bureaucracy, pictures should indicate who or what was behind their venality and corruption.[43]

Of course, Dmitriev's was an extreme statement. Only the radical fringe of the democratic camp would insist that art communicate politically useful ideas as explicitly as this. Still, his article illustrates the fervor with which the role of art in reforming Russia was discussed. And it conveys in most extreme terms the widely accepted postulate of the "sixties": the obligation of artists to participate in civic life.

To what extent did the fourteen protesters share the outlook and convictions of the revolutionary democrats? Can one say that they acted under the direct influence of the radical activists? Or were they more inclined to the ethos of moral and individual reform characterizing the attitudes of the liberal intelligentsia, which constituted the recognized cultural elite? The latter hypothesis is more in keeping with the evidence.

The gulf separating the Academy's students from those at the University, where the radicals had a large following, clearly delimits the political maturity among the young artists. All through the 1860s the two institutions, despite their geographic proximity on Vasilev Island in St. Petersburg, remained separate worlds, sharing no language in common. Memoirs of the period indicate that contacts were neither close nor easy. Art students felt more comfortable among themselves and were hesitant about seeking out their counterparts at the University. The latter were much more eager for contacts but were rather overbearing in insisting on instructing their semiliterate neighbors. Their condescension often spoiled the possibilities for genuine camaraderie.

Maksimov's experience seems to have been fairly typical. During 1863 he lived next to some university students who tried to undermine his "old-fashioned" beliefs. They challenged his religious convictions and engaged him in political discussions. The first he resented, the second he found unintelligible. "They spoke so much about the French Revolution, about the movement in Poland, about our nasty (*skvernyi*) government that my head would

spin from the strained effort to understand the meaning of conversations which were studded with foreign words [like] despotism, absolutism, prerogatives, etc."[44]

The political innocence of most art students matched their cultural shortcomings. At home they had not even had the opportunity to read the Russian literary classics, let alone the radical journals from St. Petersburg or London. Studies of the Peredvizhniki accept as axiomatic that young people all read the same works and shared common interests. They claim, in consequence, that the artists were swept up in the same way the university students were by the ideas expounded in *The Bell* and *The Contemporary*. But this line of argument overlooks the scant preparation and tenuous receptivity of the painters. None of the reminiscences they wrote of their student days makes any references either to any extensive reading of, or fascination with, Chernyshevsky, Pisarev, Dobroliubov or Herzen; their memoirs indicate instead that upon first exposure to the culture of the capital they were barely ready for the Russian classics.[45] Although university students introduced them to political tracts, the artists were not captivated by the writings of the radicals in the same way as they were by Russian literature. Maksimov has recorded that his university friends advised him to give up reading novels and turn instead to books on the French Revolution—advice he ignored.[46]

Nor were art students interested in political action. It was the university youth who supplied Herzen with news of all the important events in the capital, who distributed the illegal *Bell*, who printed revolutionary leaflets and staged demonstrations. I. N. Punina, a Soviet scholar who has thoroughly researched the relationship between the two groups, has uncovered only two rather inconspicuous instances of common action.[47] In 1858, a few artists joined university students at Alexander Ivanov's funeral; in 1859, young men from both institutions welcomed the return to the capital of a liberal and popular censor, Nikolai von Kruze, who had been dismissed from his job. Artists were conspicuously absent from the more overt oppositional demonstrations. There were numerous arrests in the student strike of October 1861, but the police records listed only one student from the Academy (a Sergei Filosofov) among the 240 detained.[48]

Art students were by no means wholly apolitical. They responded to and participated in the general awakening of the "sixties," but they did not embrace the cruder notions of artists as political activists advocated by Mikhailov and Dmitriev in parroting Herzen and Dobroliubov. To restate what has been said before, they reflected the far more widespread attitude of the period, that of the liberal intelligentsia, which saw artists in the role of teachers.

In his critique of Ge's "Last Supper" *(Tainaya vecheria),* shown at the 1863 Academic exhibit, the reform-minded writer Saltykov-Shchedrin (1826-89) conveys more than does any other piece of contemporary writing that

romantic notion of service, held by the moderate intelligentsia, which also guided the Peredvizhniki. Saltykov-Shchedrin interpreted the realistically painted confrontation between Christ and Judas as a statement about the conflict between generations and life styles, between youth and age, between those who embraced ideas and those preoccupied with petty personal cares. He commended Ge for having presented the viewer with an interesting concept, for fixing his attention and making him consider that there a,e higher goals in life beyond ordinary, everyday pursuits or time-worn tradition. The public must be prodded and reminded that much remains to be done; a "hot passion for action" must be aroused so that people would renounce complacent lives, be animated by ideals and act upon their better convictions. The action Saltykov-Shchedrin envisioned was less extreme and direct than what the radicals advocated. He did not expect painters to arouse viewers into marching out to abolish various political and social inequities. He wanted art to engender critical perceptions so that the public, instead of accepting the system blindly, would question it, consider it critically, and become concerned about transforming it.[49]

This is the spirit of the "sixties" that the Peredvizhniki, at their best, represented and lived by. They thought it a sufficient attainment, to cite but one example, that a painting like Pukirev's "Unequal Marriage" *(Neravnyi brak,* 1863), which showed an aged and wrinkled high official standing before the altar with his youthful pale bride, had shamed several elderly generals into not marrying impecunious young maidens, as gossip in the capital reported. They did not aspire to paint pictures that would transform the institution of marriage, eradicate its legal and social wrongs—as Dmitriev had demanded of Pukirev in *The Spark* article. They merely wanted their paintings to jolt people, to change their attitudes, not to topple institutions. As Repin put it:

The pictures of those days made the viewer blush, to shiver and carefully look into himself. . . . They upset the public and directed it onto the path of humaneness.[50]

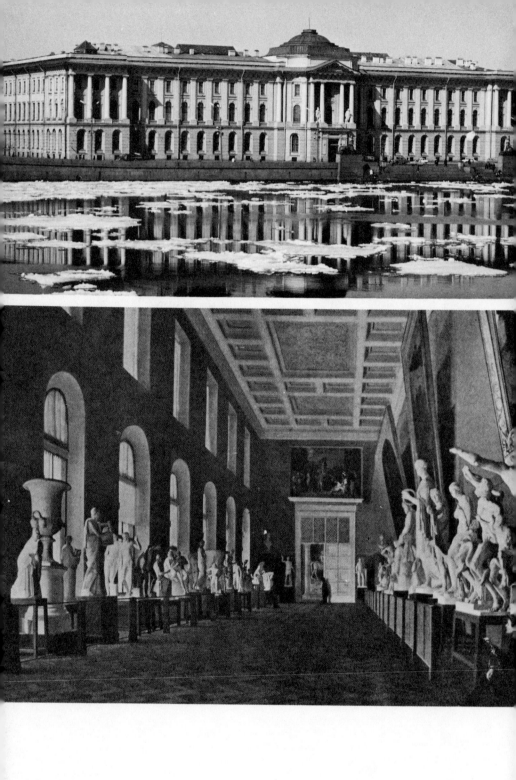

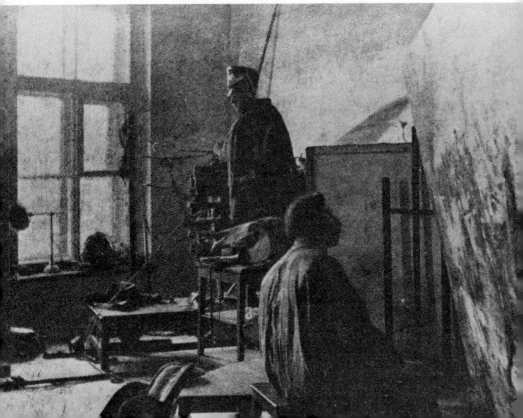

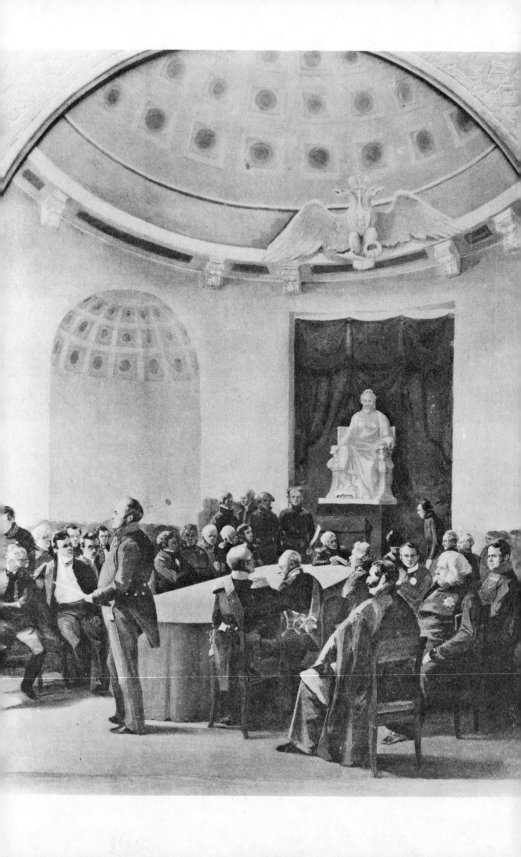

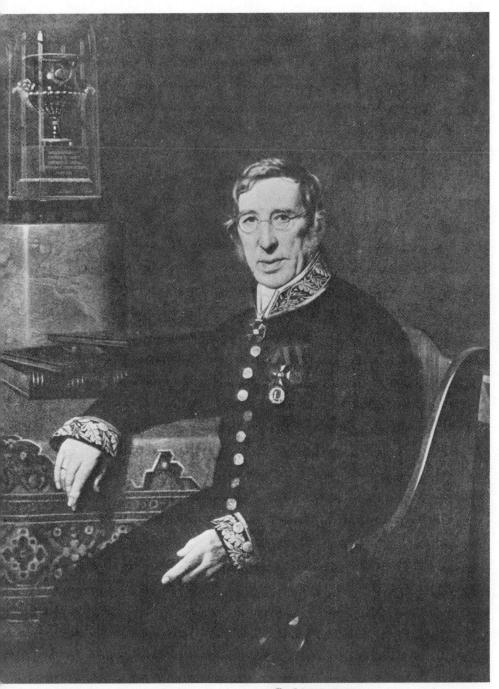

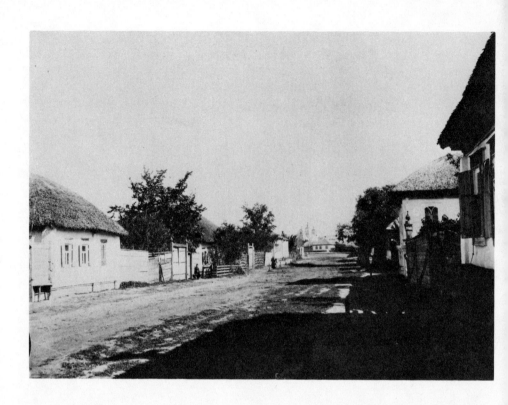

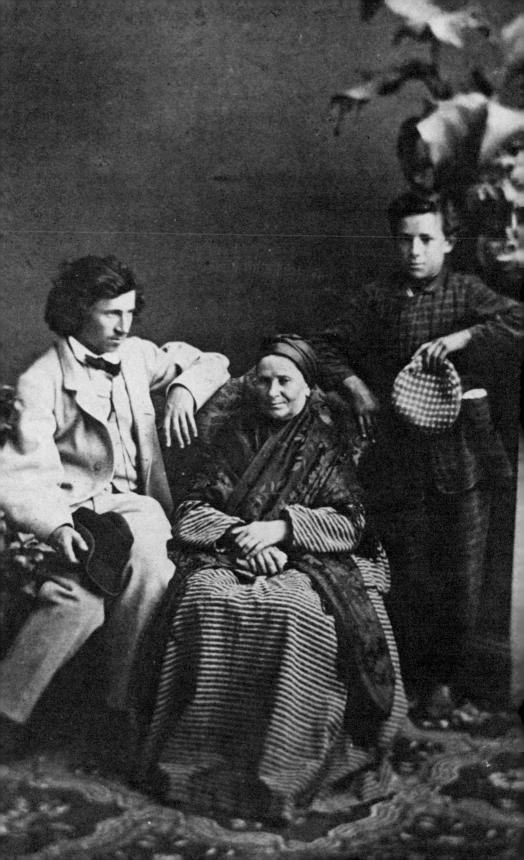

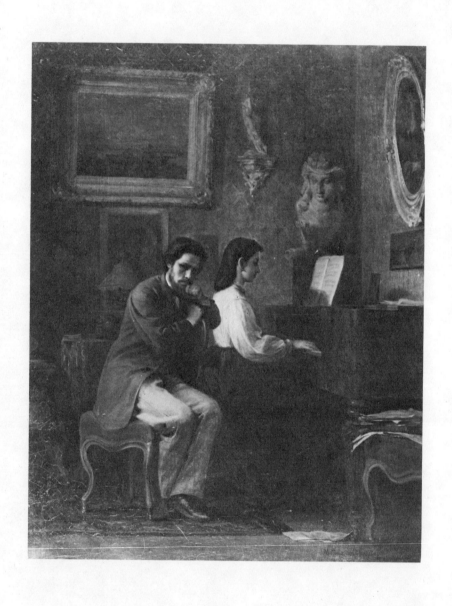

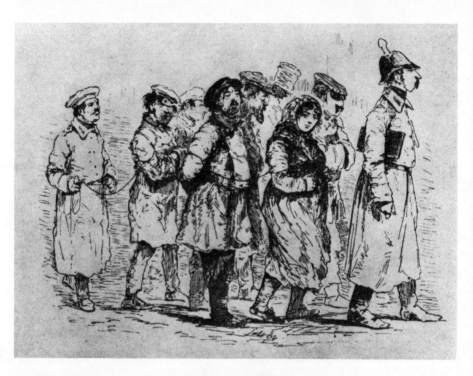

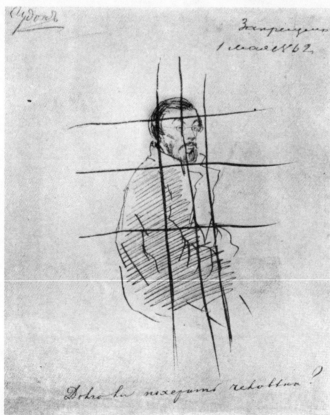

II FREE ART AND PROFESSIONAL AUTONOMY

The first organized group of Russian realists made their debut with a dramatic expression of dissent. Their secession from the Academy set the stage for the initial period of *Peredvizhnichestvo*, in which it was revered by the liberal public as free, unofficial and popular art.

In 1863 fourteen contenders declined to compete for the Big Gold Medal in affirmation of their individuality, self-determination, professional and creative independence. Their repudiation of the Academy, which, despite Lvov's efforts at reform remained a stultifying institution, expressed the liberationist mood of the 1860s, so well described by the publicist Nikolai Shelgunov (1824-91):

> We...strove for personal and social liberation and worked only for that.... We simply aimed for the wide spaces and each one liberated himself where and how he could and for what he deemed essential for himself.... The idea of freedom agitated everybody, penetrated everywhere.... Officers would retire [from the army] to set up a bookshop [or] to found a journal.... People were straining all their powers to create for themselves a new, independent situation and to transfer the weight of social initiative to themselves.[1]

Ivan Kramskoy (1837-87), the leader of the protesters, described their action in similar terms: "By 1863 I had matured so much that I sincerely wanted freedom, and so sincerely that I was ready to use all means so that others would also be free."[2]

The practice of assigning compulsory themes to students, as has been noted, had become the symbol of the artists' subjection to the Academy. Before the final competition in the fall of 1863, the issue had reached such a pass that the artists had no choice but to speak up if they wanted to redeem themselves in the eyes of the articulate public, which had been taunting them for being passive cogs in the bureaucratic machine. As a matter of fact, the top graduating painters who had been selected for the Big Gold Medal competition did petition the Academic Council a month before the examination to be allowed to choose their own topics. It is tempting to speculate that Dmitriev's attack on the passivity of artists that appeared in the October 4, 1863, issue of *The Spark* and gibes at the ridiculous obligatory program may have spurred them to action, for their petition was submitted on October 9th.

33

No definite reply was given before the students entered Catherine Hall on November 9th to face their examiners. There, they were handed a slip of paper specifying a subject from Scandinavian mythology—The Festival of the Gods in Valhalla—with detailed instructions on positioning the gods, to include moonlight, wolves, ravens, clouds, etc. The fourteen contestants refused to participate under these conditions and asked that they simply be granted diplomas and the title of Artist.[3]

It was a bold step that jeopardized their professional future and standing with the legal authorities. There was as yet no sizable private clientele, and the chances of earning a living outside the system of official commissions were precarious. Furthermore, with the onset of political reaction, any sign of insubordination to official institutions could be looked upon as subversive.[4] Indeed, the regime did not regard lightly the action of the fourteen. As it happened, they were not subjected to any punitive measures, but they were put under police surveillance—which still dogged Kramskoy nine years later. Three times in the fall of 1872, he was summoned by the police and subjected to rude interrogation. Only upon the intervention of A. V. Nikitenko, the liberal chief censor and an acquaintance, was Kramskoy's name taken off the list of suspects, where it had been placed after his departure from the Academy.

Other than their desire for freedom and dignity, the secessionists had no immediate articulated goals. Before the month was over, their hopes and ideals took form not in any specific artistic program but in the establishment of an Artel, a new form of communal living popular among the young at the time and celebrated in Chernyshevsky's novel, *What Is To Be Done?*, published earlier in 1863. In part, the Artists' Cooperative (*Artel' khudozhnikov*) was set up because of economic necessity. But the primary motivation was the desire to live a new life based on dedicated work and selfless interpersonal relations. Kramskoy was the best embodiment of that spirit. At the time of the secession he alone among the protesters was assured of a steady income, having been hired to decorate the new Church of the Redeemer in Moscow (a job for which he eventually earned the large sum of 10,000 rubles). Yet it was he who took the lead in founding the communal workshop, whose members were supposed to contribute 10 percent of their income earned independently of the Artel and 25 percent from work obtained through the Artel.[5] It was no exaggeration when he wrote to his wife: "our association, its success is dearer to me than [any] of my own undertakings."[6]

Kramskoy's vision and dedication kept the Artel going for some eight years and prevented it from becoming just a business venture. During the day, members worked at their various jobs—mostly in painting ikons or portraits from photographs and doing retouching at photographers' studios. Evenings were devoted to their own creative work, frequently accompanied by someone reading aloud. Eager to acquaint others with their style of life and their

work, the Artel held open evenings on Thursdays during which significant articles and books were read and discussed. Because of Kramskoy, these gatherings never deteriorated into mere social events. Playing cards and dancing were frowned upon, though more "innocent" games, such as blind man's buff, were played on occasions. Repin, a frequent visitor from 1865 on, considered these evenings of painting, reading and discussion his "second Academy."[7]

In their manner of painting the Artel members (*Artel'shchiki*) were not innovative or pace-setting for the times. (That happened only a decade later with the founding of the Association.) They painted contemporary subjects, predominantly scenes from the life of the lower classes, though the life of high society was also rendered. As noted in the preceding chapter, social and domestic genre had become popular with younger painters before 1863. Thus the Artel members were not breaking new ground; others also painted poor peasants, hungry children or street musicians. Like other realists of the 1860s, they painted what at the time was called genre of social or moral condemnation (*oblichitel'nyi zhanr*).

These paintings, of which Perov's "Arrival of the Rural Police Inspector" is one of the first and best examples, were patterned after the literature of exposé (*oblichitel'naya literatura*), popularized in 1856 by Saltykov-Shchedrin's bitingly satirical "Provincial Sketches."[8] The literary genre exposed various inhumanities of serfdom and the malfunctioning of a corrupt administration by describing the sufferings of the peasantry and the hard lot of the lower orders. During the 1860s, the literature of exposé had become among the liberal intelligentsia the accepted way of contributing to the reform movement, though it was sneered at as pusillanimous by radicals like Dobroliubov.[9] The Artel members, however, adopted the liberal viewpoint in depicting the misfortunes of the little people. Had they attempted the sharp, pointed political commentary that the radical critics (not altogether silenced after the reimposition of more stringent censorship in 1863) kept demanding from artists, they would have made their work the handmaiden of radical journalism and might have left a distinct imprint on the art of the 1860s. As it was, they followed the lead of liberal writers, not the radicals.

Because the Artel did not distinguish itself as a new school or trend, it made little impression on the viewing public. Critics saw no reason to single out the works of these fledgling painters. Even Stasov, who was busy promoting the fortunes of realist art, took no special notice of the Artel. And Tretiakov, who had been collecting contemporary Russian non-academic art since 1856, did not choose it for his patronage. He preferred to deal with older, more experienced painters.

It was the Artel's attempt to practice art as a free profession, to reach the public independently of the official channels, and to be accepted as members of the cultural elite that constituted the group's pioneering contribution.

35

The Artel held an exhibit and sale in their cramped quarters in the working class district on Vasilev Island; they issued two volumes of lithographic reproductions of their work; and they unsuccessfully tried to set up a larger artists' association to run a private art school but never progressed beyond giving individual drawing lessons at the Artel. The group also participated in organizing what was in effect a precursor of the traveling art exhibits in Russia. Held in 1865 at the Nizhni Novgorod fair, the exhibit was aimed at attracting new buyers among the merchants gathered for the annual event. There were about 150 canvases by the Artel members, by Academic students and recent graduates, as well as paintings by old Russian masters on loan from the Academy's museum. Although reviewed favorably in the local press, the venture was not a financial success and was not repeated in that decade.[10]

The young men also tried to enter the magic circle of public opinion-makers, but not one of their writings was ever printed in the 1860s. Right after the walk-out, Kramskoy was asked by some unnamed "literati" to write down "the words he had spoken to the Academic Council so that they could be printed." The offer must have been withdrawn, for what he produced was a very pedestrian account of all the facts but failed to convey the drama of the event or to set off its importance against the larger issues at stake.[11] Three long-winded essays that Kramskoy wrote subsequently on how to reorganize the Academy and to teach art properly also were never published during his lifetime.[12] Antokolsky's article on problems of modern art, "written under the influence of Proudhon," never reached beyond the Thursday evenings' audience.[13] And nothing came of Ivan Shishkin's plans to publish a magazine that would bring about a rapprochement between art and learning.[14] It was only in the 1870s, and largely through the energetic and often unscrupulous efforts of Stasov, that the views of realist painters on art and esthetics became known via the printed word.

In sum, the Artel was but a first, half-way stage in the liberation of art and artists. Having taken the resolute step in 1863, the protesters were forced by circumstances, as well as by their own timidity, to founder at the very edges of the official world while aspiring to be counted among the intelligentsia.

The reasons why the painters were not accepted by the cultural elite are easily perceived. Moving into the ranks of the cultured could not be engineered overnight—prejudices died slowly and it took time for outsiders to acquire the requisite attributes. As for their continued connections with the Academy, the fact that the umbilical cord was never wholly cut can be blamed only in part on poor market conditions and the semi-moribund state of artistic life throughout the country. In terms of economics, the Artel members really had no other choice; they simply had to turn to the Academy for commissions, exhibitions and even studio space. But they compromised on a much more fundamental issue—that of titles and rank. By 1869 seven painters from the

Artel had sought and received the title of Academician for works submitted to Academic exhibits.

Kramskoy realized the anomaly of this position for artists who had walked out of the Academy in protest against various bureaucratic controls violating the dignity and autonomy of the profession. Yet he lacked the courage to take an open stand on the issue. In 1863 he had vowed "never to accept or to try to gain any other title except that of Artist," and when the Academy granted him that of Academician in 1869, he requested in writing that the Council not go through with the nomination.[15] But when his request was ignored, Kramskoy did not press his conviction. A sense of burning shame remained, however. So when, in 1874, Vasili Vereshchagin published in the papers a terse refusal of the professorial title that the Academy had bestowed on him—"considering all ranks and honors in art very harmful, I absolutely reject this title"[16]—Kramskoy confessed to Tretiakov: "He did what we all think about, know about and maybe even dream about, but we lack the courage, the character and at times even the honesty to act like that."[17]

The social status of the Artel members undoubtedly had something to do with their unwillingness to reject the Academy and its titles altogether. As creative artists, they had no more liking for the civil service ratings than did Vereshchagin. But ranks and titles were then the only means by which people born in the lower estates could attain full-fledged citizenship—something that the gentry-born Vereshchagin did not have to worry about. However much they felt the humiliation that stigmatized painters as civil servants, they could not abjure the system of ranks altogether, for it did offer them social advancement and other tangible advantages.

The Association of Traveling Art Exhibits

What Kramskoy wanted the Artel to stand for—a well-known and influential organization of independent artists—became a reality only in 1870-71 with the establishment of the Association of Traveling Art Exhibits (*Tovarishchestvo peredvizhnykh khudozhestvennykh vystavok*). Despite the common assertion to the contrary, the *Tovarishchestvo* was not a direct continuation of the Artel, for it took fresh blood and bolder spirits to set up a group which embodied the ideas never fully realized by the Artel.

The *Tovarishchestvo* was born under a lucky star. Unlike the Artel, it had almost everything working in its favor: energetic organizers, well-known members, a favorable press, good patronage and a receptive public. Whereas the Artel came too early to emancipate artists fully from the Academy and

state service, the Association emerged at just the right juncture to succeed.

Grigori Miasoedov (1835-1911) and Nikolai Ge (1831-94) were both several notches above the average Artel member. They had leadership qualities based in part on the self-assurance and conviction that a gentry background and a better education could provide in nineteenth-century Russia. Furthermore, both had articulate artistic and political convictions and were ready to act upon them.

Ge, whose rebelliousness was fed by extensive reading in Belinsky and Herzen, left for Western Europe in 1857, as soon as Nicholas' ban on foreign travel was lifted, in order to find and to experience "freedom" and "broad vistas." While in Italy, he sought out Herzen, whom the other pensioners avoided for fear of reprisal from the authorities.[18] Back at the Academy for the triumphal showing of his "Last Supper" in 1863 (which immediately gained for him the title of Professor, skipping that of Academician), he became the center of dissatisfaction. So much so, that Lvov claimed that Ge's passionate advocacy of the "freedom of creativity" was one of the contributing causes to the secession that took place later on in the fall.

Miasoedov's outstanding qualities were his administrative abilities and independence of mind. He left home in 1853, against his father's wishes, to study at the Academy. An enthusiastic violinist and music lover, he became acquainted in 1856 with Mili Balakirev, who was active in the revival of Russian national music, and with Stasov, who was then better known as a literary and music critic.[19] Balakirev's opening of the Free Music School in 1862, a rival to the official Conservatory, must have spurred Miasoedov's interests in extricating painters from the excessive tutelage of the state. As pensioner of the Academy abroad, he paid close attention to the organization and conduct of artistic life in the West, especially to anything that related to professional autonomy.[20] Upon returning in 1869, he resolved to do something about the subordinate position of Russian painters. Miasoedev first settled in Moscow, where he found ready support for his plans among the local artists—Vasili Perov, Alexei Savrasov, Illarion Prianishnikov and Lev Kamenev—who were more experienced and enjoyed more recognition than the young men in St. Petersburg. They all taught at the Moscow School of Painting and Sculpture, which, despite administrative supervision by the Academy, managed to follow a somewhat different path, and all were active in the Moscow Society of the Lovers of Art, the first benevolent organization for the promotion of art to include artists along with patrons on its executive board.

In short, this group of artists represented not only energetic men of conviction but also well-known painters whose works, especially those of Perov and Ge, had received wide public acclaim as fine examples of realism. On November 23, 1869, they signed the draft Statutes for a new organization to manage art exhibits that would circulate to the major cities of Russia and sent it, with an explanatory letter, for consideration to the Artel in St. Petersburg.

It is not possible to disentangle the mixture of economic, liberationist and missionary motives that animated the painters in Moscow. Some were intent on proselytizing the new art (Ge, for example); others (like Perov) wanted to share in the admission fees to the exhibits. But all the artists wished to disengage themselves wholly from bondage to the Academy and reach out beyond the traditional patronage of the Court and the two capitals. The letter inviting the Artel to join in the undertaking stated in part:

> All of us...have agreed on a single idea concerning the usefulness of an exhibition managed by the painters themselves.... We think that there is a possibility to free art from bureaucratic control and to widen the circle of those interested in art and, subsequently, to widen the circle of buyers.

Paradoxically, it was the aim of setting out on a genuinely independent course that frightened the St. Petersburg painters. In their answer of January 30, 1870, they cautioned that it would be safer not to ask for official approval of the Statutes but to make use of the right which the Artel already had to exhibit, so as not to create the impression that this "novel venture" was directed against any other institution. This reluctance to go counter to the Academy obviously came as a shock, and Miasoedov's reply to Kramskoy verged on the sardonic. What made the proposal seem so audacious to the Artel members was, in Miasoedov's opinion, their own "fright and timidity" since the Academy had never discriminated against the secessionists in awarding either commissions or titles. Despite the forcefulness and logic of these arguments, only four members of the Artel had the conviction and courage to sign the final draft of the Statutes that was submitted to the authorities for approval in September 1870.[21]

Resolution and clear goals were evident in the *Tovarishchestvo*. Its Statutes proposed to organize traveling art exhibits to all cities of the Empire, to give people in the provinces the opportunity to get acquainted with Russian art, to develop art appreciation, and to facilitate for artists the sale of their works. Acquainting a wider public with contemporary art came first among the enumerated aims, a civic-minded purpose that was sure to elicit a respectful response from the critics and the public. They would also be assured of the independent character of the Association's exhibits, since the Statutes specified that each picture submitted for consideration had to be painted for that particular show. Membership was not open to any artist who wished to join, as was the case with the Artel, but was subject to a vote at the annual meeting upon submission of a work. Thus, from the outset, the *Tovarishchestvo* had stated social objectives and an organization to implement them. This does not mean that it functioned smoothly. On the contrary,

tensions and resignations abounded throughout its long history. But when it made its appearance, there was an air of resolve about what the group proposed to do, and this commanded public attention and respect.

The first Peredvizhnik exhibit opened in St. Petersburg on November 28, 1871, in the cavernous halls of the Academy of Arts.[22] The 46 pictures displayed were a modest number by comparison with the customary 350 to 400 entries at the annual Academic shows, but the institutional and ideological novelty of the venture was at once picked up by the press. The liberal *Cause (Delo)* welcomed "these first steps of free, creative . . . artists. . . . The traveling exhibit is the first [sic] step made for the liberation of artists from the serf-like dependence on the Academy." And *Notes of the Fatherland (Otechestvennye zapiski)* remarked that the "young talents" had spoken a "new language," hitherto characteristic of poets and writers but not of artists.[23]

For the next fifteen years the *Tovarishchestvo* and its annual exhibits were an integral part of the intelligentsia's strivings to liberate thought and activity from the close supervision of the state. The Association worked energetically to make its art "serve society"; the "thinking" public supported the Peredvizhniki wholeheartedly; and the Academy's bureaucracy combatted the new group once it recognized the full implication of its autonomous exhibits.

The pride that Russian society took in the free artists and the results it expected from their work may have been excessive, but both the pride and the hope were genuine. The tenor of these expectations is well conveyed in one emotional review that likened the Peredvizhnik exhibits to a

> triumphant holiday [at which] all existence, all people and all activities would be transformed for the better. . . . For such is the nature of fine arts . . . , [like] a fructifying rain, they irrigate the parched soil and make it come alive.[24]

Through resolute action, consonance with the liberationist aspirations of various sections of Russian society, and the growing fame of its members and their work, the *Tovarishchestvo* soon became an alternate artistic center. Kramskoy worked hard to attract the most gifted graduates from the Academy and enlist them in the Association's ranks. Despite considerable effort on the part of the Academy to discourage its students from consorting with the dissidents (in 1873, for example, Konstantin Savitsky was disbarred from the Big Gold Medal competition for having participated in the second Peredvizhnik exhibit), young painters gravitated to the Association: Maksimov joined it in 1872, Savitsky in 1874, Kuindzhi in 1875, Yaroshenko in 1876, Polenov, Repin and Vasnetsov two years later, and Surikov in 1881.[25] In varying degree they all conformed in their work to the spirit of independent creativity,

40

of civic and moral dedication—the hallmark of *Peredvizhnichestvo* in its initial creative period.

As well as recruiting talented converts, the Association sought wider recognition of its separate identity. Already in 1873, when the Academy was assembling a show for the London International Exhibit, the Peredvizhniki proposed that they themselves select pictures to represent their group. Officials duly noted this challenge to the Academy as the arbiter of what was Russian art and turned down the proposal. The rebuff did not daunt the Peredvizhniki. When the All-Russian Art-Industrial Exhibition was being organized in Moscow in 1880, they asked for a separate hall in which to hang canvases of their own choice.[26] Again they were refused.

More important, the Peredvizhniki courageously withstood the Academy's wiles and moves to re-absorb the group. Soon after the first traveling exhibit, the Academy's bureaucrats realized that the activities of the autonomous group, which had the enthusiastic support of the public, undermined their conservative views and monopolistic controls. Appropriate action was taken. In late 1872, Conference Secretary Petr Iseev wrote to Grand Duke Vladimir Alexandrovich (soon to become the Academy's President), calling his attention to the fact that exhibits by independent artists of "works nowhere else exhibited" were "dealing a blow [to the] moral and artistic" prestige of the Academy.[27] This reminder in due course moved the Grand Duke to convey to the Association his wish that it combine its St. Petersburg showings with the annual Academic exhibits and find other ways to coordinate the "aims" of the two centers.

It is to the credit, even the glory, of the *Tovarishchestvo* that the proposed merger—which, given the political realities of Tsarist Russia, was equivalent to an order—did not intimidate the group into compliance. The Association decided at its annual meeting in January 1874 to send the Grand Duke a respectful but firm reply that asserted its "right" to a "separate existence." Although the Association offered to accommodate the Grand Duke to the extent of agreeing to open its exhibits in St. Petersburg concurrently with the annual shows of the Academy, nevertheless it insisted on a separate hall and catalogue in order to preserve its autonomy.[28] When the Grand Duke decided to press his case more vigorously and summoned Nikolai Ge and Ivan Kramskoy for a personal interview, the painters did not succumb to official pressures.[29] It was an act of civic courage; there can be no doubt that the painters were risking much by not acceding to the Grand Duke's wishes. And the repercussions that soon followed (and continued for the next fifteen years) demonstrate that their refusal was not taken lightly. Although the Academy did not close down the Association, it resorted to various harassments to make life difficult for the Peredvizhniki.

Early in 1875 the *Tovarishchestvo* was curtly notified that it could no longer hold its exhibits in the Academy's halls, and the Academy's students

were expressly forbidden to show their works with the Peredvizhniki. When the *Tovarishchestvo* tried to make up the loss of good exhibition space by proposing to build its own headquarters in St. Petersburg, it met with an endless chain of refusals from the city authorities. The rebuffs were based on flimsy formalistic excuses, evidently prompted by instructions from above. For example, the mayor refused in 1880 on grounds that the *Tovarishchestvo* Statutes did not provide for "permanent exhibits."[30] But the Association's petitions to have the Statutes revised accordingly were disregarded until 1890, when the whole issue of a separate, permanent exhibition hall had lost its immediacy.

Later in 1875 the Grand Duke authorized the formation of a Society of Art Exhibits *(Obshchestvo vystavok khudozhestvennykh proizvedenii)* under the aegis of the Academy. It gave artists considerable administrative leeway in order to demonstrate to the public that the Academy was willing to divest itself of some bureaucratic controls. This "liberal" concession was also meant to drive a wedge among the Peredvizhniki. For the Conference Secretary instructed a factotum of his, one Orlovsky, to try to induce leading Peredvizhniki to join the new Society, fully expecting that if someone like Ge or Kramskoy should take the bait, the group's solidarity would be breached and others would rejoin the fold.[31] Later, the Academy attempted to undermine the popularity of the Association in the provinces. In 1885 it organized traveling exhibits of its own, and fixed the admission price at 10 kopeks below that charged by the *Tovarishchestvo* in order to cut attendance at the rival show.

Official patronage dried up after 1871. The account books of the Ministry of the Imperial Household show that while in the early 1870s the Academy bought a Shishkin painting from a *Tovarishchestvo* exhibit and Alexander II placed a few commissions with Association members, by 1876 all official purchases and orders were placed exclusively through or with the Academy.[32] These economic retaliations cannot be dismissed as insignificant. Even though the traveling exhibits became a financial success, the organization faced economic uncertainties and an uphill struggle in the early years. Middle-class patronage and receipts from the sale of tickets and catalogues[33] could not fully replace official munificence, especially Imperial orders. In the 1870s, the 1,000-2,000 rubles paid by Tretiakov for an original painting was considered a high price (it was already more than double what he used to pay in the 1860s). But the Romanov family would pay 1,500 rubles merely for a copy, and as much as 10,000 or 15,000 rubles for an original work.[34] Yet, the *Tovarishchestvo* did not capitulate, only tightened its belt and carefully guarded its financial independence. All donations by wealthy visitors were turned over to charities; painters who accompanied the Association's exhibits to provincial towns were instructed to travel in the cheaper second-class carriages; and, wherever possible, the Association tried to obtain free exhibition space.[35]

Censorship was also applied to muffle independent views about the Peredvizhniki and dampen the enthusiastic support of their art among the public. In January 1878 the Minister of the Imperial Household and the Academy's Conference Secretary were instrumental in having *New Times (Novoe vremia)* discontinue publication of Kramskoy's long essay, "The Destiny of Russian Art," after three installments. His criticism of the Academy's disregard for the creative rights of students, they held, was "seditious": it would undermine "respect for their teachers" among the students and the public's confidence in government institutions.[36] Both officials so aroused the suspicions of the Academy's President with their warnings about the subversive nature of the Association that he requested the censors to suppress Adrian Prakhov's acclaim of Peredvizhnik art in the illustrated magazine *The Bee (Pchela)*. The Grand Duke was convinced that Prakhov's commendation transgressed even the most lenient interpretation of what constituted the permissible range of liberal criticism. As a result, Prakhov's outspoken reviews were first censored, then the publication of *The Bee* itself was suspended, and finally Prakhov himself was dismissed from his lectureship in art history at the Academy.[37]

The Independent Exhibits

Although the founding of the Association was spurred by a mixture of motives (not all of them idealistic), and it became prestigious and commercially successful (there were no other truly independent shows until the 1890s), the fact that the traveling exhibits functioned outside the bureaucratic framework earned it the loyal support of many segments of Russian society. The original image of the Peredvizhniki as knights-errant of a free art that served and instructed the nation was formulated by the liberal intelligentsia, but it was later picked up by other groups to express their own strivings and dissatisfactions.

Saltykov-Shchedrin's review of the first Peredvizhnik exhibit conveys best the expectations of the liberals. As in his review of the Academic exhibit in 1863, he chose a canvas by Nikolai Ge as springboard for his discussion of topical problems. Ge's "Peter and Alexis"—the confrontation between the determined Tsar-reformer and his sullen son—represented for Saltykov-Shchedrin the opposition between two outlooks, two policies: the one fully cognizant of Russia's pressing and continuing need for renovation and change; the other, tradition-bound and totally unsympathetic to this effort, unwilling to carry it on. Saltykov-Shchedrin interpreted Ge's picture as an expression of fears pre-

43

valent among many thoughtful Russians that the Great Reforms of the "sixties," most of which offered partial solutions to political and social problems, would be left to stand incomplete and that the process of transforming Russia into a more equitable state under the rule of law would wither because of indifference at the top and absence of pressure from below. He saw the mission of Peredvizhnik art as an auxiliary to the reform movement. Even his satirical gibes were meant to reinforce this argument: the Peredvizhniki should paint, say, a provincial judge performing his duties under a statue of Apollo so beautifully rendered that its perfection would dumbfound officials, inhibiting them from ever again accepting a bribe.[38]

As public issues changed and new preoccupations engrossed Russian society, so did the commentary on the traveling exhibits. By the late 1870s the question of reform lost its topicality and realist art was no longer exclusively treated as a spur to social change; it began to be discussed more in terms of its native idiom. Moderate liberals and the middle class endorsed the Peredvizhnik canvases as genuine Russian art based on national themes and compared it favorably with the cosmopolitan pseudo-classicism promoted by the Academy. Although these nationalist sentiments diluted the civic-mindedness that had hitherto been the distinctive feature of the traveling exhibits, still the public's response was meant as a criticism of the regime's policies and as an assertion that all that was good or popular in Russia was developing independently of and despite the autocracy. This is why the Academy's President, Grand Duke Vladimir Alexandrovich, was so upset with Adrian Prakhov's reviews. In writing of the selections for the 1878 International Exhibit in Paris, for example, Prakhov berated the Academy for bypassing the Peredvizhniki, for ignoring what had been the most popular art since 1863 and sending instead of their "deeply committed" canvases the uninspired, bland samples of official pseudo-classicism.[39]

The middle class also came to regard the traveling exhibits as the vehicle of genuine Russian art and in a less explicit way demonstrated its preferences. When the Academy prevented the Association from presenting itself as a separate group at the 1882 Moscow arts and industries exhibit (it purposely scattered some 100 Peredvizhnik canvases among 428 samples of "official" art on religious or classical subjects and Mediterranean genre scenes), the city's entrepreneurs privately printed a catalogue on contemporary Russian art that was exclusively devoted to the Peredvizhniki.[40] The reproductions included many well-known Peredvizhnik works that had roused much discussion but did not appear at the exhibit. There was Ge's "Peter and Alexis," which Saltykov-Shchedrin had analyzed in terms of the liberals' aspirations; Repin's portrait of Vladimir Stasov, the most outspoken critic of Academic art; and two pictures of decidedly anti-clerical character: Konstantin Savitsky's scene of opulent clergymen displaying an ikon while presenting a collection box to poverty-stricken peasants, and Ilya Repin's judgment on the indif-

ference of the clergy in his portrait of a gluttonous member in minor orders. In this seemingly innocuous, roundabout way, middle-class society in Moscow was stating what it considered to be representative of Russia's art.

In art criticism, too, Academic and traveling exhibits were reviewed in terms of polarities. Although after the 1860s art criticism increasingly became the domain of professionals trained in art history and esthetics, rather than of writers and political commentators, the essentially political juxtaposition of the two trends in Russian art persisted. For instance, Ippolit Vasilevsky (1850-?), who from 1875 commented on the St. Petersburg scene under the pseudonym "Bukva," almost always reviewed the Academic and the *Tovarishchestvo* exhibits together in order to point up the differences. When the Peredvizhniki were at the height of their technical skill and ideological influence, his reviews equated their shows with "all that is new, young, inquisitive, striking with life, thought and talent," and described the Academic exhibits as "inept, colorless, flat...and mediocre" performances.[41] As the Association's professional and ideological standards began to slip, Vasilevsky did not hesitate to denounce the sloppy brush work, the poverty of conception, and to express apprehension about the convergence of the two art centers. And when that did happen, the critic liked to remind his readers of what the *Tovarishchestvo* had once represented:

> The Association had taught artists genuinely and seriously to understand and love the Russian people, Russian nature, the Russian way of life, Russian society with its worries and adversities.... On the other hand, it taught our public to love and understand our painters.... The Peredvizhniki proceeded from the position that our art can unite and organically combine beauty and excellence of execution with a certain clarity and maturity of thought.[42]

Russians in the provinces were among the most enthusiastic supporters of the traveling exhibits. Here, however, the common notion that the Association brought art to the "people" has to be qualified. Its exhibits were neither intended for nor ever reached the Russian peasantry and the working class. Unlike the populists of the 1870s, the Peredvizhniki did not go to the rural areas where 80 percent of the population lived in poverty and squalor; they never "soiled their hands" in actual contact with the rural masses.[43] But they did introduce art to the provinces—to the educated provincial elite, to be more exact.

The traveling exhibits did yeoman public service in popularizing art and enlivening cultural life outside the two capitals, not only in the 1870s but well through the succeeding decades. When one considers how limited artistic life in the two principal cities of the Russian Empire was by comparison with that in Western Europe—even as late as 1880, they held but two or three art

exhibits a year—then one can imagine what backwaters the smaller cities were when the *Tovarishchestvo* brought them their first public art shows ever. The appearance of the Association's exhibits in the provincial towns roused great interest in art, even if its appreciation was primarily on the level of "civic commentary." If the first Peredvizhnik exhibits created much interest and excitement in Moscow and St. Petersburg, there was an even livelier response in provincial cities where the local intelligentsia was no less agitated by the problems of reform. (The memoirs of Vladimir Korolenko (1853-1921), a humane and liberal writer who spent his youth in southwestern Russia, well convey the often naive spirit of dedication to the betterment of public life that prevailed in the 1870s. He recounts a poignant story of his journalist brother who felt triumphant when his reports to a St. Petersburg newspaper about the negligence of the local administration led to the repair of a street lamp."For a while it burned and shed light in honor [of the power] of publicity," and everyone who passed it at night shared his conviction in the force of public opinion.)[44]

Among the receptive provincial viewers, the Peredvizhnik exhibits were the main subject of conversation and press commentary for many weeks: "When the exhibits came, the sleepy provincial towns at least for a short period got away from cards, gossip, boredom and breathed the fresh currents of free art. Discussions and disagreements arose on themes over which the citizens had never thought before."[45] Everywhere the traveling exhibits stirred up much comment of a socio-political sort. But while the press in the capitals often would go beyond the message of a canvas and criticize adversely the technical skill of the painter, the provincial reviewers tended to interpret Peredvizhnik art simply for the light it shed on the path of progress. Frequently, the canvases would be discussed solely in terms of the social issue at hand; an Odessa paper commented as follows on Konstantin Savitsky's "Repairing the Railroad" (1874)—a group of peasants at work, fashioned after Repin's "Boat Haulers":

> It is known that our workers keep building and building railroads but not to ride on them.... We do not even have to talk about the hardships of their work, about the frequent cases of illness among workers who are made to toil in the middle of empty steppes.... All this has made the railroad workers a problem, an evil of the day, an interesting social question. And here Mr. Savitsky treats that subject in a number of marvelously expressive figures that fill his entire picture....[46]

This type of civic-minded response prevailed much longer in the provinces than it did in the capitals. Thus in 1883 someone could write in Kiev:

The tenth Peredvizhnik exhibit, as the preceding ones, can be a cause

for rejoicing for friends of progress.... Russian art is working in unison with the progressive wing of the Russian press and society. Having been nurtured...on the same soil and in the same atmosphere, it concerns itself with the same worries and strivings that inspire Russian progressive literature. Humanism is the most outstanding trait of contemporary Russian art.[47]

This ready and simple appreciation of the moral messages and social commentary was much prized by the Peredvizhniki. Miasoedov in 1887 contrasted it approvingly with the criticism of the Moscow and St. Petersburg reviewers "who did not understand art and its mission."[48] And Stasov repaid this loyal support with flattery:

> Our provincial press...has outdistanced the press of the capitals, because it sincerely and naively enjoys what is talented, healthy, truthful and fresh in the pictures of our new artists, and is not hampered by [any] retrogressive [i.e., purely esthetic] notions.[49]

Proud of its role in the provinces, the *Tovarishchestvo* extended the circuit of its traveling shows. To the original four cities, St. Petersburg, Moscow, Kiev and Kharkov, eleven more had been added by 1897: Tula, Yaroslavl, Tambov, Odessa, Kursk, Elizavetgrad, Poltava, Saratov, Kazan, Vilna and Warsaw. And even if the provincial exhibits suffered financial losses, as they often did, the leadership insisted that it was the moral duty of the Association to enlighten the outlying districts, despite the costs involved.[50] Furthermore, the Peredvizhniki jealously guarded their mission. One reason for their refusal in 1874 to join the Academy of Arts in a combined exhibit was that this would "disorient" the provinces. In other words, it would erase the line dividing the official from free art and deprive provincial society of the opportunity properly to distinguish and interpret Peredvizhnik pictures.[51]
Another factor that helped the Peredvizhniki to capture the esthetic and civic sensibilities of the provinces was the founding of the first art schools and museums by the loyal supporters of their trend. Kiev was a good illustration. In 1875 Nikolai Murashko (1844-1908), a close friend of the first-generation Peredvizhniki, set up the first art school in this sizable provincial capital when it had no art museum and fewer than a dozen professional artists. For the next twenty-five years the Peredvizhniki remained the school's guiding spirit. In Murashko's words:

> The arrival of a traveling exhibit was a holiday for us. I demanded that the students not only look at but carefully study the works of masters.... [They] would visit the exhibit early in the morning, before the public, to make small pencil and brush sketches.... Our students...owe

much of their development to these exhibits. Without a museum or a permanent exhibit, this was the only artistic stimulus besides that of the school itself.[52]

Murashko's initiative was supported by the Tereshchenko family, the local sugar-beet magnates. Ivan Nikolaevich Tereshchenko (1854-1903) readily donated part of his fortune to open the school. And Kiev's first public museum was formed mainly from the collection of Fedor Artemovich Tereshchenko (1819-1903), in which the Peredvizhnik canvases, particularly those by Ge and Shishkin, predominated. This pattern was repeated in many other towns, especially in southern Russia, which had experienced an economic boom after the Emancipation. Public museums were filled with paintings bought from the traveling exhibits or painted in imitation of the Peredvizhniki by local artists. In addition, the Association generously donated its members' works to help build up provincial collections—a gesture of public service in awakening the artistic life of the country.

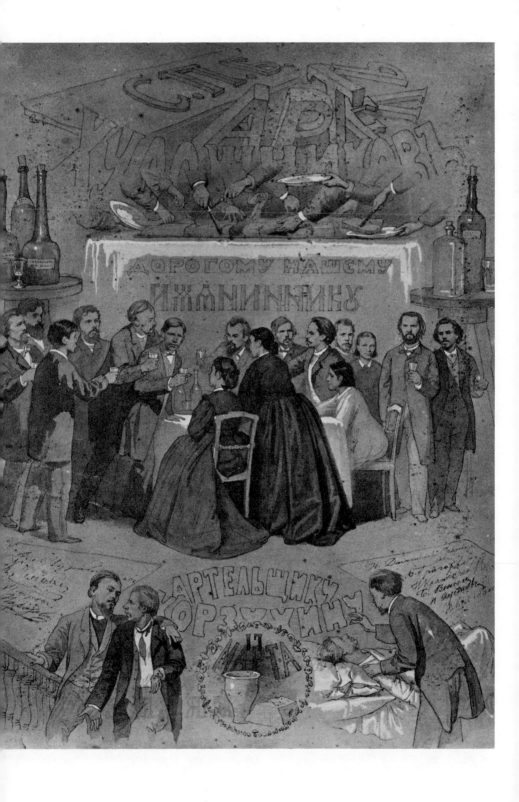

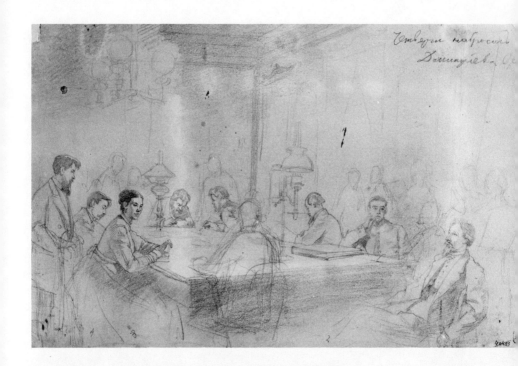

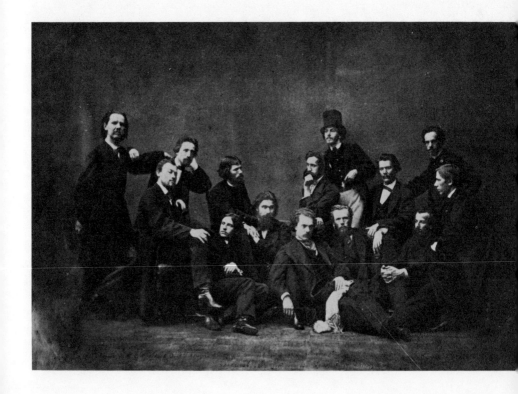

How nationalist were the realist painters, in the sense of working to create a distinctive, peculiarly Russian style that would *ipso facto* be superior to Western art? Many Peredvizhniki themselves by the 1880s and most of the later commentators (both in Tsarist and Soviet Russia) interpreted the whole movement in these terms. But a historical survey of *Peredvizhnichestvo* makes it clear that such narrow nationalism was not the motivation in the 1860s and 1870s. The chauvinistic elements were grafted onto *Peredvizhnichestvo* at a later date.

Non-esthetic issues were very much part of the turmoil on the artistic scene during the 1860s, but a conscious purpose to juxtapose the new realist Russian art to contemporary European art was not one of them. When the early Peredvizhniki chose to concentrate on Russian subjects, it was their way of participating in the general surge of national renovation, of demonstrating their recently acquired independence and of asserting the new role for Russian art. Immersion in domestic concerns was not seen as the basis for creating a Russian school that would outshine others or feed national pride. Nevertheless, the fact that the realism of the Peredvizhniki was defined in terms of national preoccupations facilitated its evolution into a narrowly defined national school.

When public discussion around 1860 touched upon the state of the fine arts in Russia, many critics pointed out that the Academy was turning out inferior painters whose work fell below West European standards and lagged far behind developments abroad. Several liberal commentators blamed the isolation that Nicholas had imposed on the country after the 1848 revolutions as being in part responsible and suggested that a better knowledge of the West was one way toward improvement. To them, re-integration with Europe, where a variety of trends and expressions flourished, would enable Russian art to break loose from the monotonous routine it had fallen into. For example, Karl Gerts, commenting in 1860 on the new Statutes of the Academy, ascribed the sorry state of art to excessive isolation:

> One of the causes of the backward state of present-day Russian art is, without a doubt, its ignorance of present-day European art [and] its main trends.... Acquaintance with modern art in the West would open new paths...and would be most beneficial for our artists from the

technical side.[1]

He advocated the introduction of courses in foreign languages and in the history of Western and modern art, the better to acquaint Russian artists with the outside world.

Another critic, L.M. Zhemchuzhnikov, likewise advocated a more extensive knowledge of the West and foreign travel:

> Europe is making great strides, while we remain Old Believers.... In Europe, fashions and gods in art change all the time, [while we] live in a small motionless world and [isolate] ourselves from the rest by a Chinese wall.[2]

Both men practiced what they preached. They were active in the Moscow Society of the Lovers of Art, which, through exhibits and scholarships, aimed to raise Russian painting to the contemporary European level, and Gerts' lectures on art at Moscow University covered recent trends abroad.

The consequences of isolation were also sensed by many artists, though not as keenly as by the critics. Kramskoy had relinquished his chance to study abroad on an Academic fellowship by walking out of the Big Gold Medal competition, but he did go abroad in 1869 as soon as he could afford to do so on his own. As his letters to his wife show, he was full of curiosity. Even though many things in the West, from the deportment of women to some of the art, baffled this provincial, nevertheless he did not defensively seek justification for his cultural shock by reference to some superior virtues that distinguished Russia from Europe. When Mrs. Kramskoy asked whether the trip had been worthwhile, his answer was a definite yes, for not to have seen all he had seen would have been a "real shame."[3]

What Western artists and influences did the Russian realists respond to? The question is not an easy one to answer. Primary sources are scarce, and thus far the extent of foreign influence on the nascent Russian realism has been little studied.[4] In general, however, one can discern what the public, tired of Academic art, favored and what the budding realists were partial to. The best Russian collection of contemporary European art, that of Prince Kushelev-Bezborodko, mainly covered French art from 1830 to 1850 and contained fine canvases by Delacroix, Millet, Corot, Rousseau and Courbet.[5] When the Moscow Society of the Lovers of Art held its first exhibit in 1861, it leaned heavily on the Düsseldorf school. But by 1868, its shows included Biedermeyer genre and Barbizon landscapes.[6]

However, neither these artists nor schools were openly acknowledged by the Russian realists as being a formative influence. Antokolsky, who had studied at the Academy as an auditor during 1862-68, indicates that they disdained the painstaking, sentimental German landscape and genre and were

avid for a glimpse of the "chic" French art. They knew it only from photographs and engravings, but even these imperfect reproductions produced a thrilled response:

> Good God, what a happy time it was for us! We glued ourselves to these photographs with a passion and trembling that only young hearts can possess. We especially got to love Gérôme, Meissonier, and, chiefly, Delaroche. How much feeling in his works, what drama, and how deeply he touched us. How much poetry in Gérôme, what a reflection of the Far East and what mystery in Meissonier.[7]

When the Kushelev-Bezborodko collection was donated to the Academy and put on public display in 1866 in a separate gallery, it became a mecca for inquisitive students. However, it was not the now-acknowledged French masters that the students "devoured." Antokolsky lists the following as being their "beloved": Troyon's picture of early morning, Meissonier's small canvas "The Smoker" ("dressed in red that shone like a ruby"), Ary Scheffer's "Faust," and Delaroche's "Cromwell at the Tomb of Charles I." Clearly, the young Russians, eager for "fresh air" from the West, responded to Salon realism marked by a heavy rhetoric; they were attracted by its facile virtuosity and its dramatic content. In the 1870s, when the art of the Peredvizhniki took on definition, its adherents flocked to Paris where they gushed over the international luminaries like Fortuny, Munkacsy and Knaus, in addition to the names already singled out by Antokolsky.[8]

The first-generation Peredvizhniki showed no marked interest in the innovative trends in the West. To be sure, it was well-nigh impossible at that time to get acquainted with these currents in Russia itself—there were few illustrated publications and Russian collectors of Western art had very conventional tastes. Yet when Russian painters went abroad, they showed little or no interest in the controversial new art. Vasili Perov was in Paris in 1862-64 during the episode of the *Salon des refusés,* which "reached the proportion of a public scandal," yet in his writings and work there is no "hint that he was aware of the position taken by Courbet, Manet, or Whistler."[9] During his 1869 trip, Kramskoy visited only the well-known museums—like the Dresden gallery or the Louvre—and made no effort to search out the studios of working artists. He had read Proudhon's *Du principe de l'art et de sa destination sociale* in 1866 (just after it was published in Russian translation) and was so taken with its message that he re-read some passages many times and argued that it would benefit Russian artists to "learn by heart all that [Proudhon] has to say."[10] Yet he made no attempt to seek out Courbet, who was praised in the book as a "critical" and "humanitarian" painter. Inability to speak any foreign language undoubtedly prevented Kramskoy from being more venturesome. But the source of his timidity probably went much deeper. A meager

general cultural background and an unease with the ways of the world deprived him of the curiosity and resourcefulness to look for like-minded innovators, let alone painters like Manet, whose handling of color and light was under discussion in France by then.

Though the West was not rejected or belittled, the seeds of cultural chauvinism were present and, given favorable circumstances, could sprout from a vague sense of difference and inferiority into full-blown theories of superiority. The relevance of European experience was questioned at times. Some painters, like Maksimov, considered going abroad altogether unnecessary for their own development. Instead, they turned to what might be called field study trips at home. At first, around 1860, these were summers spent in the countryside near St. Petersburg, but the range soon extended to the colorful Ukraine. By the end of the decade, trips down the Volga were favored, that taken by Repin in 1870 to learn about the boat haulers being the best known.

Others would either delay their departure for Western Europe on the Academic fellowship (as Repin did) or, like Perov, cut short their stay abroad. In petitioning for permission to return home after two years in the West, Perov explained that as a painter of scenes from daily life he could not work in France: "Lack of knowledge of the character and the moral life of the people makes it impossible for me to finish any one of my works." He had found working in a foreign country "less rewarding" than study of the "immeasurably rich subjects from urban and rural life in our fatherland."[11]

Not all the painters who went abroad were as impressed with European variety and vitality as were the more sophisticated critics. Many experienced cultural shock when they first left familiar ground. When Zhemchuzhnikov recommended foreign travel to widen the horizons of Russian artists, he conceded that "the disorder, absence of discipline, the constant tearing down of idols,...thousands of artists each following his own way,...his own views" might frighten his compatriots. But at the sime time he warned against lapsing into easy abuse of the West and its ways as a device of self-defense.[12] Since a negative response to the bewildering welter of trends and opinions abroad was recognized at that time for what it was—a crude cover-up for one's ignorance —the painters did not indulge in it. During his 1869 trip, Kramskoy was balanced in his praise and criticism: in Paris he had seen many "extraordinary things in painting, in color," though few that "moved his soul." But he did not dwell or theorize on what met with his disapproval, as became the fashion later.

Another, and perhaps more compelling, reason for this respectful attitude toward Europe was the prevalent pro-Western spirit among the reform-minded public in the 1860s and through much of the succeeding decade. To the extent that the realists wanted to be part of the intelligentsia and to participate in its work of national renovation, they were guided by the same ethos that animated the pro-Western purveyors of enlightenment (the *prosve-*

titeli), so well personified by Potugin, a character in Turgenev's novel *Smoke* (1867). He would fulminate against "Russian self-educated rough diamonds" who disparaged the West, and gave the following advice to a young friend returning home after completing his studies abroad:

> Every time it is your lot to undertake any piece of work, ask yourself: Are you serving the cause of civilization in the true and strictest sense of the word; are you promoting one of the ideals of civilization; have your labors that educating, Europeanizing character which alone is beneficial and profitable in our day among us?[13]

But later, the attitudes of many liberals toward Europe changed and so did the painters' outlook. What was once considered a failure to comprehend a more advanced and complex culture came to be lauded as a specific Russian virtue.

Vladimir Stasov

The activities and writings of Vladimir Stasov (1824-1906) contributed a large share to fitting Russian realism into a nationalistic mold. Among critics it was he, more than anyone else, who created the public image of *Peredvizhnichestvo* during its first phase—and for much of Soviet historiography as well. Because Stasov has been so widely accepted as the pre-eminent spokesman for the Peredvizhniki, it is necessary to examine how faithfully he represented the views of the painters and the extent to which he foisted his own opinions on the group.

At the time of the secession Stasov was well known as a writer on literature, music and, more recently, on art. During the 1850s his views on art shifted from an admiration of the grand Academic style to the advocacy of social genre, which he saw as a sign of changing times throughout Europe. There was at first nothing original about his writings on realism. They reflected the current utilitarian esthetics that elevated content above form and the intelligentsia's desire that the new non-Academic art convey a sense of critical urgency about the country's problems. But in 1862 a different note appeared in Stasov's essays and set him apart from other liberal commentators. He began to promote a native Russian school of painting and to define its elements. During that decade and part of the next, his was not a widely accepted view. Eventually, however, the emergent cultural nationalism among the moderate intelligentsia caught up with what Stasov had been advocating, and a pro-

nounced strain of chauvinism also appeared in Russian realism.

It was Russia's participation at the Third International Exhibition, held in London in 1862, that galvanized Stasov into an ardent proponent of native art. This first Russian appearance at an international forum was not a success. (Russia had not taken part in either the 1851 or 1855 world fairs, first because Nicholas had put a tight lid on contacts with Europe after the 1848 revolutions, later because of the Crimean War.) In his report from London, Stasov felt he could not evade what one English critic, Francis Taylor, had written: "It is curious to see at the Russian exhibit a collection of all the various influences under the weight of which Russian art has developed to its present, very inferior level."

The condescending reception in the West stung Stasov to the quick and led him to add another theme to his perorations. As well as his initial concern for an art that would serve civic purposes with its "truthful" rendering of reality, he now proposed another goal: an autochthonous Russian realism sharply differentiated from what obtained in Europe. Only by underscoring its Russianness, he argued, would the art of his country win due recognition in the West. His emotional review of the Russian canvases shown in London attributed the dismal failure to an "absence of a defined national style." The remedy he prescribed: "return to the national path." For, as soon as Russian painters would start depicting daily life in the city and countryside, the peasant and merchant types, the unique Russian landscape, then "we shall become appreciated."[14]

Stasov's preoccupation with national distinctiveness henceforth tended to blur and confuse his arguments. Realism no longer had the single "civic-minded" purpose; Stasov began to press for both the national *(natsional'nyi)* and the popular *(narodnyi)* spirit in painting. He wanted art in Russia to be "national," in the sense of being readily identifiable as different from French or German painting. (At this stage, Russian art had only to be different; during the 1880s it became *ipso facto* superior.) And it also had to be "popular," in the sense of representing the life of the common people and awakening a greater understanding of their plight among other classes of the population. The two elements were inseparably mixed in most of Stasov's arguments, as he never considered them incompatible; and it is pointless to isolate either one or the other as predominant in his thought.[15]

It should be noted, however, that Stasov's promotion of a national school of painting—though in some ways it presaged the Russophilism that became the hallmark of *Peredvizhnichestvo* during its decline and in Stalinist historiography—was at first an integral part of the liberals' campaign to bring enlightenment, legality and public participation into Russian life. For Stasov, art held in thrall to the Court and its needs signified not only the enserfment of painters to an unpopular regime but also the imposition on Russian art of the foreign models favored by the Court. While most men of principle fo-

cused on the first aspect, Stasov was concerned about both enserfment and imitation. What now may seem like xenophobia was in Stasov's case an ardent protest against the controls exercised by the Court and high government circles which, until the reign of Alexander III, were more French and German than Russian in language, habits and outlook.

Further, for Stasov, the return to the national path was not coupled with any blind veneration for things Russian. He did not propose to base Russian painting on native traditions nor did he regard the common folk as the source of poetic or moral values.[16] In his insistence that the Russian school be distinguishable by its depiction of contemporary types and issues, by looking at the people *(narod)* only from the social side, by seeing the Orthodox faith as one of the main pillars of the autocratic system, Stasov was wholly within the tradition of the Westernizing reformers. In their view, the "people" and their mentality were symbols of Russia's ills—political, cultural and social. The *narod* had to be brought out of its isolation and backwardness so that the country could be transformed. From Belinsky on, the radical and liberal publicists derided any infatuation with popular tradition—which they identified with bast shoes, long linen shirts, illiteracy and ignorance—and warned that the "passion for the past" was nothing but an obstacle to change.[17]

To what extent did the Peredvizhniki share Stasov's views on the primacy of topical content, the need to keep to Russian subjects, and a distinctly national art? Unquestionably, they valued and needed his unfailing support. No other critic promoted the young realists as loyally, vehemently and doggedly as did Stasov, who from the first exhibit of the *Tovarishchestvo* proceeded to act as their self-appointed spokesman. As a fledgling group, they let this established member of the cultural elite speak on their behalf. But his relations with Repin (and to some extent with Antokolsky and Kramskoy) indicate that Stasov expended not only his energies but also considerable cunning to create ("shape" would be a more exact word) a certain public image that did not always correspond to the painters' preferences and aspirations. In fact, he did not hesitate to distort their views in order to promote his own vision of a Russian school of painting that was both national and civic-minded.

Stasov must be given the credit of having launched Ilya Repin (1844-1930) in 1871 while still a student at the Academy. The concluding sentence of Stasov's review of the first Peredvizhnik exhibit advised readers to be sure not to miss another hall in the Academy, where the works of graduating students were being shown, and to look at the "wonderful" picture by Repin—"The Resurrection of Jairus' Daughter."[18] From then on, Stasov lauded Repin as the outstanding artist of the new Russian school, industriously promoted his renown in these terms and held him to the "right" path. Repin appreciated the backing of such an influential person and repaid the support with genuine devotion, which at times included putting up with Stasov's

doctrinaire opinions.

The first skirmish over Repin's artistic allegiances took place in 1873, when his "Boat Haulers" *(Burlaki)* was shown at the Academic exhibit. Stasov praised the canvas for its deep immersion in "national life and popular interests," and its author for being a "powerful artist and thinker." He saw the picture as a representation of the latent force of the people and pointed out that among the submissive and broken-down crew of older haulers there was a youngster who, by straightening up his back, was indicating his protest and opposition to the hopeless resignation of his fellows.[19]

Probably the most telling riposte from the conservative camp—which by now tolerated scenes of contemporary life but resented tendentious treatment—came from the pen of Dostoevsky. He had gone to the exhibit expecting to see a didactic picture, assailing the conscience of the upper classes. But Dostoevsky was pleasantly surprised, and praised "The Boat Haulers" in the reactionary weekly *The Citizen (Grazhdanin)* as a talented canvas that did not scream at the spectators: "Look how unfortunate I am, and what indebtedness you incurred to the people." Then he went on to lecture " a certain dear critic...that every artistic creation without preconceived tendency, produced solely because of the artistic urge, dealing with strictly neutral subjects, hinting at nothing tendentious...will prove much more useful for that [critic's] purpose than, for instance, all the songs of the shirt."[20]

Repin was not in the least disconcerted that two such prominent writers were quarrelling about the purport of his canvas—this served to call attention to it. But Stasov feared that sudden recognition of Repin's genius, even among the conservatives, might go to Repin's head and lead him to abandon ideologically tinted realism and paint "solely because of the artistic urge." On top of it all, Repin left shortly after the opening of the exhibit for a three years' Academic fellowship abroad, where there were many more temptations to lure the impressionable young man away from Stasov's influence.

And indeed, once Repin settled in Paris and quickly got over the initial cultural shock that made him scoff at the unfamiliar ways of the West, he began to write Stasov positively alarming letters about the lightness and grace of the French, the Gallic ability to find beauty in everything, the variety of artistic trends. He fell under the sway of the Velasquez fashion, started by Manet, and acknowledged that there was "something" to the Impressionists.[21] Gradually he began to paint for the pleasure of it, setting aside a canvas depicting the legendary Sadko in the underworld kingdom and turning to Parisian café scenes and French landscape. He was happy with the novelty of the situation and especially with the freedom from the "analytical urge" that so obsessed painters in Russia. In the fall of 1874, Kramskoy, who also worried about Repin's allegiance and had been keeping in touch with Stasov about their mutual friend, received the following letter:

I have now quite forgotten how to reflect and pass judgment *(rassuzh-dat')*, and I do not regret the loss of this faculty which used to eat me up; on the contrary, I would rather that it never return, though I feel that back in my dear fatherland it will claim its right over me—that is the climate! May God...save Russian art from corrosive analysis. When will it force its way out of the fog?! It's a misfortune which terribly fetters it to barren accuracy in...technique and to rational concepts in ideas, drawn from political economy. How far removed poetry is in such a situation! But it's a transitional period; a lively reaction is taking place among the young generation [which] will produce things full of life, force and harmony.... The new things will be painted with warmth and color....[22]

Something drastic had to be done to bring the straying protégé, whom the opposing camp of uncommitted art was ready to claim, back to the straight and righteous path of critical realism. Lest the change in Repin's views become public knowledge and possibly lead to his defection, Stasov published, without Repin's permission, excerpts from his letters from Italy and Paris in the illustrated weekly *The Bee*, along with a reproduction of "The Boat Haulers."[23] It was flagrant dishonesty, calculated to fix in the public mind Stasov's view of Repin as a civic-minded Russian artist, which bore little resemblance to the painter's changeable convictions at the time. By deceptive editing and quotation out of context, by drawing chiefly from the early letters, the impression was conveyed that Repin disliked the mannerism of the old Italian masters because it had de-nationalized Italian art, that he disapproved of the contemporary Western search for form at the expense of content and its indifference to "life" (i.e., moral or civic problems), and that he preferred to work in Russia where artists were "consumed by reflection."

In the way Stasov had distorted them, Repin's views appeared simplistically extreme and created revulsion among intellectuals of varying political opinion. Repin was quite upset when he found out about the article and remonstrated in letters both to Stasov and to Kramskoy.[24] But only upon realizing the full extent of the public furor when he returned to Russia one year later, did Repin compose a rejoinder to set straight his views and to exonerate himself. Naive man that he was, he sent the announcement to Stasov, of all people, with the request to help place it in *New Times*. Naturally, Stasov did not do so. Instead, Stasov's own diatribe against Repin's critics appeared in the January 8, 1877, issue of the newspaper.[25] The article was mainly concerned with refuting critics like Adrian Prakhov, who, on the evidence of Repin's exhibit in St. Petersburg in the fall of 1876 (at which both the Russian "Sadko" and the Parisian "Café" were shown), held that Repin had the talent to paint with equal facility and expertise any subject, whether it was the

Volga boat haulers or high society. In his eagerness to prove beyond all doubt that Repin was a civic-minded painter devoted above all to Russia and its problems, Stasov grasped at any argument, serious or silly. For example, he berated Prakhov for interpreting "Sadko" as the temptation of a Russian youth by foreign sirens, arguing with aplomb that the picture showed Sadko choosing the figure representing Russia, just as Repin himself had done.

Stasov treated Mark Antokolsky (1843-1902) in a similar manner, but without much success. He had "discovered" the young sculptor in 1865, supported him, guided his education and promoted his career. Antokolsky managed to escape Stasov's grip, in part because he resided abroad much of the time. As early as 1872, he revolted against his mentor's dictates and declined to work on a statue of Pugachev, the peasant rebel: "I no longer want to spoil other people's nerves with my art, to rouse bile *(zhelch)*...and hatred among people. This is the consequence of tendentiousness [in art] and I have given it up...."[26] But Stasov kept up his hopes and pressures for another decade. Only in 1883 was he forced to admit defeat and to concede that Antokolsky had ceased to be "our Russian sculptor" and the "representative of the plebs and democracy."[27]

Stasov tried to channel Kramskoy's thinking as well. The first attempt in 1876 was a failure. Despite quite pointed suggestions that Kramskoy expand his "Slavophile" comments on how young Russians could provide a fresh stimulus to the overripe French art,[28] the painter never produced an appropriate programmatic statement. The essay on "The Destiny of Russian Art" *(Sud'by russkogo iskusstva)* that appeared in the nationalist *New Times* did not, despite its ambitious title, deal with the esthetic, philosophical and historical foundations of the new Russian school.[29] It argued that artists should be completely liberated from the still existing controls exercised by the Academy so that national art could flourish. Kramskoy did not specify any components of "Russian art" but laid stress on creative freedom, which indicates that he saw the problems of artists in the liberationist spirit of the 1860s, a point of view that did not altogether correspond to Stasov's.

It was not until after Kramskoy's death in 1887 that Stasov again attempted to present him to the public as the philosopher of Russian realism. Within a week after the painter's death, everybody was busy gathering his correspondence and writings for an anthology Stasov proposed to publish. When the material was assembled, Stasov wrote Tretiakov that he had discovered Kramskoy to be a first-rate art critic—a bold, independent and original mind that the rest of Europe would envy—adding a revealing note about his own motivation and methods: "I am proud that it will be I who will be the first to announce this for all to hear, and I hope that I shall prove it."[30] This momentous discovery was communicated to the public in three lengthy articles on Kramskoy and in a collection of his writings.[31] But not everybody would agree with Stasov's strident characterization of Kramskoy as another Belinsky

in the world of art, as "our first and best art critic," as a fighter for democratic and national Russian painting who had always considered purely artistic goals as secondary. M. Stasiulevich, the editor of *The Messenger of Europe (Vestnik Evropy)*, accepted the first two articles but refused to publish the third on the grounds that Kramskoy's random thoughts could not and hence should not be reduced to dogma.[32]

No one could prove how biased Stasov's selections were, since almost all the sources were in his possession.[33] But many challenged his assessments. Some pointed out that Kramskoy's writings did not amount to a well-thought-out system but were merely his immediate and varied responses to questions as they arose. Others discounted the acuity of Kramskoy's views, arguing that he never rose above "expressing elementary truths." Still others, and quite rightly, pointed out that during the last years of his life Kramskoy had become more interested in matters of technique than in content.[34]

With characteristic disregard for any opinions other than his own, Stasov dismissed the other critics as "idiots," and urged Repin to complete his reminiscences of Kramskoy as a teacher, undertaken at Stasov's suggestion. When the memoirs appeared in *Russian Antiquity (Russkaya starina)* in 1888, Stasov's hand was visible in those sections which ascribed to Kramskoy a concern for national art all the way back to 1863: "The protest of the young [i.e., the secession] had a deep national basis." The memoirs attributed the following words to Kramskoy—words that ring true in terms of Stasov's chauvinism, quite pronounced by the 1880s, but certainly not to Kramskoy's beliefs in 1863:

> It is time to think about founding our Russian school, [our] national art.... I believe that our art is a slave of Western art. Our present-day task, the task of Russian painters, is to be liberated from that slavery.[35]

That Repin, one of the most liberal Peredvizhniki, accepted so distorted a version of the original aims of the movement was symptomatic of much more than just Stasov's powers of persuasion. It demonstrated the degree to which Stasov himself, the painters and a large segment of the intelligentsia had, over the course of twenty-five years, become caught up in cultural nationalism.

Tretiakov and the New Patronage

Middle-class patronage did much to infuse Russian realism with a na-

tionalist ethos. As elsewhere in Europe, the Russian bourgeoisie was turning away from the pseudo-classical art of the Academy and the Court in defining a distinctive role for itself in the cultural life of the nation.

The first capitalist patrons of realist art were for the most part centered in Moscow which, since the days of Peter the Great, had retained its own traditional identity in contrast to that of the Westernized St. Petersburg. By the 1850s the scions of the city's leading business families hardly resembled the uncouth boors depicted in Ostrovsky's plays about the despotic, patriarchal life of Russian merchants—a world Dobroliubov and others described as a "kingdom of darkness." The new generation did not attend the university but received sufficient education from tutors to develop lively interests in the theater, literature and art. They met regularly in one another's homes to read books, discuss ideas and make music. Yet the Tsarist officialdom and the nobility continued to treat the new entrepreneurial class as inferiors. As late as 1873 the Governor of Moscow did not feel constrained in viciously reprimanding in public the middle-class chairman of the city Council *(Duma)* for not appearing in proper uniform at some official function.[36] As for the gentry, it confined contacts to business deals. No nobleman would ever dream of extending a dinner invitation, for it was "known" that members of the "merchant class" *(kuptsy)* were apt to use table napkins as handkerchiefs.[37]

The cultural interests of the moneyed bourgeoisie were equally suspect. When the noted legal historian Boris Chicherin (1828-1904) returned to live in Moscow in the early 1870s after an absence of almost twenty years, he noted a profound change in the art scene: formerly, the wealthy nobility who had traveled or served abroad set the tone, and their collections contained Renaissance and eighteenth-century art. Now, it was the *nouveaux riches* industrialists who collected contemporary art. To Chicherin, the collections of the brothers Tretiakov, of D. P. Botkin, and of K.T. Soldatenkov were not a welcome diversification of national culture but signified the general deterioration of artistic taste and standards.[38]

In many cases, though by no means all, there was a strong admixture of ethnocentrism in the undertakings of the young entrepreneurs.[39] It was generated in part by a reaction to the condescending treatment from representatives of the aristocratic culture, in part by an identification with the ancient capital of Russia whose history and monuments were a constant reminder of the old traditions, in part by scant familiarity with foreign languages and culture, and a feeling of resentment toward cosmopolitan St. Petersburg which favored Western investment and wantonly adopted foreign ways.[40] There were two separate plans in 1860 to found a public art museum in Moscow, which testifies to the self-assertiveness of the city's haute bourgeoisie and its ambition to rival St. Petersburg. The Society of the Lovers of Art, founded by middle-class patrons, proposed to open a public art gallery. Pavel Tretiakov drafted a will at the age of twenty-eight in which he specified that some

150,000 rubles (almost half the capital he then possessed) be used to set up a museum of Russian art—the first one in the country.[41]

The patronage of Pavel Mikhailovich Tretiakov (1832-98) exemplifies the nature and measure of the identification that existed between realist art and the rising entrepreneurial class. Because his support for non-Academic art challenged the Court's monopoly over patronage and taste, liberals and revolutionaries always had an affectionate regard for his Gallery, tending indulgently to overlook his highly conservative views.

Tretiakov came from an old merchant family and personified the recent economic as well as cultural evolution of his class.[42] He and his brother Sergei multiplied the considerable family fortune by re-equipping the textile mills in Kostroma with modern Western machinery and expanding the firm's marketing facilities in Moscow. They began collecting art in the 1850s: Sergei liked Western Salon art; Pavel, too, at first bought the Dutch school. But after seeing in St. Petersburg the F. Prianishnikov collection, unique in its day in being almost entirely composed of Russian paintings,[43] Pavel switched his interests to Russian art. As he quickly discovered, recognized masters commanded higher prices than he was ready to pay; consequently, he settled on collecting contemporary works and bought his first picture by a young graduate of the Academy—N. G. Shilder's "Temptation" *(Iskushenie)*—for 150 rubles in 1856. Soon his collecting became a factor of importance for Russian art and an avocation that instilled Pavel Mikhailovich with a sense of patriotic mission and responsibility. Four pictures from his collection were chosen for the London Exhibition in 1862,[44] and the Academy elected him to honorary membership in 1868 in recognition of the support he rendered "to our national talent."

Other Moscow industrialists—notably Vasili Alexandrovich Kokorev (1817-89), Kozma Terentovich Soldatenkov (1818-1901) and Gerasim Ivanovich Khliudov (1821-85)—had been collecting the works of living Russian artists and supporting young struggling realists. It was Khliudov who bought Perov's ground-breaking "Arrival of the Rural Police Inspector" in 1857; and Soldatenkov gave Perov a small stipend in 1861 to enable him to attend the Academy in St. Petersburg. None of them however, acquired any lasting fame or had the same impact as did Tretiakov. For one, their holdings were smaller, not exceeding 250 paintings; when Tretiakov's collection was given to the city of Moscow in 1893, it contained 1,757 items. Nor were the other collections associated with the names of the original owners, being dispersed after their deaths. Third, they were all formed before 1870 and did not grow, the way Tretiakov's did, with the success of the new school and talent.

Tretiakov's intention to create a gallery of national art became generally known when his private collection was transferred from his residence into an adjoining building, begun in 1872 and opened to the public two years later. In effect, it was the first museum to be devoted entirely to Russian art,

since the only other public museum in the Empire, the Hermitage, was almost exclusively given over to foreign masters. And even though Tretiakov was a retiring person, extremely shy of publicity, the tenor of the times was such that his project caught the public imagination and received enthusiastic, even jingoist, endorsement. It inspired several other industrialists to start similar galleries in other cities, notably the Tereshchenkos in Kiev.

Tretiakov bought by far the most pictures at the first Peredvizhnik exhibit. From then on his massive patronage not only gave the Peredvizhniki economic support (between 1871 and 1897 he spent the enormous sum of 839,000 rubles on purchases); it also associated their work with an enterprise of national importance. Tretiakov's commitment was so strong, his dedication so steadfast, that he inculcated much of the same devotion to the cause among the painters. Time and again the Peredvizhniki would sell him their works at a lower price than that offered by some other buyer because the canvas would hang in a "national" gallery. They would even donate paintings to him; in 1875, for example, Ge proposed to give five of his portraits of well-known Russians to the gallery of national celebrities Tretiakov had started in 1869.

Though both Stasov and Tretiakov, each in his own way, did so much to promote the Peredvizhniki, their views on the national school did not coincide. Tretiakov had a far broader concept of that school. For Stasov, in his narrow partisanship, genuine Russian art had emerged only in the 1850s with "national realism." In contrast, Tretiakov's approach was historical. Once he could affort it, he started collecting everything: medieval ikons, eighteenth-century masters, renowned names of the early nineteenth century, as well as works of living artists. This was also the outlook of the Peredvizhniki, who helped him locate the old canvases and acted as go-between in negotiations. For instance, they all appreciated Karl Briullov (1799-1852), against whom Stasov was waging a vendetta because he held this fine painter to be personally presponsible for the perpetuation of Italianesque academic style in Russia.

But the Peredvizhniki were broad-minded only so far as the past was concerned. When Tretiakov wanted his collection to cover all contemporary trends, they were less tolerant. The Peredvizhniki were not content to consider themselves as merely one of the current trends in Russia. Their original dedication and subsequent success turned their heads, and as time went on they increasingly sought to monopolize artistic expression in Russia, to gain preeminence as *the* Russian school. In this endeavor and conceit they were heartily encouraged and supported by Stasov, but not by Tretiakov. The great collector had close personal relations with most Peredvizhniki; many spent summers at his country estate, and all were frequent visitors in his Moscow home. But, in matters artistic, he would not identify exclusively with any one group. In 1878 Tretiakov refused to finance a network of Peredvizhnik art schools to popularize their way of painting and to combat the persisting influence of the

Academy.[45] He also turned down their request to construct a separate Peredvizhnik pavilion for the 1878 Paris International Exhibition, which they wanted to set up because the Academy had slighted the group in its selections for the Russian section.[46] Both times, Tretiakov justified his refusal by his commitment to the overall collection—which foreclosed any such costly partisanship. Pavel Mikhailovich's cool selection of what was best on the market early struck Kramskoy as a heartless calculation, and he wrote half-reproachfully to the patron: "I have always been intrigued...by one question—how such a genuine lover of art ever developed in you? I know...that is is very difficult to love with one's mind."[47]

There is another reason why Tretiakov could never wholly commit himself to the Peredvizhniki. His sense of mission was founded primarily on nationalistic and artistic values; he never had the moral-social convictions which the painters had carried over from the "sixties." Even though as a group the Peredvizhniki were certainly not radical (ranging from the conservative Maksimov and Shishkin, through the quite moderate Kramskoy, to the left liberal Repin, Ge and Yaroshenko), nevertheless, taken together, they were more liberal than Tretiakov, who was a conservative and deeply religious man with strong Slavophile sympathies.[48] Like other rising entrepreneurs, he had his quarrels with the bureaucracy, but he retained a patriarchal respect for the existing order. His promotion of a Russian school of painting was prompted by an ethnocentric outlook, not by any desire to reform autocracy.

Tretiakov regarded his collection as a national museum, not as a repository for the progressive aspirations of the best minds of the nation—which was the view held by the liberal Peredvizhniki and the intelligentsia. The portrait gallery of outstanding public figures, most of them painted by the Peredvizhniki, points up the collector's aims. Portraits of men like Nekrasov, Tolstoy or Mendeleev were then, and still are, cherished as inspiring models—as "ikons" of a sort—that convey the spirit of steadfast dedication to the cause of the "people," to literature, to learning and science. (This is why Ge had offered to donate a unique likeness of Herzen he had painted from life.) But Tretiakov's choices were not limited to these stars in the liberals' pantheon. Also included were Dostoevsky, whose conservative definition of "Russian individuality" Tretiakov shared wholeheartedly;[49] Ivan Aksakov, whose promotion of Russian interests among the Balkan Slavs received Tretiakov's moral and financial support;[50] and the arch-reactionary journalist Mikhail Katkov.

When requested to paint Katkov, Repin was struck by the inappropriateness of this man's likeness in the Gallery and he tried to dissuade Tretiakov:

You'll bring a shadow to your beautiful and enlightened collecting activity.... What sense is there to place among men like Nekrasov, Tolstoy,

Shevchenko...a portrait of someone who for so long and with such a passion has been attacking every worthy thought, who despises every free word?[51]

Repin's letter expressed the strongest protest from a liberal-minded member of the *Tovarishchestvo* to their most important supporter. There is evidence that the Peredvizhniki, in their early days, found the middle-class patronage a burden. Kramskoy confessed to Repin at one point that he too was dreaming of the day when artists would be completely free, unencumbered by the "merchants"; he fully understood Repin's complaints about unwelcome pressures from the "quagmire...of merchant freaks *(boloto...urodov kuptsov)*."[52]

However, no Peredvizhnik ever charged Tretiakov openly with misconstruing their goals or cramping their style, and he quietly whittled away at their penchant for tendentious canvases. Even though he claimed indifference to content, he disliked excessive political commentary. Thus he refused to purchase a painting depicting Belinsky being visited shortly before his death by a police inspector, not because it was a poor work but because of the subject—the persecution of free, enlightened thought.[53] He was also unwilling to acquire Nikolai Yaroshenko's "Student" *(Kursistka)*—a prototype of the committed populist youth—until Stasov persuaded him that it was not a political statement but an excellent rendition of a typical young woman of the times, worthy of hanging in a gallery representing the development of Russian art, society and culture. He disliked Repin's picture of the returning exile, "They Did Not Await Him," and bought it only on Stasov's insistence, stipulating, however, that Repin repaint the face of the suffering and exhausted man—which the artist did readily enough.[54]

Tretiakov's preference for landscape was another factor in diluting the original Peredvizhnik ethos. Already in 1857, Tretiakov had written a young painter that instead of lush growth, grandiose composition and the effects of light, he wanted "simple nature," even the most unassuming scenes, but painted with a feeling for "truth and poetry, [because] poetry should be everywhere."[55] This was the type of landscape he supported generously in the 1860s—Vasilev, who died prematurely, was his protégé—and in the 1870s the poetically rendered Russian landscape became a hallmark of *Peredvizhnichestvo*. And even though the reform-minded liberals scorned these paintings since they contributed nothing to the "cause," the Peredvizhniki kept producing them in great numbers, for such canvases always found ready and generous buyers.

Religious pictures of purely devotional content were also turned out because of the patrons' preferences. The Peredvizhnik tradition at the outset had been to paint religious themes only in so far as they touched on moral issues—this was Kramskoy's approach—or to expose the venal side of the

67

Church as an institution—as did Perov, Savitsky and Repin. Yet, in time, quite a few members of the *Tovarishchestvo* supplied devotional pictures of the revered saints in the Orthodox calendar for many prominent collectors. Tretiakov's devout faith was well known to the painters, and the further fact that he would pay more for a painting on a religious subject. Thus, Perov received 2,000 rubles for his "Bird Catcher" (1870) and 8,000 for his "Nikita Pustosviat" (1881), the representation of a saintly hermit.[56] Since Perov did not undergo a religious conversion, the many religious pictures he painted late in life can be ascribed to this financial factor.

To the extent, then, that the critical approach persisted among the Peredvizhniki, it was mainly due to the influence of the intelligentsia and the survival of the ethos of the "sixties," and not to the tastes of affluent middle-class patronage.

Populism and Neo-Slavophilism

In the beginning, only a small segment of society regarded realist art as a significant element in national culture. During the 1870s fresh currents—populism and the nationalistic wave that engulfed the intelligentsia when it took up the cause of liberating the Balkan Slavs—generated different attitudes toward the common people and the country's problems. The resulting peculiar blend of liberal cultural nationalism contributed to a turn-about in the fortunes of realist painters and their work. Peredvizhnik art, now seen as reflecting a broader range of issues, gained popularity among a much wider public.

The change in the outlook of the intelligentsia that occurred around 1870 created an entirely new framework for the artists—one that provided a much more hospitable atmosphere for people of humble origins. The spirit of reform and criticism in the 1860s was premised on the belief that educated people, the custodians of intellect, were the chosen ones to perceive and promote the new moral, humane and rational order. Knowledge provided the means to overcome conservative traditions, to transform outdated institutions. This conviction was the basis for the sense of superiority and mission among university students and other intellectuals and for the ready acceptance of this elitism by the young realist artists.

During the 1870s the political hopes of the intelligentsia had shifted. As Russia pliantly accepted Alexander II's incomplete reforms, the intellectuals came to realize that their own efforts had been insufficient to engender a strong and lasting impetus to change. In consequence, they looked for and

found another social group that would bring regeneration—the peasantry, the *narod*. Not the educated elite, but the masses would be the vehicle for the realization of justice on earth. The university-educated now began to look with respect at the virtues of people of lowly birth. The former arrogant condescension—well characterized by Pisarev's phrase, "the fate of the people is decided not in the village schools but in the universities"[57]—was replaced by admiration, often uncritical, for the uncorrupted human, moral and institutional qualities of the *narod*. In the words of one liberal writer:

> Everyone recognized that in those peasant masses there was ripening or perhaps had already ripened some *Word* that would resolve all doubts.... Faith in the people gave our aspirations a kind of wide, vital foundation, something that the previous generation of realists had lacked.[58]

Populism *(narodnichestvo)* had its political and cultural aspects. Politically, it counted on the revolutionary potential of the masses and in 1874 led to a trek of university students to the countryside to awaken that sleeping giant, the peasantry, either through social work or political propaganda *(khozhdenie v narod)*. When the movement was stifled by numerous arrests, the young radicals turned in 1876 to forming revolutionary circles—Land and Freedom *(Zemlia i volia)* being the best known—and the following year, to political assassinations. The cultural aspects of populism had many more and much longer-lasting ramifications. They ranged from novels idealizing the virtues of the peasantry to ethnographic, philological and historical studies of peasant life and culture, all tending to laud the unspoiled character of the Russian folk and its autochthonous institutions (the peasant commune, the *mir*). In either case, the masses instead of being the object of condescension suddenly became the object of respectful attention, even veneration.

This changed status of the people on the intelligentsia's scale of values had a profound effect on the Peredvizhniki. Personally, they no longer had to feel ashamed or apologetic about their origins. Their canvases depicting the everyday life of the people rose in general esteem, being valued for showing the intrinsic virtues of the Russian masses. Both the painters and their work spoke with greater conviction and assurance concerning the cultural life of the nation. A passage in a letter by Kramskoy reflects the newly-acquired self-confidence:

> My views may seem provincial...but it does not worry me in the least... [for] opinions and sympathies of provincials are decisively more healthy and even more progressive than those of the capital cities in all that concerns the main aspects of national life: economy, education, justice and much else. Yes, who keeps things moving *(kto dvigaet delo)*? The capitals? You're wrong—the provincials who come to the capitals be-

69

cause they know well that life which has to be changed, [because] they carry within themselves the conscious demands of what should be done and how. And only such genuine people as provincials can get anything worthwhile *(putnoe)* accomplished.[59]

Stasov, it should be noted, frowned upon such excessive populist self-confidence. In one of the essays he wrote about Kramskoy after his death, he stated that the painter had a number of erroneous views, one of them being that the opinions of "simple, unsophisticated people, who had been ignored until then," had to be taken into consideration.[60] But this was an isolated opinion. Public and critics were ready to acknowledge the importance of painters precisely because of their humble origins. For example, Adrian Prakhov wrote in 1878 that because the Peredvizhniki had come from the "depth of Russia" and from the lower social classes, which had been the least "de-nationalized," they could paint such marvelous and meaningful pictures of their country.[61]

The upsurge of patriotism and ethnic feelings that greeted the revolts of the Balkan Slavs against Turkish rule introduced a note of strident nationalism into the vocabulary of the moderate and liberal intelligentsia. The Herzegovinian and Bulgarian uprisings of 1875 and 1876, followed by Serbia's declaration of war against Turkey in defense of fellow Slavs, aroused vociferous response among the Russian public, the liberals no less than the reactionaries. Support of peoples fighting their oppressors was natural for the liberals. What made this cause even more attractive was the fact that the Tsarist government at first maintained a neutral stance in the conflict (it moved against Turkey only in April 1877—nine months after Serbia did). Thus, support of the national liberation movement in the Balkans fitted neatly into the intelligentsia's traditional frame of reference—acting in opposition to the government.

However, since the conservatives, for their own reasons, were also backing the cause, the well-marked line that had separated conservative from liberal opinion became indistinct. At times allegiances were completely switched.

Here, the transformation in the views of the liberal publicist Alexei Suvorin (1834-1912) is instructive. During 1876 he lost interest in championing the extension of political and personal liberties within the framework of non-bureaucratic local government (the *zemstva*) and an independent judicial system—a program containing seeds of Western legalism. By year's end, Suvorin's newspaper, *New Times,* backed Russian expansion in Central Asia (the Khanate of Kokand was annexed in 1876), advocated Russia's mission among the Southern Slavs, and coupled both with ridding Russia of excessive dependence on the West. To Suvorin, this was "not only a question about the liberation of the Slavs but also a question of our liberation from the foreign yoke that lies on us like a heavy weight." He pressed for the annexation of the Dardanelles, because "as long as we have only the Baltic Sea, we will for-

ever sit only by the window to Europe and pay dearly for the light that comes through it."[62]

Suvorin's transformation was symptomatic of the nationalism that infected a large segment of the intelligentsia. His militant *New Times* became the favorite newspaper of both the conservative and the liberal interventionists, while journals which either questioned or opposed Russia's protection of the Southern Slavs *(Notes of the Fatherland* and *Cause)* found their circulation dropping markedly.[63] Nobody seemed to heed Saltykov-Shchedrin's admonitions that excessive preoccupation with the Balkans channeled energies away from domestic issues and left unattended the crying need for further reforms at home.[64] The short stories of Vsevolod Garshin, a populist writer and close friend of Repin and Yaroshenko, which expressed doubts about the relevance of the war to the cause of the people, found no response either.[65]

The Peredvizhniki were swept up in the general enthusiasm. Neither their actions, correspondence nor canvases showed any qualms raised by the anti-interventionist writers. Antokolsky and others donated their works to auctions for the Herzegovinian or Bulgarian causes. Konstantin Makovsky, after traveling in the Balkans, painted an emotional picture entitled "Bulgarian Martyrs" *(Bolgarskie muchenitsy)*, which was widely exhibited and reproduced to help rouse public indignation. Polenov joined other Russian volunteers in Serbia. Kramskoy believed that "not a single war of the nineteenth century has involved such humanitarian reasons" as did the Serbo-Turkish war.[66] When Russia finally declared war against Turkey, there was a nationwide euphoria—a sense of exaltation that the largest Slavic power was at last assuming its historic mission—and Repin called it "our war."[67]

It was Vereshchagin, close to the Peredvizhniki in his views about the didactic role of art but never a member of the Association, who painted *the* denunciatory picture of this war. Entitled "All is Quiet at Shipka" *(Na Shipke vse spokoino)*, it showed the solitary figure of a poorly-clad and half-frozen sentry keeping a lonely watch in a snowbound field. The subject was enough of an indictment of the sufferings of the common soldier. But the title leveled another charge, namely, the scandalous conduct of the commanding officers who through graft and oversight had deprived the fighting men of proper food, equipment and clothing. This was public knowledge, for there had been an investigation of the scandal which the general in charge tried to squelch with a bland telegram that stated: "All is calm on the Shipka front."[68]

No Peredvizhnik painted such an unequivocal condemnation of the war. At best, their canvases only partially touched upon the hardships endured by the common people. Savitsky's "To the War" *(Na voinu,* 1880-88 but conceived in 1876) depicted the joyful and sorrowful scenes of soldiers bidding their goodbys before boarding a troop train. As for Repin, he painted both a proud soldier recounting his exploits to a wide-mouthed audience ("He Returned," *Vernulsia,* 1877) and a maimed but decorated veteran trudging wear-

ily on crutches along an empty country road ("The Hero of the Last War," *Geroi minuvshei voiny*, 1878).

The intelligentsia's involvement in the populist movement and its support for the Balkan cause had a much more profound effect on *Peredvizhnichestvo* than bolstering the painters' feeling of self-assurance and adding patriotic themes to their repertoire. It started the process of dissociating Peredvizhnik art from the cause of reform and laid the foundations for its Russification. From now on, the Russianness of realist art was increasingly conceived not in terms of what it meant in the 1860s (discussion of domestic issues in order to transform the country so that it could measure up to general European standards), but in terms of lauding, preserving, studying what was native, *sui generis*, or praiseworthy in the country as it was. This process gradually turned *Peredvizhnichestvo* into an art that had a much wider general appeal and meaning since it could be "dear to every Russian heart."

The re-alignment and general confusion in the allegiances that had demarked various groups since 1860 were noted by contemporaries. The strongly liberal *Cause* put its finger on what had contributed to blurring the distinct lines that had hitherto separated liberals from conservatives, why "strange bedfellows" were now appearing everywhere. Conservative Slavophiles like Fedor Dostoevsky and oppositionist populists like Nikolai Mikhailovsky were advocating the cause of the "Russian people." And even though their political premises were fundamentally different, nevertheless both publicists were propagating ideals represented by the Russian *narod* and juxtaposing them to those of Europe. The similarity between some aspects of the Slavophile and populist rhetorics undercut the hitherto strong identification of reform with a rapprochement with the West. The movement to the people, the newspaper argued, had replaced the "movement toward Europe," which since the days of Novikov in the eighteenth century had sustained and guided all persons who wanted to introduce concepts of truth and justice—wise and humane concepts, worked out by the best minds of the civilized world but hated and derided by the "old, moribund, routine, reactionary and moldy elements of the ignorant [Russian] public under the cover of national tradition *(narodnost')*."[69]

The fears expressed by *Cause* were most applicable to the fine arts, for the greatly increased public interest in the Peredvizhniki around this time was strongly tinged with Russophilia. By 1875 Adrian Prakhov, originally an advocate of pure art forms in his lectures on Western art, became interested in Russian realist painting. As art editor of the new illustrated magazine *The Bee*, he was instrumental in popularizing the Peredvizhnik *oeuvre* through numerous reviews and reproductions. But Prakhov's appreciation of *Peredvizhnichestvo* derived from entirely new premises. The aim of the magazine, subtitled "Russian Illustration," was to provide "a pictorial geography and ethnography of Russia and the Slavic world";[70] in other words, to inform, to

72

popularize, not to enlighten or change. To this end Prakhov advocated that the Peredvizhniki cease being so exclusively associated with "tendentious" social issues and take up instead the full richness of national life as represented and preserved by the common people, their customs, songs and legends.[71]

Even though Prakhov praised the Peredvizhnik art for being "free" and characterized the 1863 secession as the date on which Russia art was "liberated," these words had a novel meaning. Realist art was not set free from Academic controls to serve the transformation of Russia, but to depict native subjects of interest to everybody. In this frame of reference the Academy was no longer, as in the 1860s, an arm of a regime that stifled all forms of indedendent expression, but rather it symbolized Western influence and domination that prevented the flowering of native art.[72]

It was a portent that the process whereby the Peredvizhniki and their art became accepted by a broader segment of the educated public was so closely associated with a strong anti-Western bias. For, once this type of nationalism was embraced by part of the cultural elite, the painters could more readily respond to the ethnocentrism and chauvinism of middle-class patrons. Although the entrepreneurs—eager to foster independent Russian economic development, to ease out foreign capital and to find new markets—paid for the realist art, it was still the intelligentsia that set the tone and pace for the painters. When the intelligentsia became caught up with Russia's "manifest destiny," it legitimized new themes for Peredvizhnik painting, such as territorial expansion or military exploits, themes extolling Russia's greatness, past and present. A foretaste of things to come was a picture by Repin, started in the fall of 1878, depicting the triumphant return of the victorious Russian troops to St. Petersburg through the arch commemorating the victories of the Russian armies against Napoleon in 1812.

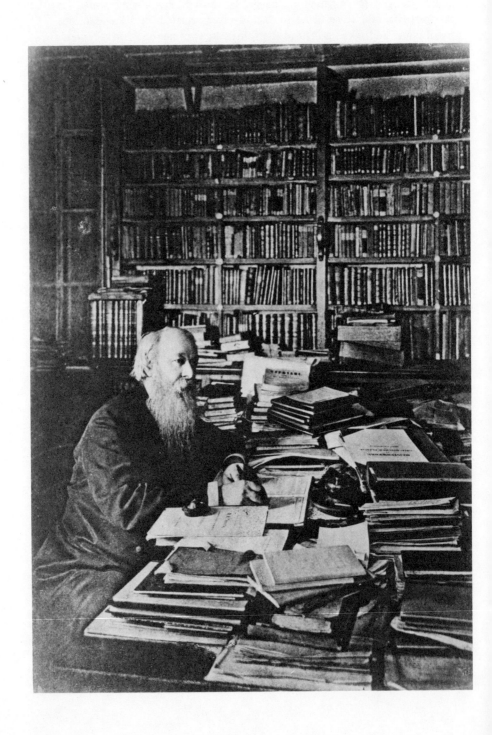

IV THE PEREDVIZHNIK THEMES AND THEIR APPEAL

Peredvizhnichestvo is customarily associated with critical or ideological realism. But any examination of its spectrum of themes reveals a much broader range of subjects and manner of treatment, extending far beyond the hallowed category of socio-political or moral commentary. The preceding chapters have indicated the extent to which the Peredvizhniki represented the liberal spirit of the "sixties" and how in the following decades they responded to other intellectual currents, reflecting a more extensive array of interests. To gain a better idea of how and why the art of the Peredvizhniki came to satisfy quite diverse tastes—it elicited warm response from radical youth as well as from conservative nationalists—it is necessary to discuss the main themes in their paintings and to pinpoint the sources of their popularity during their heyday in the 1870s and 1880s and with later generations.

Landscape

It is best to start with landscape, because it was among the favorite modes of expression of the Peredvizhniki and one that the public especially enjoyed. But landscape was never accepted as an appropriate subject by those who wanted art to publicize causes. Landscape as subject-matter neatly demonstrates how complicated it is to disentangle the component strands which make up *Peredvizhnichestvo*—namely, the preferences of the painters themselves, the taste of the general public and the program of the committed intelligentsia.

The Peredvizhniki liked to depict the beauties of their native land. Their canvases conveyed the unassuming charm of empty country roads, the expectancy of spring promised by melting snow, the endless expanse of southern steppe, the stillness of a deep pine forest, the unearthly quality of moonlit nights. All this had been set down and celebrated in Russian literature ever since Pushkin, but it was the Peredvizhniki who managed to convey in painting the particularities of the Russian landscape, to stir the nostalgia of viewers.

Pictures of ordinary Russian landscape first appeared at the Academic exhibits in the late 1850s. This was appreciated by the public as a welcome departure from the exaggerated artificial set-pieces of Italian groves or Swiss mountains. During the 1860s realist landscape incorporated social commen-

tary. Perov's "Last Tavern at the City Gates" (*Poslednii kabak u zastavy*, 1868) is perhaps the most apt example of this trend, even though Perov did not specialize in painting landscapes. Showing in the foreground a snow-covered sleigh (with the barely visible figure of a woman) in front of an inn, lights shining dimly through frosted-over windows and in the background the city gates leading out into the open countryside, the picture conveys much more than the early evening atmosphere of deep winter in Russia. It makes a comment as well on the desolation of peasants driven to drink by their hard lives, on the lot of peasant women, on the opposition of town and country. It is an animated landscape, and the viewer is more likely to react to the human situation than to nature.

Around 1870 a definite change took place, and nature itself became the subject of poetic rendering. Five painters are associated with the new approach: Ivan Shishkin, Fedor Vasilev, Alexei Savrasov, Mikhail Klodt, and Lev Kamenev; and, except for Vasilev (who studied with Kramskoy and Shishkin), they were among the founders of the Association. The change they initiated went counter to the socio-political prescriptions of various publicists. But in painting the beauties of the Russian countryside the artists expressed their own preferences and those of the buying public.

When Savrasov's wintry landscape with the first tenuous but sure signs of spring, "The Rooks Have Come" (*Grachi prileteli*), was shown at the first Peredvizhnik exhibit in 1871, the liberal *Cause* noted frostily:

> In general, we do not very much like artists who have chosen landscape for their exclusive and only specialty. . . . Such one-sidedness is strange to us. . . . Landscape is necessary to the artists as background, as a decoration. . . . But by itself landscape is pointless.[1]

Later on in the decade, the populists expressed similar doubts about the contribution of landscape painting to *their* cause. Vsevolod Garshin was highly critical of painters who concentrated on this genre, because "poetic feelings," technique and "love of nature" took the upper hand and absolved artists from concentrating on topical Russian issues.[2] As for Stasov, with his mixed categories, he commended the landscapists generously all through the 1870s, for he considered the appearance of talented painters of the native scene an additional source of strength for the Russian school he was laboring to create. But when during the period of general reaction in the 1880s even civic-minded painters like Miasoedov and Yaroshenko gave up their former "telling subjects," he branded their landscapes as an evasion of responsibilities. Attempting to forestall any further backsliding, Stasov admonished them that landscape painting should not take precedence over other subjects.[3]

The public, however, liked the fresh departures in landscape painting. As Karl Gerts phrased it in *Moscow News (Moskovskie vedemosti),* reviewing

Savrasov's picture of an island in a suburban park (*Losinyi ostrov v Sokol'ni-kakh*): "One cannot but look with pleasure at a work in which the painter could so poetically depict on canvas a piece of nature from the Moscow suburbs familiar to us all. Only the eyes of a poet or an artist can look at nature this way."[4] For Savrasov, this 1869 canvas marked a departure from scenes of the poverty-stricken countryside for the poetic, idealized emotion of the familiar—the hallmark of national landscape painting that is associated with the Peredvizhniki. Tretiakov had expressed his preference for this approach as early as 1857, and by the 1870s even the official world found it attractive. The Empress ordered a copy of Savrasov's "Rooks," which was sent to the Vienna International Exhibit in 1873, together with Vasilev's picture of a flooded meadow (*Mokryi lug*), painted with similar sentimentality. And in 1872 M. K. Klodt, one of the first to paint in this style, was appointed to teach at the Academy of Arts.

Kramskoy's opinions on landscape help to elucidate what the Peredvizhniki strove for and achieved as a school. When Ivan Shishkin (1832-98) started exhibiting in the 1860s, Kramskoy admired his careful renditions of Russian forests as an advance over the concocted scenes that predominated among landscape painters. But he regarded Shishkin's meticulous devotion to realistic detail as only the first, basic step in the creation of a new school of landscape painting. Shishkin's pedantic insistence on the concrete rendering of the "individuality" of each tree, as well as of all the botanical detail, was so extreme that he became known among his students as "the accountant of leaves" *(bukhkhalter listochkov).* This fidelity to detail, Kramskoy felt, had to be supplemented by emotion and some poetic license:

> Shishkin amazes us with his knowledge.... I think that he is the only person among us who knows landscape scientifically.... But he only knows it.... He does not have those spiritual nerves which are so sensitive to the sounds and music in nature.... He expresses himself very clearly...but what an effect there would be if he also had a note that could become a song.... In the future something else is necessary.[5]

Kramskoy hoped that Vasilev would supply this missing element, for he found his pictures permeated with "high poetry." Vasilev died prematurely, but other Peredvizhniki from Savrasov to Levitan played on the lyricism of Russian scenery for all that it was worth. And the public considered landscape to be one of the glories of *Peredvizhnichestvo.* Its popularity was undeniable—at the first exhibit 22 out of 46 pictures were landscapes, and in subsequent exhibits the proportion was even higher. Since then, Russian viewers and critics, whether under the Tsars or the Soviets, have cherished these scenes for their sentimentality, nostalgia and fidelity.

Kramskoy had found Savrasov's "Rooks" the best of its kind at the

first traveling exhibit because it had and expressed, in that omnibus word, a "soul."[6] His evaluation hardly differs from one in the sophisticated art journal *Apollo (Apollon),* which in 1910 warmly praised Levitan's work as being in the best Peredvizhnik tradition:

> There are almost no figures in Levitan's landscapes. But strange as this may seem, it in no way excludes human thought and feelings. . . . Levitan's landscapes are closely connected with a whole sphere of Russian life. Their themes, colors, their very air expresses paeans of the familiar. They bring to our minds thousands of remembrances about places, people, events in our lives. Amidst these fields, forests, rivers, summer sunsets, the life history of each one of us was played out.[7]

And compare this with a recent Soviet history of art:

> Savrasov finds in the modest landscape a moving charm and beauty, inspiring it by the rendering of the joyous mood of approaching spring. He succeeds in seeing Russian nature in [its] national peculiarity... in feeling and rendering the beauty of truth, the poetry of the ordinary.[8]

Portraits

In portrait painting, the Peredvizhniki have left an imprint so strong that to this day their likenesses of cultural figures are *the* mental images that Russians have of Dostoevsky, Tolstoy or Nekrasov. These pictures are as thoroughly familar to today's public as family photos. Every schoolchild gets them fixed in his mind, since they inevitably adorn the popular editions of Russian classics; and one finds reproductions hanging in many a Soviet home.

As in the case of landscape, the portraits done by the Peredvizhniki came to reflect a characteristic blend of political currents, cultural tradition, public demand and the artists' own sensitive response. Tretiakov's decision to assemble a gallery of famous nineteenth-century writers, thinkers and scholars was crucial for the evolution of the Peredvizhnik style in portraiture. Previously, the young realists had not made any personal statement in their bland and accurate likenesses of gentry and middle-class patrons. Tretiakov first commissioned Perov, next Kramskoy and soon other Peredvizhniki to paint Dostoevsky, Tolstoy, Ostrovsky, Mendeleev and many other notables. Though done by different hands, all these portraits are infused with a similar intent to convey the steadfast dedication of the public figures.

79

Given the uniformity of rendition, it is tempting to speculate that these portraits were the Peredvizhniki's response to the frequent proddings from the intelligentsia to paint forceful personalities that would arouse others to action. This is a constant refrain, for instance, in Stasov's reviews, beginning with his comments in 1863 on Ge's "Last Supper," in which he disliked the representation of Christ as a "weak" person preoccupied with a "petty quarrel," a representation that failed to convey those qualities which had enabled him to "transform the world," to become the "prophet of new life and truth."[9]

Never themselves venturing into militant activism, the Peredvizhniki were not really disposed to paint what in Soviet parlance is referred to as "positive heroes." But work on portraits of nationally prominent figures gave them the opportunity to state the admired qualities of these men so as to inspire others, thereby making their own contribution to the eternal question torturing the intelligentsia—What is to be done?

The stages in Kramskoy's composition of Nekrasov on his deathbed in 1877 serve as an apposite text on what the Peredvizhnik portrait at its best was meant to convey, and in what way it differed from ordinary portraiture. The initial sketches, as well as letters to Tretiakov, show that Kramskoy intended to represent the poet lying in bed, almost supine, with hands stretched out weakly and helplessly, surrounded by mementoes of his passion for hunting—a glassed-in gun-case over the bed, a hound at the bedside—to underscore the debilitating effects of illness. Nekrasov died before the picture was finished, and Kramskoy altered his composition significantly. The poet's position was changed to a sitting one, the limp hands took up pencil and paper. His posture was now a reaffirmation of dedication and action up to the last moment.

Kramskoy also changed the background of the picture. Instead of hunting equipment, the poet's bed was surrounded with cultural symbols—a bust of Belinsky, pictures of Dobroliubov and of the romantic Polish poet-patriot Mickiewicz on the walls. This new decor alluded eloquently to Nekrasov's career as a poet, placing him in the living tradition of civic-minded men of letters. Instead of an anecdotal portrayal of the ardent hunter trapped by lingering illness, there emerged the personification of the dedicated life with attendant symbols.[10]

This iconology was as immediately legible to Russian viewers in the nineteenth century as it is to Soviet viewers today. Later generations have interpreted the Peredvizhnik portraits in similar terms, showing hardly any traces of additional insights that sociology, psychology or esthetics might have offered in the interim. Reactions to Perov's portrait of Dostoevsky demonstrate this point. When it was exhibited at the second traveling exhibit in 1872, P. M. Kovalevsky wrote that the canvas was no mere likeness but transcended the narrow confines of verisimilitude to tell a story; whereupon he

described at length how the picture recounted Dostoevsky's torment, compounded by "all the accursed problems" *(prokliatye voprosy)*.[11] Practically the same story-telling interpretation is found in the most authoritative Soviet history of art. There it is described as a very convincing portrayal of the writer racked by the problems of his times: the fine hands nervously clasped around the knees and the troubled gaze are said to express the inner torture and restlessness so convincingly that "in our minds the image of Dostoevsky is most often associated with Perov's portrait."[12]

When the Peredvizhniki painted ordinary individuals, they strove equally to convey more than the mere likeness of the subject. At its best, the Peredvizhnik portrait was always a comment on the general through the particular, an outstanding example being Repin's "Archdeacon" *(Protodiakon)*. It was painted in 1877 in the Ukrainian village where Repin had gone after his return from France to soak up that "Russianness" which had evaporated abroad, and which his mentors Kramskoy and Stasov considered essential for his return to the fold and his expected contribution to realist art. Repin was struck by the physical attributes of the overfed and besodden clergyman in minor orders. In a letter to Stasov, he described him as a "glutton," and his spirited brush did full justice to the Gargantuan qualities of the deacon. But he was also attempting an artistic generalization, a comment on a certain kind of person, if not on the entire clergy. First of all, Repin's portrait of the deacon was a faithful likeness, for everyone in Chuguev recognized the sitter instantly. At the same time Repin was aiming at something deeper. As he wrote Tretiakov: "It is more than a portrait, it is a type. In a word it is...an extract of all deacons, those lions of the clergy...a most typical, the most terrible of all deacons."[13]

To transcend the momentary and the particular is an attribute of good portraiture anywhere. But in Russia, consonant with the social thinking of the time, it was the objective of the Peredvizhniki to convey the general, the typical, to go behind the individual by emphasizing those qualities that would carry a positive message and give the picture a deeper significance. This attitude was so well engrained in viewers that when Repin's portrait of Musorgsky (1881), painted a few days before the composer's death, was exhibited, the public did not appreciate his unflattering statement about the decline and agony of the great musician. The "disrespectful" portrayal of Musorgsky's face, bloated by alcoholism, his unkempt hair and matted beard, raised a furor of protest.

In landscape painting the emotional response of the Peredvizhniki to their native land was strong and evident from the very beginning, but in historical painting a sense of reverence for the national past was slower to develop. At the outset, in the 1860s, the realists painted some straightforward, narrative pictures from Russian history that carried no second message. They eschewed the Academy's "grand manner" and subjects from antiquity for less pretentiously rendered scenes of medieval Russia. Their focus was on a documentary account of the old Rus, not on heroic deeds or elevated sentiments.

Viacheslav Shvarts (1838-69), a close friend of Perov, was the best-known representative of the realists' initial approach to historical subjects.[14] His works include, "Ivan the Terrible by the Body of his Son" (1864), "Tsar Alexis Playing Chess" (1865), and "Patriarch Nikon at the New Jerusalem Monastery" (1867). All are marked by faithful attention to historical detail—costume, architecture, manners—and an absence of any latter-day analogies.

In the 1870s critical realism in this branch of painting came to stand for reform-minded commentary about contemporary problems, conveyed through an apt choice of subject. As Kramskoy envisioned it, "Historical painting is necessary . . . and must occupy present-day artists to the degree that it parallels the present . . . and gives the viewer food for thought."[15] Ge's "Peter and Alexis," displayed at the first traveling exhibit and discussed at length by Saltykov-Shchedrin, conveys well how the first-generation Peredvizhniki viewed the past during that decade. A roseate, jingoist nationalism was as alien to them as it was to the purveyors of enlightenment, who believed that little of value could be found in Russia's past to instruct the public. Hence the definite coolness of the movement's mentors toward subjects chosen by Surikov and Vasnetsov for their dramatic canvases that showed a genuine appreciation for old Russian traditions. Yet, these colorful, highly emotional paintings were much acclaimed at the traveling exhibits after 1880 and have since been accepted as prime examples of Peredvizhnik historical painting, especially during periods of heightened nationalism both in Tsarist Russia and the Soviet Union.

The younger realists were reflecting and responding to the changes in the public's interests that had taken place in the 1870s. The more popular realist art became with general viewers, the more demand there was that the Peredvizhniki abandon topical issues of interest only to dedicated liberals and take up themes of wider appeal. Typical of such demands was Adrian Prakhov's review of the fourth Peredvizhnik exhibit in 1875, which concluded that no matter how great one's enjoyment, still one left the exhibit without having experienced any edifying, grand emotions. Accordingly, he recommended that painters take up inspiring subjects from the "rich sources of our

Russian history."[16]

Prakhov's suggestion was symptomatic of the qualitative change in the articulate public's views on the course of Russian history. The shift, which undercut the pro-Western aims of enlightenment initially guiding the realists, can best be illustrated by the evolution of the image of Peter the Great, who had been a potent symbol for the intelligentsia until the mid-1870s. A passage by Konstantin Kavelin (1818-85), a historian of law active in the judicial reforms of Alexander II, conveys the meaning Peter had for people who believed that Russia could be raised to general European standards of individual liberty and justice. When presented with Peter's portrait, he wrote:

> I shall have it framed and I will pay idolatrous tribute *(idolopoklonstvovat')* to [this] great Russian demi-god. The country that has produced such a genius cannot perish. . . . Whenever I am depressed by some gloomy event in Russian life, when my heart is filled with bitterness and whenever depression threatens, I recall Peter . . . and peace descends upon my soul.[17]

In the course of the decade, however, Peter ceased being the praiseworthy figure whose reforms brought beneficial change to Russia. He became the autocrat who had uprooted native traditions and saddled Russia with alien and oppressive institutions. The populist infatuation with the pristine goodness of the "people" and its communal ways first engendered hostility toward Peter's Westernization that destroyed the traditional harmonies in Russian society. Later, the cause of liberating Southern Slavs (whose Turkish oppressors were supported by France and England) added grist for anti-Western sentiments, and Peter was even more roundly blamed for deleterious imitation of the West.

To the first-generation Peredvizhniki, Peter was the personification of enlightenment. As a schoolboy, Kramskoy had written an essay "On Gratitude," with an apostrophe to Peter for initiating "our spiritual and physical transformation."[18] The first traveling exhibit displayed two canvases of Peter the Reformer: Ge's "Peter and Alexis" and Miasoedov's "Grandfather of the Russian Navy" *(Dedushka russkogo flota).* Subsequently, Antokolsky sculpted a statue of Peter, conceived to contrast with Ivan the Terrible as a positive force in Russian history.[19]

The general re-examination of Peter's legacy and of the value of old traditions did not substantially shake the original beliefs of the older painters. Repin had some second thoughts:

> Yes, bureaucracy, bureaucracy! No matter what you say it's one of Peter's accomplishments. He enserfed Russia, gave it in servitude to foreigners. Russia stopped to think, feel and act consciously by itself. He

transformed it into an instructed automaton, into a silent slave. Every untalented German became a full master and enlightener of Russia. . . . Gifted people were silenced for a long time. Our ancestors before Peter were not stupid (I am studying those days now), they were learning from foreigners, but freely, selecting what was best... From Peter on, something wholly different—every half-literate German soldier imagined himself a great civilizer...., and each Russian bureaucrat [who followed] tried to act as a foreigner, otherwise he would not be a master. How much of that survives to this day![20]

But neither he nor his generation produced a painting that would cast Peter in a different light. Not so the younger painters.

When Vasili Surikov (1848-1916) began to exhibit, he took for his subjects the people who had suffered for their devotion to the old Muscovite ways that Peter tried to eradicate.[21] His "Morning of the Streltsy Execution" (*Utro streletskoi kazni,* 1881) shows a group of mutinous old-fashioned mercenaries who opposed modernization. While they await their fate, Peter, surrounded by foreigners, stares unfeelingly at the scene from the side. Another painting of that decade, "Lady Morozova" (*Boyarinia Morozova,* 1887), depicts an aristocratic member of the Old Believers (a dissident sect that upheld popular religious traditions against Church reforms imposed by the centralized state) being hauled away to prison with a gesture of undaunted defiance. As for the modernizers, Surikov chose to paint one of Peter's main henchmen suffering retribution after his master's death—"Menshikov in Exile" (*Menshikov v Berezove,* 1883). The canvas represents this once-powerful courtier huddled with his cold and sickly children in a miserable hut, as though to demonstrate that the Petrine transgressions against national traditions did not go unpunished.

The public doted with pleasure and pride on Surikov's luscious renderings of Muscovite Russia's color and drama, but those critics who subscribed to the original aims of *Peredvizhnichestvo* saw his work as a backsliding from the group's mission. "Morozova" was the first of Surikov's pictures for which Stasov had some favorable words. (He had passed over the "Streltsy" in chilly but eloquent silence and mentioned "Menshikov" only in passing.) He was impressed by Morozova's character, force and spirit, but, "We cannot be moved any more by the issues that agitated this poor fanatical woman some two hundred years ago; we are now faced by completely different problems, deeper and broader." For Stasov, the vivid depiction of seventeenth-century costumes and events testified to Surikov's partiality for the conservative tradition and indifference to current oppression.[22] Vsevolod Garshin was not taken with "Morozova" either. For him, she was nothing more than a misguided fanatic, an obscurantist who chose martyrdom in defense of the outward, formal aspects of religion, and thus could not serve as an inspiration for

those who labored for justice, truth and goodness.[23] Political and moral pre-occupations blinded both critics to Surikov's talent; both resented the public response to the seductiveness of Surikov's picturesque pre-Petrine Russia.

Stasov's assessment of Viktor Vasnetsov (1848-1926) is another instance of how those associated with the original Peredvizhnik ethos reacted when a painter started to glorify the "wrong" historic tradition. Vasnetsov, now famous for pictures based on the epic tales of medieval times *(byliny)*, was very close to the original spirit of the movement at the start of his career, when his canvases dealt with singing beggars, a poor old couple in search of lodgings, or common people in taverns. On the side, however, he painted some pictures of ancient Russian heroes, and when neo-Slavophilism began to affect the intelligentsia, these studies attracted attention.[24] During 1878-79, Vasnetsov became friendly with Savva Mamontov, who appreciated and supported his interest in the epic past. But several members of the Association disapproved of Vasnetsov's evolution. When he submitted the painting entitled "After Igor's Battle with the Polovtsy" *(Posle poboishcha Igoria Sviato-slavicha s polovtsami)*, for the Peredvizhnik exhibit of 1880, Miasoedov and Yaroshenko (both of whom had a strong "civic" sense) threatened to resign if this canvas of a battlefield strewn with corpses of twelfth-century Russian knights were accepted.[25] It was exhibited and Tretiakov bought it; but Stasov did not mention it in his review, which, to all concerned, was an unmistakeable sign. Two years later he commented on Vasnetsov in an essay, "Twenty-Five Years of Russian Art." Here he argued that the further back in history artists went in search of themes, the worse their work became and capped his point with, "Such a talented . . . artist as Vasnetsov became unrecognizable when he began to busy himself with Russian antiquity."[26]

Kramskoy also was lukewarm about the younger generation's turn to history and tried to convince them to pick "meaningful" subjects. When in 1886, Nesterov sought his opinion about his ornate picture of the arrival of petitioners before a medieval Tsar, "Petitioners Coming to the Sovereign" *(Do gosudaria chelobitniki)*, Kramskoy thought the scene much too insignificant for such a huge canvas and told Nesterov that Russian history offered many more telling topics to which the young painter, who "used to be closer to life," could address himself instead.[27]

Stasov's and Kramskoy's fears about the distortion of the civic-minded and morally-reflective canons of Peredvizhnik art in the hands of the younger historical painters were well-founded. Vasnetsov's enthusiasm for the ancient defenders of his homeland reached such proportions that in 1881 he painted "Battle Between Russians and Scythians" *(Bitva russkikh so skifami)*, a glaring anachronism, since there were no Russians in the fifth century B.C. to withstand the Scythian invasion of the southern steppes. (Nowadays it is often entitled "The Battle Between Slavs and Scythians," but the presence of Slavs that far back on what is now Russian soil is still a matter of controversy

among historians.) Similarly, Surikov's next historical canvases after "Morozova" took as subjects Ermak's conquest of Siberia in the late sixteenth century and Suvorov crossing the Alps.[28] Depiction of "significant" episodes in Russian history had deteriorated into a glorification of military exploits and territorial expansion.

<div align="right">Peasants</div>

The Peredvizhniki also introduced a fresh spirit into social genre. From the obvious and easy effects of the small anecdotal pictures in the 1860s about poverty, sickness and drunkenness, they shifted to larger canvases attempting to make a more elaborate artistic statement, a more profound comment on conditions in Russia. These departures are best exemplified in the way the Peredvizhniki began to portray peasants. In part, the change reflected a growing sophistication of the realists—Kramskoy had warned against obvious sermonizing: "A picture will be well-painted only when it perfectly expresses a thought without commentary."[29] In part, it was due to the new intellectual climate—the populist *(narodnik)* appreciation of the common people.

The alteration in Repin's plans for "The Boat Haulers" *(Burlaki)* shows what the new handling of the subject entailed. At first he had wanted to paint the boat haulers against a background of elegant Sunday picnickers. But Fedor Vasilev found this juxtaposition of light and dark, wealth and poverty, leisure and toil, much too explicit and advised Repin to concentrate on the haulers alone. Repin concurred, and the two young men spent the summer of 1870 on the banks of the Volga getting acquainted with and sketching the boatmen. Repin's memoirs contain vivid descriptions of each man he portrayed: each is described as a personality endowed with memorable qualities and not as another link in the endless chain of human degradation.[30] As much as anything else, he tried to convey this sense of personality in the painting.

The Peredvizhnik gallery of peasant types covered an extensive range from the rebellious to the resigned; and, though less grandiose in intention, it almost matched that of the cultural celebrities assembled by Tretiakov. Perov's "Fomushka-sych" (1868) was the first of the series. It is a study of character—the wrinkles, the tousled hair, the intelligent eyes show a wise, experienced old man, not a downtrodden or hungry being. Stasov, always quick to catch novel nuances, reacted instantly to this positive approach. When Perov's picture of a bird catcher *(Ptitselov)* was shown at the 1870 Academic

exhibit, Stasov likened its strength of "spiritual characterization," its "genuineness" and "simplicity" of treatment to Turgenev's *Sportsman's Sketches*.[31] It was an apt comparison, for Turgenev's stories, written 1847-51, were a landmark in the description of the *muzhik* in Russian literature, giving him for the first time the same objective character study and individualization that hitherto only those higher on the social ladder had received.

A common trait in many peasant portraits was the sense of inner calm and wisdom that marked Perov's "Fomushka-sych." But this was not the only dimension. Kramskoy's "Forester" (*Polesovshchik*, 1874) exudes the spirit of fierce independence. He is a youngish man with regular features, penetrating gaze, wearing a cap with bullet holes in it and a gun in hand. What Kramskoy sought to depict is set down in a letter to Tretiakov:

> He . . . should represent one of those types (they do exist among Russian people) who understand much about political and social institutions and in whom there is a deeply ingrained dissatisfaction bordering on hatred. In difficult times, Razins and Pugachevs recruit their bands from among such people; and in ordinary times they live alone and make out as best they can.[32]

Some of the qualities customarily associated with the peasantry were also rendered: superstition and hesitant reserve, for instance, as in two Repin canvases of 1877—"Timid Peasant" *(Muzhichok iz robkikh)* and "Peasant with an Evil Eye" *(Muzhik s durnym glazom)*. But on the whole, little sentimentalizing was involved, as in populist writings. The painters generally represented the peasant as a full member of the nation with his own characteristics, endowments and ways that commanded respect.

Vasili Maksimov (1844-1911) is the best exponent of this aspect of *Peredvizhnichestvo*. Born a state peasant, Maksimov quit the Academy in 1866 after finishing the basic program. Shunning the competition for medals or higher titles, he returned to live and work in his native village. Maksimov was quite impervious to, even scornful of, the city intelligentsia's theorizing about the *narod*, whether by the radicals of the 1860s or the rhapsodizing populists of the 1870s. Having himself experienced the isolation, drudgery and poverty of peasant life, he found "the pretty words about the 'people' made over a glass of beer in noisy company" downright fatuous and was equally critical of overly sentimental pictures of peasant misery. In his own work he strove to represent peasant life such as it was, directly, with clear-eyed understanding and no "false tears" about the fate of the *muzhik*.[33]

A fine example of Maksimov's style and interpretation is "The Arrival of the Sorcerer at the Peasant Wedding" (*Prikhod kolduna na krest'ianskuyu svad'bu*, 1875). The picture is suffused with monumentality, not only because of the size of the canvas (almost four by six feet), but also by the gravity

of the event—the young pair at the threshold of a new life being confronted by the forces of the unknown—and the statuesque proportions of all the figures. The scene is serious in its human dimensions but not melodramatic in terms of specifically peasant attributes.

Of all the Peredvizhniki, Maksimov was the most convincing and consistent in his objectivity about the peasants. Repin, too, pursued a similar goal, though not as singlemindedly as Maksimov. Even if his "Boat Haulers" now seems like a comment on the lot of Russia's toiling masses, this was not the spirit in which Repin undertook the subject; he considered the bargemen fascinating individuals and rendered them as such on canvas. But among Repin's other scenes of peasant life only "The Recruit's Farewell" (*Provody novobrantsa*, 1878) matches in its depiction of a family bidding goodbye to a young peasant the simple, unadorned dignity of Maksimov's work. Many of Repin's other pictures—a returned soldier amusing the assembled company with stories of his army exploits, young girls dancing, or examination-time in a village school—contain elements of romanticized story-telling.

Despite occasional lapses into sentimentality, the Peredvizhniki avoided the populists' emotional commitment to the "people" and idealization of rural customs. When Nikolai Yaroshenko painted "The Stoker" (*Kochegar,* 1878), he conveyed both the strain of the physical labor in an iron mill and the proud strength of the worker. This was not the way populist writers handled the theme. Yaroshenko's canvas moved Garshin to write a short story, "The Artists" (1879), which epitomizes the approach of the populist intelligentsia, burdened with feelings of guilt toward the "people." Garshin's overwrought imagination transformed the stoker into a physically broken-down laborer and the painter Riabinin into a conscience-stricken artist who settles his and society's debt to the victimized peasantry by becoming a village teacher.

Similarly, the Peredvizhniki never extolled the communal institutions of the village (the enlarged family, the common landholdings) as models of social unity and cooperation for Russia in making a smooth transition into a better future. The reason for this is quite simple. Having grown up in the countryside, painters like Repin and Maksimov held no starry-eyed views of communal customs, which, for them, meant only one thing—a bondage that had to be broken at considerable expense and energy in order to attend the Academy of Arts. To the Peredvizhniki, the *mir* or *obshchina* were not democratic egalitarianism but hobbling fetters that impeded the emancipation of the individual. That is why Maksimov was able to paint without any nostalgic overtones a picture about the division of an enlarged patriarchal family's property ("Family Division," *Semeinyi razdel,* 1876) at a time when populist economists and writers were busy proving the natural superiority of communal traditions and arguing that they should be preserved in the Russian village.

Instead of seeing the *muzhik* as the harbinger of the future, the Pere-

dvizhniki drew attention to his equivocal position in the recently reformed institutions. Miasoedov's "Zemstvo at Lunch" (*Zemstvo obedaet*, 1872) points out the gulf separating peasant and gentry members of the elected self-governing bodies created in 1864. The peasant deputies are shown seated on the ground outside the building, eating black bread and onions; a few chickens are scratching for crumbs. Inside, through the open window, one sees bustling preparations for the gentry deputies' sumptuous lunch. One could hardly ask for a more explicit comment on the unresolved problems of local self-government.

The clear-eyed depiction of the peasants' character and legal position was a short-lived response of the first-generation Peredvizhniki to the discovery of the "people" in the 1870s. During the next decade their work deteriorated into sorrowfully sentimental formulas about rural life, and the initial Courbet-like objectivity disappeared. By the 1890s Nikolai Bogdanov-Belsky (1868-1945) had become the successful and acclaimed painter of dilapidated huts and tattered urchins, complacently admired by the public.

Because this later handling of peasant themes was so persistent and because the populist writers had been so gushingly emotional about the *narod*, Marxist critics after the October Revolution summarily dismissed the Peredvizhniki as passive and tearful "populists," forgetting that this was not the way the artists had looked at the common man during the opening, vigorous phase of the movement. The best realist paintings conveyed the inner strength of the peasantry and avoided the routinized sentimentality that prevailed in the 1860s and again during the last thirty years of the Empire.

Revolutionaries

Before being sent to Siberian exile in May 1864, Chernyshevsky was stripped of his civil rights (the so-called civil execution) in the central square of St. Petersburg. Revolted by this "barbaric ceremony," Herzen called on Russian artists to paint a denunciatory picture of the event as a reminder and as an inspiration to future generations.[34] But Herzen's call went unheeded. Neither in the 1860s nor during the heyday of *Peredvizhnichestvo* was there any painting of Chernyshevsky's humiliation, or, for that matter, of an unequivocally heroic revolutionary figure (with the possible exception of Repin's "Refusal of Confession").

Of course, censorship and legal penalties prevented painters from addressing such a theme, or rather from publicly exhibiting such a painting.[35] Although none of the Peredvizhniki was in full sympathy with the revolu-

tionary movement or, except for Yaroshenko, even friendly with its proponents, the theme of revolutionaries appears with a curious consistency in the Peredvizhnik *oeuvre*. The painters never presented the rebels in a negative light—which betokened their respect. But they interpreted the revolutionaries as isolated individuals rejected by society.

It is as though having themselves experienced rejection by the intellectuals early in their own careers, the Peredvizhniki sensed only too well the social alienation of revolutionary agitators. Radical activists were depicted as solitary figures either in prison or under arrest, never among a sympathetic and responsive group. Moreover, the recurrence of the theme suggests that, although the Peredvizhniki did not labor under feelings of an unpaid debt owed the people, as did the intelligentsia, they did have an uneasy conscience about the revolutionaries. These desperate individuals had the strength of their convictions and actively fought the system they were opposed to, whereas the Peredvizhniki themselves, once also rebellious up to a point, had made their peace and compromised with the system.

Before ideological realism went into decline, there were two periods of revolutionary upsurge, each followed by stringent offical countermeasures. In the early 1860s there were student disorders and political proclamations, leading to Karakozov's unsuccessful attempt in 1866 on the life of Alexander II. The next wave started peacefully in 1874 with the spontaneous educational crusade of university students who were "going to the people" in droves. After the failure of this venture, some young people turned to revolutionary plots that culminated in the assassination of Alexander II in March 1881.

The political unrest of the 1860s did not pass unrecorded, for it inspired several paintings of imprisonment and exile, notably Valeri Yakobi's "Prisoners' Stop-over" (*Prival arestantov*)—a ragged convoy on the way to Siberia—which caused a stir at the 1861 Academic exhibit.[36]

However, members of the Artel left no picture of political significance. It is known that one member, Mikhail Peskov, painted an exiled settler but the canvas has since been lost. Repin recounts how as a student he carried in his pocket cherished pictures of radical heroes—"Chernyshevsky, Kosciuszko and many Polish insurrectionists"—but does not mention ever having drawn a similar memento himself.[37] Soviet researchers have not turned up in either the Artel's or the censor's files a single cartoon by an Artel member for the satirical weeklies that flourished during the first years of Alexander II's reign.[38] This form of silence attests to the lack of interest in any political activism among the Peredvizhniki in their youth, as mentioned before.

The revolutionaries of the 1870s were painted by the Peredvizhniki, but with the qualifications noted above. Repin, who spent 1876-78 in the rural South where the populists were most active, came closest to seeing the movement at first hand. His first comment, "Under Conveyance" (*Pod*

90

konvoem, 1876), was laconic; it simply showed an arrested young man accompanied by two gendarmes in a peasant cart. The second, "The Propagandist's Arrest" (*Arest propagandista,* 1878-92), underwent considerable change, the direction of which is interesting since it traces a pattern that seems general and not just idiosyncratic to Repin. The first studies were of a young man with no particular expression, tied to a pillar, surrounded by peasants who seemed to sympathize with his plight. In subsequent versions, Repin began to work on the expression of the *narodnik.* The more determined and dedicated he looked, the farther the peasants receded. The final version (1880-92) shows him surrounded by police busily searching through the leaflets in his briefcase and four peasants huddled in a corner of the hut casting suspicious, if not hostile, glances at the radical. What might have been a heroic confrontation between a revolutionary and the forces of tsardom turned, in effect, into a commentary on the tragic isolation of the populist from the people.[39]

Repin's next picture of a revolutionary facing society, "They Did Not Await Him" (*Ne zhdali,* 1883-88), also underwent significant alterations, all in the direction of lessening the man's inner conviction and the cordial reception of the family. The initial sketches in 1883 were variants with either a man or a woman as the returning political exile and the semi-comical figure of an older man announcing the unexpected arrival to the rest of the family. The returning man had a calm, intelligent expression; the young woman resembled Yaroshenko's picture of a serious girl student (*Kursistka*). There was no tension in the picture—the exiles expressed confidence and the family was happy to see them. The central figure, certainly not heroic, was nevertheless someone who did not feel guilty about the past or uncertain about the future.

By the time the picture was finished for the twelfth Peredvizhnik exhibit in 1884, the returning man's countenance had been substantially changed—an element of physical exhaustion and suffering appeared. There was enough ambiguity for the liberal press to claim that the painting represented a suffering, yet unbroken man and for the conservative papers to argue that Repin, despite his sympathies, portrayed a "political criminal." *The Messenger of Europe* wrote: "We feel [in him] a chipped but not yet crushed force; he will keep searching for the way out as long and as much as his emaciated body will allow."[40] At the other end of the political spectrum, Katkov's *Moscow News* and Meshchersky's *Citizen* rejoiced that Repin had given his "beloved exile" such an "unattractive" and "semi-idiotic face."[41]

Because of the furor in the press and Tretiakov's objections, Repin repainted the face, emphasizing the sense of vacillation more than the element of personal suffering. The 1886 version replaced the innocent victim with a figure whose pitiful rags, hesitant gait and confused look expressed shame, guilt, uncertainty. The 1888 version, the one now on display, is a

combination of the 1884-86 reworkings. It is hard to decide whether suffering or confusion predominates. But there is no doubt that the original positive image of a confident radical returning to a family that is ready to welcome him has been replaced by a hesitant and indecisive figure facing a gamut of reactions—the stolid indifference of the maid, the uncertainty of the mother, the happy expectancy of the boy, and the fearful confusion of the girl.[42]

Conviction and inner strength are expressed only in canvases depicting clandestine meetings—for example, V. Makovsky's "Evening Gathering" (*Vecherinka*, 1875-97), Repin's "Meeting of Revolutionaries" (*Skhodka revoliutsionerov*, 1883); or portraits—Yaroshenko's "Student" (1881) and *Kursistka* (1883); or as solitary figures—Yaroshenko's "At the Litovsky Fortress" (1881). In these pictures the rebels are seen either among themselves or completely alone; they are not interacting with society. Several other paintings underscore the revolutionaries' solitariness or indecision. Yaroshenko's "Prisoner" (*Zakliuchennyi*, 1878) shows him standing on a chair in his cell, his back to the viewer, straining toward the source of light, a small window. V. Makovsky's "Prisoner" (*Uznik*, 1882) is a large canvas wholly filled with a sitting figure that is somewhat reminiscent of Kramskoy's "Christ in the Desert"—both are deep in thought, hands clasped around their knees. Both are studies of meditation, not of action or determination. Only Repin's "Refusal of Confession" (*Otkaz ot ispovedi*, 1879-85) —a young revolutionary refusing the sacrament before execution—presents an unequivocal stance. But conviction and heroism in this situation seem a rather futile gesture.

Despite the Peredvizhniki's ambivalence toward the revolutionary movement in Russia, despite their failure to render unambiguously the heroism of its participants,[43] the intelligentsia's need for myth-making was such that they chose to see a succession of positive heroes in these paintings. Stasov, constantly prodding the artists to create positive images of activists, saw a steadfast figure in the 1884 version of "They Did Not Await Him"; he argued that the exile's "entire face and body express energy and will unbroken by any misfortune."[44] For their part, the revolutionaries wanted and needed an iconography of their movement. A number of their memoirs speak of Peredvizhnik paintings as a source of inspiration, as commemoration of their endeavors. Vera Figner (1852-1942), the revolutionary populist, who saw a reproduction of "Lady Morozova" when in Siberian exile, wrote:

> The engraving produced a very moving impression. In iron chains Morozova is being taken to exile and prison where she will die.... Her emaciated face is marked by resolution to go to the end.... The engraving spoke of the struggle for beliefs, of persecution, of death,...of Sofia Perovskaya—the Tsar's assassin.[45]

And the Socialist Revolutionary agitator Vladimir Bonch-Bruevich (1873-1955) set down his youthful reactions as follows:

> The sensations of the revolutionaries have not yet been described anywhere, the oaths we swore at the Tretiakov Gallery on seeing such pictures . . . as the one where the proud member of the People's Will, firm in his conviction, refuses the priest's blessing before execution. We used to contemplate too . . . the fate of political offenders—our fate—shown in [Yakobi's] "The Prisoners' Stop-over."[46]

Emotionality, Typicalness and Topicality

As the foregoing discussion of the range of subjects and treatment makes clear, the promotion of political, moral or civic causes by no means encompasses *Peredvizhnichestvo*. Members of the Association often ignored Kramskoy's dictum that the aim of art should not be a reposeful soothing effect on the viewer, given the "life of penal servitude" (*katorzhnaya zhizn'*) in Russia.[47] Even Kramskoy painted "May Night" (*Maiskaya noch'*, 1871), a poetic scene of nymphs in moonlight, after Gogol's story of the same title. Tendentiousness would never by itself account for the Peredvizhniki's popularity, despite the penchant of the literate Russian public to seek serious commentary or practical guidelines in every creative work. The success of the Peredvizhniki is as much, if not more, due to their ability to move the public, as to the professed goals to instruct or to publicize various causes.

A revealing clue to the school's motivation is Kramskoy's definition of subjectivity:

> An artist, as a citizen and as a man, . . . without fail *loves* something and *hates* something. One assumes that he loves that which is noble and hates what deserves hatred. Love and hatred are not in the least logical deductions but feelings. [The artist] need only be sincere in order to be tendentious.[48]

This formulation—in my view a succinct definition of the Peredvizhniki's approach—indicates that personal commitment was uppermost, and emotional involvement more important than critical commentary. Whatever they painted—whether it was a poetic landscape, the figure of a pensive Christ or an imprisoned revolutionary—they did it with feeling and they expected the viewer to respond in like manner. Repin wrote that the artist "must believe in what he paints and...the viewer should not judge whether [a picture]

is well or badly painted, he should be simply captured by the image, the live people and the drama of life."[49] The absence of overriding interest among the Peredvizhniki in technique *per se* is well known. It underlay much of their indifference, even hostility, to contemporary Western painters, whose technical innovations were often ignored or passed off as merely the will-o'-wisp chase after novelty. They criticized European art for not communicating emotionally with the viewer; the charge that Western paintings do not "touch your heart" is a frequent refrain in their writings.

In addition, the Peredvizhniki sought to paint the general, the common, not the incidental or the particular. They wanted to render what would be of interest to the public, not something that would have meaning to the individual artist alone. This conscious search after a general statement was certain to make their art popular. Kramskoy's correspondence with various younger artists abounds in advice to paint typical scenes and typical representatives of different social strata, trying to convince them that at present "type alone constitutes the entire historic task of our art. . . ."[50] In the late 1870s Miasoedov wrote an article on how painters were living at a time "when private life assumed secondary importance, giving place to the interests of society," and when artists "should broaden their goals" to paint pictures that would be "generalizations of a number of individual cases, a genuine transition from the private to the general (*ot chastnogo k obshchemu*)."[51] His painting "Reading of the Emancipation Manifesto" (*Chtenie Manifesta,* 1873) was done according to this formula, with the individual figures serving as "bricks in a construction." Miasoedov has described in some detail how each peasant represented a particular, readily recognizable type—the wealthy farmer and the pauper; the pre-Emancipation village elder who knew how to please the landowner and his independent-minded successor; the literate, intelligent peasant as well as the simple-minded, timid type.[52] No wonder that Stasov called such group pictures "choral canvases."

Even if a picture portrayed but one person, it would be intended to convey some general concept and was interpreted in those terms by viewers. Thus Yaroshenko's portrait of Anna Chertkova (1859-1927), liberated daughter of an army general who was active with her husband in publishing educational booklets for the lower classes, was titled "The Girl Student" *(Kursistka,* 1883). To Yaroshenko, her intense personality was typical of her generation's dedication. To Gleb Uspensky, the populist writer, her portrait became the subject for a disquisition on the women's question: To some viewers, she would represent a rebellious daughter, who would not die a natural death; others would be moved to think that motherhood was the ordained role for women. She would remind some about the thirst for education among girls; others would start to argue that the female brain was too small to get involved in books. Still others might be moved to wonder about what makes for an ideal marriage.[53]

As time went on and issues changed, the content of the "typical"

changed too; but the need of artists, the critics and the public to see the portrayal of the typical in Peredvizhnik pictures did not diminish in the least. By 1890 the Peredvizhniki were being rhapsodically lauded for conveying the "poetry of every-day life." Critics were commenting with a sigh of relief that the times had passed when painters like Yaroshenko, "from whose pictures one could create an entire [rogues'] gallery of prisoners, arrested and [other] evil-looking people," no longer set the tone for the movement and that the painters turned to more ordinary themes.[54] Vladimir Makovsky, who by then had given up genre scenes of social significance and took up such banal subjects as dance lessons, became the acclaimed master of the "commonplace." His numerous and superficial pictures, full of good-natured comment on the life and foibles of average people, were praised both for their "inoffensiveness" and their "obviousness" that gave the "average viewer" much pleasure and satisfaction.[55]

Third, the Peredvizhniki painted topical subjects. Essentially, they narrated the story of what Russia was living through during the thirty years of their ascendancy, times that were marked by rapid social, economic, and cultural change. Their pictures gave the contemporary public a commentary on current happenings, and to succeeding generations a pictorial documentation of the past. They commented on the fate of the impoverished gentry: V. Maksimov's "All in the Past" (*Vse v proshlom*, 1889)—an old lady in lace cap sitting next to her faithful peasant servant with the boarded-up run-down mansion in the background; on economic change: V. Makovsky's "Bank Failure" (*Krakh banka*, 1881)—depositors reacting to a bank's failure, or K. Savitsky's "Repairing the Railroad" (*Remontnye raboty na zheleznoi doroge*, 1874)—peasants working on the railroad; on generational strife: N. Yaroshenko's "Conflict between Generations" (*Spor starogo pokoleniya s molodym*, 1881)—a fiery student arguing with his father; on the migration of landless peasants: Sergei Ivanov's "A Resettler's Death" (*Smert' pereselentsa*, 1889)—a grief-stricken woman and child by the body of her husband stretched on a dusty and lonely road; on the appearance of the proletariat: Nikolai Kasatkin's "Miners" (*Uglekopy*, 1895)—showing a change of shift in a mine; and so forth and so on.

The extent to which story-telling dominated the Peredvizhnik painting can be gauged well from their method of composition. The secession of the realists from the Academy was not marked by any technical innovation as was the case with many dissident painters in the West. The Artel members and the Peredvizhniki retained to the end the methods and habits acquired at the Academy of starting with a theme that had been set in advance, carefully working out preparatory sketches of figures or nature, and finally combining everything in proper perspective on the canvas. This is how Kramskoy described a scene he had thought up:

The subject consists in the arrival of an old, noble-looking owner, a

bachelor, to his family estate after a long, very long absence and finding the house in a dilapidated condition: the ceiling has collapsed in one place, cobwebs and moldiness everywhere, on the walls a number of ancestral portraits. [He is accompanied] by two women (foreigners of doubtful reputation), behind him a buyer—fat merchant—to whom the ruin-of-an-old servant explains . . . the family portraits.[56]

It reads like stage directions for *The Cherry Orchard,* twenty years before Chekhov wrote it.

The combination of emotionalism, typicalness and topicality largely accounts for the interest with which the Russian public has looked at the Peredvizhnik paintings, even to this day. In part, this response lies in the little explored realm of general Russian moral and esthetic perceptions and the extraordinary persistence of certain common experiences in national culture, a phenomenon that cannot be wholly explained by reference to the imposed resuscitation of the Peredvizhnik tradition after 1932.

Excerpts from essays by two art historians, written some fifty years apart, testify to the intense power of evocation the Peredvizhnik canvases have wielded all along. Prakhov has described how Perov's "Bird Catcher" recreated a whole way of life:

Looking at the "Bird Catcher" you will at once recognize in that tall, heavy old man in the blue coat and velvet boots no one else but the aristocrat among servants, a retired *kammerdiener* who had gotten used to wearing Palmerston-like, narrow sideburns and to shaving the rest of his face. . . . This retired Palmerston has retained from his service a whole set of habits imitating his master's whims [including] the arthritis wracking . . . his legs. It is good that he has inherited the velvet boots, which once upon a time have trod the soft rugs of a bedroom; and now, graced with new soles applied by a humble shoemaker, they render excellent service in the fields and in the woods, rain or shine, safeguarding the aging legs of this old eagle of lackeys.[57]

What the nineteenth-century viewers experienced so intensely is not so much different from the effect of Peredvizhnik canvases on present-day spectators. A leading Soviet art historian, Mikhail Alpatov (b. 1902), writes as follows about their appeal and value in recreating the past:

Many of us already from childhood were attracted and conquered by the Tretiakov Gallery, especially with its numerous pictures of the Russian past. No matter how our tastes have changed with the years, in the treasured corners of our minds, [the Peredvizhnik] pictures have kept their importance of honorable witness to the lives of our ancestors.[58]

96

The interested response that one observes today in the Peredvizhnik sections of the Tretiakov Gallery in Moscow and in the Russian Museum in Leningrad attests to the perennial attraction of these canvases and their secure place in the continuity of Russian culture. What Nesterov wrote about the Peredvizhniki in the 1880s could still be said about them today: "The public went with pleasure and readily to their beloved Peredvizhniki, the same way it loved reading its favorite authors."[59]

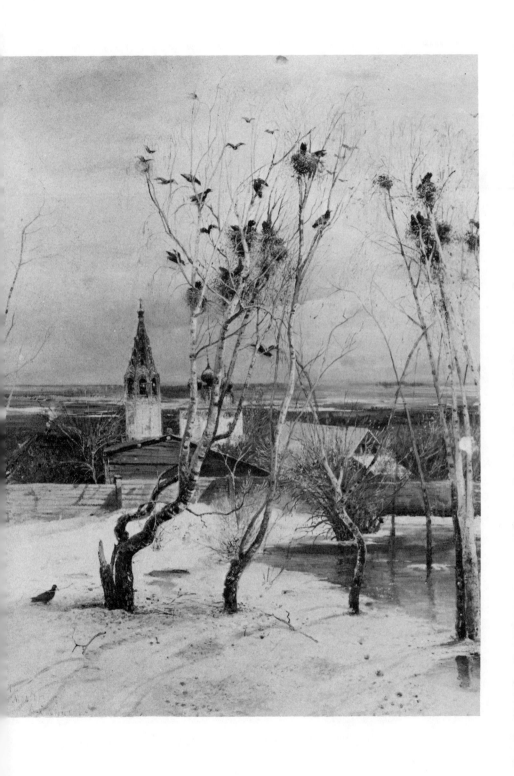

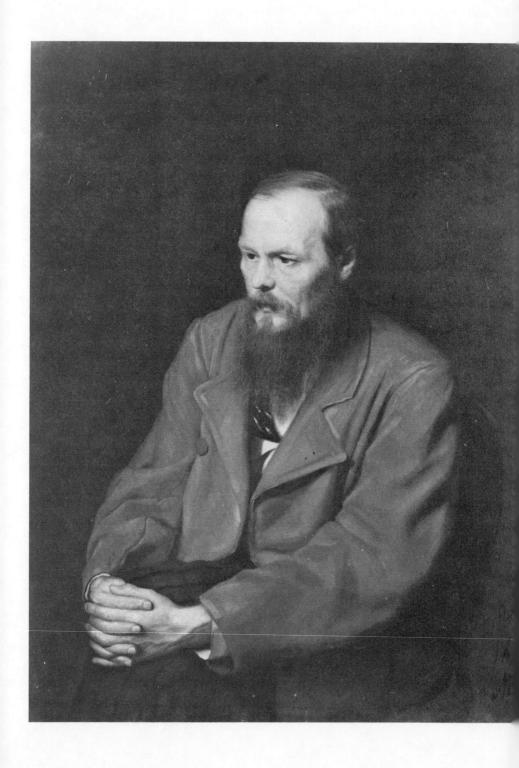

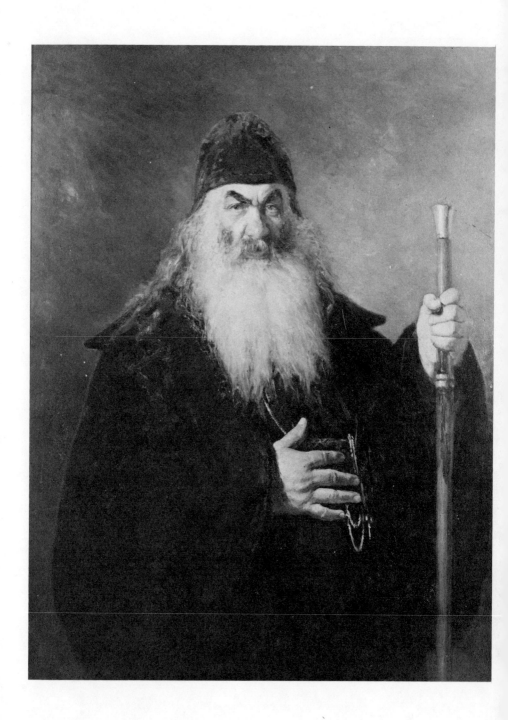

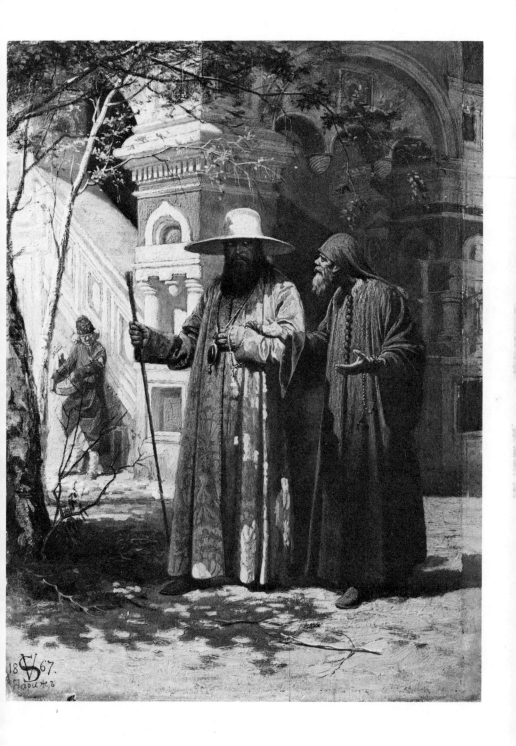

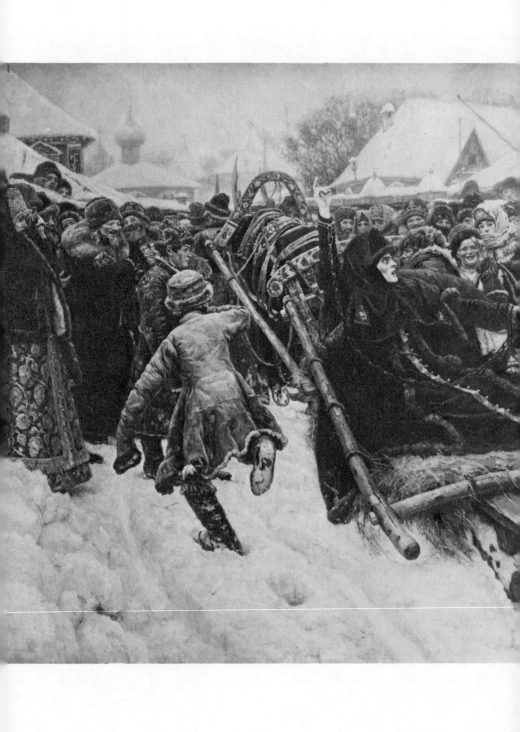

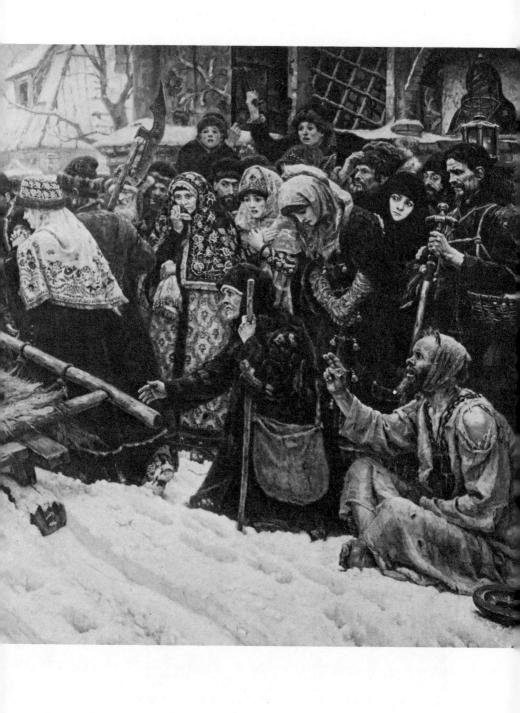

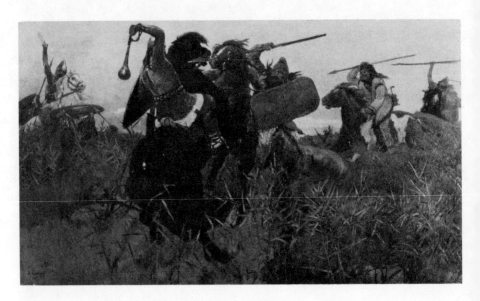

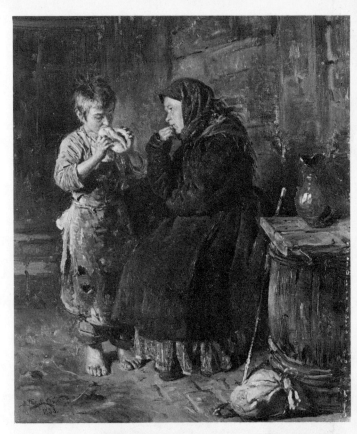

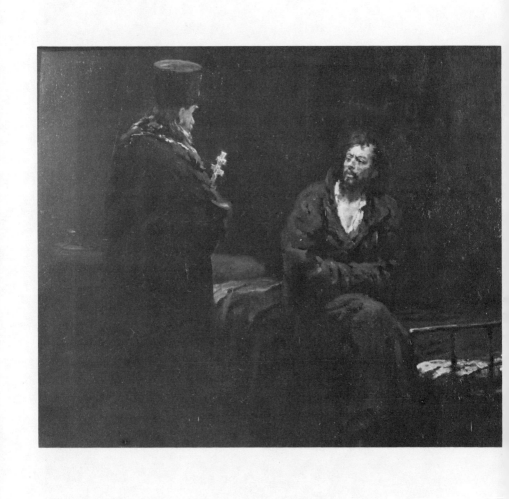

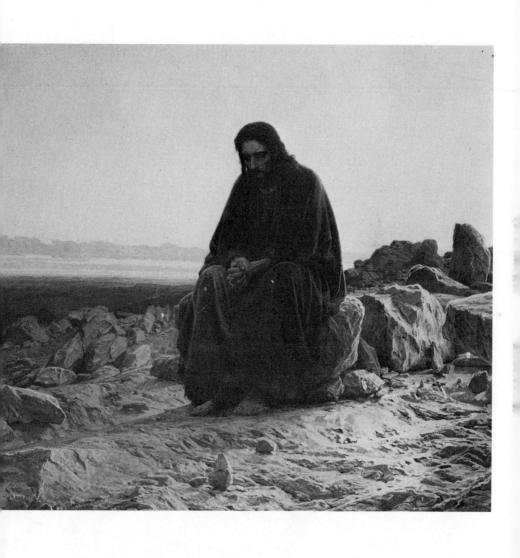

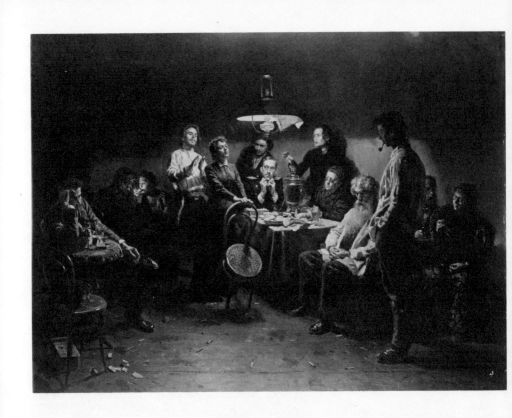

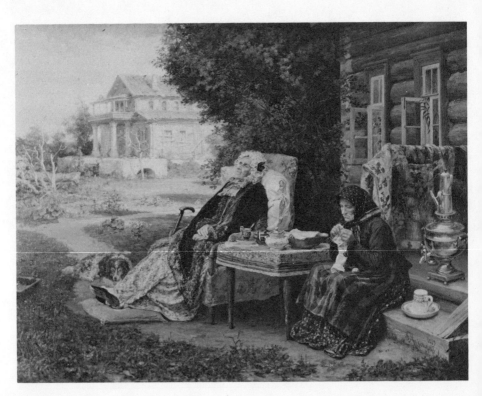

V THE DECLINE OF AN ETHOS

As we have seen, fourteen graduates seceded from the Academy of Arts in 1863 in protest against its constricting regimentation, and, seven years later, the Peredvizhniki set up a rival organization. By 1893 they had returned to the fold. Ironic as it may seem, many prominent members of the *Tovarishchestvo* agreed in 1890 to help reorganize the Academy and later joined it either as teachers or as members of its governing Assembly.

How does one account for this reversal? Was it opportunism? Had the youthful protesters become middle-aged conservatives, stuffy and self-satisfied? Or is the explanation somewhat more complex than the common story of compromise and accommodation?

When one has examined their initial sense of mission, noted their wide acceptance in the 1880s as the exponents of national art and, along with success, their personal embourgeoisement, and seen all this against the background of a growing cultural pluralism that was undermining their hard-won success, then the merger of the Peredvizhniki with the Academy is not so surprising. This step institutionalized their convictions at a time when their views and interests were being challenged.

The Peredvizhniki's Sense of Mission

The fourteen protesters were not demanding absolute freedom. This was never the point at issue, either for themselves or, by extension, for others. Long after the event Kramskoy justified their action in these words:

> Free from what? Only, of course, from the administrative supervision; for the artist had instead to learn higher obligations, dependence on the instincts and needs of [his] people and the harmonization of his inner feelings and personal strivings with the general striving.[1]

Rejecting with their gesture one mode of prescriptive behavior, they assumed another. Freed from servitude to the Court and bureaucracy, their art was now to serve other needs and causes, mainly moral and humanitarian. Views on what constituted "service to society" differed considerably among members of the Association. Some, like Yaroshenko and Miasoedov, interpreted

115

the painters' mission in pretty straightforward civic-minded terms; Ge saw it more in terms of free art and untrammelled creativity. But as it was Kramskoy who more than anyone worked on recruiting new members, on articulating, spreading and transmitting the group's ideals, his views can be taken as expressing the best aspirations of the movement.

Kramskoy's writings abound with statements about the non-esthetic attributes of art. For instance, his proposal for reforming the Academy included the suggestion that a Belinsky-like critic be included on the teaching staff to imbue students with a sense of obligation to society.[2] Of course, Kramskoy never envisioned an enforced moral and ethical education of artists. He always assumed that the ideological stance would be a concomitant and unobtrusive component of the creative process, something that would emerge naturally in composition and enrich the content. Kramskoy had defined his thoughts on the subject early and kept repeating the same theme in slightly differing variations until his death:

> It is essential not only to draw and paint well but also to convey . . . thought clearly and expressively, [however] without the slightest [visible] trace of tendentiousness or moralizing so that the conclusion presents itself [independently] to the mind of the viewer and that it all will be not only wise but also pleasant, not only didactic but also beautiful.[3]

Yet, he did insist on the moral role of art and, like Stasov, kept a sharp eye on younger artists who became too absorbed in its other aspects. He never resorted to the questionable measures or wild invectives of the critic, but did try to prevent deviation from what he considered to be the basic obligation of Russian realists.

For Kramskoy the mission of art was similar to that of religion. "Serious . . . art should uplift, fill man with the power to rise, strengthen his spiritual make-up and, so to speak, keep abreast with religion *(idti v nogu religii)*," he wrote to Suvorin.[4] An agnostic himself, he wanted art to engender a moral regeneration—a function which religion seemed no longer able to fulfill. His views on this remained fairly constant throughout his life. At the start of his career he had noted in an essay:

> A genuine artist is faced with the tremendous task of shouting to the world for all to hear . . ., of putting before people's faces a mirror which would make their hearts beat with fear and make everyone admit that he sees in it his own portrait. . . . And only he will be a genuine artist who will show the distance separating principles from their implementation.[5]

Sixteen years later he was preaching the same message to younger artists:

> I think I am not far from the truth when I say that not only in Russia
> but everywhere genuine people are tormented and are awaiting a voice
> from art! [They] are straining their eyes and ears—isn't a messiah com-
> ing?[6]

Not surprisingly, the figure of Christ occupied an important place in
Kramskoy's *oeuvre*. His two most ambitious paintings were "Christ in the
Desert" *(Khristos v pustyne,* 1872) and "Derisive Laughter" *(Khokhot),*
which remained unfinished. The first picture, a naturalistically rendered
Christ seated on a stone with clasped hands and a pensive face, was painted,
according to Kramskoy's testimony, with "tears and blood."[7] Among the
public there was much controversy as to whether Christ was represented as a
resolute person or as a disillusioned, exhausted man. But to Kramskoy the
picture was a symbol of the moral problem everyone faced at a decisive mo-
ment of his life—whether to serve an ideal ("not to recede an inch before
evil") or to succumb to petty, private interests. He wanted to communicate
to the viewer the reality of this moral decision.[8] Having himself chosen to
tread the path of moral indignation and having suffered many disappoint-
ments, Kramskoy worked with intermittent obsessiveness during the last ten
years of his life on Christ being mocked by the people.

Kramskoy expected others to be equally dedicated and was apt to treat
any slackening in commitment as a desertion from the cause. A spirited disa-
greement occurred between Kramskoy and Repin when the latter was living
in Paris as a pensioner of the Academy and became absorbed in painting purely
French scenes, such as "Paris Café" with galants and cocottes, which were ex-
hibited in Parisian Salons. Kramskoy reproached his former student for hav-
ing forgotten his obligations to his native land. He lectured Repin that in Rus-
sia, unlike the rest of Europe, "artists [were] not free as birds"; conditions
were such as to oblige them to deal with themes other than beauty and bliss,
to take a stand on various issues being thrashed out at home.[9]

Repin defended his right as an artist to paint what he wished. And the
first picture he produced upon returning to Russia in 1876 was a lovely Im-
pressionist outdoor scene of a family outing in vibrant summer light, "On a
Turf Bench" *(Na dernovoi skam'e)*. But apparently he found no sympathetic
response, for this canvas was not exhibited until 1916. Instead, he was con-
stantly being pressed by Kramskoy and Stasov to paint "the life of the peop-
le." By the end of the year the two had succeeded in persuading Repin that
he must "exorcise foreign devils" and devote himself to "full-blooded Russian
scenes." Stasov's letter of November 7, 1876, to Kramskoy sums up their po-
sition:

During these three years [Repin] was in a milieu that was harmful for him. . . . Somewhere inside Russia he will get rid of it and regain his powers—the full power of a realist, of a nationalist artist . . . fully capable of creating and representing thoroughly national types and scenes.[10]

Shortly thereafter Repin was settled in the Ukrainian village of Chuguev, where he produced among other things the "full-blooded" portrait of the clergyman in minor orders *(Protodiakon)*. The episode left no visible scars on the resilient Repin. It shows, however, the seriousness with which Kramskoy maintained his conviction that the step taken in 1863 was not an assertion of unqualified individual freedom but the assumption of new responsibilities to society.

Kramskoy wanted the principles of realist art to be imparted through proper schooling. Despite having led the secession, he would never say, "Down with the Academy," for his protest was not posited on the rejection of formal training. Russian realists were at the opposite pole from Courbet, who answered the petition of dissatisfied students at the *Ecole des Beaux Arts* that he set up a studio to teach the theory and practice of realism with: "I deny that art can be taught, . . . in other words, I maintain that art is completely individual."[11] To the end of his life Kramskoy was concerned with a structured art training, either in connection with or in opposition to the Academy. In the 1860s he had written two essays on reforming the Academy to provide its students with courses in general education, an early start in drawing from life, philosophical guidance and, of course, creative freedom.[12] Even in the early 1870s, after the founding of the Association, Kramskoy, Ge and several other Peredvizhniki sat intermittently on a commission to review the Statutes of the Academy in hopes of ridding it of its fossilized methods.

After the complete break between the Association and the Academy in 1875, Kramskoy laid plans for a separate school to perpetuate the artistic concepts of *Peredvizhnichestvo*. He tried, unsuccessfully, to persuade Tretiakov to finance the venture, arguing in near hysterical terms that the new-born Russian realist art faced extinction for lack of appropriate schooling, that the Association would "die childless" since it could not train followers and its influence on the public through exhibits was insufficient.[13]

If these plans now seem like an attempt to create a closed system, this was not the intention of the leading Peredvizhniki while the movement retained its original vitality. The leaders' surveillance of the allegiance of individual members and the proposals to assure better training and philosophical guidance for the next generation were not motivated at first by any desire to monopolize the field. Rather, they should be seen as the continuation of the task undertaken in 1863 and reaffirmed in 1871: to free Russian art from official controls. As late as 1887 the Academy still saddled the graduating class with obligatory themes on the following order: "Old Priam Pleads with

118

Achilles for the Body of his Son," plus appropriate references to the Iliad to ensure accuracy; or "Rural Churchyard," with detailed instructions that the scene include clumps of oak and maple as well as a group of worshippers.[14]

The Association was a small group struggling to survive, and its members had to give sustenance to one another. This is why Kramskoy proposed to Repin in 1877 that a "philosophical system" mapping out broad principles of the movement be formulated by some talented writer. It would guide the artists in their endeavors, reassure them that others were pursuing similar ends, strengthen their powers "tenfold," and hold them to their "loftiest goals."[15]

Given the character and pervasive power of the Imperial Academy, the Peredvizhniki had to talk of extreme measures to preserve their separate identity and have their private exhibits play the role of an innovative and educational catalyst. Precisely because the situation in Russia up through the 1880s offered so few other options, the artistic scene was viewed not as a field for the free play of different styles and subject matter but as a battlefield. Back in 1862, Stasov had already noted that the Academic exhibits were being enlivened by the appearance of new styles. Significantly, he was uninterested in variety *per se* but argued that this was the sign of the oncoming strife. Future exhibits, in his opinion, "will be characterized by struggle, duels of . . . overarching trends, and this will persist until the time when at last one trend . . . will be victorious [and] will place its resolute foot on the head of all the others."[16] This combative attitude did not subside with time; the imagery persisted. Kramskoy had accused Repin of deserting the "battlefield" in their correspondence in 1875; a decade later he still was worried about the "army of our opponents."[17]

There was no monotonous uniformity in either style or themes during their most creative phase even though the Peredvizhniki tried to muster a united front against official and conservative hostility. They certainly did not consider their liberated art dogmatically. The variety in themes—not all of them doggedly on moral or social issues—has already been noted. As for style: in landscape, for example, it could range from the photographic exactness of Ivan Shishkin to Arkhip Kuindzhi's simplified use of large areas of color that resembled early Impressionist technique. Typical of the spirit of tolerance and open-minded group loyalty that prevailed in the Association at the start was the reaction of other Peredvizhniki to M. K. Klodt's vicious diatribe against Kuindzhi's unorthodox handling of light. Klodt accused his fellow-member of violating the rules on the proper transition from one tone to another, of nonchalantly painting chance phenomena, and of presenting the public with rough impressions instead of a carefully finished canvas.[18] While Kramskoy withheld judgment (he found Kuindzhi's manner puzzling but was nevertheless willing to entertain the thought that it represented entirely new

painterly principles), Yaroshenko came to Kuindzhi's defense. He dispatched a strongly worded letter to Klodt stating that his review had been motivated not by "love for or interest in art" but by "petty . . . envy . . . of an artist with a much fresher and stronger talent."[19]

But as time went on and *Peredvizhnichestvo* lost its vitality as an artistic force, as it failed to attract gifted recruits, the Association began to be prescriptive about the way painters should look at and interpret the world. The original dedication to popularizing new and free art turned into a possessive obsession that could not view the movement as a stage in the continuum of development. The Association came to regard its output as a terminal perfection, not to be superseded by another trend. This attitude, a perversion of the original commitment to free realist art, contributed to the Peredvizhniki's readiness to join the Academy. That was a step which would help perpetuate their system of values.

Embourgeoisement

The embourgeoisement of the Peredvizhniki exemplified their system of values in an all-too-human way and thus is vulnerable to unfair criticism. The nature of their dissent made them susceptible to accommodation. As painters, they had followed the lead of the intelligentsia rather than formulating their own ideas about subject and approach. In like manner, they did not assert an individual pattern in their personal lives but conformed to current social norms. Of all the leading Peredvizhniki only Maksimov lived on the verge of poverty and only Kuindzhi lived an unconventional sort of life. He furnished his apartment with bargains bought at auctions, made do without servants, and put up a simple one-room dwelling to serve as a dacha-cum-studio on land he bought in the Crimea.[20] All the other painters sought to live in a way indistinguishable from that of the upper-middle class, a pattern that also characterized the lives of almost all the recognized crusading writers and journalists.

In this respect, the life-style of the protesting Russian painters contrasts with that of many West European artists in the mid-nineteenth century. In the West, those artists who rebelled against the Academy or the prevalent style would often underscore their independence by a deliberately cultivated unconventionality. *La vie bohème* and the alienation of artists from society in the West may often have been more a literary image than an actuality; still, even if only a myth, it was one that many writers or artists wanted to embody and felt gratified with. To the Peredvizhniki, on the other hand, wordly

achievement was the visible sign of the success and rightness of their cause.

The establishment of the Artel was in keeping with the protest of the young in that decade. But the way the artists chose to live was very "tame" compared with the pranks of other emancipated youths, the "nihilists," who sought to prove their liberation from the hypocritical ways of their gentry parents by rejecting accepted social behavior. The Artel members were concerned with the moral dimensions of the new life, not in asserting their independence by flouting social conventions. They were all properly married; they did not sport outlandish clothes; and as soon as they could afford it, the Artel moved out of the working-class district into the central and fashionable part of town. Having escaped provincial surroundings, they were eager to assimilate the conventions of the capital and not to stand out as the country bumpkins which everybody indicated to them they were. Students of gentry background, whether from the University or the Academy, might don peasant shirts and scorn refined city ways, but Artel members tried their best to shed the telltale traces of their plebeian origins. When Kramskoy returned on a visit to his native village after a relatively short stay at the Academy, no one there could recognize the "gentleman from the capital."[21]

An *arriviste* mentality was the rule rather than the exception among the Peredvizhniki. The case of Fedor Vasilev, on whom Kramskoy and Tretiakov placed great hopes as a landscape painter, demonstrates vividly how important social acceptance was to the artists and to what extremes some went to attain it. An exceptionally gifted and attractive person, he gave up his job as a postal clerk in 1868 to study with Kramskoy and Shishkin at the art school run by the St. Petersburg Society for the Promotion of Art. Not satisfied with the quick recognition of his talent by the directors of the Society and by Tretiakov, all of whom gave him stipends, he assiduously sought access to high social circles and spent money recklessly to dress and live like a gentleman *(barin)*. Both Repin and Kramskoy savored with obvious relish and pride Vasilev's ability to pass himself off in society, to make the well-born believe, what with his fashionable suits and nonchalant use of a few French phrases, that surely he was related to some prince or the illegitimate child of some celebrity and not the son of a petty official, with no formal education.[22]

Despite his usual moral earnestness, Kramskoy never reproached Vasilev for living above his means, although this must have been detrimental to both his art and health. It was Tretiakov who lectured the young man on managing frugally and, after his death, reclaimed the sums he had advanced, while Kramskoy looked on indulgently and undertook to pay off the extensive debts Vasilev had run up during his short and meteoric career.

The other Peredvizhniki did not have Vasilev's flair or luck to gain such speedy entrance into society, but slowly over the years they all managed to become accepted and be assimilated. Not one of them tried to gain notoriety as the untutored genius or the rough-hewn provincial, unspoiled by urban

sophistication. Their effort to leave behind their origins and live like cultured gentlemen partly explains the absence of the primitve or rustic in their works.

Even though the Peredvizhniki painted the life of the people and came to regard themselves as the creators of a distinct national style, they borrowed little from traditional folk art, such as the peasant woodcut *(lubok)*. At times they might use a subject or composition from a *lubok*, but they painted it in a style that hardly differed from the language of the Academy. Neither the Artel members nor the Peredvizhniki seemed ever to be attracted to the simplicity of rendition in the *lubok*, perhaps because in the cultural world which they aspired to enter the term "lubok-like" *(lubochnyi)* was one of opprobrium reserved for something artistically crude and inept. The world of the peasant woodcut was on the far side of the social and cultural gulf. At best, the members of the Association might paint scenes of a village dance or a fair with these popular engravings on sale at a kiosk.[23] Unlike Courbet, who consciously affected a plebeian style in his personal behavior and who painted without applying the learned devices of the Academy, the Peredvizhniki sought to distance themselves completely from the naive and the primitive.[24]

The acquisition of a country estate, its costly renovation, and the constant expense of running it form a frequent enough pattern in the careers of prominent Peredvizhniki to merit some attention. Moreover, in the cases of Perov, Kramskoy, Maksimov, Ge and even Repin it was often accompanied by a noticeable decline in their creative powers, which were diverted either into managing the estate (Ge, Repin) or to painting routine, fashionable pictures to pay for the extravaganza of country living à la nobility (Maksimov, Kramskoy). It was not so much that gentry estates were quite cheaply available on the market after the Emancipation, because many became too unprofitable for the traditional owners to run. Rather, the painters seemed to want to appropriate a style of life that carried a certain sanction, and success did not seem complete with just an elegantly furnished city apartment and an opulent studio.

The craving for an upper-class life and the considerable personal wealth amassed by prominent Peredvizhniki have been a sore subject for the public, fellow painters, radical youth—and for Soviet historiography. All wanted to believe that dedication to "the cause" was uppermost in the painters' minds, and that they did not soil their hands with the dirty business of making a good living.[25] Repin's reminiscences of his teacher described the country residence (to which the new proprietor added a large studio, a landscaped park and separate servants' quarters) as symbolic of Kramskoy's abandoning the moral radicalism of his youth for the pompousness of his declining years, the security of painting official portraits, and acceptance in high society. These "revelations" offended many sensibilities and called forth indignant objections when published in magazine form in 1888.[26] Kuindzhi was disliked

among his fellow members in part because, even though he lived very simply, he engaged in land and real estate speculations that enabled him to leave a half-million ruble fund for the establishment of an art association in his name.[27]

Radical youth so idolized the Peredvizhniki's service to the people that it expected them to observe a radical asceticism in their personal lives. When one activist, A. Altaeva, visited Bogdanov-Belsky in 1889, she was shocked to find this painter of rural poverty living in an elegant neighborhood and sporting expensive clothes. She fully expected that a Peredvizhnik who came from the peasantry and who depicted the hardships of their existence would be living in penury sharing the lot of the underprivileged.[28]

This "embarrassing" subject has not been honestly treated by Soviet art historians, except in the 1920s when a Marxist school that dispassionately researched and discussed the economics of the art scene briefly flourished. Under the Stalinist regime old hypocrisies were revived; the matter was left unmentioned lest it detract from the reputation of the Peredvizhniki. Hence the published version of Altaeva's memoirs of meeting various artists does not include the episode describing her disillusionment with Bogdanov-Belsky.[29]

Alexander III and the Peredvizhniki

In a generation's time, the Peredvizhniki moved from their marginal position practically to stage center in the national scene. The process was a gradual one. By 1871 they were accepted by liberals as men of ideas; by the end of the decade a broader spectrum of the intelligentsia welcomed them as the creators of an original Russian art that challenged the formalism of official art; by 1890 they were embraced by the regime and the conservatives as the founders of a national school. This recognition marked the consummation of their success, marrying the last thirty active years of their movement to the establishment.

The union was brought about by Alexander III (1881-94). Like Nicholas I, the other outstanding autocrat of the century, Alexander was a thoroughly committed patron of the arts: appropriations for the Academy were increased substantially, as were the state funds for purchasing new works; public construction and official commissions, almost at a standstill during the preceding reign, revived; a network of provincial public art museums and schools was started.[30] For both rulers the promotion of art was an important component of state policy. But unlike his grandfather, Alexander made his support of art an active element in the promotion of modern nationalism—

whereas Nicholas had favored the international style of pseudo-classicism, Alexander championed Russian art *sui generis.*

Alexander III was the most outwardly nationalist of the last four Russian rulers. During his reign the Court, until then very much French and German in language and habit, became thoroughly Russified. Undoubtedly, this transformation in the official world was connected with the capitalist development the country was undergoing after the Emancipation and which quickened toward the end of the century. The personal preferences of the Tsar paralleled the ethnocentrism of the ascending bourgeoisie; in fact, Alexander III can be called the bourgeois Tsar.

In art, Alexander's tastes matched those commonly ascribed to the middle class. (It was Alexander who purchased most of the Russian canvases from the Kokorev collection when the Moscow businessman went bankrupt in 1869 and, symbolic of changes to come, redecorated his residence in Tsarskoe Selo with these genre scenes, taking down the pseudo-classical pictures that had hung there since the days of Nicholas I.)[31] At first Alexander tended to patronize those young Russian realists who painted contemporary foreign scenes,[32] a preference that disappeared with time. Very soon after he became Tsar, the promotion of a native school of painting, based on Russian subject matter and marked by genuine Slavic qualities, became an inseparable part of his program for the creation of a powerful national state. For the new Tsar believed that the state gained in strength to the degree that it eschewed borrowings from abroad in the sphere of ideas and institutions, to the extent that it cultivated a national culture with its own distinctive personality. The change in his attitude toward Antokolsky is telltale. In 1874 Alexander had no hesitation in buying Antokolsky's statues of Peter the Great and of Christ, but by 1885 he shared the doubts of his former tutor, the arch-conservative Konstantin Pobedonostsev, whether this "Jew" and "cosmopolite" could grasp the "central idea" essential for sculpting an appropriate monument to Alexander II.[33]

The Tsar took energetic steps to promote authentic Russian artistic expression. In architecture, there was a switch from the neo-Byzantine forms favored by Nicholas I to a revival of the Muscovite sixteenth- and seventeenth-century style. Churches, civic buildings and railroad stations imitated the exuberant, heavily ornamented style of old Muscovy. So did, by the way, the private residences of Moscow businessmen and the decorations on Tretiakov's art gallery.[34] In religious art, Alexander also favored the infusion of national spirit. In 1884 he chose Adrian Prakhov, who by then had turned into a conservative advocate of old Russian traditions, to supervise the decorations of St. Vladimir's Cathedral in Kiev in commemoration of the millennial anniversary of Russia's conversion to Christianity. To the present-day viewer, these frescoes do not in the least approximate the originality and intensity of medieval Russian ikons; the central fresco of the Virgin resembles the senti-

mental Madonnas painted around this time in bourgeois France by William Bouguereau. But for contemporary observers they had successfully recaptured the essence of Russian orthodoxy and were praised for having reinstated a national style in religious art.[35]

In his program of Russification the Tsar decided to found in St. Petersburg a museum devoted exclusively to Russian art.[36] Until then the nation's capital had only one public museum, the Hermitage, filled with nothing but European masters. This anomaly had raised public comment during the nationalist wave that engulfed the intelligentsia in the late 1870s, and Stasov suggested that the Hermitage collection be supplemented with the new realist art to acquire the missing "national, Russian character." When Alexander's decision to set up a separate museum of Russian art became known, Stasov, with his usual obliviousness to any other viewpoint, claimed that the move was tantamount to recognizing the *oeuvre* of the Peredvizhniki as the national school. As a matter of course, he assumed that they would take an active part in the museum's organization and their work would form the core of the collection. Quite prophetically, without realizing the irony of his phrase, Stasov, the defender of free unofficial art, proclaimed that what the Peredvizhniki had battled for was now fully recognized, that "their ship had reached a safe haven."[37]

Stasov correctly sensed that Alexander was ending the official hostility toward the Association. But he was not perceptive about Alexander's intentions. The Tsar was eager to mend the split between the two art centers, but on his own terms. His aim, obviously enough, was not to base the national school he was promoting on the original constructs of *Peredvizhnichestvo*— i.e., service to the nation in its struggle for free expression—but to enlist it under an all-encompassing nationalism that served the needs of the state.

Before his accession to the throne, Alexander had displayed some interest in the young realists who were dissatisfied with the ossified Academy. He looked them up in their studios while visiting Paris in 1874, even though painters like Repin had already been the subject of much controversy over their political allegiances and had been reprimanded by the Academy for too close an association with the *Tovarishchestvo*. Once Tsar, Alexander did not at first attempt to curtail the personal vendetta against the independent grouping waged by Petr Iseev, the Academy's Conference Secretary (1868-89). But his conciliatory attitude could be sensed in the tone of the articles that appeared in *Messenger of Fine Arts (Vestnik iziashchnykh iskusstv)*, an expensively-produced art journal that the Academy started publishing in 1883 with a subsidy from the Imperial family. It eschewed narrow partisanship and counted such avowed enemies of Academism as Stasov among its contributors. as if to stress the common bonds that united all who were interested in the success of art in Russia. Moreover, none of its articles spoke slightingly of realism—quite the contrary, in fact.

But the realism the Tsar was ready to promote was quite different from the realism that *Peredvizhnichestvo* had originally stood for. One essay in the Academy's new journal, Nikolai Akhsharumov's "The Tasks of Painting During the Period of the Formation of a National School," delineates the style favored in official circles.[38] It quoted approvingly from Stasov in asserting that art had lost popularity in Russia because foreign influences had been so predominant. But there the similarity ended, for Stasov was both a nationalist and a man of the "sixties," whereas Akhsharumov was a typical chauvinist conservative of Alexander III's reign. Though both considered Fedotov and Perov as the founders of Russian realism, each interpreted differently the intent of their work in deducing a different set of guiding principles for the entire school.

For Stasov, Fedotov and Perov were primarily critical realists, but Akhsharumov valued them as painters of purely Russian themes. Stasov praised Perov not only for depicting common national types, but also for creating a gallery straight out of Ostrovsky's "kingdom of darkness," which (it was his expectation) would lead viewers to reflect on the system that produced and nourished such imbeciles.[39] To Akhsharumov, Perov's types were a source of pleasure; he discussed pictures of fishermen, bird catchers and hunters—so evocative of national pastimes—and left unmentioned the canvases with drunken priests or the poverty-stricken lower classes.

The elements that Akhsharumov noted as typical were certainly present in Peredvizhnik art all along, but they had never been set up as guiding principles for the movement by its liberal founders and supporters. Conservative nationalists, however, just like their counterparts among the wealthy middle-class patrons, tried to emasculate realism of its socio-moral content and to promote instead the sentimental, evocative aspects of *Peredvizhnichestvo*.[40]

Another indication of the Tsar's more gracious attitude toward the Peredvizhniki was the resumption of official commissions. His father, Alexander II, had come to ignore the Association completely. But it had also been a point of honor for these painters to turn down orders from the Court. After 1881 both sides relaxed their intransigence. In 1883 Kramskoy painted the coronation of the new Tsar. The next year Repin agreed to depict Alexander III addressing village elders after his coronation, even though he considered it a "very conservative" speech that marked a "real turn in Russian life."[41] In his enthusiasm and naiveté he hoped he would be able to present a contrast between Tsar and people. But his first sketches were firmly turned down by the Court, which wanted a scene resembling that of Christ preaching a sermon to the faithful. After much haggling, Repin finally painted the Tsar full face to the viewer, addressing a crowd of peasants, only their backs showing— which could have been taken as an allusion to the mute role of the populace. Nevertheless, Repin was dissatisfied with his picture and unhappy about the episode.

126

Whatever Repin's feelings and intentions, the canvas was displayed at the fourteenth traveling exhibit in 1886, an indication that by then the Association no longer jealously regarded its shows as a display of independent art uncontaminated by either the Academic spirit or official patronage. (The newspapers were quick to note this slippage, and one ruefully stated that Repin's painting could hardly be commented on since the high provenance of the commission tied the hands of both the artist and the reviewer.)[42]

The fourteenth Peredvizhnik exhibit marked an even more important turning point in the Association's relationship to official circles—it was attended by the Tsar. Because the new, much stricter censorship laws were being enforced for the first time that year—laws that required approval of an exhibit's content prior to its opening—the Association suffered the indignity and anxiety of having its show approved by the censor only at 8 AM on the day of the opening. To forestall any similar harassment in the future, Kramskoy took the bold step of inviting the Tsar to visit the exhibit, which Alexander readily did a few days later.[43] As luck had it, Alexander saw the Peredvizhnik exhibit right after having seen the rival show at the Academy. And according to all the eye-witness accounts he was struck by how "dry and deadly" the official show was by comparison. He demonstrated his appreciation of Peredvizhnik art by purchasing five canvases. And even more important, having found that many pictures he liked had already been acquired by Tretiakov, the Tsar requested that henceforth he be invited to attend before the opening so as to have first pick of the lot. Soon Imperial patronage began to outweigh that of the most knowledgeable middle-class collector.[44]

As the Peredvizhniki began to lose their creative impulse and settle into the comfortable groove of plain naturalism, the Court with its new taste for bland depictions of the Russian scene became an important client. The Imperial family's extensive purchasing at the traveling exhibits coincided with Alexander's plans to set up a museum of Russian art. At the same time Tretiakov, with a much finer eye for the technical and esthetic qualities in art, began to shift his support to younger talents who in their search for different subjects and novel ways of expression no longer followed the lead of the Peredvizhniki. No wonder then that the proposed museum of Russian art became a "safe haven"—but not as envisaged by Stasov. The Peredvizhniki were ensconced on the walls of an Imperial museum not as representatives of free art and critical realism but as beneficiaries of the Tsar's bountiful, prestigious and jingoistic patronage.[45]

That the next generation finds its predecessor pompous and tedious is a truism from which the Peredvizhniki were not exempt. The generation of painters born in the 1860s either became indifferent to or openly disavowed the original Association goals and esthetics. The appeal and authority of *Peredvizhnichestvo* began to wear thin around 1885 for many gifted young artists, such as Mikhail Nesterov, Isaak Levitan, Valentin Serov, Konstantin Korovin, and Mikhail Vrubel.

Mikhail Nesterov (1862-1942) is an apposite case of someone who started out committed to the Peredvizhnik tradition but moved out of its ambit as he matured in the 1880s. When in the late 1870s, his teacher Perov told him he was headed straight for membership in the Association, he considered this the finest accolade he could ever receive. The Peredvizhnik approach and subject matter had so captured everybody's imagination that when Vasnetsov switched in 1880 from social genre to painting the legendary past and heroes, Nesterov and other students at the Moscow School regarded him as an apostate. Yet when Nesterov came to St. Petersburg soon thereafter, he turned down the offer to work in Kramskoy's studio, fearing an overbearing influence that might cripple his individuality. He underwent a spiritual crisis in 1886, after which he began to paint Russian saints in a lyrical manner.[46]

Others had never been swept up in the Peredvizhnik ethos to begin with. Valentin Serov (1865-1911) studied with Repin, but this training was modified early in his career by close association with Mamontov's Abramtsevo circle, where decorative aspects of art were of primary interest.[47] Mikhail Vrubel (1856-1910) began formal training at a later age than most (he entered the Academy in 1880) and from the start displayed an independent mind. Already in 1883, when Repin's "Procession of the Cross in the Kursk Province" was being widely praised with tiresomely reiterated descriptions of all the provincial types represented on the canvas, Vrubel wrote sardonically that the Peredvizhniki, instead of serving refined art to the public, gave it "coarse kasha (i.e., gruel) . . ., items which touch upon the interests of the day." Perceptively he saw that the Peredvizhniki had become all too thoroughly enmeshed in their efforts to create popular art:

> They are eternally right that artists lacking the recognition of their public do not have a claim to exist. But once recognized, the artist does not have to become a slave. He has his own original special business in which he is the better judge—a matter which he must honor and not destroy its significance to the point that it becomes a tool of journalism *(publitsistika)*.[48]

128

This is not the place to take up at length the reasons for the new generation's growing interest in different modes of expression and in the language of art itself, which made it scorn the older Peredvizhniki's preoccupation with meaningful content at the expense of technique. But since the social background and education of the early realists had significantly shaped their outlook, the circumstances of the younger painters should also be noted. They came, for the most part, from families that were economically better-off and were better educated. Vrubel completed his legal studies at the University before entering the Academy; Serov's father was a well-known composer and his mother a pianist; Korovin's father was a successfull businessman; and Nesterov came from a cultured merchant family. Only Levitan's background was similar to that of the early Peredvizhniki, his father being a minor railroad employee in the provinces. Not only were they born into socially secure positions, but they became artists at a time when the profession no longer carried a social stigma. For one thing, becoming an artist was no longer a clever way of escaping the inequities borne by the lower estates, for these inequities were being righted.[49] Furthermore, the cultural elite accepted artists into their ranks, and painters no longer had to assume the concerns of others in order to be certified as "belonging" to the intelligentsia. Nor was the tenor of the 1880s such as to predispose the new generation of artists to become involved in social problems or reform—the decade was marked by unmitigated reaction and general quiescence. Times had changed, and many artists were a different breed of men with other interests, for whom the simplicity and clarity of old assumptions were no longer valid.

The new generation felt at ease with Russian society; it was also less insecure and defensive about the West. Nesterov went abroad with an open mind in 1889. Though he had difficulty adjusting to the "technically excellent art" without much "depth" to it, he was fully aware of the extent to which he had been conditioned at home to react this way, "having been brought up on Ruskin and theoreticians like him."[50] Even some of the established Peredvizhniki were beginning to take a new look at Western art. When Surikov visited Vasili Polenov in Rome in 1884, he was very much taken with the idea of art for art's sake and talked about how it "was a sin not to be a colorist." Though his views may have in part echoed those of Polenov himself, who culturally was the most sophisticated Peredvizhnik, they also testify to a more open-minded attitude toward developments abroad among many painters by the mid-1880s.[51]

The parochialism with which Russian painters were afflicted in the preceding two decades was diluted by greater familiarity with modern Western art, gained through exhibits of contemporary European paintings. What seems to have been the first exhibit of modern French art opened in the capital in 1888.[52] The works shown were by Fortuny, Meissonier, Bastien-Lepage, Jules Breton, Léon L'Hermitte, Dagnan-Bouveret—painters who were fashion-

able abroad and whom the Russian public also liked. Though there was a wider knowledge of Western art, nevertheless there was a notable difference in tastes between the older and younger generation, and it became a matter of contention. The old Peredvizhniki continued to revere the dramatic, story-telling canvases by Fortuny, Regnault, Munkacsy, Makart, Matejko, while the younger artists favored the romantic pathos and spirituality of Bastien-Lepage, Puvis de Chavannes and the Pre-Raphaelites. The differences in taste were sufficiently marked and articulated so that the younger painters accused the older men of trying to maintain a "Chinese wall" vis-à-vis the West.

But the most irksome issue between the established painters and the new generation was that of freer access to the Peredvizhnik exhibits, which remained the most prestigious shows in Russia. The older painters were loath to encourage the young and very grudgingly admitted them first as exhibitors in the annual shows and then to full membership in the Association. Serov gained membership in 1894 after several years of exhibiting; Korovin was never admitted, even though he had nine works accepted by the Peredvizhnik jury between 1889 and 1898; and Vrubel never made it past the jury. While these painters, now recognized as masters of Russian art, were being slighted, many a mediocre Salon talent long since forgotten (such as E. Volkov, Yu. Leman or N. Bodarevsky) was readily admitted to the Peredvizhnik exhibits and to the Association.[53]

Polenov, Repin and Ge were among the liberal Peredvizhniki who were more generously disposed toward the "younger brothers." But they were in a minority, regularly outvoted by V. Makovsky, Kiselev, Miasoedov and Lemokh. The passions aroused by paintings "not in keeping with the goals of the Association" (whatever these goals were by then) reached ridiculous proportions. When in 1889 Tretiakov bought Serov's "Girl in Sunlight" (*Devushka, osveshchennaia solntsem*), one of the first *plein air* portraits in Russia, Makovsky asked him sardonically: "Since when, Pavel Mikhailovich, have you started infecting your gallery with syphilis?" And when Nesterov's "Young Bartholomew's Vision" (*Videnie otroku Varfolomeyu*) was admitted to the 1890 exhibit and purchased by Tretiakov, Miasoedov demanded not only that the saintly shepherd boy's vision be taken off the wall but also that Tretiakov renege on his purchase![54]

Matters came to a head in March 1890. Exasperated by frequent and "unjust" rejections of their entries, a group of young Muscovite painters, led by Sergei Ivanov (1864-1910) and supported by their teacher Polenov, addressed a note to the Association suggesting that the jury, hitherto composed only of members, be enlarged to include exhibitors whose "artistic direction" had proved acceptable to the Association by repeated participation in the annual exhibits.[55]

In irate reaction, the leadership adopted new Statutes in April which not only made no allowance for the participation of younger painters on the

jury, but placed the administration of the Association wholly in the hands of the original members. Henceforth the Executive Board was to be composed only of the founders, thus effectively excluding men like Polenov and Repin from decision-making. This step brought Repin's resignation (and he held his own separate retrospective exhibit in 1891). But the public scandal only seemed to make the six remaining original members cling all the more desperately to the monopoly on artistic taste they had come to think was their birthright to exercise. An extract from the circular issued in 1892 by Yaroshenko to clarify the basis on which pictures would be admitted to the traveling exhibits reveals to what extent the original dedication, fresh outlook and open-mindedness of the Peredvizhniki had deteriorated into a set of rigid rules aimed at forestalling change:

> The Association's exhibits accept works in all possible genres under the condition that these canvases represent not painting for its own sake *(prostoe uprazhenie)* but...an attempt to render a story, an experience, a feeling, a mood, a poetic moment—in a word, that the work be not devoid of artistic aim and concept. Studies of heads, portraits, still lifes are being accepted on much more strict conditions; heads and portraits in addition to being well-painted should be typical and... [of general] interest...; still lifes, flowers, bouquets, etc., will be accepted only in case they are painted with exceptional virtuosity.[56]

Because the spirit of intolerance and bureaucratic proclivities came to prevail in the Association, the younger painters drew a clear distinction between an "artist" and a "Peredvizhnik."[57] Ironically for the Peredvizhniki, the substance and intensity of the disagreements between the young talents and the unyielding upholders of an ossified tradition now approximated the animosities between the Gold Medal competitors and the Academy some thirty years earlier.

The Peredvizhniki Rejoin the Academy

The Peredvizhniki waged a losing battle, for the young painters were not only abandoning the canons of strict realism but also forming their own exhibiting societies. The St. Petersburg Society of Artists *(Obshchestvo khudozhnikov)* was established in 1890-91, and the Moscow Association of Artists *(Tovarishchestvo khudozhnikov)* in 1893. The Moscow organization was especially liberal, admitting to its showings all trends—from the adherents of

art for art's sake to the followers of the Peredvizhnik tradition. Significantly, 1890 saw also the formation of Alexander Benois' circle, the future World of Art *(Mir iskusstva)*. Pluralism had arrived.[58]

It was at this point that the Academy of Arts extended another feeler to the Association asking several members to assist in the reorganization of the venerable institution. Alexander III was the man behind this move. Dismissing Petr Iseev, the intractable foe of the *Tovarishchestvo,* in 1889 for the misappropriation of funds, Alexander appointed the younger and more liberal Count Ivan Tolstoy (1858-1916), directing him to prune the dead wood and call in the Peredvizhniki.[59] A range of opinion on ways of reforming the Academy was consulted for the sake of appearances,[60] but Tolstoy concentrated on cultivating the Peredvizhniki. Unlike Iseev, he did not try to undermine the unity of the group by dealing with a few select painters, but directed his request for cooperation to all the members of the Association, a step that initially created an atmosphere of good will. The Count pleaded that it would be sinful for the "moguls *(kity)* of Russian art" not to share their "knowledge and talent" in the reorganization and not to join in the reformed Academy. He also intimated that the Peredvizhniki were free to make the Academy into their own school.[61] These must have been very persuasive arguments for aging men who were seeing their pre-eminence challenged. And so five Peredvizhniki—Repin, Polenov, Kuindzhi, Savitsky and Miasoedov—sat on the government commission which drafted the new Statutes, approved in October 1893 and adopted a year later.[62] Furthermore, Repin, V. Makovsky, Shishkin and Kuindzhi became professors at the revamped Academy, and twelve other Peredvizhniki joined the 80-man governing Assembly.

Among the Peredvizhniki and their supporters opinions differed on what these steps portended. Stasov considered the Peredvizhniki's entry into the Academy as apostasy from everything that the *Tovarishchestvo* had stood for. He refused to join the commission on reorganization and predicted to his brother that a "betrayal of republicanism and democracy in art, desertion to the monarchic and autocratic camp of art" was in the making. When the details of reorganization were announced, he considered his premonitions confirmed and wrote to Tretiakov: "What I had foreseen and foretold has happened. The former Peredvizhniki no longer exist!!!... From free men they have become transformed into the most humble Academicians and courtiers." Yaroshenko's reaction was similar. He simply could not accept it that so many Peredvizhniki, members of a free association "based on the rejection of state management, regulation and support of art," could have entered the Academy "of their own free will." And to show what he thought of his colleagues who had jettisoned their principles, he painted a canvas entitled "Judas." Those critics who, like Vasilevsky, had for years contrasted Academic and free art wrote eloquent articles on the "betrayal" with pointed references to the worldly honors that had lured the painters: gold-braided uniforms,

132

large rent-free apartments in the Academy's building, government salaries and pensions.[63]

The Peredvizhniki who participated in the reform and joined in one capacity or another obviously did not think that they had bartered their autonomy and principles for prestigious official jobs and connections. They sincerely believed that they could and would change the institution and its role. But there was no agreement on what measures would bring this about. Some believed that it was enough for the Peredvizhniki to teach in the Academy and to sit in its Assembly (which, among other things, was to oversee the entire system of art education) to change the tenor of artistic life in the country. Others, like Polenov, fought (but without much success) for institutional guarantees of effective self-government in order to preclude Court interference. [64]

It cannot be concluded that the Peredvizhniki managed to remake the Academy to accommodate all the aspirations of independent artists. The basic quarrel between them as dissidents and the Academy as a government institution had concerned two issues: the methods of instruction and bureaucratic domination of art and artists. More of the Peredvizhnik goals were realized in the former area than in the latter.

The reformed Academy, standing at the apex of a well-organized network of lower art schools, was supposed to train creative talent. Thus, courses in general education as well as classroom art instruction were discontinued. Only properly qualified persons were to be admitted and would study with a professor of their own choice in his studio. Instead of taking competitive exams on assigned themes, students were to demonstrate progress by submitting for the professors' criticism their works on freely selected subjects. Repin was most pleased with this aspect of the 1893 reform, for he believed that shifting the training from classroom to studio would guarantee full freedom of instruction as well as inviolability of the students' artistic personality. For him, this particular change made the slogan "For the Free Arts," that graced the entrance to the Academy, fully operative at last.[65]

As for de-bureaucratizing artistic life, the reformers managed to do away with the civil service ranking that the artists had found so humiliating in the past. Under the new Statutes, each graduate received an Artist's diploma that carried no rank. But should he want to enter government service as a teacher of art or in some other capacity, he was entitled to claim the 10th grade. Hierarchical gradation of independent careers was also lessened, since honorific titles to be granted by the Academy for creative work were reduced to a single one—that of Academician. Measures like these went a considerable way toward divesting artists of the stigma of being civil servants or servitors of the Court (to the extent that this still was an issue).

But the Academy did not become an autonomous professional organization, and professional independence had also been an aim of the dissenting

artists. The Academy remained under the jurisdiction of the Ministry of the Imperial Household; the Presidency was reserved for those of Grand Ducal rank; and many honorary as well as active members (all of whom were entitled to participate in the governing Assembly) came from the reigning family.[66] Polenov fought hard for adoption of the elective principle for all positions, especially the election of professors by the Assembly. But to no avail; even before the new Statutes were promulgated, the Court announced the appointments to the teaching staff (the liberal Polenov was excluded), and the Grand Duke informed the commission that there would be no discussion or change in these decisions. How necessary Polenov's attempts were was demonstrated in 1897 when Grand Duke Vladimir summarily dismissed Kuindzhi for first taking up the defense of a student, rudely reprimanded for having failed to bow properly to the Rector, and then speaking out against the dismissal of students who went on a sympathy strike.[67]

Should anyone have accused the Peredvizhniki of forfeiting their independence, they could always point to their own Association and to their separate annual traveling exhibits, which continued to be held until the end of the *Tovarishchestvo*'s existence in 1923. Yaroshenko, who after 1893 had become chief spokesman for the Association, vowed to preserve "our cause" and to infuse the *Tovarishchestvo* "with new life."[68] But his efforts were in vain, and in the eyes of the public the differences between the independent artists and the Academy, once so clearly marked and articulated, ceased to exist. For one, the Peredvizhnik exhibits, excluded from the Academy's galleries in 1875 in reprisal for insubordination, quickly moved back in after the 1893 reform. Second, the subject matter at both exhibits had become all too similar. As the review of the twenty-sixth Peredvizhnik exhibit in 1898 by I. Vasilevsky succinctly put it:

Already for a few years there keeps disappearing, like a stream in sand, the former difference between the two chief camps of our artists—between the Peredvizhniki and the Academicians. The Peredvizhnik [social] genre has mellowed and has been shattered, a stamp of ordinariness and weariness lies upon it. On the other hand, genre has also found its way among the Academic painters.[69]

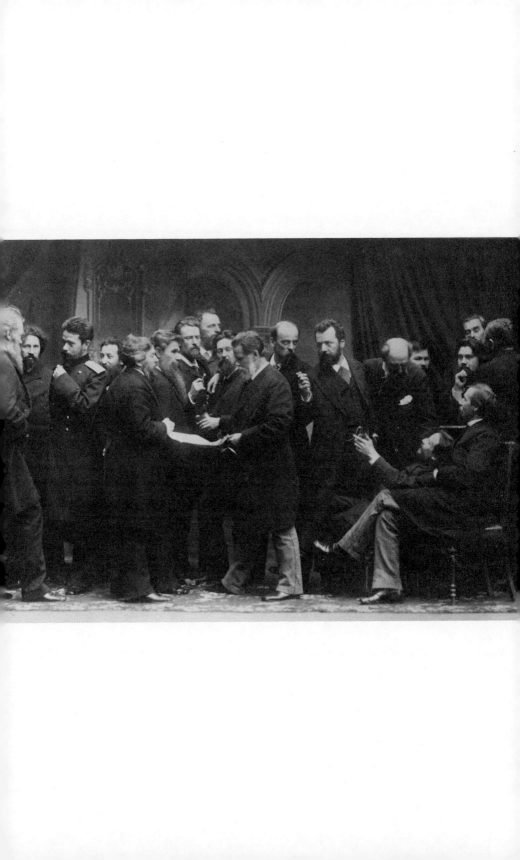

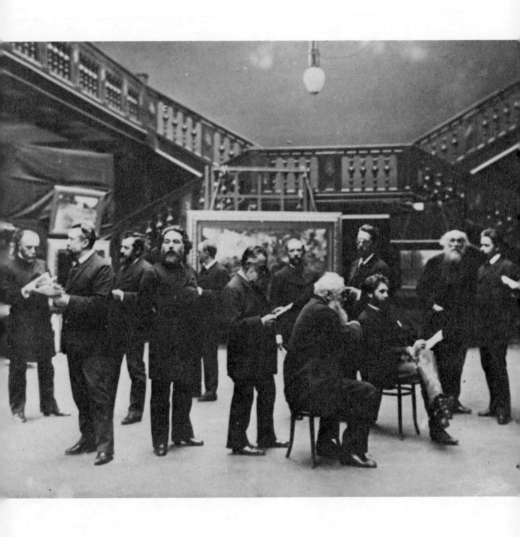

VI THE PEREDVIZHNIKI AND REVOLUTION

The return of the Peredvizhniki to the Academic fold in 1893, it would seem, wrote *finis* to a major chapter in Russian art. The *Tovarishchestvo* was no longer the springboard of new art, and the work of its members could no longer claim to be the untrammelled expression of independent painters. But *Peredvizhnichestvo* did not expire—the chapter continued.

Instead of being laid to rest—having run its life-span and achieved much —Peredvizhnik realism, with its fidelity to Russian subjects and society, remained a matter of lively contention between official culture and new creative impulses, between conservative and progressive opinion, between ethnocentric and cosmopolitan tendencies, before and after the October Revolution. Nor were these issues moribund in 1932 when the art of the Peredvizhniki underwent a spectacular resuscitation to serve the extreme politicization of art, carried out under the slogan of Socialist Realism.

Art history after 1932, the publication of source materials, and art criticism—all were slanted to demonstrate that there had never been a break in the committed, civic-minded tradition of Russian realism. The original ethos of the Association of Traveling Art Exhibits, it was said, had never flagged either with the artists themselves or in public estimation; it had been carried forward by the Association of Artists of Revolutionary Russia (AKhRR) after 1917; it was now fully embodied in Socialist Realism.

This Stalinist version—which survives to this day in many Soviet publications and is at times repeated in Western writings—is a complete distortion. The plain facts are that the latter-day Peredvizhniki identified with the bourgeois and the socialist revolutions of the twentieth century far less than did the first-generation realists with the revolutionary democrats of the 1860s. Furthermore, during the forty years from the time when the Tsarist cultural establishment absorbed the Peredvizhniki until the Stalinist bureaucrats perverted their legacy in order to subjugate art to the needs of the state, those creative artists and radical intelligentsia who worked to restore a living nexus between art and society, to create a new or revolutionary art, regarded *Peredvizhnichestvo* as the huge stumbling block. The artistic and political reputation of the movement was so unsavory that even during the 1920s, when abstractionism and constructivism gave way to a voluntary return to a socially responsive realism, the Peredvizhniki served not as models but were rejected with scorn.

However much artistic theories and practices changed after 1890—ranging from new experiments in color and light to abstraction[1]—the criticisms leveled at the Peredvizhniki remained fairly consistent. In their style of painting they were blamed for low technical standards, bland naturalism and a parochial isolation from the West. On the political level the Peredvizhniki were criticized for their monopolistic position in the elaborate system of the state's administration and patronage of the arts, as well as for political convictions that comported with their official position.

The conduct of the Peredvizhniki during the 1905 Revolution points up their close identification with the establishment. The painters shunned the tribune, let alone the barricades. Throughout that Revolution, the Peredvizhniki maintained a loyalist position.

Repin's reaction to Bloody Sunday, the unprovoked firing on January 9, 1905, upon an unarmed and orderly crowd marching peacefully to petition the Tsar, can be taken as symptomatic. Valentin Serov, who was close to the Peredvizhniki as Repin's former student and as a member of the Association (1890-99), witnessed the massacre of the innocent crowd from the windows of the Academy. Reacting instantly to this wanton brutality, he decided to resign from the Academy, whose President, Grand Duke Vladimir, was also commandant of the capital's troops. Serov appealed to Repin, the "senior" painter of the country, to join in the protest and add prominence to the gesture. But Repin failed to grasp the broader political and moral implications of the shooting; he declined, giving as his lame excuse the "fact" that the troops around the Academy were not under the command of the Grand Duke but of some local police official. In the end, Serov alone resigned, for Polenov, the only Peredvizhnik to respond to the appeal, changed his mind.[2] Significantly, Repin later characterized this courageous and honorable action by the otherwise apolitical Serov as "extreme political views."[3]

Other artistic and professional groups were not afraid to press demands for freedom of speech and assembly and, above all, for an elected legislative body. Thus, the Union of Russian Artists *(Soyuz russkikh khudozhnikov)*, a large exhibiting organization composed of former members of World of Art and those former Peredvizhniki who were too drawn to Impressionism to remain in the *Tovarishchestvo*, supported the first public petition for reform, issued in November 1904 by moderate representatives of local government (the *zemstva)*. At its annual meeting the following month the Union adopted a resolution in support of the *zemstva's* "call for liberation" because free art could flourish only in a free Russia.[4]

138

The Association ignored the *zemstva's* initiative. But when Nicholas II finally issued a rescript on February 18, 1905, containing vague promises to convene a consultative assembly "to underake preliminary examination of legislative measures," the Association collected over one hundred signatures under a very mild statement that humbly petitioned the Tsar for a speedy implementation of his promise, pointing out that greater calamities would ensue in case of further delays.[5]

This loyalist position of the Peredvizhniki contrasted sharply with the opinions of other painters (Alexander Benois, for example, held that "it is naive to believe in a revolution from the throne"[6]) and with the declarations issued by other professional groups. Scholars from the Academy of Sciences and the universities countered what they considered the inadequate concessions of the February rescript with an outspoken "Statement of 342," which held that Russia could enjoy the full benefits of education only "after freely elected representatives of the people were given power to make laws and keep check on the administration."[7] Similarly, playwrights, composers and musicians issued a declaration stating that the continuation of the autocratic regime made the normal discharge of their professional duties impossible.[8]

Altogether, the conduct of the Association during the 1905 Revolution left such a bad aftertaste that henceforth their critics invariably categorized the Peredvizhniki with those parties that sat on the extreme right of the Duma and at times even with the notorious Black Hundreds.[9]

As artists the Peredvizhniki also side-stepped the issues of the revolutionary upsurge. Other painters, notably Valentin Serov, Petr Dobrynin and Mstislav Dobuzhinsky, executed some striking Goya-like renditions of the shootings, pogroms and hangings with which the government had responded to the upheaval. The old and the young Peredvizhniki, with the notable exception of Sergei Ivanov, turned to less brutal and bloody scenes, such as meetings of students, convoys of the arrested, or the joyful response to the October Manifesto that finally granted Russia basic freedoms. This fact is blurred over in Soviet post-1932 historiography, which sets up a simple equation between Repin's "October Manifesto" or Vladimir Makovsky's "The Dispersal of a Demonstration" and their supposed political sympathies: obviously, since they painted revolutionary events, their hearts lay with the revolution.[10] But these canvases were not painted because of any desire on the part of the artists to participate in the course of events, as was the case during the initial stage of *Peredvizhnichestvo*. Symptomatically, Makovsky painted his "Dispersal of a Demonstration" (after he had seen the January 9th massacre) in the ivory tower of his large studio above the luxurious ten-room apartment he occupied in the Academy, and he showed it with great caution only to close friends. (The picture was first publicly exhibited under the Soviets.[11]) By contrast, the vivid graphics of Serov, Dobuzhinsky and Dobrynin appeared in the satirical weeklies like *Bugbear (Zhupel)* and *Hellish Post (Adskaya*

pochta), serving as agitational posters to remind the public that the regime had tried to drown in blood the demands for reform.

The Peredvizhnik hegemony in the Academy of Arts was another sore point among creative painters. After a very brief renaissance following the 1893 reform, the Academy sank into the routine promotion of Peredvizhnik naturalism. So much so that the more gifted students began to leave this stronghold of national tradition to seek more up-to-date training in Munich or Paris. This "desertion" was a painful shock to the Academic authorities, the old Peredvizhniki and the advocates of native Russian art, for they equated study abroad with undesirable and inevitable "infection" by some alien spirit. At meetings of the Academic Council, Russophile painters like Surikov would denounce the "harmful influence of the West" and impotently ponder ways to combat Impressionism, mysticism, symbolism and other "decadence."[12]

The Academy came under two barrages of criticism before 1914. The first occurred in 1905, when middle-of-the-road painters took advantage of relaxed censorship to demand that the venerable institution be reorganized in conformity with the country's freer political life. Soon after the October Manifesto, some St. Petersburg newspapers printed a statement signed by Alexander Benois, Mstislav Dobuzhinsky, Evgeni Lanceray and Konstantin Somov, challenging the Peredvizhnik ascendancy. They argued that a reorganization of the Academy, based on a fair representation of a variety of trends, would liberalize the artistic scene and bring art closer to the public.[13] Their demand was taken up by the new monthly, *Golden Fleece (Zolotoe runo)*. It printed articles suggesting a different relationship between art and the state, predicated on the elimination of tight bureaucratic controls by an unrepresentative government agency hopelessly out of touch both with recent developments in the field and with the tastes of the public.[14] This criticism was met with stony silence by the authorities and by the painters imbedded in the Academy. The only response from the latter was a brief flurry of activity in 1905, when the professors unsuccessfully pressed for greater autonomy for themselves, though not for expanded representation.[15]

Attacks on the Academy reached a new height after 1909, when the strong-minded Grand Duchess Maria Pavlovna took over the Presidency, vacated by the death of Grand Duke Vladimir Alexandrovich, and began to impose her personal tastes in a manner reminiscent of Nicholas I. She would decide which student could go abroad, override the Academic Council's elections of museum directors, pass on the more important purchases and insist on addressing everyone in French.[16] Her autocratic ways clashed with an awakened public opinion and produced on the eve of World War I a situation similar to that of the early 1860s. Once again the overweening role of a state institution under the thumb of the Imperial family and favoring an outdated artistic style came under attack from liberal and radical quarters.

There was one new twist to the old story: this time it was the Pered-

vizhniki (some fifty years after their own secession) who were dubbed "bureaucrats" *(chinovniki)* and were blamed for perpetuating unpopular formulas through the government apparatus. In the eyes of the opposition, they were academism incarnate despite their separate organization and their separate traveling annual exhibits. Peredvizhniki held the top posts in the Academy— Vladimir Makovsky, the leading exponent of latter-day social genre, was its Rector, and Nikolai Dubovskoy, the acknowledged spokesman for the Association after Yaroshenko's death, directed instruction in landscape painting. Peredvizhniki were appointed to head the provincial art schools. Their works were favored in official purchases and commissions. (Each time the Academy would buy another undistinguished painting from a Peredvizhnik exhibit, there would be a pained chorus of protest pointing out that artists like Vrubel were completely unrepresented in state collections.[17]) And they were indiscriminately honored with the Academic titles that were withheld from such first-rate painters as Vrubel. (In his case, the matter became such a scandal that he finally received the title of Academician, but only in 1906.)

Nothing was done prior to 1914 to change the official policies. Of course, the Academy no longer wielded the same control and influence as it had in the preceding century, for plurality in patronage, groups and style had arrived. Still the power of an ossified institution with an annual budget of one million rubles was not insignificant. The Academy continued to discharge its functions so routinely that Alexander Benois compared it in 1912 to a "malignant growth that feeds itself unproductively on national resources."[18]

An episode in 1913 sums up the embattled position of Peredvizhnik realism on the eve of World War I, and shows as well the intensity of controversy on art. One of Repin's revered masterpieces, "Ivan the Terrible" (1885, depicting the Tsar's remorse upon killing his only son), was slashed by a mentally deranged ikon painter, Balashev. Repin intemperately accused in print the modernists, "who had no respect for old art," as being responsible for Balashev's vandalism. (His reaction was in part induced by the antics of the ebullient advocates of neo-primitivism and Cubo-futurism—the vanguard on the art scene—who sought to discredit both the ponderous realism of the numerous epigones of *Peredvizhnichestvo* and the decorative elegance of World of Art through provocative exhibits, self-assertive manifestoes and outlandish personal behavior.)

Repin's charges gave rise to a veritable campaign against the modernists in defense of "national honor" and "Russian art." One Moscow newspaper initiated the collection and publication of loyalist addresses to Repin, praising the venerable painter as *the* personification of Russian artistic achievement.

The modernists, jauntily entering the fray, countered by organizing a public discussion of the artistic merits of Repin's canvas, held at the Polytechnical Museum in Moscow. The meeting, attended by some of the most radical advocates of the new concepts as well as by Repin, degenerated into shouting,

141

insults and name-calling. For the Burliuk brothers, Vladimir Mayakovsky and Maksimilian Voloshin, the vandalism was a fit pronouncement on the stifling Peredvizhnik tradition, the sign that it was high time to cleanse museums of the "old trash" and make room for genuine art. Repin and his supporters responded with equally foolish arguments to defend the sanctity of the "national tradition."

Even at the time, one critic deplored the extreme polarity that marked the debate as something all-too-characteristic:

> We Russians always resort to Pisarev-like polemics, [we] always exaggerate. The old generation values only content and rejects all else. Present-day youths in Moscow reject all except color and resort to esthetic isolationism. The former glorify national tradition, the latter reject it in the name of internationalism.

And he concluded that the incident, which in the West would have affected but a small circle and turned on theoretical arguments about art, assumed in Russia the proportions of an all-out battle turning on politics and the entire historical tradition.[19]

The February Revolution of 1917 abolished Tsarism and deposed the Romanovs but left the Academy untouched and did not remove the Peredvizhniki from their positions. The Provisional Government dismissed the Grand Duchess and put the Academy under Commissar F.F. Golovin, who took charge of the former Ministry of the Imperial Household. While he was drawing up plans to reorganize the administration of the country's artistic life to conform with free political institutions, the Academy was allowed to start reforming itself. (Hostile critics quipped that leaving reform up to the Academicians was like asking the ultra-reactionary Union of the Russian People to set up a republic.[20])

Meanwhile, those groups that had been trying to dislodge the Peredvizhniki from the commanding heights since 1905—i.e., the middle-of-the-road painters associated with the World of Art and the Union of Russian Artists— mounted a headlong attack against the Academy. They banded into a large organization, the Union of Art Workers *(Soyuz deyatelei iskusstv)*, that advocated establishment of a Ministry of Arts as an umbrella organization to supervise and direct the nation's drama, music and fine arts with more impartiality than had the old Tsarist institutions.[21] The Peredvizhnik Academicians sensed rightly that this proposal was meant to divest them of authority and subordinate the Academy to a higher organization, administered by "hostile" forces. Among themselves they passed notes full of invectives against the "upstarts" (that is, people like Benois, Igor Grabar, Dobuzhinsky, Lanceray and Nikolai Roerikh) who were trying to "seize power." They justified their resistance by references to a concern for the destiny of Russian art which, without the Peredvizhniki, would fall into the hands of persons who did not have the same

love for "our fatherland" and for "our native art," and vowed not to give up the "sacred" mission of providing the proper moral guidance for the young generation.[22]

However, what was more significant for the future of artistic life was not this infighting between the compromised Peredvizhniki and the generation ready to replace them, but the coalescence of young Leftists around the poet-painter Vladimir Mayakovsky and the art critic Nikolai Punin. They were the vociferous proponents of the view that art could flourish only when completely liberated from state supervision. Opposed both to the Academy and the projected Ministry of Arts as entrenched bureaucracies, they proposed to bring about genuine emancipation through a thorough-going decentralization that would hand over the running of schools, museums and libraries to municipal self-government in which local artists would have a voice. The Leftists banded into a small but very vigorous organization under the name of Freedom to Art *(Svoboda iskusstvu)*. It tried not only to force its program of complete autonomy on the Union of Art Workers but also to narrow the gap between art and society by opening its studios to artists too poor to afford tuition, by holding lectures for workers and by offering its services to the Soviets of Workers' Deputies.[23] These activities gave the young rebels valuable organizational experience as well as an acquaintance with the political Left, which they turned to advantage after the October Revolution.

The Freeing of the Arts

The October Revolution liberated the arts. The departure of the Peredvizhniki from all positions of influence and the partial eclipse of realism were its inevitable by-products—though not, however, the result of a deliberate state policy. If one can speak of a state policy in the arts during those turbulent years when the Soviet government was fighting for its existence against civil war, foreign intervention and famine, it was a policy that extended freedom of creativity to all artists and all trends. As Osip Mandelstam wrote at the time: "Culture, like the Church, has been separated from the state.... The state's present attitude to culture is best characterized by the word 'tolerance'."[24] This tolerance was a natural reaction to the excessive government interference under the Tsarist regime and a typical expression of the libertarian hopes of the first years of the Revolution.

The policy of maximum freedom for artists was put into effect by Anatoli Lunacharsky (1875-1933), a sophisticated Bolshevik writer who, as Commissar of Instruction, was in charge of overseeing the nation's cultural life. Himself an embodiment of high culture, he never sneered at mass culture and

143

tried to make it possible for both to flourish. Though Lunacharsky befriended and appreciated modernist painters, he also respected the popular attachment to conventional art and throughout his tenure (1917-29) made the conscious effort not to show preference for any one trend or group. What he said in 1918 about the role of the People's Commissariat of Instruction (Narkompros, for short) remained his guiding principle to the end:

> [It] must be impartial and let all artistic personalities and groups have the freedom to develop.... It would be harmful if artistic innovators should come to represent themselves as a state art school, as the exponents of official, though revolutionary, art dictated from above.[25]

Shortly after assuming his post, Lunacharsky invited the entire artistic community to help staff the two sections of Narkompros that were to deal with art matters—the Department of Fine Arts (IZO, for short) and the Department of Museums and the Preservation of Antiquities. However, it was mainly the Leftist painters and intelligentsia—the frustrated outsiders before World War I—who responded to this open-ended invitation. Artists like Malevich, Tatlin, Rodchenko, Gabo and Kandinsky considered their pre-1917 radical discoveries in art as a counterpart to the political revolution carried out by the Bolsheviks and were eager to see their ideas recognized and put into practice.

There was hostile silence from the artists of more conservative persuasion, both the moderates (the descendants of World of Art) and the Academicians (the Peredvizhniki). Among the former, there were a few exceptions, such as Igor Grabar (1871-1960), a former student of Repin and a member of the Union of Russian Artists, who became head of the Moscow section of the Museum Department; and Alexander Benois (1870-1960), one of the founders of World of Art, who assumed charge of the Hermitage until his emigration in 1925. As for the members of the Association of Traveling Art Exhibits, those who did not emigrate refused to have anything to do with the Bolsheviks. Offered the opportunity to work for the Soviet government, they declined and sulked in moral and political indignation. It was largely because of this boycott, and not because the cultural authorities gave them a *carte blanche*, that the radical Left came to exercise a virtual dictatorship in the administration of the arts. This was noted at the time in a tone of regret, not of triumph, by David Shterenberg (1881-1948), the modernist painter in charge of the Fine Arts Department in Leningrad, in his first annual report:

> I will not make the least reference...to the so-called political sabotage, not wishing...to hurt either this or that trend. But I consider it my obligation to stress that it was the Left bloc, with rare exceptions... [that] gave their energies to help the young proletarian revolution.[26]

144

Excluded by their own choice from the new central administration, the Peredvizhniki next lost their pre-eminence in the Academy. That institution was summarily liquidated on April 18, 1918. A printed proclamation explained at considerable length how the original function of the Academy—to provide professional training—had degenerated into the imposition of stultifying state supervision over all aspects of artistic life, and how the decree of the revolutionary government intended to restore full freedom.[27]

The Free Art Studios (*Svobodnye khudozhestvennye masterskie,* or Svomas, for short) that replaced the Academy introduced the complete decentralization that the Leftist artists had been advocating since the February Revolution. High administrators and professors were evicted from their plush apartments, and the extensive space thus gained was made available to all who wished to enter and take up art. One only had to apply to be admitted, all educational prerequisites and entrance exams having been abolished. The response was enthusiastic; in the fall of 1918 the building was filled with 30 different studios and about 600 students, twice as many as before the Revolution.[28] Broad autonomy was granted to the students; if they wished to, they could study independently without any supervision; or they could form likeminded groups and elect their own professors. Any artist was entitled to present his candidacy for a teaching position, for it was specified that "all artistic trends are assured a place" in the Free Studios. However, if students registered their dislike for an instructor by not appearing in his studio for three months, he was to be dismissed at the end of the school year.[29] (The entire system of art education was decentralized, and other higher schools of art were also converted into autonomous studios.)

Hardly any Peredvizhniki managed to remain on the teaching staff of the Free Art Studios. Arkadi Rylov (1870-1939), a former student of Kuindzhi, was among the few who stayed on. But he was wholly out of place in an institution permeated with shrill irreverence for tradition, as exemplified by the slogans in its long corridors—"Burn Raphael" or "Shoot Rastrelli"—or by the opinions of its first Rector, Nikolai Punin (1888-1953), who believed that "realism and lack of talent are synonymous." When Rylov on his own initiative started a course in composition to provide some formal training the dominant innovators forced him to discontinue it, even though the autonomy instituted in the Free Art Studios was supposed to allow complete freedom of instruction. Eventually, according to Rylov, all the higher schools of art fired most of the "best professors" for their "realist tendency."[30]

As for exhibits and state commissions—here the realists were not excluded, but they no longer could count on official favoritism. To make exhibits accessible to all artists, regardless of their stylistic preferences, the Fine Arts Department organized free Exhibits of All Artistic Trends, in which the entries were not subject to selection by a jury. It is another story that now one, now another, group would choose to boycott these exhibits, would

try to gain ascendancy or would charge discrimination. This situation resulted from the inevitable in-fighting within the profession and not from any policy of the state, which tried its best to maintain conditions of free competition.[31] In distributing commissions, the authorities also tried to be fair. For example, the May 1st decorations in Moscow in 1919 were entrusted both to the modernists and to the defenders of realism, for in the preceding year Leftists had monopolized the display.

In allocating its two-million ruble Purchasing Fund, however, the Fine Arts Department did not dispense it equally among all trends. Rather, it tried to redress the previous imbalance and utilized a significant portion to introduce the first modern works to public museums. When charged with discrimination, Lunacharsky explained: "Purchases are made from all painters, but in the first place from those...who were outlawed during the reign of bourgeois taste and who therefore are not represented in our galleries." Similarly, the network of Museums of Artistic Culture *(Muzei zhivopisnoi kul'tury)*, authorized by IZO in 1919, relied very heavily, though not exclusively, on Leftist works to fulfill its purpose of broadening esthetic horizons and raising the level of art appreciation.[32]

Deposed from the secure positions they had held in Tsarist Russia, many prominent Peredvizhniki left Moscow and Petersburg for the country to take up farming or simple trade. But despite unemployment and isolation, they did not give up hope. One senses a resolve to make some sort of comeback in a letter written by Vladimir Makovsky's son, himself a painter in the Peredvizhnik tradition: "We sit in our holes, hungry and cold, and dream of how to make a penny. But all the same we get together for discussion and, even though nothing results, we get to feel a bit more alive." At these meetings members of *Tovarishchestvo* decided grudgingly to participate in the IZO-sponsored free Exhibits of All Artistic Trends, in part "not to be accused of sabotage," in part to respond to public demand, for they were convinced that their art was much more appreciated by the "people" than was that of the Leftists.[33]

Some proponents of new art reached similar conclusions about popular preferences. In 1919, after two strenuous years of administrative and creative effort to launch a proletarian culture unrelated to Russia's heritage, Nikolai Punin in effect admitted defeat and acknowledged a "psychological" affinity between the Soviet masses and the Peredvizhnik type of realism. Naturally he sneered at the low cultural level of both and haughtily consigned the numerous admirers of over-expressive naturalism to the *lumpenproletariat* (for the genuine proletariat would readily identify with the new non-realist art). But what is significant in retrospect is Punin's admission that the "coarse, naive" Peredvizhnik canvases enjoyed "mass popularity" and that the art of the future had as yet almost no popular appeal.[34]

Many Bolshevik leaders did not approve of the new art forms either.

But their personal tastes in no way determined official policies. Lenin was profoundly conservative in esthetic matters ("he valued the art of the past, especially Russian realism, including the Peredvizhniki"[35]); disliked the work of the innovators ("I do not understand them, I do not experience any pleasure from them"[36]); and did not think that the art of the revolutionary epoch should be severed from all tradition. Yet, he never publicly advocated any interference or prescriptive guidance by the state. When questioned by Klara Zetkin about the regime's policies in art, Lenin first stressed that the Soviet government had liberated artists from the oppressive patronage of Court and bourgeoisie and had given them genuine creative freedom. And though the proletarian state was interested in bringing art to the people, he would not presume to specify either the style that would find the best response among the illiterate masses or the form in which it would be popularized.[37]

Moreover, in the one case where Lenin wanted to utilize art for political agitation, he did not consider the Peredvizhnik masters suitable for inculcating the revolutionary spirit among the masses. Inspired by Campanella's *Kingdom of the Sun,* which described how frescoes on the walls of the utopian socialist city instilled civic virtues, Lenin conceived a similar policy for Russia. The decree on Monumental Propaganda, promulgated on April 18, 1918, specified that politically offensive and artistically worthless monuments from Tsarist times were to be replaced by statues of revolutionary heroes, and that streets, as well as buildings, were to be decorated with revolutionary slogans. Lenin requested Lunacharsky to supply a list of "those forerunners of socialism,...and luminaries of philosophical thought, learning, art, etc., who, though not directly connected with socialism, were nevertheless genuine heroes of culture." A list was supplied, and after slight amendments—Lenin deleted the conservative philosopher Vladimir Solovev and recommended the inclusion of noted foreign writers like Heine—it was approved by the Council of People's Commissars and signed by Lenin on July 30, 1918.[38]

Since the project of Monumental Propaganda was one of Lenin's pet schemes, on which he kept close watch,[39] it is revealing to see whom he approved as worthy exemplars. The list of sixty-six names, ranging from Spartacus, Stepan Razin, to Marx, included four Russian painters: Rublev, Kiprensky, Ivanov and Vrubel.[40] The choice of such old masters as Rublev (c. 1370-1430) or Ivanov (1806-58) underscored Lenin's opposition to the nihilistic denial of past cultural achievements by the Leftist proponents of proletarian culture. But that there was no Peredvizhnik on the original list is surprising, especially since it included Modest Musorgsky (1839-81), one of the founders of the national school of music, and the noted populist writer, Gleb Uspensky (1843-1902). The omission is all the more noticeable given the inclusion of Mikhail Vrubel (1856-1910), a symbolist painter scorned by the Peredvizhniki during his lifetime, and still scorned by conservative Soviet art his-

torians because he was in no way connected with the "democratic move-ment."[41] Surprising as the exclusion of the Peredvizhniki from the revolutionary pantheon of popular heroes is, it testifies to their low political standing among the Bolshevik leaders, which paralleled the esthetic disdain felt for them by the intellectuals. It was the nadir of the Peredvizhniki and their tradition after the October Revolution.

The Comeback of Realism

The years between 1921 and 1932 comprise two distinct phases in Soviet political and economic history—a retreat from utopian Communist goals during the New Economic Policy (NEP), and then the upsurge of revolutionary aims during the first Five Year Plan. In the arts, however, there is no clear break. The period was marked by the continuing absence of any prescriptive official policy and by a spontaneous re-emergence of realism as the dominant style—an occurrence, however, which in no way diminished variety in its forms or in artistic life. Constructivism, industrial design and scientific analysis had run their brief natural course; artists turned to a revival of figurative painting to register the dynamic pulse and the romantic ethos of their revolutionary society. But as they wanted to infuse realism with new perceptions and new sensibilities, there was no question of taking over any part of the Russian nineteenth-century tradition.

The years 1921-22 saw the formation of neo-realist groups, as well as the revival of the pre-war defenders of traditional realism, all of them ready to serve or reflect the new times. Ironically, the neo-realists came from among the first graduates of the experimental Free Art Studios. They turned against the non-objective, "analytical" art of their mentors (which, according to one faction, had reached a "point of no return") and decided to follow the path of "thematic realist" painting. Even though these young artists took easel painting and content as their point of departure, they rejected rigid realist principles. Thus, the NOZH group (*Novoe obshchestvo zhivopistsev*, New Society of Painters) turned to primitive satirical genre scenes; the Life *(Byte)* organization concentrated on landscape, showing a strong admixture of Cézanne's influence; and members of *Makovets* favored the "monumental representation" of reality. Up through 1930 a host of neo-representational groups, all small, but all vigorous in voicing their individual credos, appeared, merged and disappeared, those known by the acronyms and names of OST (*Obshchestvo stankovistov*, Association of Easel Painters), Four Arts (*Chetire iskusstva)*, OMKh (*Obshchestvo moskovskikh khudozhnikov*, Association of Moscow Painters) being among the more outstanding.[42]

148

At the other end of the spectrum, the Association of Traveling Art Exhibits held its forty-seventh, and first post-Revolutionary, exhibit in February 1922. The verbose and pretentious titles of some canvases betray a pathetic effort to adjust to the times: "A Revolutionary, Gun in Hand, Defends Burning Documents," "An Imprisoned Worker Fights Death Which Has Come to Strangle Him," or "Reaction of 1906: Hungry Wives of Striking Workers and Their Children Assault a Factory, Demanding Work for Their Husbands." Critics were quick to note that this was a very mediocre show and that "the realism we await after the liquidation of futurism is not the realism of the Peredvizhniki." The spirit and manner of execution of the works on exhibit were such that the Peredvizhniki were told they could just as well have hung Miasoedov's "Reading of the Emancipation Manifesto" (1873) under a new label—"Reading of the Land Decree"—and nobody would have noticed the difference.[43]

But the Peredvizhniki were convinced that their warmed-up recipes were indeed relevant. The exhibit catalogue was prefaced with a declaration of purpose. Without any reference to the cataclysmic changes the country had undergone, it declared the Association's determination to go on reflecting "with documentary truthfulness in genre, portrait and landscape the life of contemporary Russia," and called on "all the young forces" to join the *Tovarishchestvo* to "expand and to continue a strictly realist school of painting."[44]

This rigid adherence to the principles of latter-day *Peredvizhnichestvo* cost the Association its life. Not only did the "young forces" ignore the appeal, but the younger members (Pavel Radimov) and exhibitors (Evgeni Katsman and Viktor Perelman)—chastened by the hostile reception by the press and the sharp attacks against everything that the *Tovarishchestvo* stood for during the public lecture on the importance of social genre which it had sponsored—revolted against the passive documentary style advocated by the Peredvizhniki. By May 1922 they had formed a new realist group of twenty-five members, named the Association of Artists of Revolutionary Russia (*Assotsiatsiya khudozhnikov revoliutsionnoi Rossii*, AKhRR for short), and went on record as being totally committed to the Revolution. The new organization undertook as its "civic duty before humanity" to immortalize "the greatest historical moment"; and to dissociate itself from all pre-1917 traditions, it announced the birth of a new style—heroic realism.[45]

While the *Tovarishchestvo* died a natural death within a year (it held its last exhibit in 1923), and the other neo-realist groupings never managed to acquire a large following, the AKhRR rapidly grew from an insignificant group into a large and successful exhibiting society. Until it met with adversities in 1928-29, during the renewed revolutionary upsurge generated by the first Five Year Plan, the Association mounted eleven exhibits. By 1926 it had 34 local branches, a membership of 650 and a thriving publishing business.[46]

The organizational success of AKhRR was quite phenomenal. And its ability to "bring art to the people" was equally impressive. Members of AKhRR (*Akhrovtsy*) made no innovations in the language of painting itself, but they devised the formula that popularized their art among the untutored mass viewers. They mounted large exhibits on topical subjects and helped set up museums that documented the exploits of Soviet soldiers and workers. By concentrating on contemporary subjects rendered in a readily intelligible manner–the dedicated Communist types (G. Riazhsky), the new industrial landscape (P. Kotov), the romantic exploits of Soviet armies during the Civil War (M. Grekov), faithful likenesses of revolutionary heroes (E. Katsman), the changing rural scene (E. Cheptsov), the tragic fate of homeless children (F. Bogorodsky), solemn political events (I. Brodsky)–they gave the average Soviet viewer the pleasure of sheer recognition and attracted the public in droves. By establishing branches in provincial cities and in the union republics and by organizing a network of amateurs' clubs, the *Akhrovtsy* spread art appreciation to remote corners of the country and infused large segments of the population with an interest in painting.[47]

The accomplishments of AKhRR in popularizing art among the masses are undeniable. But other aspects of this group's activity are far less commendable. Members of AKhRR curried favor with the authorities to gain recognition for their narrative paintings as *the* art of revolutionary Russia–an aim that undercut the efforts of the Narkompros to create conditions for an open interplay of various trends. In this pursuit, they established certain patterns of communication, both pictorial and administrative, that violated the tenets of free creativity. And, finally, though they cleverly avoided assuming the mantle of the still-tainted *Peredvizhnichestvo*, they played on the ethnocentric prejudices of a conservative officialdom, which preferred the traditional idiom of "subject over style," in order to discredit their more cosmopolitan-minded rivals. These practices established precedents that proved useful once the government decided to promote Socialist Realism and subjugate artists to the needs of the state by references to national tradition.

As has been noted, there was no government line on art throughout the period, a policy scrupulously implemented by Lunacharsky, who remained in charge of the Narkompros until late 1929. The most authoritative expression of this policy was the Central Committee's resolution on *belles lettres* issued in July 1925. Although it called for the creation of a style appropriate to the times and "comprehensible to the millions," it carefully avoided defining what would constitute an "appropriate style." Even more important, it stated unequivocally that the evolution of new art forms was a matter infinitely more complex than the establishment of a proletarian state and could not be brought about by administrative intervention. On the contrary, its birth would be facilitated by the open competition of various groups and trends.[48]

Yet, despite the best intentions of men like Lunacharsky and Bukharin

(an amateur painter and a person of high culture) to preclude state intervention in the arts, there were certain realities in the situation that made the full implementation of this resolution problematical. After the first flush of hope for private patronage with the onset of NEP, when art groups financed their own exhibits and private stores opened in anticipation of a new clientele, it soon became obvious that artists could not support themselves in the exiguous market that did emerge. (Already in 1924 Alexander Benois and Igor Grabar tried to find private patronage abroad and helped organize an exhibit of Soviet art in the United States—the Grand Central Palace exhibition.) In these circumstances the state remained the principal, if not the sole, source of livelihood for painters. Add to this the fact that the regime wanted an art "comprehensible to the millions," and it is evident that full creative freedom, which only a pluralistic patronage could assure, was a quixotic dream.

It is this stark reality that AKhRR exploited unscrupulously. Its founders demonstrated truly extraordinary talents in promoting their own fortunes. They sought out the right backers, adopted an appropriate style and self-image to ingratiate themselves with their patrons, and devised a formula for a "productive" relationship between artists and organs of the state. It was this self-seeking resourcefulness, more than any creative artistic drive, that transformed a small group of untested talent into a large and financially successful organization. Shortly after the Association was formed, it offered its services to the Central Committee. When told to "go to the factories," because contact with the masses would suggest the direction their work should take, the founders of AKhRR went instead to the Trade Union and the Red Army administrations.[49] Narkompros, which they cleverly avoided, no longer had large subsidies at its disposal, and besides it was still dominated by high-brow intellectuals (though no longer the Leftists). And so the *Akhrovtsy* made themselves available to the bureaucratic organizations with large funds, well-defined needs and far less sophisticated views on art.[50]

The calculation paid off handsomely. With free space, transportation and printing provided by its patrons, AKhRR was launched on a good start: it was able to mount two exhibits in 1922, one on the Red Army, the other on the workers. The generals were so pleased with the portrayal of famous commanders and military exploits that they commissioned AKhRR to prepare a more ambitious show for the fifth anniversary of the Red Army the next year. The other 1922 exhibit, "Life of the Workers," was opportunely coordinated with the opening of the Fifth Congress of Trade Unions. The delegates, taken to the exhibit in organized group tours, responded to the documentation of their lives with such enthusiasm that the Trade Union administration bought every single item in the show and set up a Museum of Labor, which relied on AKhRR artists to enlarge its collection.[51]

But the assured patronage and financial security which AKhRR was so fortunate to gain at the outset carried a price. Trade Union and Army officials

151

had definite stylistic preferences, which they were not remiss in communicating. Military commanders were especially ready to express their ideas on art. In the opinion of Mikhail Frunze, for example, "The trend headed by Mayakovsky is not easily accessible either to my mind or heart. I prefer more realistic renditions that [do not] elevate form to primary importance.... During the times we are living through, what is essential is the promotion of content.... I prefer works which have our own, specific (*nashe, svoe*) content." A contemporary newspaper article on what the Military Council expected from painters indicates amply how these preferences turned into outright orders when it came to mounting an exhibit: "In keeping with the sober Marxist view on art, [it] demanded from the artist in the first place a complete intelligibility and realism..., based on a subject and a full banishment of any 'intellectualizing'."[52] From the start the AKhRR leadership pliably adapted to their patrons' suggestions. Marshal Kliment Voroshilov—an amateur painter and self-styled connoisseur who admired Russian nineteenth-century realism—was closely consulted whenever an exhibit was in preparation, and it was conveyed to him that his "advice and ideological consultations" were deemed to be highly valuable to the young artists.[53]

The two exhibits which the Association mounted in 1922 determined the format for subsequent shows. Henceforth AKhRR specialized in large thematic exhibits on the life and labor of workers, soldiers, revolutionary leaders or simply the "peoples" of the Soviet Union, with canvases and sculptures commissioned in advance by some state organization. When it undertook to mount a thematic exhibit, AKhRR would accept a list of the subjects from the commissioning institution and then get preliminary sketches on these topics from painters (regardless of whether they were members or not, for the Association was as much an exhibiting society as an artistic grouping). Once the preliminary sketch was approved in consultations with the patron, AKhRR would advance the painter part of the fee with the rest paid upon completion of the work and its final acceptance. This method of ordering and advance approval produced much consternation amog creative artists. Even if they had previously painted pictures of the Civil War or the Red Army, they did it on their own initiative and according to their own vision. The new arrangement rankled: painters found it trying to work on a minutely specified subject under instructions that it must be painted with "strict attention" to historical details and rigid realist principles.[54] As for critics, they charged AKhRR with opportunism and asserted that the original aim of the Association to produce heroic realism had deteriorated into a servility of truly heroic proportions (*geroicheskii servilizm*).[55]

In handling the issue of national tradition, there was a certain duplicity in the behavior of the group. On the one hand, to lay claim to a distinctive style and thereby win acceptance among those who were working out an innovative realist language, the *Akhrovtsy* disclaimed any descent from the Pe-

redvizhniki. They asserted, in setting up their separate organization, that they were making a fresh start in restoring content to painting. In an essay celebrating the fourth anniversary of AKhRR, Evgeni Katsman (b. 1890), their most energetic organizer, disdainfully dismissed the Peredvizhniki as "sentimental populists" whose traditions were unfit for the "heroic ideals of the revolution" and the "beautiful severity of Bolshevism." His chief associate, Viktor Perelman (b. 1894), would admit only a tenuous historical precedent: "The relationship of *Peredvizhnichestvo* to AKhRR is the same as that of populism to revolutionary Marxism." Further, he argued that the *Akhrovtsy* were no mere neo-Peredvizhniki (as their opponents charged) but creative revolutionary artists who would surpass both the civic-minded *Tovarishchestvo* and the World of Art esthetes by combining novel content with superior technique.[56]

But on the other hand, in order to build up some reputation for the fledgling organization (which the recognized painters at first ignored) and gain credit with their conservative supporters, AKhRR was at the same time eager to establish links with the survivors of old-fashioned realism, ostracized since 1917. They asked the pre-war realists, like Nikolai Kasatkin, to join their group. They suggested to the Council of People's Commissars that this venerable painter—who alone among the Peredvizhniki had made the proletariat the subject of his work—be honored with the title of People's Artist. And when the title was bestowed in May 1923, AKhRR claimed, with much publicity, that the artist thus officially honored "came from among our ranks." The next step was an attempt to induce Repin to return from exile in Finland and have him awarded the title of People's Artist. This raised a storm of protest, for in too many quarters Repin's artistic and political reputation made his candidacy totally unacceptable. Although after much bickering an AKhRR delegation finally managed to visit Repin at his estate in Penaty in 1926 (Voroshilov was instrumental in getting it the necessary papers and funds, which other authorities were loath to grant), it failed to persuade the great painter to return to his homeland.[57]

Furthermore, AkhRR would argue that Soviet art should be wholly nurtured on native soil. This stance was meant to discredit the contention that the work of their neo-realist rivals was more suitable for Soviet Russia than the old-fashioned realism of the Akhrovtsy. The controversy played up to the prejudices of the "native-minded"officialdom, which disliked the paintings of the neo-realists and was suspicious of their alleged "cultivation" of West European currents. This was the audience and patronage that Perelman had in mind when he maintained that AKhRR stood on guard against the influx of foreign influence:

It is essential to review in a most decisive manner that phony law which has an axiomatic authority for most [people] . I am speaking about that

153

conviction that without French art Russian art will not survive, that there is no other way for Russian art but to acknowledge the hegemony of Paris.... It is essential to stress that the basic trends in French late 19th- and early 20th-century art, whose appearance in France is understandable and organic, represent an alien growth on our soil, which it is not necessary to cultivate.... We have our own path of development.[58]

Such arguments found no response from most of the top political and cultural authorities, among whom the Westernized Old Bolsheviks and intellectuals predominated. For these men, the Russian Revolution, as well as art, derived from a common European political and cultural mainstream. In consequence, they had made it possible for painters, exhibits and publications to move to and from Western capitals in the belief that this was contributing to an international cultural upsurge. An open and tolerant attitude toward the West prevailed (one example of this being the conversion of the nationalized Morozov and Shchukin collections into a separate Museum of Modern Western Art in Moscow), and the historic or ethnic antecedents of the Soviet Union's revolutionary art were not a central issue in the 1920s. But AKhRR resuscitated an old specter, one that was to loom large in the next decade as the internationalist-minded Party leadership was defeated and replaced by the "natives," personified by Stalin and his cohorts.

The ambiguity of the *Akhrovtsy* toward Russian traditions and their inability to produce a genuinely new style were evident to critics. They would yoke the old-fashioned realism of AKhRR to that of the Peredvizhniki either to keep the group from backsliding into documentary verisimilitude or to dismiss it as worthless. In the vocabulary of the critics of the 1920s, whether esthetes or Marxists, the term *Peredvizhnichestvo* was used to belabor simplistic and inept art. Friendly critics—and they were a minority—used the example of the Peredvizhniki to warn the *Akhrovtsy* not to delimit their artistic endeavor to illustrated catalogues of Soviet life and achievements. Nikolai Shchekotov (1884-1945) praised both groups for "performing civic services with their brush." But noting the decline of the *Tovarishchestvo* in the 1880s, he advised the *Akhrovtsy* to combine the militant traditions of the movement with the formal attainments of modern art. F. Roginskaya (1898-1963) paid more attention to style than to the social role of art. While she would praise any traces of a romantic or epic strain, she would invariably liken examples of pedantic naturalism to the art of the Peredvizhniki.[59]

The esthetically inclined critics would bring up the Peredvizhniki when berating the members of AKhRR for excessive concentration on subject matter or when reminding them not to persist in a provincial rejection of the advances made by Western art. Foremost among these critics was Ya. Tugendhold (1872-1928), one of the first pre-1914 writers to acquaint the Russian public with the formal discoveries of the French. He referred to the AKhRR's style

as "primitive realism" and argued that the "realism of our day cannot be a simple social genre (*bytovism*), a throw-back to some sort of Bogdanov-Belsky. It should be equipped with all the professional attainments of contemporary masters." He castigated any sign of professional or revolutionary smugness on the part of the painters and pointed out that "what our backward country needs...is not self-satisfaction but study."[60]

The new breed of Marxist critics and art historians placed the *Akhrovtsy* in the same socio-political stratum as the Peredvizhniki. Boris Arvatov (1896-1940) attacked them as a bourgeois grouping with firm roots in the past, whose "pseudo-revolutionary" claims only sowed confusion and prevented the emergence of an art genuinely reflecting the revolutionary epoch. Alexei Fedorov-Davydov (1900-69) referred to them as "those Peredvizhniki of our day." For him, both groups were petty-bourgeois, passive observers who could never rise above inept and "petty realism." Their social origin prevented them from ever producing art that would either stir the masses or properly represent their strivings. (The reactions of such radical Western painters as Diego Rivera and Käthe Kollwitz were similar to the opinions expressed by the Marxist critics, though lacking their political partisanship. During visits to the USSR, both expressed genuine surprise at the conservative pictorial language used by the *Akhrovtsy* and at the predominance of scenes from daily life.)[61]

As for Lunacharsky, he valued the capacity of AKhRR to attract large working-class crowds and on a number of occasions spoke flatteringly about its art having answered the needs of the people, about its members having "spoken the language of the masses." But he never endorsed the simple naturalism of the *Akhrovtsy* (calling it "naive" in 1926) as the new style for revolutionary Russia.[62]

The Second Revolution

Producing art to direct command from state organizations, painting in an old-fashioned documentary style, upholding the traditions of Russian realism—all this did not stand AKhRR in good stead during the cultural revolution that accompanied the first Five Year Plan (1928-32). During the feverish drive for rapid industrialization and total collectivization, for which everyone was being mobilized, there was a return to radical militancy (and a search for new means of artistic expression) that was reminiscent of the fervor of War Communism. All that smacked of tradition and establishment came under vehement abuse from dedicated Communists, old and young, who had chafed

in the half-way house of the NEP. They were eager, at last, to create a class, proletarian art to ride the renewed revolutionary wave, to exemplify the hegemony of the working class and to participate in the construction of socialism. The gradualist, tolerant approach of the preceding seven years was replaced by a purposeful class war on the cultural front. The administrative practices, the political coloration and the esthetic formulas of AKhRR came under concerted attack from many quarters: the Party, the new generation of Communist painters, and critics.

In the eyes of the zealots of proletarian purity who surfaced with the onset of the new revolution, the success of AKhRR was synonymous with bureaucratic featherbedding and influence-peddling that had flourished during the corrupt days of the NEP. The *Akhrovtsy*'s accommodation to the requirements of officialdom was not seen as service to the masses but as a conformist and comfortable way of making a good living out of vested interests. What was being questioned was not whether the revolutionary regime had the right to harness art to its needs. On the contrary, demands of that sort assumed ever greater frequency and urgency, given the mobilization of all resources to transform the country. What was criticized was AKhRR's policy of worming a privileged position by doing portraits of the establishment figures, who in turn passed on lucrative commissions to the Association on behalf of the organizations they headed.[63]

There were various attempts to organize artists so as to eliminate one-sided patronage gained through "petty bourgeois favoritism." A federation of all artistic groupings to facilitate an equitable distribution of work was proposed as early as 1928, and a Federation of Soviet Artists' Associations (*Federatsiya ob'edinenii sovetskikh khudozhnikov*, FOSKh for short) was formed in June 1930. But this step did not quiet the internecine quarrels because FOSKh was joined only by a minority of the existing associations. For its part, the Narkompros set up again a special department to deal with the arts, Glaviskusstvo (*Glavnoe upravlenie po delam khudozhestvennoi literatury i iskusstva*) and tried to work out some sort of cultural plan to match the economic blueprints. A final and operative plan never materialized, despite much discussion and paperwork. Organizational anarchy persisted, though the sharp turn toward radically-oriented art made considerable inroads on the privileged position AKhRR had come to claim and expect during the NEP.

With the greater politicization of culture, the AKhRR method of bringing art to the people through the uncomplicated illustration of daily life came under a barrage of ideological criticism. Attacked mainly for stylistic unoriginality before 1928, the *Akhrovtsy* were now accused of being politically retrogressive. Advocates of proletarian art that would actively organize life and transform the human psyche for the collective task of socialist construction found AKhRR output much too passive and ascribed this shortcoming to the wrong class coloration. Thus, the Central Committee's Agitation and Propa-

ganda Department blamed the concentration on rural and Civil War themes in AKhRR exhibits, amateur clubs and publications on "petty bourgeois, populist tendencies" and demanded that the Association focus on the leading role of the proletariat, that it coordinate its work with the promotion of current Party campaigns—elections, industrialization, collectivization, anti-religious and anti-alcoholism drives.[64]

Though the Party called for a "high ideological content" and expected painters to help out with various practical chores, it did not specify the style in which these tasks were to be accomplished. It was interested in the functions, not the forms, of art. But the visionary elements in artistic circles took the class approach much further. They relegated easel painting in general and AKhRR realism in particular to the bourgeois epoch and argued that entirely new forms of art were necessary to re-order society and support the Five Year Plan. Ready to acknowledge some indebtedness to Russian constructivism of the early 1920s, as well as an affinity to several contemporary American and European radical painters,[65] they rejected the nineteenth-century artistic legacy as being of alien class origin. For this reason the Peredvizhnik tradition was once again dragged into the skirmish, this time to discredit the AKhRR output as based on the wrong class antecedents. It was denounced as a "restoration of *Peredvizhnichestvo*" and a "return to bourgeois positions." Young Communist critics dubbed the Association and its unselective documentation of Soviet reality as a typical fellow-traveler attitude that failed to accord the proletariat a central role in history (a shortcoming with which the *Tovarishchestvo* had also been charged.)[66]

These efforts on the part of Communist critics to discredit the AKhRR by comparison with the Peredvizhniki were reinforced by the appearance of the first Marxist works on the history of Russian art. The economic determinists among the younger art historians argued that no matter what Stasov, Kramskoy or the liberal journalists might have written, what had really motivated the Peredvizhniki was not ideology but monetary gain. The *Tovarishchestvo* was interested in broadening the market, not in spreading ideas. In this scheme, the message of paintings, as well as their size, were nothing more than reflections of market relations. Those scholars who assumed a direct relationship between style and class structure were a bit more sympathetic to the civic-mindedness of the Peredvizhniki. It was ascribed to the class interests of the bourgeoisie, whose struggle for recognition spawned the art of protest in the 1860s and the 1870s. But critical realism had a short life-span; once the haute bourgeoisie attained power, it made peace with reaction and this fact was reflected in the anecdotal social genre that came to prevail in the 1880s.[67] Either way, the Peredvizhniki were stripped of the aura of selfless service to society and, with the help of harsh, cold facts, represented as a group with circumscribed aims and interests. Scholarly works of this type buttressed the current campaign that likened the activities of the *Akhrovtsy*

to the commercial interests of the Peredvizhniki.

Disdain for realism and its Russian nineteenth-century variant took other forms in the Academy of Arts, which had been restored in 1921 as the highest training center after the experimental methods of the Free Art Studios were abandoned. Its teaching staff was overhauled: among the twenty-five professors dismissed were the few surviving realists of conservative persuasion. Formal instruction was now replaced by practical courses for industrial designers and instructors for workers' clubs. Teaching was reduced to a minimum; students spent more time sketching in factories than in classes. To underscore the birth of a new proletarian style unfettered by tradition, the Rector appointed in 1928 held several *autos-da-fé* at which many plaster casts of antique statues were smashed and some large nineteenth-century canvases were slashed.[68] Museums resorted to a less drastic but equally hostile purge of conventional art. Peredvizhnik canvases were removed in large numbers to make room for functional exhibits devoted to industrial design, book illustration or stage sets.[69] And if they were exhibited, it was mainly to serve as visual aids in shows devoted to anti-religious propaganda or to a socio-economic characterization of the 1860-80 period.

Committed to its claim to be the preferred art of Soviet Russia, the AKhRR tried to adapt to the renewed revolutionary fervor. The Association held its first Congress in May 1928 and adopted a new declaration of aims. The 1922 goal of "artistically documenting the greatest moment in history" was replaced by a pledge to "actively carry out in the visual arts the slogans of the cultural revolution by organizing the feelings, thoughts and the will of the masses...to help the proletariat accomplish its class goals."[70] (Its acronym was shortened to AKhR.) Practical steps were taken to implement this program, such as the organization of traveling exhibits, the publication of a new art journal *Art to the Masses (Iskusstvo v massy),* the adaptation of easel painting to the needs of production. In addition, there was an energetic effort to cleanse its realism of undesirable political—i.e., passive, traditionalist—coloration. The first issue of the new magazine, *Art to the Masses,* conceded that in the past the *Akhrovtsy* had "spoken...in a language of academism and *Peredvizhnichestvo,"* and averred that the former "story-telling," "apathetic" realism was being replaced by a "full-blooded," "energetic," "grandiose" style that would be a genuine component of socialist construction.[71]

What resulted from these intentions, however, was not a new style but a political purge of "fellow-travelers" in its own ranks. The ouster most talked about was that of Isaak Brodsky (1884-1939). This former student of Repin, who after the Revolution gave up Impressionist landscapes to paint meticulously detailed group pictures of revolutionary events such as the mammoth "Opening of the Second Congress of the Comintern" (1924; no less than 200 portraits, most of them copied from photographs), was unceremoniously

and acrimoniously expelled for his "photo-illusionism."[72] In addition, the AKhR barred from its exhibits not only such older, pre-Revolutionary artists with Impressionist leanings as Igor Grabar or Konstantin Yuon but also Abram Arkhipov (1862-1930), who had studied with Perov and Vladimir Makovsky, had been a member of the Association, and in 1927 was awarded the title of "People's Artist" in recognition for his portrayals of peasant women at work.[73]

These tactics to adapt to the times were unsuccessful. There was a revolt within the ranks of AKhR itself. In May 1931, the young Party members of the Association split off and, joined by young Communist rebels from several other organizations, formed the Russian Association of Proletarian Artists (RAPKh, for short). RAPKh claimed to be the genuine representatives of proletarian forces on the art front, buttressed by a new style—phrased this time as "strong *(krepkii)* realism"—and a close adherence to the Party line. The short-lived existence of RAPKh resulted not in any artistic breakthrough (for their concentration on painting industrial shock-workers was a change in content, not in style) but in an even greater subservience to politics. According to the RAPKh leaders, they had organized in response to the Central Committee's resolution of March 1931 urging a higher ideological level for posters. And they proceeded to interpret Stalin's speeches and "Leninist theories on art" as applicable to the visual arts.[74]

When the Party finally decided to intervene on the cultural front, it reasserted its own primacy. It did not choose to rely on any of the extreme advocates of proletarian art who had been claiming leadership by adopting a hyper-political approach and propagating what they thought was a Party line. Absorbed in internecine polemics, RAPKh did not sense that the replacement of Lunacharsky as Commissar of Instruction by Andrei Bubnov, a high political administrator in the Red Army and a friend of Marshal Voroshilov, or the reinstatement of Isaak Brodsky to AKhR membership through official intervention, did not augur well for painters with so little respect for tradition. Thus, when the Party did speak up in April 1932, it condemned the advocates of proletarian forms in the arts for their group exclusiveness and extremism that, instead of mobilizing broad participation in socialist construction, only alienated important segments of writers and painters. It ordered the dissolution of all the existing literary and artistic groupings and their replacement by single umbrella organizations for each profession, each with its own Communist cell.[75] The stage was set for a purposeful, centrally directed politicization of art.

159

1890.

АЛЬБОМЪ АКАДЕМИЧЕСКОЙ ВЫСТАВ

Ө. И. БУЛГАКОВ

А. Кившенко.

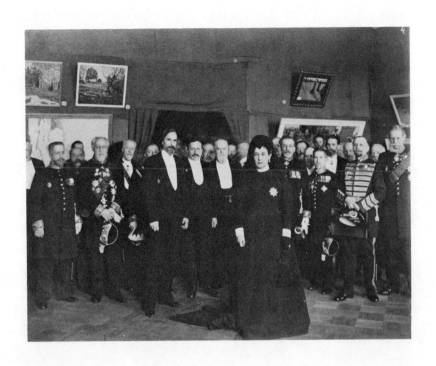

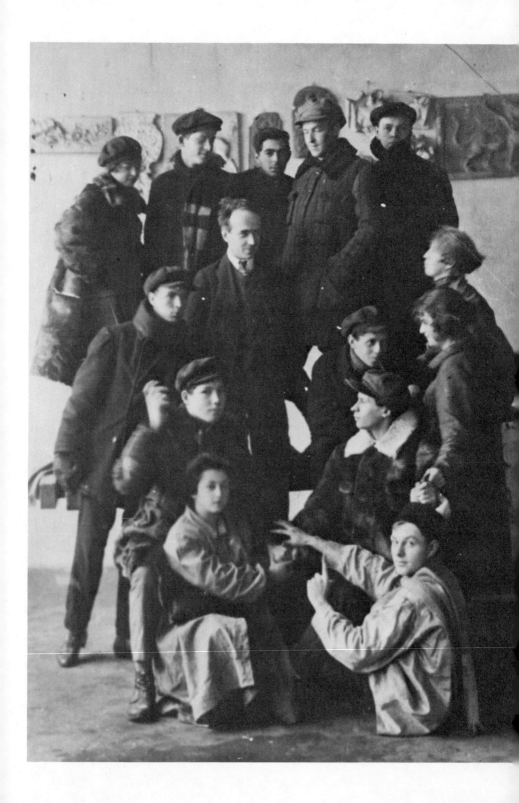

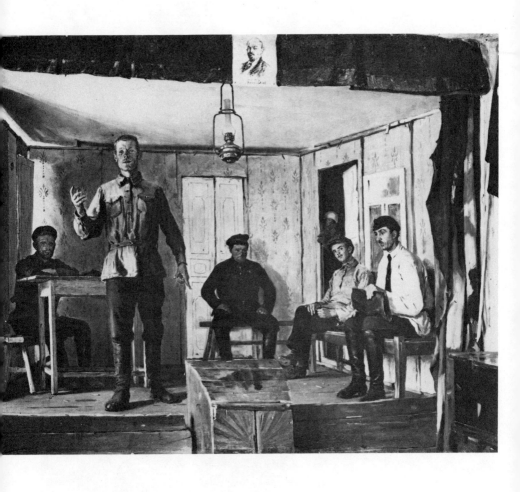

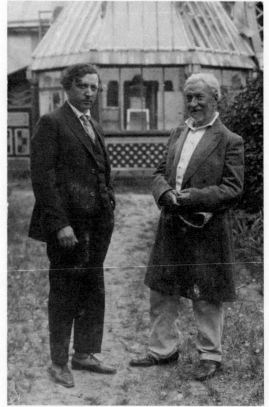

VII THE NATIVE ROOTS OF SOCIALIST REALISM

Soviet artistic life became regimented after 1932; the heterogeneity and innovation of the 1920s disappeared. But the pall of conformity did not descend immediately after the establishment of unitary professional unions and the promulgation of Socialist Realism as the single mode of expression. The new style did not appear, Athena-like from Stalin's brow, as a fully formulated theory. It took time to articulate the Party line, set up the requisite organizational channels, staff them with trustworthy personnel, and function effectively.[1] In the first years after the April Decree, the Party was not yet as monolithic in its demands on artists and writers as it became after Stalin had purged his opponents.

The subordination of the arts to the demands of the state is usually described by enumerating the Party pronouncements and the administrative measures to implement them. What has not been studied is how the ever more stringent political controls were legitimated by reference to a distorted national tradition, and the extent to which the Stalinization of Soviet artistic life was the imposition of cultural autarchy. The process of making painters toe the Party line, which started with pressure to illustrate topical issues in a strictly representational manner and ended with the requirement to glorify Stalin, is directly reflected in the way the Peredvizhnik heritage and reputation were manipulated after 1932. The more demanding and prescriptive the authorities became, the more wanton was the reduction of Russian nineteenth-century realism into a proto-political program, and the greater was the contempt for Western art with its ethos of untrammelled experimentation.

During the first four years after promulgation of the April Decree, there was a resuscitation of prominent Peredvizhniki as masters of realism from whom Soviet painters could gain insight and help in formulating the new style. Next, between the purges of 1936 and the German invasion of 1941, the Peredvizhniki as a group were rehabilitated to full artistic *and* political respectability: as such, they were to be the only models for Socialist Realism. At the same time, any artistic expression that deviated from straightforward naturalism or did not employ Soviet subject matter and iconology was denounced as "alien" to the Russian tradition. This canonization of the national antecedents for Socialist Realism and the concurrent isolation of Soviet art from almost all developments in the West did not reach its culmination until after World War II. The worst period of political controls—the so-called *Zhdanovshchina,* when artists, writers and musicians were browbeaten by Andrei Zhdanov to glorify the country's achievements and Stalin's leadership—was the time when *Peredvizhnichestvo* became the subject of a veritable cult. The

movement's place in Russian and in world art was exaggerated beyond all measure. Conversely, with the growing plurality of expression in Soviet painting and scholarship since the early 1960s, *Peredvizhnichestvo* has gradually been reduced to a truer historical perspective, and alternate artistic traditions are being acknowledged through exhibits and publications.

The Open-Ended Formula

The April Decree was at first interpreted as a gesture of reconciliation. Although it ordered all artistic forces to be mobilized for socialist construction, it was taken as signifying an end to crude artistic politics conducted by self-appointed advocates of class warfare in culture. Many believed that what the Party mainly wanted was the harmonious cooperation of all the creative intelligentsia in common tasks. Nor was this interpretation unwarranted, for representatives of all trends held positions of responsibility in the newly formed Artists' Union. For example, the Moscow branch was headed by a member of AKhRR, A. Volter, whose principal assistant was D. Shterenberg, the former Leftist administrator of the arts during the years of War Communism.

Similarly, Socialist Realism was not yet interpreted as a narrow dogma. It was discussed and accepted at the first Congress of the Writers' Union in 1934 as the only suitable mode for Soviet literature and art. But the definition of Socialist Realism provided by Andrei Zhdanov in his opening speech as the "true and historically concrete depiction of reality in its revolutionary development [aimed at] educating the workers in the spirit of Communism," was not reiterated with equal precision by others. Igor Grabar, the only painter among the 600 delegates, avoided specifying how Socialist Realism should manifest itself in the visual arts. He did pledge that painters would "use this well-tested [sic] method, the best of all existing ones"; but in the same breath he noted that painters, as well as writers, depicted life as they saw it, understood and felt it—a qualification that did not testify to a ready acceptance of that one "best" method. [2]

Belying Grabar's sanguine hopes for a creative formulation of the new style were numerous signs of conservative retrenchment, indicating that the style developed by the Peredvizhniki was to be the basis for the realism the Party expected of Soviet painters. There was the episode of re-arranging the exhibit to commemorate fifteen years of Soviet art. The way it was mounted provided a good clue as to how the cultural authorities viewed the past and future course of Soviet art. Preparations for this first retrospective of its kind

started in 1931. When the show opened in Leningrad in November 1932, it still reflected the tolerant atmosphere, prevalent before the April Decree, that accepted a wide stylistic range. It was a retrospective in the true sense of the word, giving a fair sampling of various trends that had existed before and emerged after the October Revolution. However, before the show was moved to Moscow it was censored and when it re-opened in June 1933, it gave a slanted version of the development of Soviet art, slighting the innovators and emphasizing artists whose easily intelligible, story-telling manner made them acceptable as forerunners of Socialist Realism. It was now a didactic exhibit. Its director, Nikolai Shchekotov, frankly admitted that many non-realist paintings (i.e., the "formalist" works of Malevich, Kliun, Filonov) were removed for the purpose of "warning" young artists that non-objective art had no prospects for acceptance.[3]

The speech given by the new Commissar of Instruction, Andrei Bubnov, at the Moscow opening signalled even more explicitly what style was henceforth to be favored. Noting the late nineteenth-century realist canvases in the section on pre-revolutionary trends, he stated that "the proletariat . . . in building its culture does not reject anything valuable from the legacy of the past" and "increasingly puts [this legacy] to its service." In amplification of his complimentary remarks about traditional art forms, Bubnov attacked "formalism" with its "perversion of content" and "infantile Leftism," i.e., the innovators during the periods of War Communism and the first Five Year Plan.[4]

The reorganization of the Academy of Arts was equally symptomatic. In October 1932 it was renamed the All-Russian Academy of Arts, and once again it became the highest training center in the country. During the next two years there was strife over what direction the teaching should take. In the end, the advocates of a "free school," who rejected too structured a program, lost out to the proponents of strict realism. Victory came with the help of the Party, which not only was instrumental in appointing "proper" professors—such as Isaak Brodsky—but also in commandeering the reluctant students to study with them. (When only two students signed up to study with Brodsky, the Party "persuaded" others to apply.[5]) It was Brodsky who became the Academy's Rector in 1934 and introduced a curriculum heavily laden with courses in drawing and composition, stressing clarity of presentation and the ability to draw—a reversion to the Imperial Academy's requirements. He also insisted on courses in the history of art and on lectures in Marxism-Leninism, for in the tradition of the Russian nineteenth-century positivists the new Rector believed that artists had to be "well-educated" in order to be fully competent in their *métier*.[6]

The Tretiakov Gallery likewise returned to solid respectability. Arrangements and labels which identified canvases according to their class origins and functions, introduced in 1928, were replaced by a chronological exposition

based on the historical evolution of styles and individual masters. Instructions from Narkompros, under whose administration the Gallery was operating, requested these changes for two reasons: to facilitate the proper assimilation of the artistic heritage for the current discussion about the appropriate models for Soviet Realism, and to make art more accessible to the masses.[7] There was no wholesale removal of advanced artists like Malevich and Larionov; that happened only in the late 1930s. But the historical exposition did underscore the central importance of Peredvizhnik realism in the over-all development of Russian art.

The re-arrangement met with the approval of the public. Visitors' comments, preserved in the Gallery's archives, show that they enjoyed viewing paintings in chronological sequence and listening to the guides' stories about the life and work of individual painters. This impression is supported by the memoirs of N. Mudrogel, who worked as a custodian and guide from Tretiakov's days until World War II. He heartily endorsed the removal of the "garbage" (i.e., the Marxist explanations of the socio-political background of beloved nineteenth-century masterpieces) and the return to viewing pictures in the time-honored way (i.e., unraveling the story they told and savoring one's emotional responses).[8]

The re-entry of conservative painters into the mainstream of artistic life was another indication of a reversion to the older traditions. Mikhail Nesterov (1862-1942), who had contributed a national religious strain to the Peredvizhnik exhibits and had been completely excluded from public life after the Revolution, was "rediscovered" in 1933. He was exhibited in the purged retrospective of Soviet art, and in the remaining years of his long life he enjoyed considerable success as a portraitist. Another was Arkadi Rylov (1870-1939), an old-fashioned landscapist who had led a peripheral existence after the Revolution. In 1933, much to his surprise, he was invited by the Red Army to participate in an exhibit commemorating its fifteenth anniversary, and two years later the first retrospective of his work was held.

By his own admission, Rylov's landscapes–"happy pictures when all comes to life"–did not represent anything new in art. Yet this was exactly the quality that the authorities wanted to promote. The review of his retrospective in the Narkompros periodical noted that Rylov's realistic landscapes contained elements that too many contemporary Soviet artists, educated on the "cool, soul-less, formalist and moribund landscapes of the imitators of Cézanne and the Impressionists," had forgotten about. The recommendation to these erring painters was to learn "from the deeply felt and clearly expressed canvases of Rylov."[9]

The political and cultural authorities were explicit enough about the roots on which Socialist Realism should be grafted. But the two organizations entrusted with providing the theoretical justification and practical implementation of this program–the Tretiakov Gallery and the Moscow Union of Soviet

168

Artists—harbored scholars, critics and painters who vigorously resisted pressures from above and tried to prevent Socialist Realism from backsliding into pedestrian naturalism. In those days opinions expressed by high-placed bureaucrats were not yet tantamount to orders. Thus lively debates took place between the proponents of the narrow and the open-minded approaches to the delineation of Socialist Realism.

The positions of the two camps were stated at the outset, when the retrospective of Soviet art was undergoing the stylistic purge. I. Gronsky, a prominent political administrator in journalism and literary organizations, said in a lecture to the Moscow artists in March 1933:

> If we take a very simple approach, one can say that Socialist Realism is Rembrandt, Rubens and Repin put to serve the working class. You undoubtedly know that Marx preferred Rembrandt to Raphael..., that Lenin saw Rembrandt, Rubens and Repin as artists from whom our painters should learn, whom our painters should take as the starting point.

But the editorial in the first issue of *Art (Iskusstvo)*, the organ of the newly proclaimed Union of Soviet Artists, stated that "the problems of Socialist Realism have not yet been worked out... It can be multifaceted. As Lunacharsky has said, Socialist Realism is a broad program, it includes many different methods, those we already possess [and] those we are still acquiring."[10]

There was a range of views among critics and historians who tried to prevent the official preference for concrete realism from blindly turning into a veneration of national tradition (i.e., content) and a rejection of foreign influence (i.e., form). Abram Efros (1888-1954) was one of the critics who addressed the problem of revolutionary art from cosmopolitan and esthetic positions. During stormy discussions in the spring of 1933, he remonstrated against the hazards of selectively canonizing native continuities, especially against elevating *Peredvizhnichestvo* into any sort of model; his argument was that the art of the socialist epoch had to find new responses to the new times, to combine new subjects with a new palette. But the debates were so intense that his opponents branded Efros' pleas for esthetic standards as "Russophobia" and "Francomania."[11]

Marxist scholars also were cautious about what should be taken over from the past. Their chief spokesman, Alexei Fedorov-Davydov, had by 1933 somewhat modified his previous characterization of the entire course of *Peredvizhnichestvo* as the Russian variant of bourgeois realism. He now argued that there should be a careful, selective study of its best traditions, namely those of the 1860s when it embodied the materialist esthetics of Chernyshevsky and Dobroliubov and played a progressive political role. But because the Peredvizhnik art had deteriorated during the 1870s into an uncritical docu-

mentation of bourgeois society and had lost its initial identification with the revolutionary movement (to illustrate his point, Fedorov-Davydov would cite Repin's ambivalent treatment of the returning political exile in "They Did Not Await Him"), there could be no unqualified acceptance of *Peredvizhnichestvo*. With its values and attainments, it represented a lower level of historical development. The response to the challenges of the present required something more.[12]

Among the former members of AKhRR, there was a more favorable but by no means fulsome attitude toward the Peredvizhniki. For N. Shchekotov, art historian and museum administrator, Russian realism encompassed the civic-minded Peredvizhniki, the European-oriented World of Art *(Mir iskusstva),* and the Cézannist "Knave of Diamonds" group.[13] A. Volter, chairman of the Moscow branch of the Union of Artists and editor of *Art,* advocated a creative cross-fertilization of modern Western or Russian Western-oriented art with the ideological traditions of Russian realism. To the simplistic harangues of men like Gronsky that Socialist Realism should evolve out of Rubens, Rembrandt and Repin, articles in *Art* would answer that its precursors should not be confined to this "holy" trinity, that painters like Delacroix, Courbet and Cézanne should not be forgotten, that Repin's painterly and political qualifications were by no means irreproachable.[14]

When researchers at the Tretiakov Gallery were directed by Narkompros to uncover the historical antecedents of Socialist Realism, they also took a broad view. Their studies of Russian nineteenth-century art ranged from Alexander Ivanov through World of Art, and they examined dispassionately both the "naturalist" and the "expressionist" trends in Soviet art. And when the Gallery staff worked on the Peredvizhniki, they did so without distorting the facts. Thus, the large Perov retrospective mounted in 1934—the opening venture in the long, officially sponsored campaign to study and assimilate the origins of Russian realism—had a catalogue that was no panegyric. Written by a student of Fedorov-Davydov, Petr Sysoev, it covered both the "progressive" start of Perov's career when the subject matter of his canvases reflected the spirit of the 1860s and his later evolution toward reaction. The introduction concluded with the caveat:

Viewing Perov's work from the vantage point of the legacy we must remember that he does not offer us . . . a complete, 100 per cent model for Socialist Realism, that he has a constructive side as well as a negative one, stemming from his bourgeois limitations. That is why the proletarian artists should take into account all that is positive in his work and reject all that is useless and harmful.[15]

The quality of discussion changed quite drastically after the publication of the Central Committee's Decree on the teaching of history on May 16,

1934. Aimed at the Marxist school of Pokrovsky, which had irreverently portrayed the pre-1917 Russian institutions and figures as impersonal emanations of social and economic forces, the decree ordered that "abstract sociological schemes" be replaced by a "consecutive exposition of civic history."[16] Though addressed to historians, the Party's directive was taken as a prescription for the content, method and orientation of *all* scholarship, requiring proper respect for the past. Perforce it affected the on-going re-appraisal of Russia's artistic heritage. Those persons who were inclined more toward ethnocentric formulas than to Marxism, with its supra-national spirit, were given an implicit go-ahead signal.

The switch executed by Sysoev during 1934 is a paradigm of what happened to the profession, how a new breed of historians and critics began to press classics into political service. Sysoev had written the introduction to the Perov exhibit catalogue while still under the influence of his Marxist professor. But within a year he changed course 180 degrees. In late 1934 he published a panegyric on Repin as a great painter and a revolutionary. The unfailing mastery of his realist canvases and their unwavering ideological thrust (Repin was said to have adhered faithfully to the teachings of Herzen, Bakunin and Chernyshevsky throughout his long career) were presented as perfect exemplars for Socialist Realism. Moreoever, Sysoev promoted Chernyshevsky's theories as the basic source for the new esthetics and defended them against Fedorov-Davydov's strictures that the utilitarian approach of the revolutionary democrats ignored the pictorial aspects of art. And finally Sysoev resorted to vituperative attacks on those scholars and critics who hampered the "proper" definition of Socialist Realism by being more appreciative of Cézanne than of the Russian realist tradition. He called for means even more energetic than those used by Stasov (as though it were possible to outdo that fiery and none-too-scrupulous writer) to restore the primacy of the old masters, "especially the revolutionary ones like Repin."[17]

The following year there emerged a team of neo-Stasovite critics. In a series of articles, mainly in *New World (Novyi mir),* edited by I. Gronsky, they mounted a campaign against all who failed to keep the discussions on Socialist Realism within the parameters.[18] There is nothing memorable about their oversimplified political arguments; essentially they elaborated what Sysoev had already stated. But what was significant for the time and in retrospect is that this campaign did not go unanswered despite clear indications that the Party shared the views of these critics. (*Pravda,* for example, had taken to task an album of forty reproductions from the Tretiakov Gallery because the commentary was said to have "discredited the revolutionary-democratic trend in Russian art" and to have cast aspersions on "Peredvizhnik naturalism."[19])

Probably the most outspoken riposte from the advocates of a broad definition of Socialist Realism was printed in *Soviet Art (Sovetskoe iskusstvo),* published by Narkompros. It stated that the primitive arguments advanced

in the *New World* articles would not be worth commenting on had they not become the rallying cry for a "group of simplifiers" *(uproshchentsy)* who wanted to impose a "retrogressive" and "impoverished" concept of Socialist Realism by equating this style with bourgeois realism and limiting its precursors to two or three Peredvizhnik names. The article also defended *Art* for properly carrying out the April 1932 Decree against group politics by opening its pages to a number of opinions and for seeking creative solutions to the question of heritage, i.e., one that would include the best traditions from classical antiquity, the Renaissance, the art of the French Revolution and the Commune, Russian ideological realism, as well as the subsequent *plein air* and color discoveries of the West.[20]

Art also spoke up in its own defense and tried to explain its search for a multifaceted ideological art. It argued that the discussions in its pages of the problems of light and color, of the works of Poussin and Cézanne, were not due to any Gallomania, no conspiracy to "sneak in" alien formalist elements, but were an effort to raise the quality of Soviet art to new heights. This goal necessitated a wide-ranging cultural outlook and not the descent to a parochial "neo-populist Russophilism."[21]

Despite these efforts to preserve leeway for artists, painting began to reflect the Party's decision to impose a single mode of expression and to favor an intelligible, narrative style. Here, the transformation of Kuzma Petrov-Vodkin (1878-1939) provides an apt illustration of how most painters were affected. This highly original neo-realist, who after the Revolution rendered contemporary subjects in what he called "spheric perspective" (of which his "Death of a Commissar" of 1928 is one of the finest examples), abandoned his complex mode of composition after 1932. Whereas his works from the 1920s were striking for their positioning of figures, his later canvases concentrated on details that made clear who the figures were and what events were taking place. Thus, his 1934 painting "Alarm" *(Trevoga)* did not rely on purely plastic means to convey the fear that gripped Leningrad in 1919 when the White Armies threatened the city. It showed a working family's room with windows covered up, the mother tensely clutching her child and the father anxiously peering out the window. To identify the cause of consternation, the canvas included a dated issue of a newspaper with the headline: "Enemy at the Gates."

The Peredvizhniki Rehabilitated

The year 1936 marked the end of any more or less free-ranging discus-

sion about the definition and function of Socialist Realism. From then on, the Party took an active hand in transforming the operational meaning of the concept, making it a truncheon for enforcing conformity and orthodoxy. The legitimation of authoritarian controls by reference to the historical legacy was an important part of this process. In the visual arts, Socialist Realism was defined as the logical development of a narrowly conceived Russian nineteenth-century tradition. The rehabilitation of realism in general and of its Russian variant in particular had begun in April 1932; after 1936 there was a further turn of the screw—individual Peredvizhniki and their work underwent substantial re-interpretation and upgrading.

In order to justify the official demand for party-mindedness *(partiinost')*, the painters' concern for social and moral issues began to be presented as a virtual adherence to a political program. In order to create a historical precedent for the requirement that art be close to the masses *(narodnost')*, the Peredvizhniki's catering to the middle-class viewers was idealized into "bringing art to the people." In order to deprive painters of the freedom of experimentation, of cultivating their own vision of the world, recent Western art and influences were denigrated as the tainted source of "art for art's sake."

Stalinist bureaucrats tried to re-make the leading Peredvizhniki into nationalists who faithfully carried out the precepts of revolutionary democrats. Their morally motivated, individual commitment to ideals and society, carried on at considerable personal sacrifice outside the official establishment, as well as their open-minded attitude toward fresh talent, were reduced to a didactic, semi-political program with strong isolationist overtones that had much in common with the tenor of *Peredvizhnichestvo* during its decline and hardly resembled its creative phase.

Formation of the Committee on Arts *(Komitet po delam iskusstv*, KDI for short) on January 17, 1936, by a Decree of the Central Committee and of the Council of People's Commissars, was a decisive step in establishing central control over Soviet art, music, theater and cinema. In the visual arts, the Committee took over from the Narkompros the administration of museums, research institutions, the Academy and other teaching centers. The Commissariat of Instruction had exercised a rather loose, even lackadaisical, supervision over these organizations, giving them general directions and leaving it pretty much up to the staffs to devise their own annual plans accordingly. But the Committee on Arts kept much closer watch; it required detailed monthly reports on work accomplished and strict adherence to the ideological line in various tasks assigned to the institutions under its jurisdiction.[22]

The Decree establishing the Committee was a simple administrative step —on the surface. Ominously, the issue of *Soviet Art* in which the Decree appeared also printed on the front page a doctored, composite picture of Lenin and Stalin sitting together on a bench—it was so crudely put together that the backrest did not even match—a sign of the aims the centralized direction of

173

the arts would pursue.[23] Six days later the ideological ramifications of the new set-up were elucidated in an attack on Shostakovich's opera, *Lady Macbeth of Mtsensk,* that ranged far beyond the case at hand and constituted a general condemnation of modernism: "Leftist distortion in opera stems from the same source as leftist distortion in painting, poetry, teaching and science. Petty bourgeois innovations lead to a break with real art, real science and real literature. . . ."[24]

Although *Pravda*'s attack on modernism did not explicitly insist on a chauvinist reverence for the national tradition (beyond noting that Shostakovich's "fidgety . . ., neurotic music" enjoyed great success abroad), this requirement was soon spelled out for painters by Platon Kerzhentsev, the chairman of the Committee on Arts, in an interview he held later in the spring with Mikhail Nesterov. That survivor from the late nineteenth-century scene was reported as saying that,

> the realism which is now demanded from painters, and which the Peredvizhniki had at the time of their flowering, should be genuine, based on serious study of nature and man.... We need a complete "disinfection" from the rotten perversion of nature's truth which we once took over from the West [and] which had such a harmful influence on a number of generations of our, basically sound, youth.[25]

To implement the new line, changes were made in the top administrative posts. Alexander Gerasimov (1881-1963) replaced the relatively tolerant A. Volter as head of the Moscow Union of Artists and as editor of *Art* in 1937. A mediocre photo-realist painter who made a career by producing flattering portraits of Stalin and other Party leaders, Gerasimov easily took on the coloration that was demanded of Soviet painters after 1936. Among other things, what was required was a veneration of the Peredvizhniki, and Gerasimov played up his humble social origins, provincial background and lack of cultural sophistication as factors that assured a proper appreciation for things Russian. Gerasimov's memoirs recount how he, son of a rural cattle dealer, came to Moscow in 1903 to study with Arkhipov at the Art School. He found the art scene dominated by "snobbish" golden youth who were enthusiastic about Nietzsche and Oscar Wilde, looked down on the Peredvizhniki and adored the French modernists exhibited in the collections of Sergei Shchukin and Ivan Morozov. Against these spoiled "cosmopolites" were ranged the unequal forces of the "provincials" who "adored" Gogol, Nekrasov, Chernyshevsky; who had the highest esteem for Russian realists; who were ignored by the new collectors in their quest for modish foreign novelties; and who could not make their views known in the pages of the prestigious art journals like *Apollo* or *Golden Fleece.*[26] It was this "home-grown" figure who for the next twenty years was the main conduit of the Party line in the fine

arts.

The Tretiakov Gallery was transformed into the chief center for the dissemination of the new interpretations. Under detailed instructions and close supervision from the Committee on Arts it embarked on a veritable crash program of research, publication, exhibits and conferences to acquaint the public with the works of the realist masters and to define the "characteristic traits of Russian realism" for Soviet painters and scholars. Before the outbreak of World War II, the images of Repin, Kramskoy, Surikov and Levitan were reshaped to help fashion Soviet art into the handmaiden of politics.

A mammoth Repin exhibit, the largest ever (with no less than 1,000 works), was displayed in 1936 first in Moscow, then Leningrad and Kiev. When preparations were started in 1935, the aim was to acquaint the public with the full range of Repin's subject matter and technique as part of the general re-evaluation of the great masters that had been going on since 1932. (A sizable Rembrandt exhibit was also to be held in 1936.) No one tried to enforce on the staff a "correct" interpretation of the artist's work or philosophy at the outset. But after the Gallery was placed under the Committee on Arts, the exhibit's organizers were told to pay less attention to the artistic qualities of Repin's work and to stress instead the "story" of his canvases, as well as his service to society. Despite these pressures, the catalogue did not pass over the painter's fluctuating interests and loyalties.[27] Discrimination and veracity, however, did not distinguish the discussions published in the press: Alexander Gerasimov called attention to Repin's "autochthonous talent," while the neo-Stasovite critics argued that Repin had always advocated and painted content-full, ideological art and had invariably denounced Western artists for their lack of interest in social causes.[28]

Other steps were taken to popularize the official image of Repin as a painter unfailingly dedicated to his nation and the people. For the masses, there were the guided tours of the exhibit accompanied by lectures (whose text had been approved in advance) that represented Repin as a precursor of Soviet art with his striving to "depict the most important typical elements [of his time] in a truthful, simple, deep and clear manner."[29] Furthermore, the Committee on Arts directed the Gallery to have copies made of Repin's most important works for wide distribution to schools, public institutions and museums. And finally, it instructed the Gallery to prepare no less than 100 traveling exhibits of Repin's work.[30] For the benefit of artistic circles, the Committee ordered the Tretiakov Gallery and the Russian Museum in Leningrad to hold a symposium on Repin and to prepare for publication a collection of articles dealing with such topics as "The Struggle for Realism in Russian Art and Esthetics during the 1840s and 1860s" or "Repin and the West." As work on both ventures proceeded slowly, contributors were told more and more unceremoniously that they should pay attention to the "political direction" of their researches, to interpret their material with the "urgent needs of

our day" in mind.[31]

Next, similar methods were used to popularize Kramskoy as a major theoretician. The widely publicized observance in 1937 of a double anniversary—the 100th of his birth and the 50th of his death—resuscitated the painter from virtual oblivion.[32] There was a concerted effort to construe out of Kramskoy's numerous letters and a handful of essays, which represented a tortuous and even tortured search of a morally obsessed man for a right balance between purely artistic and extra-painterly obligations, a coherent body of criticism and a well-thought-out system of utilitarian esthetics.

After undergoing severe censorship on the part of the Committee on Arts, the catalogue for the large Kramskoy exhibit presented the painter as a thinker of note whose views were shaped by extensive reading in Belinsky, Chernyshevsky and Dobroliubov; a well-educated man who was familiar with Hegel, with world literature, history and art; a politically committed person who paid close attention to all the socio-political problems of the times and held other painters to the requirements of didactic art. Moreover, through apt quotations from Stasov, the catalogue conveyed the impression that Kramskoy was regarded in his day as an authoritative art critic.[33]

The introduction to the two-volume collection of the painter's correspondence was correct on facts.[34] It did not try to cover up Kramskoy's rapprochement with the Court circles in the 1880s or his insistence on technical mastery. But otherwise, it was slanted to represent him as a counterpart to Belinsky and Chernyshevsky in the field of art. Kramskoy's concern with art of quality that would serve individual self-perception and human welfare was construed into a purposeful system requiring artists actively to help transform society. In this guise Kramskoy's writings could be useful in providing historic justification for Party demands.

Thus when Stalin, at the Eighteenth Congress of the CPSU in March 1939, called on specialists not to become isolated in their fields but with a thorough command of Marxism-Leninism to take an active part in the contruction of socialism, pliant art critics could echo his dicta with appropriate quotations from Kramskoy.[35]

The large retrospective exhibit of Surikov, held in 1937, was utilized by the authorities to enforce another function on art: to serve as a catalyst for nationalist feelings that would brace the population for the unmistakable threat of war. (Later on that year an exhibit commemorating the 125th anniversary of the Russian victory over Napoleon was held.) The Tretiakov Gallery staff was told to model their research on recent articles in *Pravda* and *Izvestiya* that extolled Pushkin as an ardent patriot. However, texts of essays that were written on the meaning of Surikov's legacy show that many scholars were unable to discover the appropriate inspiration for the Soviet people in Surikov's early partiality for the patriarchal, pre-eighteenth century Russia or in his subsequent glorification of Tsarist military exploits. Nor did they deem Suri-

176

kov's later, aggressively nationalist canvases ("Ermak's Conquest of Siberia," "Suvorov Crossing the Alps") to be a proper model for Soviet historical painters because of the visible decline of his creative power.[36]

But in the various ceremonies marking the exhibit, government officials had no reservations about Surikov's political credentials or artistic skill. Platon Kerzhentsev's speech at the opening claimed that throughout his career Surikov was a painter of unfailing power (i.e., it was wrong to cast aspersions on the quality of his later work), a steadfast democrat (i.e., his outlook, like that of Repin, was shaped by the radical-democratic thought of the 1860s and 1870s), as well as a genuine patriot (i.e., he celebrated the bravery of the Russian people, not Tsarist power). For President Kalinin, the painter's later work represented a "cultural heritage of greatest importance which could be most useful in these fearful days of Fascist threat...in mobilizing...and inspiring the Russian people."[37]

Since there was considerable divergence between the officials' remarks and the catalogue (as well as the guides' lectures prepared for the exhibit), the Tretiakov Gallery staff was subjected to a session of self-criticism at which various scholars apologized for their lack of political acuity. Perhaps the most revealing capitulation was that of Shchekotov, who directed the Gallery's research. His original response to the planned Surikov exhibit was to write an essay dealing with the often inexplicable complexity of the painter. But at the breast-beating session he found it advisable to endorse Kerzhentsev's over-categorized outline.[38]

The large Isaak Levitan (1860-1900) retrospective, held in 1938, enlisted landscape painting under the banner of nationalism. The much reworked introduction to the catalogue was designed to dispel various "legends" that this popular landscapist painted in an Impressionist manner, that he was interested in the technical problems of rendering distance, that he was not a true Peredvizhnik. Instead, it was argued that he had always painted in the time-honored Russian realist tradition (i.e., from careful preliminary sketches); that his rendition of the vast Russian plain was motivated by his love for the motherland; that he was above all interested in representing the grandeur, beauty and power of the Russian landscape.[39] The same interpretation appeared in several articles concurrently with the exhibit and at the conference for painters and art historians convened at the Tretiakov Gallery on the theme, "Levitan and the Problems of Soviet Landscape."

The official emphasis on the nationalist strain in Russian realist art was meant to promote patriotism among the public; but among painters and scholars it was intended to discourage modernist Western influences. The concept of what constituted a deviation from realism was considerably widened after 1936. After 1932 Cézanne marked the dividing line; by the late 1930s the authorities wanted to shift it to the Impressionists. That is why so much effort went into "rescuing" Levitan's reputation, to establish that he painted

meticulously finished canvases. For the same reason, the Tretiakov Gallery staff was told that since Surikov was classified as a realist, no allegation of his ever having been influenced by the Impressionists could be made, for "Impressionism is a denial of the tradition of realist art."[40] One cannot, however, ascribe these warnings solely to a renewal of traditional Russian fears of being corrupted (or outdistanced) by the West. Under the conditions of Stalinist totalitarianism, any partiality for Western trends acquired an additional stigma—that of insubordination.

Despite strong pressures and clear directives that the Peredvizhnik legacy be canonized along specific lines, the overall picture in Soviet scholarship on nineteenth-century Russian art did not look as dismal as the harangues of officials or the writings of Party hacks would seem to indicate. Although enough worthless articles of a purely political nature, based on flimsy evidence or falsified facts, appeared, only one such book was published. Written by L. Varshavsky, an art historian of some repute in the 1920s who by 1933 came to advocate a "Bolshevization" of the Tretiakov Gallery, it was a panegyric to *Peredvizhnichestvo* as the "most important trend in the history of Russian art." Its fulsome praise of the Peredvizhniki was similar in tone to the first nationalist history of the movement, published forty years earlier.[41]

Not everybody in the scholarly community submitted supinely to the principles advocated by the Committee on Arts. Minutes of the Tretiakov Gallery research staff meetings that preceded and followed various exhibits, publications or conferences indicate that individual scholars would defend their right to present undoctored facts (that Repin painted a number of religious pictures, for example) or object to having to adapt their work to the "needs of the day." Though they were severely censured for being too passive—i.e., for failing to produce properly slanted articles for the press, for not presenting the public with one clear viewpoint—many did not comply. That is why the essays written to provide new interpretations of Repin and Surikov did not receive official approval, and the two planned anthologies did not materialize before the war.

Moreover, several serious studies and collections of source materials were published. Among them were Igor Grabar's massive biography of Repin, an edition of Kramskoy's letters, and the encyclopedic commentaries to Stasov's works by Sofia Goldshtein. Each was an important contribution, based on painstaking archival research and marked by objectivity. For example, Kramskoy's letters contained his correspondence with Alexei Bogoliubov regarding the chances of the *Tovarishchestvo* rejoining the Academy, which Stasov was so careful to exclude in his edition in 1888. To be sure, these books leaned heavily toward the purely factographic and narrative side, but such "life and work" studies were a welcome corrective after the schematic excesses committed by the sociological school with its one-sided, Marxist class analysis. Also, it may well have been a consciously chosen method to ward off

the official demands for a tendentious interpretation. The purpose of these works was not to re-interpret the past in accordance with a pre-ordained model but to provide full information on a movement that had been either derided or neglected after the Revolution.

There is evidence of other attempts made by art historians to stem the escalating falsification of the Peredvizhnik tradition. Free and far-ranging discussion on art theory was no longer permitted after 1936, but it was still possible to insist, when there was a chance, on an objective treatment of the Peredvizhniki. The introduction to the catalogue of the Repin exhibit, which tried to present a better-rounded picture of the artist's motivations and accomplishments, was one example. Much more unusual, almost unique, was a scorching review of Varshavsky's book—a "primitive" work that "contributed nothing to the growth of [Soviet] artistic culture." The reviewer objected to its shallow oversimplifications that impoverished and distorted the history of Russian art. He pointed out how false it was to confine the accomplishments of Russian art to a single grouping, to reduce the complex phenomenon of realism to the works of the Peredvizhniki alone (many of whom hardly ever rose above trivial naturalism), to classify the great *oeuvre* of Repin, Surikov and Serov within a narrowly defined *Peredvizhnichestvo*.[42]

Objections to the excessive respect for the Peredvizhniki masters were used to criticize the deteriorating standards in Soviet painting as well.[43] By the late 1930s the absence of novelty and creative talent at exhibits of contemporary works could no longer be alluded to in print. But in front of a professional audience the shoddiness of Soviet art could be blamed on the fact that painters were forced to wear their grandparents' clothes. This was done by Shchekotov in a discussion of a large exhibit held in 1939 to celebrate the achievements of socialist industry. He described the prevalent style as "pseudo-realism" and traced its origins to the imposition of a Socialist Realism based exclusively on traditions bequeathed by the Peredvizhniki and other pre-1914 academic painters.

Another reason adduced by Shchekotov for the poor quality of Soviet art was the advantage most painters took of the plentiful and remunerative commissions from state organizations. These patrons were satisfied with the mere pictorial "registering" (often tinged with glorification; "varnishing" [lakirovka] was the phrase for this) of one or another achievement of their particular segment of industry, administration or the armed forces, and there was no need for painters to expend any effort on a creative interpretation of the commissioned theme. In order to bring home the routinized nature of the documentary canvases that were being passed off as genuine art, Shchekotov wittily made up a conversation between two imaginary Soviet painters on the advantages of working from photographs in speedily completing commissioned portraits, group pictures and even landscapes. This method did not waste time on many sittings or on any imaginative reworking of the subject.

Moreover, it had been successfully used by such respected masters as Shishkin, Repin and Kramskoy.[44]

Shchekotov did not go into any details about the comfortable life, the privileged social status, that accommodating painters could enjoy in return for services rendered. But he made it plain that this was what had emasculated their creative urge. No painter has published an account of how the material rewards the regime offered brought about compliance, but the prospect of getting a studio, a separate apartment, as well as admission to special stores, must have had the same magic power in this as in other professions. Nowadays, visiting Isaak Brodsky's luxurious duplex facing one of the most elegant squares in old Leningrad (it has been turned into a museum) gives one some notion of how artists—described by Khrushchev as "Court painters"—managed to live when the vast majority of the city's population had to contend with crowded communal apartments. Inevitably one is reminded of the exclusive quarters occupied by those Peredvizhniki who joined the teaching staff of the Imperial Academy, and of how these state apartments were, in the eyes of the intelligentsia, a symbol of the painters' subservience to the Tsarist regime.[45]

Cultural Autarchy Triumphant

The seven-year period of total ideological regimentation that followed World War II is the culminating stage in the distortion of the Peredvizhnik tradition. The artistic world was saddled with a grossly utilitarian and xenophobic program, supported by a crudely falsified history. Ever since 1932, Socialist Realism, in both its evolving definition and application, was entwined with a prescribed attitude toward Russia's heritage. At first, it was mainly the official endorsement of the values of realism, both Russian and Western that was entailed. After 1935 this rehabilitation of the preferred style, begun in an atmosphere of relatively free discussion, moved into a more stringent phase when the Party tried to enforce on painters, scholars and critics an orthodoxy resting on a very one-sided interpretation of the Russian realist masters. But only after World War II did the campaign of cultural pogroms, known as *Zhdanovshchina*, result in the imposition of monolithic views, based on the claim that *Peredvizhnichestvo* was the most brilliant epoch in the history of Russian art and the highest manifestation of realism in the world.

As in the post-1935 ideological witch-hunt, the fine arts were not the primary target of Party pronouncements. But the political demands on litera-

ture, theater, music or film were taken as guidelines to be scrupulously observed in the fine arts as well.[46] The Central Committee's statements were clear-cut and definitive. For example, its first resolution, dealing with literature, berated the "spirit of servility before . . . the West," condemned "any preaching of art for art's sake" as "harmful to the interests of the Soviet state," demanded "party-mindedness," and categorically stated that all creative endeavor was to serve as a "mighty weapon" of the Soviet regime. Upon appearing in *Pravda,* these exhortations were reprinted in *Soviet Art* and *Art* and were immediately discussed by painters and art historians at hurriedly convened conferences. As if this were not enough, Zhdanov would at times amplify the purport of the Central Committee's resolutions:

> In painting, as you know, the bourgeois [Left] influences were quite strong at one time. . . . The Party has fully restored the importance of the classic heritage of Repin, Briullov, Vereshchagin, Vasnetsov, Surikov. Have we not acted correctly in defending the treasures of classical art and in having crushed the liquidators of painting? Would not the prolonged existence of such [Leftist] "schools" have resulted in the death of art itself?[47]

The Party at first relied on pre-war institutions to convey its directives and oversee their implementation. The Committee on Arts functioned, as before, as a Ministry for the administration of all the arts. The Organizational Committee of the Union of Soviet Artists, created in 1939 under Gerasimov to take over executive powers from the Moscow Union (which had been too lethargic, ideologically), kept close check on working painters, state commissions and exhibitions of contemporary works. The Tretiakov Gallery was expected to produce scholarly studies expounding the new perception of the past necessary to legitimate the extreme politicization of art, isolation from the West and the aggrandizement of national achievement. But the Gallery's research staff, which had responded reluctantly before the War, performed even less satisfactorily under the stepped-up pressures. It was bombarded by the Committee on Arts with irritated inquiries why the projected works on Russian nineteenth-century art, the Soviet period and individual painters—begun some ten years earlier—were not yet ready for publication. By 1948 the tone of these inquiries changed; the Committee issued outright "orders" *(prikazy)* that this or that work be finished by a certain date. Manuscripts submitted to the Committee for its imprimatur were so heavily censored that often they barely resembled the original, and most of them seem to have been scrapped altogether.

About the only thing that the Gallery did right was to re-arrange its displays under the slogan: "great art of the great people with its own national expression and beautiful national traditions."[48] This was done by doubling

the space allotted to Repin, giving separate halls to Antokolsky and Vereshchagin, displaying a much wider selection of the less well-known Peredvizhniki (some of them good painters—like Vasilev, Kuindzhi and Polenov; some merely good "citizens"—like Miasoedov and Yaroshenko; some mere storytellers—like Makovsky). And the halls for the Soviet period were so re-arranged as to demonstrate unequivocally the organic continuity between post-revolutionary art and the nineteenth century.

Because the Tretiakov Gallery proved to be such a problematic instrument, the regime refashioned another organization to implement its directives. In August 1947 the Academy of Arts was transformed from the highest teaching center it had been since 1932 into a watchdog over research, training and indoctrination, again setting the tenor of the country's artistic life in much the same way as it had under Nicholas I. The new Statutes of the Academy specified that it was to promote the progress of Soviet art on the basis of Socialist Realism, together with a better appreciation of the "Russian realist school."[49] The man designated to oversee this undertaking was Alexander Gerasimov who, by his bureaucratic propensities, ideological convictions and stylistic preferences, had long proved himself eminently qualified.

The reconstituted Academy busily set about fulfilling its assigned tasks —mainly by seeing to it that teaching and research were purified of alien ideological elements. First of all, there was a purge within the Academy itself. Those professors who were deemed to have shown too much receptivity to "decadent" Western art were sacked. The purge extended down the educational ladder, for the Academy assumed supervision over art education throughout the country. Ideologically lax instructors were dismissed; ideologically suspect books were removed from library shelves; and the course of studies was revised to safeguard students against "harmful anti-national . . . influences" and to fully "utilize the best traditions of the Russian realist school."[50]

To promote appropriately slanted research and publications, the Academy set up the Institute of the Theory and History of Art, which began preparing the histories of Russian and Soviet art that the Tretiakov Gallery had failed to produce. To reinforce guidance and indoctrination, the Academy held annual sessions and periodic symposia on artists deemed in need of greater publicity or a different interpretation, some subject inadequately cultivated by Soviet painters, or the role of criticism and education in furthering Socialist Realism. Unlike the pre-war gatherings on topical subjects, however, these conferences resulted in publications, because of the more effective management by authorities and the greater ideological compliance of participants.

In consequence of such concerted and energetic promotion, the Peredvizhniki became the most thoroughly researched and written-about group in the course of Russian art. During the 1940s and 1950s well over half of all the art books published were devoted to the Peredvizhniki and their move-

ment. Massive monographs, multivolume editions of correspondence, popular biographies, collections of memoirs, and album reproductions covered every detail in the lives and works of major as well as minor figures, or described extensively the characteristics of Russian realist portraiture, landscape and social genre. The scholarly level of these publications was extremely uneven. Because so much of it was produced to order, one cannot dismiss the whole batch as tendentious research. Many valuable collections of source material were published, and some secondary works managed to present the facts quite objectively.

Nevertheless, taken as a whole, post-war publications have to be read and used with caution. At best, the Peredvizhniki were treated in isolation from other trends both in Russia and in the West, an approach certain to distort any evaluation of their relative importance. At worst, their aims and attainments were falsified or eulogized beyond measure. Research was expected to follow Alexander Gerasimov's dictum that art historians were to "build a bridge from the great progressive Russian art of the second half of the nineteenth and the early twentieth centuries to our contemporary Soviet art over the gaping hole of decadent West European influence into which so many of our talented but unstable artists had fallen."[51] Anything considered alien to the tradition as defined by Gerasimov & Co. was swept under this metaphorical bridge. Thus artists like Vrubel and groups like the World of Art were denigrated or ignored in publications, and their works were removed from permanent museum exhibits. In the now obligatory scheme, Russian painting over the previous eighty years had proceeded, uncontaminated by Western influence, along a straight line of evolution from the Peredvizhniki and their twentieth-century followers (the Union of Russian Artists before World War I and the AkhRR after the Revolution) to Socialist Realism.

Systematic falsification occurred in three areas: *Peredvizhnichestvo* itself, the nexus between individual artists and the movement, and the relationship of both to the West.

Peredvizhnichestvo was said to be the fountainhead of all that was exemplary in technique, content and ideological coloration. The different levels of competence and the variety in ideological commitment that had characterized the Association membership were lumped into a single program to which each painter was said to have subscribed with wholehearted dedication. It became *de rigueur* to heap extravagant praise on the artistic qualities of all the Peredvizhniki. Whereas before World War II only outstanding painters, such as Perov, Repin or Surikov, had been promoted as major artists, progressive democrats and veritable storehouses of realism, after the war such minor figures as Vladimir Makovsky or Nikolai Yaroshenko were indiscriminately admired. When some more discriminating critics warned that to equate Repin with Makovsky was a "lowering of standards," they were either reprimanded by the ideologues, told to abandon the pre-war tendency to contrast Repin favorably

183

with lesser realists, or silenced altogether.[52]

Gerasimov made it clear, in a programmatic article on the historical antecedents of Socialist Realism, that there would be no toleration for the "prejudiced" opinion about the "low artistic culture" of the Peredvizhniki. They were "excellent draughtsmen and colorists" who purposely had relegated technique to a secondary place. And since he considered content to be the basic attribute of art—"a picture representing a worthy subject with life-like verity [is] the highest form of easel painting"—he stated that it was the Russian realists who had given the "classic expression" to this principle. In their hands social genre had attained the level of "historical documents" whose message helped solve important social problems of the day: "Through the high language of art, full truth was spoken for the first time about pre- and post-reform Russia with its social contradictions and contrasts."[53]

The political complexion of *Tovarishchestvo* was also radicalized. The pre-war distinction, upheld by scholars, between the oppositional spirit of the early phase and the politically quiescent or outright conservative tenor of later years, between the original goal of serving society and the eventual reconciliation with the system, had to be abandoned. All adherents of the movement, from Perov to Kasatkin, were said to be motivated throughout their careers by the revolutionary esthetics of Chernyshevsky: "By depicting the dark side of life, the sufferings of working people...they tried to evoke warm sympathy and love for the oppressed" and were at the same time undermining "the foundations of autocracy."[54] The mantle of radicalism became large enough to encompass Tretiakov as well. During the 1948 observances of the fiftieth anniversary of his death, it was maintained that he had been "very much influenced by the ideas of the great Russian enlighteners (*prosvetiteli*): Belinsky, Herzen, Chernyshevsky, Dobroliubov."[55] Numerous symposia and monographs on major and minor painters would, for the most part, repeat unsubstantiated claims about the political thrust of the Peredvizhniki's realism, about their commitment to the cause of the "people," their undaunted opposition to autocracy from the 1860s through the 1905 Revolution (if not the October Revolution).

A by-product of the wholesale politicization of *Peredvizhnichestvo* was another falsification—that of early Soviet artistic policies. The general histories of Soviet art written before 1936 (nothing of note was published after that date) had faithfully surveyed the variety and complexity of groupings that could function in an atmosphere of tolerance.[56] But the post-World War II publications claimed that immediately after the Revolution the Party had asserted its leadership in the arts as well, that from the beginning it had combatted formalist trends and promoted the Russian nineteenth-century realist tradition to guide the search for a distinctive Soviet style. This attempt to buttress the Party's control of art by distorting early policies also entailed making AKhRR the most important grouping of the 1920s (not merely the

largest), the faithful followers of the Peredvizhnik tradition, and hence the Party's choice to realize its goals.[57]

As for the assessment of individual painters—while the significance of relatively minor figures was exaggerated, the creative range of major artists was diminished. Only those aspects of their lives, work and associations that reinforced the official version of the Peredvizhniki as steadfast devotees to the national and radical cause were likely to be dealt with; everything that did not fit into this scheme was ignored or suppressed. Thus Nikolai Ge became known as the creator of the civic-minded canvas—"Peter and Alexis"—and his far more numerous paintings on religious themes were neither written about nor exhibited. Valentin Serov was popularized as a painter of rural scenes and landscapes, and his ground-breaking *plein air* pictures as well as his later experimentation in form were ignored. Both artists became one-dimensional figures.

The several editions of Repin's letters demonstrate how even the publication of documents could be so slanted as to place an effervescent personality and wide-ranging talent on the procrustean bed of a programmatic *Peredvizhnichestvo*. Only his correspondence with persons directly related to the officially promoted image was printed: i.e., with Kramskoy, the utilitarian philosopher of the movement; with Tretiakov, its patriotic patron; and with Stasov, the civic-minded critic.[58] By narrowing down the circle of Repin's friends and associates, the range of his interests was correspondingly circumscribed. Erased was Repin's friendship with Savva Mamontov, who was too much engrossed in the decorative aspects of art to be recognized by the Stalinists as a figure of cultural importance. Likewise, Repin's life-long friendship with Adrian Prakhov, especially close during their youth when Prakhov admired Western painting and advocated art for art's sake, was ignored. The molding of Repin as the linchpin of *Peredvizhnichestvo* was to be so thorough that Alexander Gerasimov suggested revising Grabar's detailed and objective biography of the painter, published in 1937, in order to eliminate a number of "false assertions."[59]

Finally, to reinforce the image of *Peredvizhnichestvo* as the model for a xenophobic version of Socialist Realism, an iron curtain against Western influence was lowered. The Museum of Modern Western Art, which since the early 1920s had exhibited the nationalized Morozov and Shchukin collections of the French modernists, was closed. Ironically, it was the All-Union Academy of Arts, dedicated to eradicating decadent Western influence, that moved into the fine palace which had been made ready to house the Museum after the war.

Research and publishing reflected the *Zhdanovshchina*'s repudiation of the West. Many fewer works on Western art appeared. Moreover, the list of "acceptable" painters was much curtailed. Courbet and Millet still passed muster as more or less "orthodox" realists. But Manet, Degas, Monet, Pissarro,

185

Sisley, Renoir and Gauguin were placed on the "enemy" list. In the late 1930s Van Gogh was highly regarded, and a fine two-volume edition of his letters was published. But by 1950 the zealots of purity would group Van Gogh, Gauguin and Cézanne as "rabid formalists."[60] A few select Western masters were recognized, though grudgingly. For example, E. Melikadze, a member of the neo-Stasovite team, would argue:

> What visual art of another country in the nineteenth century can be compared to the art of...Repin, Surikov or the Peredvizhniki in general?... Maybe French art?... Yes, we do give his due to the marvelous artist [Courbet] But the ideological depth of his work, his treatment of the social life of contemporary France, cannot be compared with that of Repin.[61]

Such overbearingly patronizing views were not characteristic of all publications. Yet this was the line that the spokesmen for the regime tried to enforce. As a result, the gamut of the Peredvizhniki's response to the West, ranging as it did from sincere appreciation to envious animosity, could not be openly discussed in print, and it became customary to underscore the hostility.[62] This is why Stasov's reputation acquired a new luster. During the 1930s he had been cited as the exemplar of the civic-minded critic who prodded painters on their duty to society. After the war, it was Stasov's xenophobic opposition to "alien influences" (*inostranshchina*)—it had become very pronounced in the late 1880s when he sensed that his unchanging opinions on the civic role of art were increasingly out of step with the times—that provided a rich lode of ready phrase and argument. Zhdanov would approvingly quote Stasov's encomium of Russian artists who showed no servility before the West but boldly trod their independent national path; and Gerasimov would praise the critic for his "hatred of the cosmopolites."[63]

Post-Stalinist Continuities and Departures

Since Stalin's death in 1953 the pre-eminence of *Peredvizhnichestvo* has been eroding. Its stranglehold on art history and criticism has gradually loosened with the cultural thaw and increased contacts with the outside world.

The course of liberalization, however, has not been smooth. The Party has seen fit to ease the rigid politicization of art. Concurrently, the creative intelligentsia has pressed for a freer artistic life, an end to the distortion of history and tradition, and the restoration of esthetic standards to criticism.

186

But speedier progress has been impeded by the cultural bureaucrats. Jealous of their power and perquisites, they have capitalized on deep-seated fears of plurality and diversity of opinion among important segments of the Party and have retarded the dismantling of the "cult" of *Peredvizhnichestvo*, the creation of which had brought them into prominence.

Soon after Stalin's death it became evident that tight controls over cultural life would be eased. The watchdog Committee on Arts was abolished on March 13, 1953, and all its functions were transferred to the Ministry of Culture. By the end of the year a number of articles in the Party and professional press began to admit that "standardization," no matter how high the standards may be, had disastrous consequences in the arts, to argue that Socialist Realism offered boundless vistas to creative artists, and to hint that "new departures" would be encouraged. The liberals seized upon these signs to try to bring about a further easing of administrative controls. In 1956 and in 1962, prior to the First and Second Congresses of Soviet Artists (held in February-March 1957 and April 1963, respectively), they were able to stage two open challenges to the cultural establishment.

Hopes for thoroughgoing changes ran high on the eve of the first gathering of Soviet artists. Their expectations were sustained by Khrushchev's denunciation of Stalinist excesses at the Twentieth Party Congress in February 1956, which betokened serious political reforms; and by the first post-war exhibitions of Western art (official French and Belgian shows, held in the fall of 1956) that signalled an end to cultural isolation. At the pre-Congress meetings in the local Artists' Unions and in the press, young rebels pointed accusing fingers at the three institutions responsible for having brought Soviet painting and scholarship to its deplorably low level: the Committe on Arts, the Artists' Union and the Academy. Less bold critics suggested a change in the leadership of the central administrative organs; more intrepid souls proposed altering the Academy's Statutes to divest it of its prescriptive functions, or replacing the single professional organization with several artistic groupings freely competing with one another, as during the 1920s.[64]

The barrage of criticism resulted only in Alexander Gerasimov's resignation from the Presidency of the Academy on the eve of the First Congress. At the meeting itself the Academy's function and structure were not changed in any way. In addition, the formation of a nation-wide professional organization was finally completed. The Organizational Committee, active since June 1939 in exercising control over local branches in major cities and in constituent republics, was replaced by the full-fledged Union of Artists, USSR, charged by its Statutes with the responsibility of organizing and directing Soviet artists and scholars "to assist in the construction of Communism."[65] The top posts in the Academy and the Union went to men who were less discredited than Gerasimov, but who nevertheless stood on the far right with their belief that realism, "untainted by experimentation and fantasizing," should

be the prescribed style for Soviet painters, and that Party guidance was indispensable for the "full development" of their "creativity."[66]

Another attempt to curtail bureaucratic controls was made in 1962 in connection with preparations for the Second Congress of Artists and the thirty years' retrospective exhibit of Socialist Realist painting. The Moscow Union of Artists, where the revisionist forces were strongest, was about to propose to the government that the Academy, so extremely expensive to maintain and more an obstacle than a spur to art, be abolished altogether. (Alexander Benois had leveled similar criticism at the Imperial Academy and suggested the same solution at the 1912 Congress of Russian Artists.) But the Soviet Academicians, like their predecessors in Tsarist Russia, resisted any threat to their power, their high standard of living and their overriding voice in dispensing the large sums the regime spends annually on the arts. What has since become known as the Manège affair—a confrontation in November 1962 between Khrushchev and the non-conformist sculptor Ernst Neizvestny—was actually a provocation staged by the establishment. It was they who either instigated or permitted the transfer of Neizvestny's work (as well as that of other unofficial artists) from a smaller exhibit in a teacher's studio to the large retrospective held in the former Riding School. At any rate, they made a point of exposing Khrushchev to the full shock of totally unfamiliar art in order to persuade him that without proper controls and guidance Soviet art would degenerate into these "depraved" forms.[67]

The provocation worked; Khrushchev was highly incensed, and the Second Congress left the Academy intact to forestall any departures from strict realism and to keep artists mobilized in the service of Communism. To this day the Academy remains one of the main pillars of conservatism in the administration of the state's vast program for the arts. Its 45 active and 55 corresponding members, drawn from among artists, scholars and critics, are the top administrators in the Ministries of Culture and the Artists' Unions, both nation-wide and in the constituent republics. As such, they have the decisive voice in formulating school programs, selecting works for the prestigious republic and All-Union exhibits, awarding state commissions, titles and prizes, and setting the tone for research and publications. Although the Academy no longer enjoys the same pervasive power it had after 1947, it is still a formidable institution and an obstacle to greater plurality in creative and scholarly work.

While the revisionists were unsuccessful in abolishing administrative controls—the Academy and the "closed-shop union"—their efforts to dilute the dogmatic interpretation of art history and to change the tone of criticism have had results. The discussions preceding the first two Artists' Congresses were as outspoken about the mendacious politicization of art as about the institutions and men that had perpetrated it. The use and abuse of history was central to these debates. An end had to be put to the constricting power of

the "legacy," for the terminal view of history that had prevailed under Stalin precluded genuinely independent work at the easel or on a book. Any lasting and meaningful liberalization of the art scene required an impartial look at the past.

Articles and speeches urged that there be a broader concept of what constituted Russia's artistic heritage: i.e., that the first half of the nineteenth century as well as the early twentieth century be seen as having made lasting contributions; that *Peredvizhnichestvo* be studied in its various ramifications; that the great masters not be demeaned into pedestrian purveyors of social genre and sentimental landscape; that the 1920s be represented in all their richness and not reduced to the AKhRR; that art not be viewed solely as the presentation of ideas but be granted the right to speak its own language; that Western painting not be shrouded in obscurantist fears.[68]

At first these proposals were vehemently resisted by the guardians of the official doctrine, who reacted to any fresh interpretation of the past as a profanation. Thus, when one revisionist critic quoted Repin's remarks in 1893 about the limited value of noble intentions in art and his admission that "each useless trifle painted artistically...fills me with endless admiration," he was reprimanded by a conservative for choosing from Repin's "valuable treasury of thought" only those "mistaken pronouncements" made during a period of "momentary confusion...opinions whose purport was belied by the rest of Repin's life and work."[69]

With time, recriminations have abated, and the artistic scene has settled down into a coexistence of conservative and liberal trends. No affection is lost between the two camps, but each has come to accept the other as an "inevitable nuisance," especially since the Party is willing to tolerate both, despite occasional grumbling about the need for greater party-mindedness.[70] This situation permits a measure of variety in expression. Both camps have highly placed representatives in art schools, universities and research institutes. But the custodians of tradition certainly predominate in the high-level positions in government and the Party. However, the censorship and controls they want or have been able to exercise are selective. Many of the old, politically slanted interpretations, the uncritical reverence for *Peredvizhnichestvo,* permeate officials' speeches, school textbooks, catalogues of large exhibits, the popular press and mass publications. Despite the passage of time and the changing tastes in a large segment of Soviet society, these statements differ little in their ardent purposefulness and ideological certitude from Stalinist pronouncements made forty years ago.[71]

But the more specialized monographs for the experts that offer objective or new interpretations (and usually appear in small or expensive editions) are also published.[72] Currently, many scholars at research institutes as well as university professors place *Peredvizhnichestvo* in historical perspective. It is no longer treated, in Stasov's manner, as the most important and talent-rich

trend in Russian art that replaced arid academism and was in turn succeeded by decline and decadence until AKhRR revived its tenets. Trends that appeared after 1890 are being investigated and a few publications with ample illustrations show hitherto little seen or unseen art. Historical monographs describing the socio-economic processes that underlay the changes in taste after 1890, as well as the relationship of Russian art to developments in contemporary Europe, are also published and point up the historical relativity of styles. And there are studies of painters and patrons who were in no way connected with *Tovarishchestvo*, though their life-span coincided with the years of its ascendency. As for the pre-1860 period, painters like Fedotov are no longer treated as mere precursors of the Peredvizhniki but are analyzed within the context of their own day and for their own individual manner. Gradually, the history of Russian art is being restored to its full richness and variety, and other, alternate traditions are being rediscovered and rehabilitated.[73]

The story of *Peredvizhnichestvo* itself—its goals, principles, attainments —has been written about with more attention to historical veracity and greater emphasis on the painterly aspects of the movement. No longer is the Peredvizhnik *oeuvre* equated exclusively with narrative genre or evocative landscape. Thus, painters like Makovsky or Yaroshenko have been demoted to the second rank, as they deserve, and there is serious discussion of the techniques of the genuine masters like Surikov or Repin. The venerable historian, Mikhail Alpatov, published in 1967 a collection of essays in which the major Peredvizhnik canvases were discussed primarily in terms of color, light and composition. Grabar's detailed biography of Serov, which treated him as a painter and made no pious references to his service to the nation and to the "people," could finally be published in 1965. Attention to the esthetic side of *Peredvizhnichestvo* has elicited a rising interest in the comparative treatment of Russian and Western realism. Freed of the former prejudices and phobias, scholars analyse this subject as a general historical phenomenon with certain underlying characteristics that transcend national peculiarities.[74]

Along with the discovery of the artistic side of *Peredvizhnichestvo*, there has been a markedly diminished emphasis on the alleged radicalism of the movement. The earliest attempt at an impartial look at the Peredvizhniki's commitment to society was Dmitri Sarabianov's book on the political ideology of Russian realist painting of the second half of the nineteenth century, published in 1955. It carefully examined the extent to which the theories of Chernyshevsky and Dobroliubov actually guided the work of the painters and brought out the degree to which ethical concerns, the desire to contribute to a moral regeneration of society, motivated the Peredvizhniki. The broader interpretation of the nature of the painters' commitment that has since become accepted has made possible a revival of interest in such painters as Nikolai Ge in whose work the figure of Christ occupies a central place. The first exhibit of his paintings since 1917 was held in 1969. Similarly,

the publication of sources has been affected. A recent collection of Repin's letters fully reflects the scope of his personality, work, interests and friends. Furthermore, its short, factual notes are a notable departure from the copious and tendentious editorializing of the earlier editions. Another indication that civic-mindedness or opposition to autocracy is no longer regarded as encompassing all the Association's aims, is the frank discussion of the practical economic reasons that underlay its founding. One history of the movement has frankly stated that the traveling exhibits were intended to create a larger market and not just to "bring art to the people."[75]

As part of the de-politicization of Peredvizhnik art there is a noticeable deflation of Stasov's reputation. Several scholars have referred critically to Stasov's publicistic intransigence and provincialism, his lack of esthetic discrimination, his exclusive preoccupation with content, and his inability to move with the times and be open-minded about new currents. Although there has as yet been no public unmasking of this particular "personality cult" created during the Stalin era, suggestions that there be a thorough review of *Stasovshchina* have been made at professional gatherings, and reputable scholars no longer treat the "furious Vladimir" as the stellar Russian critic whose opinions retain an undiminished relevance for our day.[76]

Other signs of the de-politicization of art, however tenuous and fitful it may be, are the voices which point out that Lunacharsky never advocated a literal return to the Peredvizhniki and that the Party did not follow a prescriptive policy during the 1920s. On the crest of the drive for liberalization that preceded the Soviet invasion of Czechoslovakia, *New World* reprinted a number of Lunacharsky's pronouncements in which he explained why the regime did not intend to endorse any one particular artistic trend, as well as why the "old realists" were inadequate prototypes for the artistic needs of the proletarian epoch. Since then, despite the dampeners put on the intelligentsia's demands for change, several wistful articles about Lunacharsky's wise tolerance, his skepticism about the uncritical take-over of "legacies," and the absence of a binding cultural line during the 1920s have appeared.[77]

Of course, to repeat, the revisionist tone characterizes for the most part a relatively small, specialized segment of recent Soviet publications. Alongside these works that strive to restore standards of veracity and perspective to history and esthetic principles to criticism, there are scores of others that continue to describe the Peredvizhniki in terms of an unflinching devotion to the people and their revolutionary cause; of treating Stasov as the greatest art critic who miraculously managed to follow the injunctions of Belinsky, Chernyshevsky, Dobroliubov and Pisarev, no matter how disparate their political and esthetic views were; and of insisting that the Party, following Lenin's injunctions, favored from the beginning of the Soviet regime a realism modeled on that of the Peredvizhniki.[78]

The way the centenary of the first *Tovarishchestvo* exhibit was cele-

brated in 1971 reflects the two levels on which the Peredvizhnik tradition is observed today. The anniversary was marked by no less than five exhibits: a reconstruction of the original show in 1871; a retrospective of the Peredvizhnik *oeuvre* at the Tretiakov Gallery; and three separate traveling shows of Peredvizhnik social genre, landscape and portraiture. Handsomely produced catalogues with beautiful reproductions and extensive texts were available for each exhibit; high Party officials participated at the gala openings and gave laudatory speeches. Their remarks reiterated the old views about the appearance of the Association as being the key moment in the history of Russian art, about Peredvizhnik realism continuing to provide the living exemplar for Soviet painters with its concern for content, progress and the people.[79]

Yet, the anniversary was not marked by large, well-publicized conferences or publications of voluminous symposia, extolling in unison the civic and artistic virtues of the Russian realists. In other words, the entire artistic community was not mobilized to mark the occasion and to popularize a certain image, as used to be the case after 1935 and especially during the 1947-53 period. Moreover, the two leading art magazines, *Art* and *Creation (Tvorchestvo)*, gave limited space to the Association's anniversary. And, among the few articles that did appear, several expounded revisionist interpretations. They portrayed the Peredvizhniki as painters who strove for high professional standards; whose essence lay not in petty narrative genre but in large philosophical generalizations, not so much in civic-mindedness as in personal moral commitment; who, despite their penchant for group exclusiveness, did not scorn contemporary trends; whose interests transcended content and included form; and whose realism was influenced by Western romanticism more than by contemporary European realist painting.[80]

The contrast between the ways the official and the scholarly worlds celebrated the centenary of the movement shows that *Peredvizhnichestvo* has not yet ceased being a controversial issue in the politics of Soviet art. The political and cultural authorities continue to find it useful and necessary to preserve a public image of the Peredvizhniki as the ever-applicable models for a politically and socially committed national art. Among the creative intelligentsia, however, there is an ongoing effort to place the Peredvizhniki in a truer perspective in the history of Russian art in order to end the tyrannical misuse of tradition.

* * *

One point should be alluded to in closing. My account of the rise and decline of *Peredvizhnichestvo* is an essay in the social and cultural aspects of the movement, and in the political use that has been made of it. As stated in the Introduction, esthetic evaluation has not been central to my concerns, though it has impinged upon them. Further, a study of several score artists,

which covers more than a century, cannot linger over interesting features and details of individual canvases.

But the fact remains that in the prodigious output of the Peredvizhniki there are many fine works of art. As one gets to know their paintings—in the range of subjects, variety of treatment and idiosyncratic styles of the artists—one often comes upon the pleasing, the apt, the skillfully rendered, the satisfying picture. For me, this has been one of the rewarding parts of my venture into nineteenth-century Russian cultural history and its continuities in our day. Undeniably, their *oeuvre* has left a strong imprint on Russian pictorial expression. Regardless of the reputations (exaggerated or deflated) of the various realists, their art has a demonstrated life of its own, which should not be slighted.

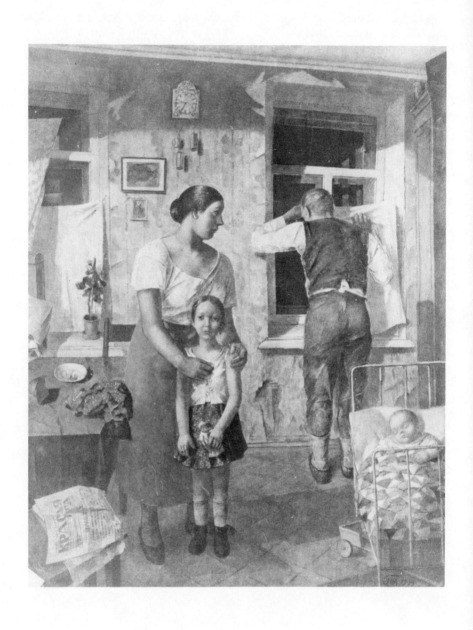

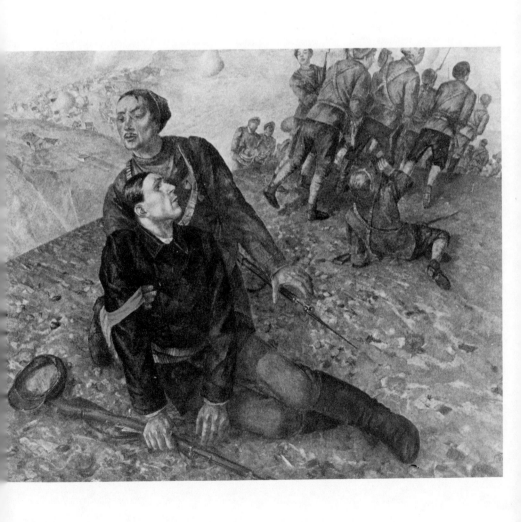

Chapter 1

1. Text in S. N. Kondakov, *Yubileinyi spravochnik Imperatorskoi Akademii Khudozhestv* (St. Petersburg, 1904), v. 1, pp. 152-60. Hereafter cited as *Yubileinyi spravochnik.*

2. See Sidney Monas, *The Third Section: Police and Society under Nicholas I* (Cambridge, Mass., 1961).

3. See the report by Count F. P. Tolstoy, the Academy's Vice President, who guided Nicholas in Rome, "Imperator Nikolai Pavlovich i russkie khudozhniki v 1839 g.," *Russkaya starina,* v. 21 (1878), pp. 347-56. Alexander Ivanov, a pensioner during 1830-36, wrote as follows about their position: "We were lowly laborers *(prostye rabotniki)* who, should they fulfill the Court orders properly..., could look forward to money and appointments." Cited in D. V. Sarabianov, *Narodno-osvoboditel'nye idei russkoi zhivopisi vtoroi poloviny XIX veka* (Moscow, 1955), p. 16. Hereafter cited as *Osvoboditel'nye idei.*

4. Text of the 1830 and 1840 amendments in S. N. Kondakov, *Yubileinyi spravochnik,* v. 1, pp. 171-79, 184-86. For a discussion of the legal and social aspects of the system of ranks which, ever since it was introduced by Peter the Great, not only enabled officials to climb up the civil service hierarchy but also offered persons of non-noble birth the prospects of attaining gentry status, see pp. 11ff., above.

5. Civil service ranks that were to accompany these titles were not specified in the amendment. But Professors Third and Second Grade, when they taught at the Academy, held the 8th and the 7th ranks. S. N. Kondakov, *Yubileinyi spravochnik,* v. 1, p. 180.

6. The most informative are: N. Ge, "Zhizn' khudozhnika shestidesiatykh godov," *Severnyi vestnik,* v. 8, no. 3, pt. 1 (March 1893), pp. 266-87 [hereafter cited as "Zhizn' khudozhnika"] ; M. O. Mikeshin, "Malen'kaya serebrianaya," *Pchela,* nos. 17-20 (1876); L. M. Zhemchuzhnikov, *Moi vospominaniya* (Moscow, 1926); N. D. Akhsharumov, "Zadachi zhivopisi v period obrazovaniya russkoi narodnoi shkoly," *Vestnik iziashchnykh iskusstv,* v. 2, pt. 2 (1884), pp. 143-68 [hereafter cited as "Zadachi zhivopisi"] .

7. V. Stasov, "N. N. Ge," *Severnyi vestnik,* v. 10, no. 2, pt. 1 (February 1895), pp. 212-13.

8. N. V. Yaroslavskaya, "Akademiya khudozhestv i khudozhestvennoe obrazovanie v Rossii v XIX v.," Akademiya khudozhestv SSSR, *Sessii. Diesiataya* (Moscow, 1959), pp. 148-50.

9. N. Dmitrieva's *Moskovskoe uchilishche zhivopisi, vayaniya i zodchestva* (Moscow, 1951) offers the best historical account.

10. Thus Vasili Perov, while studying at the Moscow School, regularly submitted his pictures to the Academy from 1856 on. He received the First Silver Medal in 1857, after which the Academy gave him a studio and upkeep so that he could work for the Second Gold Medal, which he won in 1860. N. P. Sobko, *Slovar' russkikh khudozhnikov* (Moscow, 1893-99), v. 3, pt. 1, pp. 95-97. Hereafter cited as *Slovar'.*

11. "Imperatorskoe obshchestvo pooshchreniya khudozhestv," S. N. Kondakov, *Yubileinyi spravochnik,* v. 1, pp. 263-64.

12. Minutes for the years 1843-64 are reprinted in P. N. Petrov. ed., *Sbornik materialov dlia istorii Imperatorskoi Akademii khudozhestv za sto let eya suschestvovaniya* (St. Petersburg, 1864-1866), v. 3.

13. Alexei Venetsianov (1780-1847) was a rare example of a painter who pursued

an independent and non-conformist career. After graduating from the Academy, he bought a small property, started teaching on his own, and his pupils became known as the Venetsianov school for their depiction of rural life and country mansions. Although Pavel Fedotov (1815-52), the other outstanding talent of Nicholas' reign, painted social genre that went against the prevalent style and subject matter, he was totally dependent for his livelihood, titles, pension, and even hospital bills, either on the Imperial family or on the Academy.

14. Text of the 1859 Statutes, S. N. Kondakov, *Yubileinyi spravochnik*, v. 1, pp. 188-97. Lvov's memoirs, "Akademiya khudozhestv v gody eya vozrozhdeniya," *Russkaya starina*, v. 29 (1880), pp. 385-416. Hereafter cited as "Akademiya khudozhestv."

15. K. Gerts, "Novyi ustav Akademii khudozhestv," *Russkii vestnik,* v. 28, pt. 2 (1860), pp. 149-57. See also the "congratulatory" comment in *Sovremennik*, v. 78 pt. 3 (November-December 1859), p. 390.

16. V. Stasov, "Khudozhestvennaya statistika" (1887), *Izbrannye sochineniya*, ed. P. T. Shchipunov (Moscow, 1952), v. 1, p. 229. Painters were considered artisans. Gentry, to be sure, learned to draw and paint as a social grace and polite accomplishment but scorned anything that smacked of the manual or professional.

17. N. M. Korkunov, *Russkoe gosudarstvennoe pravo* (St. Petersburg, 1909), v. 1, pp. 275-79, 302, 306; M. Polievktov, *Nikolai I* (Moscow, 1918), pp. 291-98.

18. V. M. Maksimov, "Avtobiograficheskie zapiski," *Golos minuvshego*, v. 1, no. 6 (June 1913), pp. 161-75. Hereafter cited as "Zapiski."

19. Quoted by Kramskoy in a lengthy account of Vasilev's life and troubles, written for N. A. Alexandrov in August 1877, *Ivan Nikolaevich Kramskoy. Pis'ma. Stat'i*, ed. S. N. Goldshtein (Moscow, 1965), v. 1, p. 419. Hereafter cited as *Kramskoy. Pis'ma.*

20. Letter of September 29, 1873, *ibid.,* p. 202.

21. Quoted in I. E. Grabar, *Repin* (Moscow, 1963), v. 1, p. 64.

22. F. F. Lvov, "Akademiya khudozhestv," pp. 392-95.

23. I. Repin, *Dalekoe blizkoe* (Moscow, 1937), p. 156.

24. Letter to A. K. Sheller-Mikhailov, written sometime in 1880, *Kramskoy. Pis'ma*, v. 2, p. 46.

25. Letter of August 9, 1881, to V. Stasov, *Pis'ma I. E. Repina. I. E. Repin i V. V. Stasov. Perepiska*, ed. A. K. Lebedev (Moscow-Leningrad, 1948-50), v. 2, p. 68. Hereafter cited as *Repin-Stasov. Perepiska.*

26. "Zapiska po povodu peresmotra ustava Akademii khudozhestv" (1867), *Kramskoy. Pis'ma*, v. 2, pp. 297-98.

27. Karl Gerts (1820-83), who taught at the University of Moscow and was one of the first Russian art historians to study abroad, drew attention to this fact, "Novyi ustav Akademii khudozhestv."

28. "Zametki po povodu predydushchei stat'i" (1858), *Polnoe sobranie sochinenii* (Moscow, 1950), v. 5, pp. 335-40.

29. N. V. Shelgunov et al., *Vospominaniya* (Moscow, 1967), v. 1, p. 194.

30. While there is considerable controversy among Russian and Western historians as to who and what the Russian intelligentsia was—whether it should be defined by political attitudes, by social origin, or by emotional make-up—there was no confusion on the subject in the 1860s. Education was the prerequisite for membership. For this reason, a recent Soviet book on the origins of the intelligentsia excludes artists from the discussion. V. R. Leikina-Svirskaya, *Intelligentsiya v Rossii vo vtoroi polovine XIX v.* (Moscow, 1971).

31. Letter of December 1, 1876, to V. Stasov, *Kramskoy. Pis'ma*, v. 1, p. 387.

32. See N. V. Shelgunov et al., *Vospominaniya*, v. 1; F. Venturi, *Roots of Revolution* (New York, 1966); A. Kornilov, *Obshchestvennoe dvizhenie pri Aleksandre II*

(Paris, 1905).

33. Some explanation should be given about the use of the word "genre" in this chapter. It is used more or less interchangeably with "realism," for this is generally the way artists and critics used the term during the 1860s. Although the realistic representation of the everyday world also included portraiture and landscape painting, it was mainly the anecdotal vignettes of domestic and social life that were under public discussion and popular among those painters who repudiated the academic tradition.

34. "Sud'by russkogo iskusstva" (1877), *Kramskoy. Pis'ma*, v. 2, p. 318.

35. A. Avdaev, "Vystavka Imperatorskoi Akademii khudozhestv v S. Peterburge," *Russkii vestnik*, v. 8, pt. 2 (1857), pp. 143-62.

36. V. Stasov, "O gollandskoi zhivopisi" (1856), *Izbrannye sochineniya*, v. 1, pp. 31-36. For debate on the respective merits of the realist and academic styles, see the V. Stasov-N. A. Ramazanov controversy on the pages of *Sovremennaya letopis'*, nos. 42, 44, 46, 49 (November-December 1862), occasioned by Stasov's review of the 1862 Academic exhibit. These and some other arguments are summarized in S. N. Goldshtein, *Kommentarii k izbrannym sochineniyam V. V. Stasova* (Moscow-Leningrad, 1938), pp. 35-38. Hereafter cited as *Kommentarii*.

37. "Peterburgskaya zhizn'," *Sovremennik*, v. 69, pt. 2 (May-June 1858), pp. 82-91.

38. "A. A. Ivanov," *Kolokol*, no. 22 (September 1, 1858), pp. 177-78.

39. "Pamiati khudozhnika," *Poliarnaya zvezda*, v. 5 (1859), pp. 238-52. It should be noted that what Ogarev advocated from London and what radicals came to voice in Russia was never shared by Chernyshevsky. His materialist esthetics did not have the political thrust that the didactic and utilitarian views of Dobroliubov and Pisarev had. W. F. Woehrlin's *Chernyshevskii. The Man and the Journalist* (Cambridge, Mass., 1971) provides the best discussion on this much misunderstood subject, pp. 155-59, 176-85.

40. The influence of London can be detected in the first very critical review of the Academic exhibit that appeared in *Sovremennik*. It was written by the revolutionary poet, M. I. Mikhailov (1829-65), who had visited Herzen earlier in the year during his first trip abroad. "Khudozhestvennaya vystavka v Peterburge," *Sovremennik*, v. 76, pt. 2 (July-August 1859), pp. 105-15.

41. The word "truth" *(pravda)* in Russian has a double connotation. Along with its usual meaning of verity, it also means justice. For example, Pavel Pestel, one of the leaders of the Decembrist uprising, entitled his programmatic book *Russkaya pravda (Russian Justice)*.

42. "Rassharkivayushcheesia iskusstvo," *Iskra*, no. 38 (October 4, 1863), pp. 521-30. On Dmitriev see E. Kovtun, "Zabytyi kritik-shestidesiatnik," *Iskusstvo*, no. 6 (1955), pp. 66-69.

43. Dmitriev's argument seems to have been derived directly from Dobroliubov's essay, "Russian Satire in the Age of Catherine" (*Russkaya satira v vek Ekateriny*, 1859), which stated: "Our. . . satirists have attacked rudeness, hypocrisy, illegality. . . . But it is only rarely that such denunciations have ever hinted that these individual phenomena are the inevitable results of the abnormality of our entire social structure. For the most part, they have attacked the corruption of officials as if all the harm in taking bribes was derived from their personal habits of cheating the public. Our satires have never gone beyond the problem of bribery to examine the pervasive evil of our entire bureaucracy and of those circumstances which have given birth to bureaucracy and which have encouraged it to develop." *Sobranie sochinenii* (Moscow-Leningrad, 1962), v. 5, p. 315.

44. "Zapiski," p. 165. Repin's and Antokolsky's memoirs also refer to how university students tried to politicize the artists. I. Repin, *Dalekoe blizkoe*, p. 216; M. Antokolsky, "Iz avtobiografii," *Vestnik Evropy*, v. 22, no. 9 (September 1887), pp. 86-88.

45. This is confirmed by the diary of one university student, Adrian Prakhov, who undertook to "educate" Repin and quickly discovered that he had to start his friend from the provinces on Lermontov and Gogol, not on the radical writers. Excerpts from his diary are reprinted in *Khudozhestvennoe nasledstvo. Repin* (Moscow-Leningrad, 1948), v. 2, p. 9. Full text, RM, OR, Fond 139, ed. khr. 1.

46. Quoted from the unpublished portions of Maksimov's memoirs in A. I. Leonov's biography, *V. M. Maksimov* (Moscow, 1951), p. 46.

47. I. N. Punina, *Peterburgskaya artel' khudozhnikov* (unpublished dissertation for the degree of *Kandidat*, Department of Art History, Leningrad University, 1971), pp. 51-52.

48. The list of the arrested, together with their institutional affiliation, was printed in *Kolokol*, no. 114 (December 1, 1861), pp. 955-56.

49. "Kartina Ge" (1863), *Sobranie sochinenii* (Moscow, 1968), v. 6, pp. 148-77.

50. I. Repin, *Dalekoe blizkoe*, pp. 228-29.

Chapter 2

1. N. V. Shelgunov et al., *Vospominaniya*, v. 1, pp. 131-33.

2. Letter of July 21, 1886, to V. Stasov, *Kramskoy. Pis'ma*, v. 2, p. 252.

3. The event has been described by Kramskoy on several occasions: in a letter of November 13, 1863, to his friend M. Tulinov (*ibid.*, v. 1, pp. 9-11); in an unpublished newspaper article, "Sobyt'e v Akademii khudozhestv," written later in the month (*ibid.*, v. 2, pp. 237-75); and in a published article, "Sud'by russkogo iskusstva," 1877 (*ibid.*, pp. 316-24.)

4. The political atmosphere changed following the mysterious incendiarism in St. Petersburg in late 1862, the outbreak of the Polish uprising in January 1863, and the eruption of peasant disturbances when the terms of the Emancipation began to be implemented after a two-year waiting period.

5. Text of the Artel's Statutes in S. N. Goldshtein, *I.N. Kramskoy. Zhizn' i tvorchestvo* (Moscow, 1965), pp. 46-47. Hereafter cited as *I. N. Kramskoy.*

6. Letter of October 5, 1865, *Kramskoy. Pis'ma*, v. 1, p. 27.

7. Among the books and authors read he mentions: Chernyshevsky, *The Esthetic Relations of Art to Reality*; Pisarev, *The Destruction of Esthetics* and *Pushkin and Belinsky*; Proudhon, *Concerning the Principles of Art and its Social Destiny*; Taine's lectures on art; Owen, *Essays on the Formation of Human Character*; and the materialist works of Buckle, Moleschott, and Büchner. [I. Repin, *Dalekoe blizkoe*, pp. 229, 231.] I have been unable to ascertain from other sources that these were actually the books read. They were popular among the leftist intelligentsia, and the foreign works were available in Russian translation. [F. Venturi, *Roots of Revolution*, p. 325.] But Kramskoy's correspondence mentions only the translation of Proudhon. Nor does he ever mention either Chernyshevsky or Pisarev, though there is little doubt that the group must have read and discussed them, for by the mid-1860s the political horizon of the young artists had broadened.

8. For *oblichitel'naya literatura* from a socio-political viewpoint, consult D. N. Ovsianiko-Kulikovsky, *Istoriya russkoi literatury XIX veka* (Moscow, 1909), v. 3, p. 45 ff. For a more general treatment of the affinities between Russian painting and literature, see M. Gorkin, "The Interrelation of Painting and Literature in Russia," *Slavonic and East European Review*, v. 25 (1946-47), pp. 134-49.

9. See his "Provincial Sketches" (1857), *Selected Philosophical Essays* (Moscow, 1959), pp. 28-59.

10. On the activities of the Artel, see I. N. Punina, *Peterburgskaya artel' khudozhnikov* (Leningrad, 1966), pp. 49-65, and S. N. Goldshtein, *I. N. Kramskoy*, pp. 40-71. On the Nizhni Novgorod fair, see I. Ginzburg, "Iz predistorii peredvizhnichestva," *Iskusstvo*, no. 2 (1938), pp. 103-08.

11. See note 3, above.

12. "Zapiska po povodu peresmotra ustava Akademii khudozhestv" (1866), "S. Peterburgskaya Akademiya khudozhestv v 1867 g." (1867), "K shkole risovaniya" (1866), *Kramskoy. Pis'ma*, v. 2, pp. 275-98.

13. M. Antokolsky, "Iz avtobiografii," p. 100.

14. I. I. Shishkin, "V redaktsiyu" (dated sometime in the 1860s), TsGALI, Fond 917, op. 1, ed. khr. 2, pp. 1-4.

15. Letter of September 27, 1882, to V. Stasov, *Kramskoy. Pis'ma*, v. 2, pp. 76-77.

16. Quoted in *ibid.*, v. 1, p. 561.

17. Quoted in A. P. Botkina, *P. M. Tret'iakov v zhizni i iskusstve* (Moscow, 1960), p. 152. Hereafter cited as *P. M. Tret'iakov.*

18. N. Ge, "Vstrechi," *Severnyi vestnik*, v. 9, no. 3, pt. 1 (March 1894), p. 233.

19. I. N. Shuvalova, *Miasoedov* (Leningrad, 1971), p. 12.

20. See his report of May 2, 1864, to the Academy on the organization of the 1863 Exposition générale des beaux-arts in Brussels in *G. G. Miasoedov. Pis'ma, dokumenty, vospominaniya*, ed. V. S. Ogolovets (Moscow, 1972), pp. 38-39. Hereafter cited as *Miasoedov. Pis'ma.*

21. Text of letters from Moscow and of the Statutes, *ibid.*, pp. 50-57. The January 1870 answer is quoted in N. P. Sobko, "V. G. Perov, ego zhizn' i proizvedeniya," *Vestnik iziashchnykh iskusstv*, v. 1, pt. 1 (1883), pp. 167-68.

22. No manifesto announced the exhibit; but the Association placed advertisements about the forthcoming event in newspapers. Why the *Tovarishchestvo* chose to exhibit in the Academy cannot be determined, but apparently the members saw no incongruity in this.

23. "Na svoikh nogakh," *Delo*, no. 12 (December 1871), pp. 106-08. The *Otechestvennye zapiski* comment is quoted in A. Lebedev, G. Burova, *Tvorcheskoe sodruzhestvo. M. M. Antokol'sky i V. V. Stasov* (Leningrad, 1968), p. 36. Hereafter cited as *Antokol'sky i Stasov.*

24. G. G. Urusov, *Polnyi obzor tret'ei khudozhestvennoi vystavki Tovarishchestva peredvizhnykh vystavok v Rossii* (Moscow, 1875), p. 6.

25. Of the Academy's graduates of note during this period, only Genrikh Semiradsky (1843-1902) remained faithful to its tradition, attaining wide popularity with his melodramatic canvases on classical themes.

26. Academy of Arts, Minutes of the 1874 Council Meetings, TsGIA, Fond 789, op. 8, ed. khr. 231 (1872-), p. 40. Letter of July 2, 1880, from the *Tovarishchestvo* administration to A. Kiselev, BL, RO, Fond 127, VI, 6.6, pp. 5-6.

27. Text of Iseev's memorandum, TsGIA, Fond 789, op. 8, ed. khr. 231 (1872-), pp. 12-13.

28. The Grand Duke's wishes, conveyed in a letter dated December 31, 1873, as well as the Association's reply are in Minutes of the *Tovarishchestvo* meeting of January 3, 1874, GTG, OR, Fond 69, ed. khr. 10, pp. 9-14.

29. Iseev's minutes of the January 14, 1874, meeting, TsGIA, Fond 789, op. 8, ed. khr. 231 (1872-), pp. 14-15.

30. Minutes of the *Tovarishchestvo* meeting of November 5, 1880, GTG, OR, Fond 69, ed. khr. 10, pp. 41-42.

31. Letter of April 3, 1875, to V. D. Orlovsky outlined this stratagem, as a result

of which Iseev hoped to be able to "dictate our own terms." Cited in F. Roginskaya's unpublished manuscript on the history of the Association, and made available to me by Dr. A. Lebedev and N. Yezerskaya, Academy of Arts.

32. Ministerstvo Imperatorskogo Dvora, Kantselariya, TsGIA, Fond 468, op. 1, ed. khr. 3512 (1871); 3585 (1871-1872); 4282 (1876).

33. During the first 25 years of its existence the Association sold, on the average, about 61,000 rubles' worth of paintings annually. (*Miasoedov. Pis'ma*, p. 188). Membership during that period rose from 15 to 42. In addition, a certain number of non-member exhibitors would be admitted to each exhibit; with time their number grew from 5 to about 20.

34. Information on Tretiakov, A. Fedorov-Davydov, *Russkoe iskusstvo promyshlennogo kapitalizma* (Moscow, 1929), pp. 182, 194. Data on the Imperial family's purchases, Ministerstvo Imperatorskogo Dvora, Kantselariya, TsGIA, Fond 468, op. 1, ed. khr. 3512 (1871); 4389 (1878); 4437 (1879).

35. Minutes of the *Tovarishchestvo* meetings of January 7, 1873; February 5, 1877; March 21, 1879; GTG, OR, Fond 69, ed. khr. 10, pp. 7, 22, 37.

36. Letter of January 3, 1878, from Count Adlerberg to the Ministry of the Interior, quoted in *Kramskoy. Pis'ma*, v. 2, p. 481; letter of January 1, 1878, from P. Iseev to Grand Duke Vladimir Alexandrovich, TsGIA, Fond 528, op. 1, ed. khr. 50 (1878), pp. 1-5.

37. Academy of Arts, Minutes of the May 1, 1878, Council meeting at which the *Pchela* articles were discussed, TsGIA, Fond 789 (1875-), op. 9, delo 78, pp. 23-25.

38. "Pervaya russkaya peredvizhnaya vystavka" (1871), *Sobranie sochinenii* (Moscow, 1970), pp. 225-33. What was expressed as hopes by civic-minded critics in the nineteenth century was termed actuality by Stalinist historiography; it treated the *Tovarishchestvo* as a proto-political organization with a well-defined program.

39. Profan, "Vystavka v Akademii khudozhestv," *Pchela*, nos. 9-13 (February 28-March 26, 1878).

40. *25 let russkogo iskusstva. Illiustrirovannyi katalog khudozhestvennogo otdela vserossiiskoi vystavki v Moskve 1882 g.* (St. Petersburg, 1882). The catalog was published by Mikhail Botkin (1839-1914), scion of a Moscow tea merchant family. The introduction was written by Nikolai Sobko (1852-1902), a pedantic bibliographer and art historian, who early in his career undertook the study and promotion of *Peredvizhnichestvo*.

41. "Nabroski i nedomolvki," *Molva*, no. 61 (March 4, 1879).

42. "XXV peredvizhnaya i akademicheskaya vystavki," *Russkie vedomosti*, no. 67 (March 9, 1897).

43. Among painters associated with the *Tovarishchestvo* only Apollinari Vasnetsov (1856-1938) went to teach in a country school, much to the dismay of Viktor, his brother and the better known painter. As for the exhibits, the entrance fee of 30 kopeks (the price of a meal in a decent restaurant) and their location in the central, elegant part of town in effect excluded the lower classes from the Peredvizhnik shows.

44. V. G. Korolenko, *The Story of My Contemporary* (London, 1972), pp. 103-04.

45. Ya. D. Minchenkov, *Vospominaniya o peredvizhnikakh* (Leningrad, 1963), p. 118.

46. *Odesskii vestnik*, February 1, 1875. Quoted in Z. Zonova, "Istoriya sozdaniya kartiny K. A. Savitskogo, 'Remontnye raboty'," GTG, *Materialy* (Moscow, 1958), v. 2, p. 123.

47. *Zaria* (Kiev), January 5, 1883. Quoted in V. Vasilev, "Russkaya provintsial'naya pechat' o peredvizhnikakh," *Iskusstvo*, no. 12 (1971), p. 60.

48. G. Miasoedov's report on the 25th jubilee of the Association, *Miasoedov. Pis'-ma,* p. 184.

49. "Tormozy novogo russkogo iskusstva" (1885), *Sobranie sochinenii* (St. Petersburg, 1894), v. 1, pt. 2, p. 769.

50. See Yaroshenko's letter of April 2, 1886, to the *Tovarishchestvo* membership, BL, OR, Fond 127 (M. 5049), III.2, pp. 2-3.

51. Minutes of the *Tovarishchestvo* meeting of January 5, 1874, GTG, OR, Fond 69, ed. khr, 10, pp. 11-14.

52. N. Murashko, *Vospominaniya starogo uchitelia* (Kiev, 1907), p. 39.

Chapter 3

1. "Novyi ustav Akademii khudozhestv," p. 155.

2. "Neskol'ko zamechanii po povodu poslednei vystavki v Akademii khudozhestv," *Osnova,* February 1861, pp. 148-49.

3. Letter of December 2, 1869, *Kramskoy. Pis'ma,* v. 1, p. 84.

4. When *Peredvizhnichestvo* as a trend was written about in the 1890s, the nationalist historians would deny any foreign influence on a school they extolled for its autochthonous virtues, while the *World of Art* camp with its upper-class disdain for the "primitive provincialism" of the *Tovarishchestvo* attributed this feature to isolation from the West. Only in the late 1920s was this question seriously addressed when the new Marxist school of art history matured. Unfortunately, this interesting and fruitful research was snuffed out in the 1930s, when the new wave of cultural chauvinism made objective studies impossible.

5. V. Stasov, "Pavel Tret'iakov i ego katinnaya gallereya," *Russkaya starina,* v. 80 (1893), p. 570. [Hereafter cited as "Pavel Tret'iakov."] G. Yu. Sternin, *Khudozhestvennaya zhizn' Rossii na rubezhe XIX-XX vekov* (Moscow, 1970), p. 91. [Hereafter cited as *Khudozhestvennaya zhizn'.*]

6. A. Fedorov-Davydov, *F. Vasil'ev* (Moscow, 1937), pp. 26-27. Of course, as far as the realist tradition is concerned, both capitals were well stocked with splendid examples of Dutch and Flemish painters who had been popular with Russian collectors since Peter the Great's reign. See the three volume *Kartinnye gallerei Evropy,* ed. A. Andreev (St. Petersburg, 1862) for a detailed survey of public and private collections in St. Petersburg and Moscow.

7. "Zametki ob iskusstve," *Vestnik Evropy,* v. 32, no. 2 (February 1897), pp. 525-26.

8. After visiting Düsseldorf in 1871, Kramskoy noted in his diary: "I never came across anything . . . that was grandiose, terrible or moving," and summed up the school as being altogether too sentimental, quietistic and petty. At the Musée de Luxembourg, he admired Knaus. "Zapisnye knizhki Kramskogo," TsGALI, Fond 783, op. 1, ed. khr. 1, pp. 23, 32.

9. G. H. Hamilton, *The Art and Architecture of Russia* (Baltimore, 1954), pp. 244-45. A. Fedorov-Davydov's biography, *V. G. Perov* (Moscow, 1934), pp. 88-95, quotes from Perov's letters and reports to the Academy, written during his sojourn abroad.

10. Letter of July 9, 1866, to S. N. Kramskaya, *Kramskoy. Pis'ma,* v. 1, p. 50.

11. Quoted in N. P. Sobko, *Slovar',* v. 3, pt. 1, pp. 103-04. Significantly, what in 1863 was merely an expression of personal preference was quoted 30 years later by a nationalist historian of the Peredvizhniki as the *profession de foi* of the entire school. A. Novitsky, *Peredvizhniki i vliyanie ikh na russkoe iskusstvo* (Moscow, 1897), pp. 1-2. Hereafter cited as *Peredvizhniki.*

12. "Neskol'ko zamechanii po povodu poslednei vystavki v Akademii khudozhestv," p. 151.

13. Ivan Turgenev, *Smoke* (London, 1904), pp. 150, 289.

14. "Posle vsemirnoi vystavki" (1862), *Izbrannye sochineniya*, v. 1, pp. 65-112. The 77 oils and drawings in the Russian section included old masters, like D. Levitsky (1735-1822) and O. Kiprensky (1783-1836); Academic professors, F. Bruni (1800-75); recent graduates, K. Trutovsky (1826-93); and students, A. Morozov (1835-1904). There were 25 Russian genre scenes, ranging from "Return from the Bear Hunt" to "A Village Dance"; 5 foreign genres, such as Spanish gipsies or Italian girls; 9 religious paintings, 5 Russian landscapes; 12 foreign landscapes; 11 Russian portraits; 6 foreign portraits; 2 scenes from Russian history, and 2 from Western. International Exhibition, 1862, *Official Catalogue of the Fine Art Department* (London, 1862), pp. 227-30. Hereafter cited as *Official Catalogue*.

15. In Soviet criticism, works written before World War II tend to stress the political aspects of Stasov's writings, his efforts to liberate artists from the control of the Academy and to instill in them a sense of civic obligation. (See S. N. Goldshtein, *Kommentarii*.) Post-war comments tend to stress the *natsional'nyi* aspect of Stasov's thought, to treat him as a "patriot" who labored to create a distinctly Russian school of painting. (See A. Lebedev, G. Burova, *Antokol'sky i Stasov*.)

16. The former course was advocated in the 1860s by Fedor Buslaev (1818-97), a scholar of medieval Russian literature and architecture. [See his "Pamiatnik tysiacheletiyu Rossii" (1862), *Moi dosugi* (Moscow, 1886), v. 2, pp. 187-208, and "Zadachi sovremennoi esteticheskoi kritiki," *Russkii vestnik*, v. 77 (1868), pp. 273-336.] The latter attitude characterized the populists' outlook in the 1870s.

17. See N. G. Chernyshevsky, "Polemicheskie krasoty. Kollektsiya vtoraya" (1861), *Polnoe sobranie sochinenii*, v. 7, p. 744.

18. "Peredvizhnaya vystavka 1871 g.," *Izbrannye sochineniya*, v. 1, p. 216. Stasov helped Repin and all the other artists he took under his wing not only with favorable press reviews but also with getting commissions from his wealthy personal acquaintances and with reference material from the Imperial Public Library, where he headed the art department.

19. "Pis'mo k redaktoru" (1873), *Sobranie sochinenii*, v. 1, pt. 2, pp. 397-400.

20. "A propos of the Exhibition," *F. M. Dostoievsky, The Diary of a Writer*, ed. and trans. B. Brasol (New York, 1954), pp. 79-81. "Song of the shirt" refers to a poem by Thomas Hood (1799-1845), published in Russian translation in the 1860s.

21. Letter of April 13, 1874, quoted in I. E. Grabar, *Repin*, v. 1, p. 141.

22. Letter of October 16, 1874, *I. E. Repin. Izbrannye pis'ma*, ed. I. A. Brodsky (Moscow, 1969), v. 1, p. 143.

23. "Il'ya Efimovich Repin" (1875), *Izbrannye sochineniya*, v. 1, pp. 262-68.

24. Kramskoy's letter of April 5, 1875, to Repin, *Kramskoy. Pis'ma*, v. 1, pp. 294, 569; Repin's letter of April 1, 1875, to Stasov, *Repin-Stasov. Perepiska*, v. 1, pp. 110-11. Notes on pp. 230-31 quote the reaction of the public, ranging from Turgenev's to that of various journals.

25. "Priskorbnye estetiki" (1877), *Sobranie sochinenii*, v. 2, pt. 3, pp. 373-84.

26. Letter of March 9, 1872, quoted in A. Lebedev, G. Burova, *Antokol'sky i Stasov*, p. 62. Antokolsky's statue of Ivan the Terrible was shown at the first Peredvizhnik exhibit. Though he was close to the *Tovarishchestvo* all his life, he never became a member.

27. Letter of September 21, 1883, to M. Antokolsky, quoted in *Repin-Stasov. Perepiska*, v. 2, p. 293.

28. See Kramskoy's letters from France, July 9, 19, 21, Aug. 28, 1876, *Kramskoy.*

Pis'ma, v. 1, pp. 343-47, 350-54, 354-61, 365-68. His adverse comments on French art included charges that Western artists were motivated by sensation and publicity. It is interesting to note how ignorant most Russian painters still were about developments in Europe. In the third letter Kramskoy confessed: "I had no inkling that these Impressionists are such a burning question here."

29. Text in *Kramskoy. Pis'ma,* v. 2, pp. 304-43.

30. Letter of August 17, 1887, quoted in *Repin-Stasov. Perepiska,* v. 2, p. 337.

31. "I. N. Kramskoy," *Istoricheskii vestnik,* no. 5 (1887); "Kramskoy po ego pis'mam i stat'iam," *Vestnik Evropy,* nos. 11 and 12 (1887); "Kramskoy i russkie khudozhniki," *Severnyi vestnik,* no. 5 (1888). [The first two articles are reprinted in *Stat'i i zametki,* pp. 55-76, 76-153; the third in *Izbrannoe. Zhivopis', skul'ptura, grafika,* ed. P. T. Shchipunov (Moscow, 1950), v. 1, pp. 233-61.] *Ivan Nikolaevich Kramskoy. Ego zhizn', perepiska i khudozhestvenno-kriticheskie stat'i, 1837-1887* (St. Petersburg, 1888).

32. Quoted in V. Stasov, *Pis'ma k deyateliam russkoi kul'tury,* ed. N. D. Chernikova (Moscow, 1967), v. 2, pp. 142-43. *Vestnik Evropy,* be it noted, was the journal whose art criticism Kramskoy very much respected since it took both the esthetic and moral-civic aspects of painting into consideration. He contrasted it favorably with *Otechestvennye zapiski,* the militant populist organ, whose utilitarian esthetics Kramskoy described as "hostile" to art. Letter of March 3, 1881, to F. F. Petrushevsky, *Kramskoy. Pis'ma,* v. 2, pp. 62-62.

33. One example of Stasov's "selectivity" survives to this day. Among his papers in the Leningrad Public Library manuscript collection there lies a packet of Kramskoy's letters to A. Bogoliubov, with a note in Stasov's handwriting: "Not for publication." [Fond 82, ed. khr. 17.] They were not to see the light of day because they would have spoiled the image of Kramskoy's unflinching hostility to the official world. In these letters Kramskoy was toying with the idea of reconciliation with the Academy in hopes that the *Tovarishchestvo,* which had not managed to set up a training school of its own, would be able to convert that institution to the idea of public service.

34. These various opinions are quoted in S. N. Goldshtein, *I. N. Kramskoy,* pp. 312-16.

35. Reprinted in I. Repin, *Dalekoe blizkoe* as "Ivan Nikolaevich Kramskoy. Pamiati uchitelia," pp. 187-245.

36. N. Naidenov, *Vospominaniya o vidennom, slyshannom i ispytannom* (St. Petersburg, 1903), pp. 33-34.

37. P. A. Berlin, *Russkaya burzhuaziya v staroe i novoe vremia* (Moscow, 1922), p. 112.

38. B. Chicherin, *Vospominaniya* (Moscow, 1934), v. 3, pp. 73-77.

39. The middle-class patrons did not uniformly favor Russian art, despite the by now well-worn belief to that effect. The divergent interests of the Tretiakov brothers are the best example—Pavel collected Russian art, but Sergei preferred Western painters.

40. Even though the bourgeoisie, unlike the intelligentsia, was politically loyal to the autocracy, contemporary sources show that it resented the favors St. Petersburg extended to foreign capital and firms; that it campaigned for high tariffs, easy money, private banks; and that in general it believed the bureaucracy was not doing enough to protect and aid native businesses, to develop Russia's fledgling industries and railways with domestic capital. See the very informative memoirs of N. Naidenov (1834-?), founder of the Moscow bank, cited in note 36.

41. Text in A. P. Botkina, *P. M. Tret'iakov,* pp. 55-56. Furthermore, the will specified that the gallery not be run by the bureaucracy and that its governing board be composed of persons selected for their knowledge of art and not their birth or social

position.

42. Unless otherwise noted, all facts about Tretiakov are taken from his daughter's biography, A. Botkina, *P. M. Tret'iakov,* and from V. Stasov's "Pavel Tret'iakov."

43. F. I. Prianishnikov (1793-1867) was Director of Posts and an active member of the St. Petersburg Association for the Promotion of Art. His collection contained not only such well-known masters as V. L. Borovikovsky (1757-1825), D. G. Levitsky (1735-1822), and K. P. Briullov (1799-1852) but also some talented students of the Academy, such as A. A. Ricconi (1836-1902), to whom Tretiakov soon became a patron. See I. Anichkov, *Opisanie kartinnoi gallerei Tainogo Sovetnika Fedora Ivanovicha Prianishnikova* (St. Petersburg, 1853).

44. V. Yakobi's "The Lemon Seller" and "The Beggar's Easter Day," M. P. Klodt's "The Dying Musician," and K. Trutovsky's "A Village Dance." International Exhibition, 1862, *Official Catalogue,* pp. 228-230.

45. See Kramskoy's letter of April 15, 1878, to P. Tretiakov, *Kramskoy. Pis'ma,* v. 1, pp. 456-59.

46. S. N. Goldshtein, *I. N. Kramskoy,* p. 283; Tretiakov's letter of December 25, 1877, to I. Kramskoy, *Perepiska I. N. Kramskogo,* v. 1 (*I. N. Kramskoy i P. M. Tret'iakov*), ed. S. N. Goldshtein (Moscow, 1953), pp. 208-09.

47. Letter of October 5, 1874, *ibid.,* v. 1, p. 101.

48. On daily church attendance in the Tretiakov household, see the memoirs of the family servant, N. A. Mudrogel, "58 let v Tret'iakovskoi galleree," *Novyi mir,* no. 7 (1940), p. 138. The passage was omitted when the memoirs were published in book form in 1966. This editing is in keeping with the Stalinist historiography, which has made Tretiakov into a "democrat." See V. Kemenov's introduction to A. P. Botkina's biography.

49. See Tretiakov's letter of June 10, 1880, to Dostoevsky expressing deep appreciation for the writer's chauvinist speech at the Pushkin celebration in Moscow, BL, OR, Fond 93. II. 96. 65.

50. See Aksakov's grateful letters of acknowledgement written in 1878, GTG, OR, Fond I/406, op. 1.

51. Quoted in I. Grabar, *Repin,* v. 1, pp. 248-49.

52. Letter of December 26, 1877, *Kramskoy. Pis'ma,* v. 1, pp. 435-36.

53. "Belinsky i khudozhniki," *Sovetskoe iskusstvo,* June 11, 1936.

54. O. Liaskovskaya, "Proizvedenie I. E. Repina, 'Ne zhdali,' i problema kartiny v russkoi zhivopisi vtoroi poloviny XIX veka," GTG, *Materialy* (Moscow, 1958), v. 2, p. 108. Hereafter cited as "Proizvedenie Repina, 'Ne Zhdali'."

55. Quoted in A. P. Botkina, *P. M. Tret'iakov,* p. 9.

56. A. Fedorov-Davydov, *Russkoe iskusstvo promyshlennogo kapitalizma,* p. 197.

57. *Sochineniya* (Moscow, 1955-56), v. 3, p. 122.

58. V. G. Korolenko, *The Story of My Contemporary,* p. 178. For a fuller discussion of the shifting allegiances of the intelligentsia, see R. Wortman, *Crisis in Russian Populism* (Cambrdige, Mass., 1967), pp. 1-34.

59. Letter of September 10, 1875, to I. Repin, *Kramskoy. Pis'ma,* v. 1, p. 315.

60. "Kramskoy po pis'mam ego" (1887), *Stat'i i zametki, ne voshedshie v sobranie sochinenii,* ed. O. Gaponova, A. Shchekotova (Moscow, 1954), v. 2, p. 152. Hereafter cited as *Stat'i i zametki.*

61. "Vystavka v Akademii khudozhestv," *Pchela,* nos. 11 and 13 (March 12 and 26, 1878), pp. 173-74, 203.

62. Quoted in Effie Ambler, *Russian Journalism and Politics, 1861-1881. The Career of Aleksei Suvorin* (Detroit, 1972), pp. 132, 141.

63. A. I. Koshelev, *Zapiski, 1812-1883 gody* (Berlin, 1884), p. 228.

64. See his "Triapichkiny-ochevidtsy," *Otechestvennye zapiski,* no. 8 (1877),

pp. 533-70; and "Na dosuge," *ibid.*, no. 9 (1877), pp. 167-98. Saltykov-Shchedrin was editor of *Otechestvennye zapiski.*

65. "Chetyre dnia," "Denshchik i ofitser," *Polnoe sobranie sochinenii* (St. Petersburg, 1910), pp. 89-99, 199-211. Similar doubts assailed another populist writer, Gleb Uspensky. See G. A. Bialyi, *V. M. Garshin i literaturnaya bor'ba vosmidesiatykh godov* (Moscow, 1937), pp. 28 ff.

66. Letter of October 24, 1876, to A. Suvorin, *Kramskoy. Pis'ma,* v. 1, p. 380.

67. Letter of June 18, 1878, to V. Stasov, *Repin-Stasov. Perepiska,* v. 2, p. 31. For more detail on the response of Russian artists to the liberation of Balkan Slavs, see *Khudozhestvennoe nasledstvo. Repin,* v. 1, pp. 387-92.

68. A. Lebedev, "Iz sekretnykh arkhivov samoderzhaviya," *Iskusstvo,* no. 4 (1965), p. 68.

69. Vse togozhe, "Kul'turnye idealy i pochva," *Delo,* v. 10, pt. 2 (July 1876), pp. 41-61.

70. See Prakhov's plans for the publication, RM, OR, Fond 139, ed. khr. 337, pp. 1-21.

71. "Chetvertaya peredvizhnaya vystavka," *Pchela,* no. 10 (March 16, 1875), pp. 121-26.

72. This argument is especially prominent in the lengthy review, "Vystavka v Akademii khudozhestv," *ibid.*, nos. 9-13 (February 28-March 26, 1878).

Chapter 4

1. "Na svoikh nogakh," *Delo,* no. 12 (December 1871), p. 117.

2. "Konkurs na postoyannoi vystavke khudozhestvennykh proizvedenii" (1877), *Polnoe sobranie sochinenii,* pp. 416-21. Chekhov's story "House with an Attic" (1896) conveys this attitude well. It describes how a lady of the gentry, dedicated to teaching peasant children, wrecks the romance of her younger sister with a landscape painter because he leads a contemptibly aimless life by not representing "in all his pictures the needs of the people."

3. "Nashi peredvizhniki nynche" (1889), *Stat'i i zametki,* v. 2, p. 19.

4. Quoted in N. Novouspensky, *A. K. Savrasov* (Leningrad-Moscow, 1967), p. 48.

5. Letter of July 5, 1872, to F. Vasilev, *Kramskoy. Pis'ma,* v. 1, pp. 120-21.

6. Letter of December 6, 1871, to F. Vasilev, *ibid.,* p. 103.

7. P. Muratov, "Peizazh v russkoi zhivopisi," *Apollon,* no. 4 (1910), p. 13.

8. N. G. Mashkovtsev, ed., *Istoriya russkogo iskusstva* (Moscow, 1960), v. 2, p. 71. Hereafter cited as *Istoriya.*

9. "Akademicheskaya vystavka 1863 goda," *Sobranie sochinenii,* v. 1, pt. 2, pp. 157-58. In similar vein, Stasov found Antokolsky's statue of Spinoza in 1881 sufficiently "active and demolishing" (*aktivnyi i razrushayushchii*) and, in 1886, Surikov's *Boyarinia Morozova* lacking in "brave and decisive character." *Repin-Stasov. Perepiska,* v. 2, pp. 283-84, 335.

10. S. N. Goldshtein, "Iz istorii sozdaniya proizvedeniya I. N. Kramskogo 'Nekrasov v period poslednikh pesen'," GTG, *Materialy,* v. 2, pp. 155-59. The Nekrasov apartment in Leningrad, which is now a public museum, has preserved the bedroom intact, and it looks exactly as it does on the Kramskoy canvas. See also A. Besançon, "The Dissidence in Russian Painting," *The Structure of Russian History,* ed. M. Cherniavsky (New York, 1970), pp. 384-86 for a discussion of this picture as an example of "militant activism."

11. *Otechestvennye zapiski,* January, 1873. Quoted in E. Zhuravleva, "K voprosu o portrete-kartine v russkoi zhivopisi kontsa XIX, nachala XX stoletii," GTG, *Materialy,* v. 2, p. 210. Hereafter cited as "O portrete-kartine."

12. I. E. Grabar, ed., *Istoriya russkogo iskusstva* (Moscow, 1963-69), v. 9, pt. 1, p. 118. Hereafter cited as *Istoriya.*

13. Quoted in E. Zhuravleva, "O portrete-kartine," p. 209.

14. He was regarded as an outstanding historical painter by luminaries of the movement. See Stasov's long eulogy (1884), *Sobranie sochinenii,* v. 2, pt. 2, pp. 329-82.

15. Letter of January 21, 1885, to A. Suvorin, *Kramskoy. Pis'ma,* v. 2, p. 167.

16. "Chetvertaya peredvizhnaya vystavka," pp. 125-26. Prakhov also advised middle-class collectors to keep buying more historical canvases as this would influence the direction that Russian painting would take.

17. A. F. Koni, "Pamiati Konstantina Dmitrievicha Kavelina," *Sobranie sochinenii K. D. Kavelina* (St. Petersburg, 1899), v. 3, p. xiv. Koni described Kavelin as a foe of Chinese-like exclusiveness (*zamknutost'*) and self-satisfied smugness (*samodovol'stvo*), and a great admirer of Peter as an open-minded reformer.

18. "O blagodarnosti," BS, OR, Fond 3892, ed. khr. 5, pp. 1-2.

19. "Iz avtobiografii," p. 451.

20. Letter of December 18, 1878, to V. Stasov, *Repin-Stasov. Perepiska,* v. 2, p. 42.

21. There is much controversy over Surikov's political views and sympathies. Most pre-Revolutionary writers saw him as a conservative and a Slavophile, while post-1936 Soviet historiography makes him a progressive patriot. See M. Voloshin, "Surikov. Materialy dlia biografii," *Apollon,* no. 6-7 (1916), pp. 40-63 and V. Kemenov, *Istoricheskaya zhivopis' Surikova* (Moscow, 1963). S. Glagol's "V. I. Surikov. Iz vstrech s nim i besed," *Nasha starina,* no. 2 (1917), pp. 58-78, describes best the mixture of motives that animated Surikov—love for Russia's pristine past (which could still be experienced in Siberia and Moscow), interest in purely painterly problems (the effect of light), and a fascination with the human drama that accompanied Russia's Westernization—without pinning him with any specific political labels.

22. Quoted in Kemenov's study, cited in note 21, p. 335. Surikov's skill was appreciated by his colleagues, and Repin from the very beginning remonstrated with Stasov for his indifference to this talented painter. See his letters of March 22 and April 12, 1881, *Repin-Stasov. Perepiska,* v. 2, pp. 60, 63.

23. "Zametki o khudozhestvennykh vystavkakh" (1887), *Polnoe sobranie sochinenii,* pp. 428-40.

24. In his review of the 1876 Peredvizhnik exhibit, Adrian Prakhov commented that Vasnetsov's future did not lie in "petty" social genre scenes but in "important historical subjects." "Khudozhestvennye vystavki v Peterburge," *Pchela,* no. 11 (April 27, 1876), p. 7.

25. M. Morgunov, *V. M. Vasnetsov. Zhizn' i tvorchestvo* (Moscow, 1962), pp. 172-73. "Igor's Battle" was painted at Abramtsevo, the Mamontov's summer home, which became an artists' colony from about 1872-73 on. Even though the Abramtsevo circle was a loose association with no program or doctrine, it manifested a strong sense of cultural nationalism.

26. *Izbrannye sochineniya,* v. 2, p. 454.

27. M. V. Nesterov, *Davnie dni* (Moscow-Leningrad, 1959), p. 61.

28. As war clouds gathered in the late 1930s, a cult was made of Surikov as a historical painter; Stalin's speech on November 6, 1941, to rally the people against the Nazi invaders cited Surikov as an example of the undaunted spirit of the Russians. I. V. Stalin, *Sochineniya* (Stanford, California, 1967), v. 3, p. 24.

29. "Zapiska po povodu peresmotra ustava Akademii khudozhestv" (1865), *Kramskoy. Pis'ma,* v. 2, p. 294.

30. "Burlaki na Volge, 1868-1870," *Dalekoe blizkoe,* pp. 275-362.

31. Quoted in N. P. Sobko, *Slovar',* v. 3, pt. 1, p. 117.

32. Letter of April 19, 1875, *Kramskoy. Pis'ma,* v. 1, p. 298.

33. "Zapiski," p. 167. Vasnetsov, who grew up in a Siberian village where his father was a priest and who painted the common people before he turned to *byliny,* expressed similar feelings: "I lived in a hamlet among peasant men and women and loved them not like the populists *(ne po narodnicheski),* but directly, simply as my friends." Quoted in N. Morgunov, *V. M. Vasnetsov,* p. 10

34. "N. G. Chernyshevsky," *Kolokol,* no. 186 (June 15, 1864), p. 1525.

35. With the introduction of a new comprehensive censorship law in 1886, the Peredvizhnik exhibits became for the first time subject to preliminary censorship by the government and the Church. Prior to that measure, several paintings, such as Repin's *Ivan Groznyi* (1885), in which the Tsar cradled the body of his son whom he had just wounded mortally, and Yaroshenko's "At the Litovsky Fortress" *(U litovskogo zamka,* 1881), showing a resolute looking young woman in front of the notorious St. Petersburg prison, were removed after the opening of exhibits. There is only one recorded case of police intervention; Yaroshenko was placed under house arrest for ten days after the showing of the Litovsky fortress picture.

36. "Peterburgskaya zhizn'," *Sovremennik,* v. 89, pt. 2 (September 1861), pp. 71-75.

37. I. Repin, *Dalekoe blizkoe,* pp. 181-85.

38. L. Dintses, *Neopublikovannye karikatury "Iskry" i "Gudka"* (Moscow-Leningrad, 1939).

39. I. Zilbershtein, "Iz istorii sozdaniya kartiny 'Arest propagandista'," *Khudozhestvennoe nasledstvo. Repin,* v. 2, pp. 337-60.

40. Quoted in O. Liaskovskaya, "Proizvedenie I. E. Repina, 'Ne zhdali'," p. 107.

41. Quoted in I. E. Grabar, *Repin,* v. 1, pp. 258-59.

42. Since many Soviet scholars claim that Repin's changes reflected the failure and suppression of the revolutionary movement in the 1880s, following the assassination of Alexander II, it is worth noting that V. Makovsky's "Sentenced" *(Osuzhdennyi),* painted in 1879, shows a young prisoner facing his parents with a similar expression of guilt and uncertainty, as he is being led out of prison by two gendarmes.

43. The Peredvizhniki's behavior cannot be ascribed entirely to censorship. They could show politically motivated action without ambivalence. When Repin was in Paris in 1883, he witnessed the annual ceremony in honor of the fallen Communards at Père Lachaise cemetery. He painted the scene in an impressionistic manner. conveying the sense of an attentive, closely knit crowd straining to hear the speakers. Mass movement and participation—lacking in Russia—must have struck Repin, for he expressed it quickly and readily in the French scene.

44. "Nashi khudozhestvennye dela" (1884), *Sobranie sochinenii,* v. 1, pt. 2, pp. 745-46.

45. *Polnoe sobranie sochinenii* (Moscow, 1928), v. 1, pp. 252-53.

46. Quoted in I. E. Grabar, *Repin,* v. 1, p. 248.

47. Letter of February 26, 1885, to A. Suvorin, *Kramskoy. Pis'ma,* v. 2, p. 189.

48. *Ibid.*

49. Letter of October 30, 1891, to V. Stasov, *Repin-Stasov. Perepiska,* v. 2, p. 158.

50. Letter of May 5, 1878, to V. Vasnetsov, *Kramskoy. Pis'ma,* v. 1, p. 460.

51. Quoted in I. N. Shuvalova, *Miasoedov,* p. 56.

52. *Ibid.*, pp. 59-63.
53. "Po povodu odnoi kartinki" (1883), *Polnoe sobranie sochinenii* (Leningrad, 1949), v. 8, pp. 165-72.
54. Rectus, "Sovremennoe russkoe iskusstvo," *Artist*, no. 8 (September 1890), pp. 70-78.
55. A. Kiselev, "Etiudy po voprosam iskusstva," *ibid.*, nos. 28-31 (March-November 1893). This long essay in four installments was an unending paean to Makovsky, whom Kiselev considered an "outstanding artist."
56. Letter of August 18, 1873, to F. Vasilev, *Kramskoy. Pis'ma*, v. 1, p. 195.
57. "Vystavka v Akademii khudozhestv," *Pchela*, no. 12 (March 19, 1878), p. 190.
58. *Etiudy po istorii russkogo iskusstva* (Moscow, 1967), v. 2, p. 104.
59. *Davnie dni*, p. 168.

Chapter 5

1. Letter of July 27, 1886, to V. Stasov, *Kramskoy. Pis'ma*, v. 2, p. 252.
2. "Zapiska po povodu peresmotra ustava Akademii khudozhestv" (1865), *ibid.*, pp. 293-94.
3. *Ibid.*, p. 293.
4. Letter of January 21, 1885, *Kramskoy, Pis'ma*, v. 2, p. 168.
5. "Vzgliad na istoricheskuyu zhivopis' " (1858), *ibid.*, p. 272.
6. Letter of September 25, 1874, to K. A. Savitsky, *ibid.*, v. 1, p. 266.
7. Letter of October 10, 1872, to F. Vasilev, *ibid.*, p. 133.
8. Letter of February 16, 1878, to V. Garshin, *ibid.*, p. 446. Garshin's letter inquiring about the meaning of the picture is reprinted in his *Polnoe sobranie sochinenii*, p. 506.
9. Letters of September 28, 1874; May 16, 1875; August 20, 1875, *Kramskoy. Pis'ma*, v. 1, pp. 268-69, 300-01, 311-12.
10. Quoted in V. Stasov, *Izbrannye sochineniya*, v. 1, p. 710.
11. L. Nochlin, ed., *Realism and Tradition in Art, 1848-1900* (Englewood Cliffs, N. J., 1966), p. 34.
12. "K shkole risovaniya" (1866), "Zapiska po povodu peresmotra ustava Akademii khudozhestv" (1865), *Kramskoy. Pis'ma*, v. 2, pp. 275-95.
13. Letter of April 15, 1878, *ibid.*, v. 1, pp. 456-58.
14. Academy of Arts, Minutes of the February 11, 1887, Council meeting, TsGIA, Fond 789, ed. khr. 1773, p. 47.
15. Letter of December 26, 1877, *Kramskoy. Pis'ma*, v. 1, pp. 435-36.
16. *Sobranie sochinenii*, v. 1, pt. 2, p. 78.
17. Letter of July 21, 1886, to V. Stasov, *Kramskoy. Pis'ma*, v. 2, pp. 251-52.
18. Liubitel', "Beglye zametki po povodu retsenzii khudozhestvennykh vystavok i po povodu kartin G. Kuindzhi," *Molva*, no. 112 (April 25, 1879), pp. 1-2. I am indebted to Nataliya Primak, the Archivist at the Tretiakov Gallery, for letting me see her copy of the Klodt review.
19. I. Kramskoy, letter of March 26, 1878, to I. Repin, *Kramskoy. Pis'ma*, v. 1, p. 453. N. Yaroshenko's letter of December 10, 1879, GTG, OR, Fond 69/177 (1879), ed. khr. 1, pp. 1-2.
20. N. P. Nevedomsky, I. E. Repin, *Kuindzhi* (St. Petersburg, 1913), p. 97.
21. I. Repin, *Dalekoe blizkoe*, p. 189.
22. *Ibid.*, p. 282. Kramskoy's letter of August 11, 1877, to N. Aleksandrov, *Kramskoy. Pis'ma*, v. 1, pp. 404-12.

23. See, for example, V. Vasnetsov's painting "The Lubok Kiosk" (*Lavka luboch-nykh kartin i knizhek*), reproduced in *Pchela, no.* 27 (1875), p. 323.

24. Meyer Schapiro, "Courbet and popular imagery; an essay on realism and naiveté," *Journal of the Warburg and Courtauld Institutes,* v. 4, nos. 3 and 4 (1941), pp. 164-91. In part, this attitude was also nurtured by the disdain the Westernizing reformers had for the popular tradition that had to be surmounted if Russia was to emerge from its backwardness.

25. As time went on the Peredvizhniki could command increasingly handsome prices. During the 1880s Tretiakov would pay as much as 15,000 rubles (for Surikov's *Boyarinia Morozova* and for Repin's *Ivan Groznyi*). A. Fedorov-Davydov, *Russkoe is-kusstvo promyshlennogo kapitalizma,* p. 194.

26. Stasov's letter of May 30, 1888, to I. Repin, *Repin-Stasov. Perepiska,* v. 2, p. 131.

27. Text of Kuindzhi's testament, March 16, 1910, TsGIA, Fond 791, op. 1, ed. khr. 4 (1909-1931), p. 1.

28. A. Altaeva, "Sorok let nazad. Vospominaniya o Bogdanove-Belskom" (n.d.), TsGALI, Fond 990, op. 1, ed. khr. 235, pp. 5-6.

29. A. Altaeva, *Pamiatnye vstrechi* (Moscow, 1946).

30. The 79,000-ruble budget of Alexander II was increased to 200,000. [S. N. Kondakov, *Yubileinyi spravochnik,* v. 1, pp. 199, 202]. The new Tsar was equally interested in promoting the study and preservation of the national heritage: he headed the Imperial Russian Historical Society since its foundation in 1866; backed the establishment of the Historical Museum in Moscow (1883); and generously supported the restoration of Russian antiquities, especially in Kiev.

31. A. P. Bogoliubov, *Vospominaniya o v Boge pochivshem Imperatore Aleksandre III* (St. Petersburg, 1895), pp. 12-13. Hereafter cited as *Vospominaniya.*

32. The five canvases he lent for the Russian section of the 1873 International Exhibition in Vienna were all on French, Spanish or Italian subjects. *Ukazatel' russkogo otdela Venskoi vsemirnoi vystavki* (St. Petersburg, 1873).

33. Pobedonostsev's letter of April 15, 1885, to Alexander III, *Pis'ma Pobedonos-tseva Aleksandru III,* ed. M. N. Pokrovsky (Moscow, 1925), v. 2, pp. 72-74. Hereafter cited as *Pobedonostsev. Pis'ma.*

34. Eugene Klimoff, "Russian Architecture, 1880-1910," *Apollo,* no. 142 (December 1973), pp. 436-43.

35. Pobedonostsev's letter of July 16, 1888, to Alexander III, *Pobedonostsev. Pis'ma,* v. 2, pp. 185-86; A. Novitsky, *Peredvizhniki,* pp. 119-27. Interestingly enough, a recent Soviet history of art states that the frescoes in the St. Vladimir cathedral had restored a "national style" to religious painting. N. G. Mashkovtsev, ed., *Istoriya,* v. 2, p. 218.

36. Alexander made the decision soon after ascending the throne, but the actual opening of the museum was delayed until suitable headquarters were found—the imposing Mikhailovsky's palace, designed by K. Rossi and built in 1819-23 for Alexander I's younger brother, which needed extensive remodeling. The Russian Museum of Emperor Alexander III was opened to the public in 1898, but the project was generally known from the mid-1880s.

37. "Publichnaya biblioteka i Ermitazh" (1877), *Sobranie sochinenii,* v. 1, pt. 1, pp. 451-58. "Nashi peredvizhniki nynche" (1889), *Stat'i i zametki,* v. 2, pp. 3-6.

38. *Vestnik iziashchnykh iskusstv,* v. 2, pts. 2 and 3 (1884), pp. 143-68, 171-93.

39. "Dvadtsat' piat' let russkogo iskusstva" (1882), *Izbrannye sochineniya,* v. 2, pp. 435-36.

40. For a fulsome view on Alexander's role on behalf of Russian art that conveys

the intensity of the official nationalism, see Adrian Prakhov's essay, "Imperator Aleksandr III kak deyatel' russkogo khudozhestvennogo prosveshcheniya," *Khudozhestvennye sokrovishcha Rossii,* v. 3 (1903), pp. 125-81. It praises Alexander for ridding Russian realist art of its Western accretions (i.e., the critical spirit) and guiding it onto the right path, one that represented the ideals of the entire nation and'not just the narrow concerns of a small group brought up in the Western spirit (*po zapadnomu*), p. 136.

41. Letter of December 24, 1885, to V. Stasov, *Repin-Stasov. Perepiska,* v. 2, pp. 91-92. In that speech the Emperor recommended that the limited participation of the peasantry in local government, one of the reforms of the 1860s, be curtailed.

42. *Khudozhestvennyi zhurnal,* nos. 3-4 (1886). Quoted in N. P. Sobko, "Russkoe iskusstvo v 1886 godu," BS, OR Fond 708, no. 62, p. 204.

43. Kramskoy's letter of March 18, 1886, to A. P. Bogoliubov, described this ruse and the Tsar's visit. *Kramskoy. Pis'ma,* v. 2, pp. 241-42. Actually, the Tsar had seen the *Tovarishchestvo* exhibit the previous year. He had done so not for pleasure but only to check whether Pobedonostsev had been right in insisting that Repin's canvas, depicting Ivan the Terrible after he had fatally wounded his son, be removed for *lèse majesté.*

44. According to the official catalogues, Tretiakov bought 10 canvases and Alexander 5 at the 16th exhibition in 1888; the following year Tretiakov bought only 2, while the Imperial family purchased 27.

45. Alexander's and his family's selections for the museum favored innocuous social genre, native landscape, military scenes and religious subjects. Nicholas II kept up his father's project and purchased, among other things, Surikov's "Conquest of Siberia" (1895) and "Suvorov Crossing the Alps" (1899) for 40,000 and 25,000 rubles, respectively—the highest sums hitherto paid.

46. See Nesterov's autobiography, *Davnie dni,* pp. 58-65, 89-90.

47. M. Kopshitser, *Valentin Serov* (Moscow, 1967), p. 46.

48. Quoted in W. A. Cox, "The Art World and *Mir Iskusstva.* Studies in the Development of Russian Art. 1890-1905" (unpublished Ph.D. dissertation, University of Michigan, 1970), pp. 125-26.

49. In 1874 universal military service replaced the recruitment to which only the two lower estates had been liable. In the next decade the poll tax and corporal punishment were also abrogated.

50. M. Nesterov, *Davnie dni,* pp. 199-200.

51. Quoted in *Vasili Dmitrievich Polenov. Elena Dmitrievna Polenova. Khronika sem'i khudozhnikov,* ed., E. V. Sakharova (Moscow, 1964), pp. 337-38. [Hereafter cited as *Polenov. Khronika.*] Vasili Polenov (1844-1927) came from a well-to-do gentry family and attended the University. His colleagues constantly suspected in the 1870s that this "gentleman" (*barin*) would be seduced by foreign fashions and fail to paint "genuine" Russian pictures. But he proved his Peredvizhnik mettle and produced a "typical corner" of old Moscow—*Moskovskii dvorik*—in 1878.

52. Mentioned in V. Stasov's letter of April 18, 1888, to I. Repin, *Repin-Stasov. Perepiska,* v. 2, pp. 124-25. Exhibits from Europe became quite frequent in the following decade.

53. E. Gomberg-Verzhbinskaya, *Peredvizhniki* (Leningrad, 1972), pp. 177, 182.

54. Quoted in G. Yu. Sternin, *Khudozhestvennaya zhizn',* p. 68. M. Nesterov, *Davnie dni,* p. 159.

55. Text in *Polenov. Khronika,* pp. 450-51.

56. "Usloviya dlia priema kartin na vystavki Tovarishchestva" (May 4, 1892), GTG, OR, Fond 82/543 (1892), ed. khr. 1, p. 1.

57. E. D. Polenova's letter of March 30, 1890, to E. G. Mamontova, *Polenov. Khronika,* p. 452.

58. For full information on the artistic life of the 1890s consult G. Yu. Sternin, *Khudozhestvennaya zhizn'*. Greater pluralism in the modes of expression was part and parcel of artistic life as it quickened around 1890. Whereas in the 1880s, St. Petersburg had but two or three exhibits each year, by 1897 it could boast of sixteen. Similarly, in the 1880s about ten books on art were published annually; in the following decade the number had doubled. [A. Fedorov-Davydov, *Russkoe iskusstvo promyshlennogo kapitalizma*, p. 204.] The period also saw a cornucopia not so much of art journals (which happened only after 1900) as of illustrated weeklies abounding with reproductions of canvases that had caused a stir at various exhibits. [I.M. Pavlov, *Zhizn' russkogo gravera* (Moscow, 1940), pp. 105-21.]

59. See the excerpts from S. Kondakov's diary for March 1890, cited in A. Savinov, "Akademiya khudozhestv i Tovarishchestvo peredvizhnykh khudozhestvennykh vystavok," *Problemy razvitiya russkogo iskusstva*, v. 2 (Leningrad, 1972), p. 49.

60. The proposals were printed in a book form: *Mneniya lits sproshennykh po povodu peresmotra ustava Imperatorskoi Akademii khudozhestv* (St. Petersburg, 1891). Hereafter cited as *Mneniya lits*.

61. V.D. Polenov's letter of February 1, 1891, to his wife, *Polenov. Khronika*, p. 592; S.K. Isakov, *Akademiya khudozhestv* (Leningrad-Moscow, 1940), p. 109.

62. Text in S.N. Kondakov, *Yubileinyi spravochnik*, v. 1, pp. 202-05.

63. V. Stasov's letters of October 28, 1891, and of March 28, 1894, are quoted in *Repin-Stasov. Perepiska*, v. 2, pp. 422, 439. N. Yaroshenko, letter of December 31, 1893, to I.S. Ostroukhov, GTG, OR Fond 10/7421, ed. khr. 1 (1893), pp. 1-2. The critics' opinions are cited in I.E. Repin, "V zashchitu novoi Akademii khudozhestv" (1897), *Vospominaniya, stat'i i pis'ma iz zagranitsy* (St. Petersburg, 1901), pp. 212-13.

64. See Polenov's letters on this issue from January 1891 to January 1900, *Polenov. Khronika*, pp. 587-617.

65. I.E. Repin, "V zashchitu novoi Akademii khudozhestv," p. 221.

66. By comparison, the Imperial Academy of Sciences, though also presided over by a Grand Duke, was in effect controlled by scholars who did not accept high-handed interference from the Court. L. Graham, *The Soviet Academy of Sciences and the Communist Party, 1927-1932* (Princeton, N.J., 1967), pp. 1-24.

67. M. Moleva, *Russkaya shkola*, p. 181; S.K. Isakov, *Akademiya khudozhestv*, pp. 115-16. This basic safeguard of autonomy was also recommended by the majority of persons consulted on how to reform the Academy, but in a cautious form—the summary stated that "it would be desirable" if professors were elected by the General Assembly—indicating how delicate the issue of elections was. *Mneniya lits*, p. 34.

68. Letter of January 17, 1894, to I.S. Ostroukhov, GTG, OR, Fond 10/7422, ed. khr. 1 (1894), p. 1.

69. *Russkie vedomosti*, no. 66 (March 8, 1898). Quoted in G. Yu. Sternin, *Khudozhestvennaya zhizn'*, p. 70. Stasov's comment was similar: "The public now moves from the Academic exhibit to the Peredvizhniki without noticing any special difference between the former and the latter." [*Ibid.*] See also I. Ginzburg's "Russkaya akademicheskaya zhivopis' 1870-1880 gg.," *Iskusstvo*, no. 5 (1934), pp. 95-127, for an excellent analysis of the gradual convergence of the two art trends, resulting in a uniform "bourgeois" realism.

Chapter 6

1. See Camilla Gray, *The Russian Experiment in Art, 1863-1922* (London, 1970), pp. 37-184.

2. Texts of letters exchanged between Repin, Polenov and Serov, as well as of

Serov's letter to the Academy, in *Polenov. Khronika*, pp. 651-53.

3. *Dalekoe blizkoe*, p. 452.

4. Text in GRM, OR, Fond 115, ed. khr. 421, p. 5. The resolution was published in *Russkie vedomosti*, January 7, 1905.

5. F. Roginskaya, "Pis'mo vozvanie Peredvizhnikov perioda pervoi russkoi revoliutsii," *Iskusstvo*, no. 5 (1936), pp. 74-75. The statement was printed in *Pravo*, May 8, 1905.

6. Quoted in A. Savinov, "Alexandr Benua v 1905 godu," *Problemy razvitiya russkogo iskusstva*, v. 4 (Leningrad, 1972), p. 60.

7. Sidney Harcave, *The Russian Revolution of 1905* (New York, 1964), p. 101.

8. It was published in *Teatr i iskusstvo*, no. 6 (1905), p. 82.

9. See A. Rostislavov, "Politika v khudozhestve," *ibid.*, no. 10 (1910), pp.217-19; and his "Repinskaya polemika," *ibid.*, no. 11 (1910), p. 239.

10. E. Gomberg-Verzhbinskaya, *Russkoe iskusstvo i revoliutsiya 1905 goda* (Leningrad, 1960). For an objective account see V. Lobanov, *God 1905 v zhivopisi* (Moscow, 1922).

11. N. Kiselev, "O V. Makovskom," *Iskusstvo*, no. 3 (1964), pp. 66-68.

12. I.E. Repin, "V zashchitu novoi Akademii khudozhestv" (1897), p. 226.

13. "Golos khudozhnikov," *Rus'*, November 11, 1905; *Syn otechestva*, November 12, 1905.

14. The first issue reprinted the "Golos khudozhnikov" statement (pp. 132-33), and its editorial connected the flowering of the arts with the introduction of free institutions. "Ot Redaktsii," *Zolotoe runo*, no. 1 (1906), p. 4. See also, D. V. Filosofov, "Khudozhestvennaya zhizn' Peterburga," *ibid.*, pp. 106-11; A. Rostislav, "Deyatel'nost' Akademii," *ibid.*, no. 6 (1906), pp. 88-90.

15. N. Kravchenko, "K reforme Akademii khudozhestv," *Novoe vremia*, December 19, 1905.

16. Her "despotism" was described in some detail in the press only after the February Revolution. See Spektator, "V chiikh rukakh nakhodilos' russkoe iskusstvo," *Petrogradskaya gazeta*, March 19, 1917; N. Kravchenko, "Osvobozhdennaya Akademiya khudozhestv," *Novoe vremia*, March 17, 1917.

17. See the outcry raised in 1914 when Bogdanov-Belsky's picture of a peasant family ("New Owners") was purchased for 5,000 rubles, *Apollon*, no. 3 (1914), pp. 60-61.

18. Vserossiiskii s'ezd khudozhnikov, *Trudy* (St. Petersburg, 1912), v. 3, p. 93.

19. Ya. Tugendhold, "Moskovskie vystavki," *Apollon*, no. 3 (1913), pp. 55-59.

20. A. Rostislavov, "K akademicheskomu oproverzheniyu," *Rech'*, April 21, 1917.

21. S. Makovsky, "Ministerstvo iskusstv," *Apollon*, no. 2-3 (1917), pp. i-xvi.

22. See the undated letter of 1917 to Apollinari Vasnetsov from N.N. Dubovskoy, GTG, OR, Fond 11/554, ed. khr. 1, pp. 1-5.

23. V. Denisov, "O novom iskusstve demokraticheskoi Rossii," *Den'*, March 15, 1917; E.A. Dinershtein, "Mayakovsky v fevrale-oktiabre 1917 g.," *Literaturnoe nasledstvo* (Moscow, 1958), v. 65, pp. 541-70.

24. Quoted in Nadezhda Mandelstam, *Hope Abandoned* (New York, 1973), p. 62.

25. Quoted in V. Lobanov, *Khudozhestvennye gruppirovki za poslednie 25 let* (Moscow, 1925), p. 84. Hereafter cited as *Khudozhestvennye gruppirovki*. See also Sheila Fitzpatrick. *The Commissariat of Enlightenment. Soviet Organization of Education and the Arts under Lunacharsky* (Cambridge, 1970). Hereafter cited as *Lunacharsky*.

26. "Otchet deyatel'nosti Otdela Izobrazitel'nykh Iskusstv Narkomprosa," *Izobrazitel'noe ikusstvo*, no. 1 (1919), p. 70.

27. Deklaratsiya Kollegii po delam iskusstva i khudozhestvennoi promyshlennosti...po voprosu peterburgskoi Akademii khudozhestv (April 27, 1918), TsGIA, Fond

797, op. 1, ed. khr. 55 (1917-1918), p. 58.

28. S. K. Isakov, *Akademiya khudozhestv*, p. 127.

29. Ivan Matsa's collection of documents, *Sovetskoe iskusstvo za 15 let* (Moscow, 1933), pp. 151-53, has the text of Narkompros instructions on admission to the Free Studios and on the election of the teaching staff. Hereafter cited as *Sovetskoe iskusstvo*.

30. N. Punin, "Proletarskoe iskusstvo," *Iskusstvo kommuny*, no. 19 (April 13, 1919), p. 1; A. Rylov, *Vospominaniya* (Leningrad, 1960), pp. 174-83.

31. The first "democratic" Salon in Petersburg displayed 2,826 works by 359 artists representing seven different groups and 184 independents. V. Lobanov, *Khudozhestvennye gruppirovki*, pp. 86-88.

32. "Ot Otdela Izobrazitel'nykh Iskusstv Komissariata Narodnogo Prosveshcheniya," *Iskusstvo kommuny*, no. 1 (December 7, 1918), p. 3. See the official 1919 list of works to be bought (reprinted in I. Matsa, ed., *Sovetskoe iskusstvo*, pp. 125-26), and A. Sidorov, "Muzei zhivopisnoi kul'tury," *Tvorchestvo*, no. 4-6 (1921), pp. 43-50.

33. Letter of February 4, 1919, to V. Baksheev, quoted in the unpublished version of G. Shein's biography of Baksheev, TsGALI, Fond 2957, op. 1, ed. khr. 87, pp. 133-35.

34. "Proletarskoe iskusstvo," p. 1.

35. "Lenin i iskusstvo" (1924), A. V. Lunacharsky, *Ob izobrazitel'nom iskusstve*, ed. I. A. Sats (Moscow, 1967), v. 2, p. 11.

36. Klara Zetkin, "Vospominaniya o Lenine" (1924), I. Matsa, ed., *Sovetskoe iskusstvo*, p. 226.

37. *Ibid.*, pp. 226-28. There was one case in which the Party did express its dislike for non-realism. On December 1, 1918, *Pravda* printed a letter from the Central Committee chastizing the Proletkult for infecting the workers "with absurd, perverted taste (futurism)" in its network of clubs and studios through which this radical educational organization (operating since September 1917 outside the government and Party framework) tried to bring enlightenment to the masses and create a new proletarian culture. But this letter cannot be considered an official decree condemning non-objective art, even though it is often so interpreted by the advocates of state controls. Attacks on Proletkult were motivated primarily by the Party's desire to gain administrative control over an autonomous organization and not by the wish to dictate an artistic or literary style. For a more detailed discussion of this point, see Sheila Fitzpatrick, *Lunacharsky*, pp. 89-99.

38. A. Lunacharsky, "Lenin o monumental'noi propagande" (1933), *Iskusstvo*, no. 1 (1939), p. 27. Text of the original list and amendments, *Izvestiya*, August 2, 1918. Reprinted in A. Lunacharsky, *Ob izobrazitel'nom iskusstve*, v. 2, pp. 294-95.

39. See pp. 68-69, 73, 101, 120, 150, 182, 191-92 in *Polnoe sobranie sochinenii* (Moscow, 1965), v. 50, for the irate letters and telegrams Lenin dispatched in the course of 1918 to various officials urging speedy action.

40. The original list, as approved on July 30, 1918, was later somewhat enlarged when sculptors started submitting entries for public competition. Notable were the additions of Courbet and Cézanne, but from among the Russian painters only one Peredvizhnik—Surikov—was thus honored. S. T. Konenkov, *Moi vek* (Moscow, 1972), pp. 218-19; M. Neiman, "Iz istorii leninskogo plana 'monumental'noi propagandy'," *Stanovlenie sotsialisticheskogo realizma v sovetskom izobrazitel'nom iskusstve* (Moscow, 1960), pp. 48-50. Hereafter cited as *Stanovlenie sotsialisticheskogo realizma*.

41. After 1917, though, he was recognized as a "revolutionary in art," the first "modern Russian master" who was derided during his own time, and the nationalized Tretiakov Gallery mounted a Vrubel exhibit in 1921. A.A.S., "Po vystavkam," *Tvorchestvo*, no. 1-3 (1921), p. 31.

42. For a description of the bewildering welter of art groupings and their changing allegiances, see Camilla Gray, "The Genesis of Socialist Realist Painting," *Survey*, no. 27 (1959), pp. 32-39; and V. S. Manin, *Iz istorii khudozhestvennykh ob'edinenii Moskvy i Leningrada, 1921-1932* (unpublished dissertation for the degree of *Kandidat*, Department of the History of Russian Art, Moscow University, 1973). John E. Bowlt, "Early Soviet Art," *Art and Artists*, November 1975, pp. 36-43, discusses the expressionist, surrealist and neo-romantic strains that emerged within the framework of figurative art during the 1920s. V. Lobanov, *Khudozhestvennye gruppirovki*, pp. 100-20, and I. Matsa, ed. *Sovetskoe iskusstvo*, pp. 300 ff., contain the programs and manifestoes of the various groups. Many appear in English translation in John E. Bowlt, ed., *Russian Art of the Avant-Garde: Theory and Criticism, 1902-1934* (New York, 1976). Hereafter cited as *The Russian Avant-Garde*.

43. *Katalog 47-oi peredvizhnoi vystavki* (Moscow, 1922), pp. 10-11. D. Melnikov, "47-ya peredvizhnaya vystavka," *Tvorchestvo*, no. 1-4 (1922), pp. 70-72. See also A. Bakushinsky, "Vozvrat peredvizhnichestva," *Zhizn'*, no. 2 (1922), pp. 119-26.

44. Reprinted in *Bor'ba za realizm v izobrazitel'nom iskusstve 20-kh godov. Materialy, dokumenty, vospominaniya*, ed. V. N. Perelman (Moscow, 1962), p. 103. Hereafter cited as *Bor'ba za realizm*.

45. Text of the Declaration, *Assotsiatsiya khudozhnikov revoliutsionnoi Rossii. Sbornik vospominanii, statei, dokumentov*, eds., I. M. Gronsky, V. N. Perelman (Moscow, 1973), p. 289. Hereafter cited as *AKhRR*.

46. V. Kniazeva, *AKhRR. Assotsiatsiya khudozhnikov revoliutsionnoi Rossii* (Leningrad, 1967), p. 88.

47. Branches of AKhRR sprang up in such remote places as Tashkent, Tiflis, Ufa, Vladivostok or the Chuvash Autonomous Republic. For young people, AKhRR set up a Youth Organization (OMAKhRR) which offered art instruction in factories. F. Bogorodsky, "Filialy AKhRR i 'OMAKhRR'," *4 goda AKhRR. 1922-1926. Sbornik*, ed. A. V. Grigorev et al. (Moscow, 1926), pp. 156-60. Hereafter cited as *4 goda*.

48. "O politike partii v oblasti khudozhestvennoi literatury." Text in *O partiinoi i sovetskoi pechati, radioveshchanii i televidenii* (Moscow, 1972), pp. 392-96. It is significant that this resolution was quoted in 1965 by A. Rumiantsev, then a new editor of *Pravda*, when there was an attempt to provide firm guarantees for the haphazard cultural liberalization initiated by Khrushchev, "Partiya i intelligentsia," *Pravda*, February 21, 1965.

49. K. Katsman, "Kak sozdavalas' AKhRR," *4 goda*, p. 82.

50. As Perelman wrote in 1925: "Strange as it may seem, genuine support to the new group was shown not by the Narkompros but by the military administration." "Ot peredvizhnichestva k geroicheskomu realizmu," *ibid.*, p. 122.

51. E. Katsman, "Kak sozdavalas' AKhRR," pp. 83-86. The same results followed from the exhibit for the fifth anniversary of the Red Army. All the exhibited works were bought by the Revolutionary Military Council and formed the nucleus of the Museum of Revolution.

52. "Rech' M. V. Frunze na zasedanii literaturnoi komissii TsK VKP (b)" (March 3, 1925), *Na literaturnom postu*, no. 5-6 (1926), pp. 65-66. V. Gross, "Zakazy Revvoensoveta," *Krasnaya gazeta*, February 23, 1928. Reprinted in *AKhRR*, pp. 283-86.

53. E. Katsman, "Kak sozdavalas' AKhRR," p. 93.

54. See "Zakaz Revvoensoveta k 10-letiyu Krasnoi Armii i Flota," *Biulleten' informatsionnogo biuro AKhRR*, no. 8 (1927), for a list of topics and the method of remuneration. Reprinted in *Bor'ba za realizm*, pp. 136-38. V. Gross, "Zakazy Revvoensoveta," p. 284.

55. N. Chuzhak, "Vokrug geroicheskogo realizma," *Zhizn' iskusstva*, no. 26 (September 7, 1926), pp. 5-6.

56. E. Katsman, "Kak sozdavalas' AKhRR," *4 goda*, pp. 31-67. V. Perelman "Ot peredvizhnichestva k geroicheskomu realizmu," *ibid.*, pp. 102-25. Both essays were reprinted in the 1962 anthology, *Bor'ba za realizm v iskusstve 20-kh godov*, in shorter, milder versions. The "updated" version of Perelman's essay, for example, excluded those passages in which he stated that there was nothing that the new group could take over from the "putrid" Peredvizhniki. Moreover, it was appended with an apology for not having properly described the ties that after all did exist between the new organization and the old *Peredvizhnichestvo* (p. 318).

57. E. Katsman, "Poezdka k Repinu" (1927), TsGALI, Fond 2368, op. 1, ed. khr. 6. Repin's Penaty is located in that part of Finland which was annexed by the Soviet Union after World War II. The estate has been beautifully and lovingly restored as a museum on whose walls there hangs, among many other mementoes, a letter from Voroshilov assuring Repin that his return would "constitute a service to the nation" and that the state would take "full care" of the artist and his family.

58. "Ot peredvizhnichestva k geroicheskomu realizmu," p. 112.

59. N. M. Shchekotov, "O starykh i novykh peredvizhnikakh" (1923), "AKhRR i peredvizhniki" (1926), *Stat'i, vystupleniya, rechi, zametki*, eds., M. N. Grigoreva, Zh. E. Kaganskaya (Moscow, 1963), pp. 71-72, 73-75. [Hereafter cited as *Stat'i.*] F. Roginskaya, "Revoliutsiya, byt i trud," *Pravda*, February 15, 1925; "Novyi realizm v zhivopisi," *Krasnaya nov'*, no. 3 (1926); "Khudozhniki k desiatiletiyu Krasnoi Armii," *Izvestiya*, February 25, 1928. Reprinted in *AKhRR*, pp. 206-207, 273-81, 243-45.

60. "Puti stankovoi zhivopisi" (1926), *Iskusstvo oktiabr'skoi revoliutsii* (Moscow-Leningrad, 1930), p. 112; "Formal'nyi element v nashei zhivopisi," *Sovetskoe iskusstvo*, no. 6 (1928), p. 23.

61. B. Arvatov, "Nastuplenie pravykh," *Zhizn' iskusstva*, no. 26 (July 30, 1925); "AKhRR na zavode," *ibid.*, no. 30 (August 28, 1925). [Reprinted in *4 goda*, pp. 246-49.] A. Fedorov-Davydov, "Tendentsii sovremennoi russkoi zhivopisi v svete sotsial'nogo analiza," *Krasnaya nov'*, no. 6 (1924). [Reprinted in *4 goda*, pp. 208-13.] Diego Rivera, "AkhRR i stil' revoliutsionnogo iskusstva," *Revoliutsiya i kul'tura*, no. 6 (1928), pp. 43-44. See also A. N. Tikhomirov, "O zarubezhnykh sviaziakh AKhRR," *AKhRR*, pp. 172-73.

62. See his reviews of the group's 1925 and 1926 exhibits, *AKhRR*, pp. 211-20, 229-39.

63. See the Declaration of the *Oktiabr'* group (1928), reprinted in *Bor'ba za realizm*, pp. 243-46.

64. "Otsenka raboty AKhR APPO TsK VKP (b)," *Izvestiya*, February 14, 1929. [Reprinted in *Bor'ba za realizm*, pp. 164-65.] The ideological level of AKhRR posters and canvases was again found wanting by the Central Committee in 1931. "O plakatnoi literature. Postanovlenie TsK VKP (b) ot 11 marta 1931 g.," *O partiinoi i sovetskoi pechati. Sbornik dokumentov* (Moscow, 1954), pp. 407-08.

65. "Otkrytoe pis'mo 'Molodogo Oktiabria' Tsentral'nomu prezidiumu OMARKh" (1930), *Bor'ba za realizm*, pp. 250-53. Diego Rivera was enlisted in the campaign against AKhRR's realism, which he dubbed as proper for the times of Napoleon III or Alexander II but totally unfit for the construction of socialism. "AKhRR i stil' proletarskogo revoliutsionnogo iskusstva," *Revoliutsiya i kul'tura*, no. 6 (1928), pp. 43-44.

66. A. Kurella, "Khudozhestvennaya reaktsiya pod maskoi 'geroicheskogo realizma'," *ibid.*, no. 2 (1928), pp. 42-47, and "Ot 'iskusstva revoliutsionnoi Rosii' k proletarskomu iskusstvu," *ibid.*, no. 6 (1928), pp. 33-42; Kommunisticheskaya Akademiya, *Iskusstvo v SSSR i zadachi khudozhnikov. Disput* (Moscow, 1928); I. Matsa, "Problema tvorcheskogo metoda v proletarskom iskusstve," *Iskusstvo v massy*, no. 12 (1930), pp. 4-6.

67. A. Fedorov-Davydov, *Russkoe iskusstvo promyshlennogo kapitalizma* (Moscow, 1929). A. Mikhailov, "Zametki o razvitii burzhuaznoi zhivopisi v Rossii," *Russkaya zhivopis' XIX veka,* ed., V. Friche (Moscow, 1929). But it must be stressed that simple reductionism was not the hallmark of this new school of art history founded by V. M. Friche (1870-1929) and continued by A. Fedorov-Davydov (1890-1969). The documentary materials they published, their fresh insight and interpretations were as valuable as the work of M. A. Rozhkov and M. N. Pokrovsky in history proper.

68. He was dismissed in 1930 and brought to trial for these acts of barbarism. A. I. Zotov, *Akademiya khudozhestv* (Moscow, 1960), p. 79.

69. By 1930 the number of Russian paintings from the second half of the 19th century, for the most part those by Peredvizhniki, were reduced at the Tretiakov Gallery from 1,200 to 450. *Iskusstvo v massy,* no. 7 (1930), pp. 20-21.

70. "Deklaratsiya Assotsiatsii khudozhnikov Revoliutsii," *AKhRR,* pp. 320-21. The name of the group was also slightly altered to that of Association of Artists of the Revolution.

71. V. Perelman, "Puti AKhR," *Iskusstvo v massy,* no. 1-2 (1929), pp. 16-22; E.·Katsman, "K voprosu ob akhrovskoi samokritike," *ibid.,* no. 3-4 (1929), pp. 37-39.

72. *Iskusstvo v massy,* no. 3-4 (1929), p. 41. The young revolutionary purists, responsible for the purge, also accused Brodsky of exploiting labor and of financial speculations. I. A. Brodsky, *Isaak Izrailevich Brodsky* (Moscow, 1973), p. 403. Stories were current that he would employ other artists to paint in portraits from photographs into his group pictures, and that for a sum he would "immortalize" people by including their likenesses in his huge historical canvases.

73. A. Kniazeva, *AKhRR,* p. 41 ff.

74. Interview with F. F. Osipov, General Secretary of RAPKh, *Za proletarskoe iskusstvo,* no. 8 (1931), pp. 1-3. "Rech' tovarishcha Stalina i zadachi Izofronta," *ibid.,* no. 9 (1931), pp. 1-3.

75. "O perestroike literaturno-khudozhestvennykh organizatsii," *Pravda,* April 24, 1932. English text in John E. Bowlt, ed., *The Russian Avant-Garde,* pp. 288-90.

Chapter 7

1. Writers held their first Congress in 1934, but not until 1948 did the musicians meet as one body, and the artists only in 1957, when a nation-wide Union of Soviet Artists was formed. At first, the Moscow Union of Artists (MOSKh) acted as the executive committee supervising local organizations in large cities and in the union republics. In June 1939 the Organizational Committee of the future Union of Soviet Artists took over.

2. Text of Zhdanov's speech in *Pervyi vsesoyuznyi s'ezd sovetskikh pisatelei. Stenograficheskii otchet* (Moscow, 1934), pp. 2-5. Text of Grabar's speech in *ibid.,* pp. 545-46. Excerpts in English from both speeches in John E. Bowlt, ed., *The Russian Avant-Garde,* pp. 292-96.

3. The purge was described in the original text of Shchekotov's review of the retrospective, printed in the posthumous collection of his writings and speeches. "Sovetskie zhivopistsy. Vystavka 'Khudozhniki RSFSR za 15 let'," *Stat'i,* pp. 95-146. A shorter illustrated version, warning artists against formalism and advising them to observe the "more realistic" three-dimensional perspective, appeared under the same title in *Iskusstvo,* no. 4 (1933), pp. 51-142.

4. Text in *Iskusstvo,* no. 4 (1933), pp. 1-6.

5. Citation from Brodsky's diary, I. A. Brodsky, *Isaak Izrailevich Brodsky,* p. 368.

6. Interview with I. Brodsky, "Kakoi budet vserossiiskaya Akademiya khudo-

zhestv?" *Literaturnaya gazeta,* May 30, 1934.

7. "Postanovlenie Kollegii Narkomprosa po doklade direktora GTG t. Vol'tera o rabote Gallerei" (January 14, 1933), GTG, OR, Fond 8 II/504, p. 12; "Ob'iasnitel'naya zapiska k planu rabot GTG po 1934 g.," Fond 8 II/582, pp. 1-27.

8. N. Mudrogel, "58 let v Tret'iakovskoi galleree," *Novyi mir,* no. 7 (1940), p. 180. It is difficult to determine now whether the threefold increase in attendance at the Tretiakov Gallery during the 1930s was due to this return to "normalcy" or to the increased numbers of organized mass tours that were part of the official program of popularizing Russian 19th-century realism. At any rate, whereas attendance in 1915 and in 1927 was about 250,000 annually, by 1936 it had risen to 832,000. GTG, OR, Fond 8 II/885, p. 5.

9. A. Rylov, *Vospominaniya,* pp. 199-208. V. Kostin, "Radostnaya priroda," *Sovetskoe iskusstvo,* February 12, 1935.

10. Gronsky's 1933 remarks are quoted in *Novyi mir,* no. 11 (1935), p. 285. A. Volter, "Nashi zadachi," *Iskusstvo,* no. 1-2 (1933), p. ix.

11. A. Efros, "Vchera, segodnia, zavtra," *Iskusstvo,* no. 6 (1933), pp. 15-64. O. Beskin, "O nezainteressovannosti esteticheskogo suzhdeniya," *ibid.,* pp. 65-76.

12. *Realizm v russkoi zhivopisi XIX veka* (Moscow-Leningrad, 1933). (Hereafter cited as *Realizm.*)

13. *Stat'i,* p. 113.

14. V. Gaposhkin, "K voprosu o sotsialisticheskom realizme," *Iskusstvo,* no. 2 (1934), p. 9; B. Nikoforov, "Po masterskim khudozhnikov Belorusii," *ibid.,* no. 3 (1934), p. 114.

15. "Tvorchestvo V. G. Perova," *V. G. Perov. K stoletiyu dnia rozhdeniya* (Moscow, 1934), pp. 37-38.

16. English text in M. Pundeff, ed., *History in the USSR. Selected Readings* (San Francisco, 1967), pp. 98-99.

17. "I. E. Repin kak predstavitel' revoliutsionnogo narodnichestva," *Novyi mir,* no. 10 (1934), pp. 245-72.

18. See the three articles by the neo-Stasovites: A. Lebedev, E. Melikadze, A. Mikhailov, P. Sysoev, "Zhurnal 'Iskusstvo' i zadachi khudozhestvennoi kritiki," *Novyi mir,* no. 3 (1935), pp. 247-73; "Eshche raz o zhurnale 'Iskusstvo'," *ibid.,* no. 7 (1935), pp. 242-52; and "Gogolevskaya khivria v roli teoretika iskusstva," *ibid.,* no. 11 (1935), pp. 269-86; as well as V. Kemenov's "O zhurnale 'Iskusstvo'," *Literaturnyi kritik,* no. 8 (1935), pp. 201-14.

19. N. Gritsonenko, "Ideologicheskii i poligraficheskii brak," *Pravda,* August 22, 1935.

20. A. Karsky, "Protiv uproshchentsev," *Sovetskoe iskusstvo,* May 17, 1935.

21. O. Beskin, "S polichnym," *Iskusstvo,* no. 4 (1935), pp. 32-44.

22. The archives of the Committee on Arts, kept in the Central Archives of Literature and Art in Moscow, are not accessible to Western scholars, However, two books published in the West describe its activities in some detail: Kurt London, *The Seven Soviet Arts* (New Haven, 1938) and Juri Jelagin, *Taming of the Arts* (New York, 1951).

23. January 22, 1936. With the February 11, 1936, issue its publication was taken over by the Committee, which also joined the editorial board of *Iskusstvo.*

24. "Sumbur vmesto muzyki," *Pravda,* January 28, 1936.

25. "M. Nesterov o khudozhestvennoi shkole," *Sovetskoe iskusstvo,* May 11, 1936. Unlike music and the theater, the visual arts were not constantly bombarded with direct orders or injuctions from the Party. There was one specific Party condemnation of non-realist "excesses" in painting—a strongly worded criticism of fanciful, "formalist" illustrations of children's books that failed to provide a simple, happy and loving representation of the world. ("O khudozhnikakh pachkunakh," *Pravda,* March 1, 1936.) But

what was outlined in Party pronouncements in the other fields was scrupulously applied to painting.

26. *Zhizn' khudozhnika* (Moscow, 1963), pp. 69-71. Gerasimov's close connections with Marshal Kliment Voroshilov unquestionably aided his rise to power (and illustrates the Army's continuing role in art politics). His wife was Voroshilov's sister-in-law, and Gerasimov early became one of the official portraitists of the vain commander, whose weakness for seeing his likeness displayed was proverbial.

27. "Protokol soveshchaniya pri direktorate" (Nov. 13, 1936), GTG, OR, Fond 8 II/600, pp. 6-9. Compare the marked up copy of the typed text of the introduction in the catalogue (in GTG, OR, Fond 8 II/13) with the printed text, *Katalog vystavki proizvedenii I. E. Repina* (Moscow, 1936), pp. i-xxi.

28. A. Gerasimov, "Chego my mozhem uchit'sia u Repina?" *Sovetskoe iskusstvo,* May 17, 1936; E. Melikadze, P. Sysoev, "Il'ya Repin," *Novyi mir,* no. 8 (1936), pp. 276-300.

29. Text in GTG, OR, Fond 8 II/608, pp. 72-75.

30. Prices to be paid to the copyists were quite handsome—5,000 rubles for "Boat Haulers" and 8,000 for "The Procession of the Cross in the Kursk Province." *Ibid.,* pp. 60-61.

31. "Zhurnal zasedaniya gruppy po izucheniyu tvorchestva Repina" (June 3, 1937), GTG, OR, Fond 8 II/816, pp. 20-21.

32. Burova's bibliography records no article or exhibit devoted to Kramskoy between 1912 and 1935. This was not the fate of either Repin or Surikov, who had had small exhibits in 1924 and 1927, respectively, and a few publications about them after the Revolution.

33. "Ivan Nikolaevich Kramskoy," *Katalog vystavki k stoletiyu so dnia rozhdeniya* (Moscow-Leningrad, 1937), pp. 5-21.

34. "Vstupitel'naya stat'ia," *I. N. Kramskoy. Pis'ma* (Moscow, 1937), v. 1, pp. xi-lvii.

35. O. Beskin, "O kartine, naturalizme i realizme," *Iskusstvo,* no. 4 (1939), p. 9.

36. See the table of contents and discussions concerning the projected anthology on Surikov, GTG, OR, Fond 8 II/817, pp. 1-35.

37. I have been unable to find the texts of these two speeches. However, ample references to their main points were made during the discussions held by the Tretiakov Gallery's research staff after the opening of the exhibit. GTG, OR, Fond 8 II/680.

38. "Stenogramma zakliuchitel'nogo slova N. M. Shchekotova" (January 23, 1937), *ibid.,* pp. 28-40.

39. The level of the re-editing of the catalogue is conveyed by one example: the original text referred to Levitan's "love of nature"; this was changed to read "love for his native land." Compare the original text in GTG, OR, Fond 8 II/854, pp. 1-24, with "I. I. Levitan," *Katalog vystavki* (Moscow-Leningrad, 1938), pp. 5-18.

40. "Doklad tov. Kemenova na temu 'Nasledie Surikova i voprosy istoricheskoi zhivopisi'," GTG, OR, Fond 8 II/685, p. 51.

41. L. Varshavsky, *Peredvizhniki, ikh proiskhozhdenie i znachenie v russkom iskusstve* (Moscow, 1937); A. Novitsky *Peredvizhniki i vliyanie ikh na russkoe iskusstvo* (Moscow, 1897).

42. R. D., "L. V. Varshavsky 'Peredvizhniki'," *Iskusstvo,* no. 2 (1939), pp. 140-41.

43. The pressure on scholars to rehabilitate the Peredvizhniki and to popularize certain selected aspects of their work was paralleled by similar demands on painters to adopt a readily intelligible style. Little is available in print to indicate the exhortations or their tone that painters were subjected to at meetings of artists' organizations. Kurt

London's *The Seven Soviet Arts* (pp. 223-29) provides the most extensive, and chilling, excerpts from a verbatim record of one such session. See also V. I. Kostin, *K. S. Petrov-Vodkin* (Moscow, 1965), pp. 143-44, for information on how that painter was made to adapt to the stringent requirements of Socialist Realism.

44. Text of speech, "Tezisy doklada o vystavke 'Industriya i sotsializm'," *Stat'i*, pp. 215-21. An uncensored version of Shchekotov's review of the exhibit, "Psevdorealizm," *ibid.*, pp. 207-13. A much diluted version in *Iskusstvo*, no. 4 (1939), pp. 59-84.

45. For writers, consult Nadezhda Mandelstam, *Hope Against Hope* (New York, 1970), p. 150 and *passim*. Correspondence between artists occasionally provides revealing information. Thus, Pavel Korin, a protégé and frequent portraitist of Maxim Gorky, received for his services a studio, an apartment, a regular salary and also certain percentages from reproductions of his likenesses of the famous writer. N. Nesterov's letter of July 24, 1932, to A. Turygin, *M. N. Nesterov. Iz pisem* ed., A. Rusakova (Leningrad, 1968), p. 307. *Khrushchev Remembers* (Boston, 1974), p. 74.

46. The core of *Zhdanovshchina* is contained in four statements issued by the Central Committee: "Resolution on the Journals *Zvezda* and *Leningrad*," August 14, 1946; "On the Repertoire of the Dramatic Theaters and Measures for its Improvement," August 26, 1946; "On the Film 'Bol'shaya zhizn'," September 4, 1946; and "On the Opera 'Velikaya druzhba' by V. Muradeli," February 10, 1948.

47. Statement to musicians made following the resolution on Muradeli's opera, *Soveshchanie deyatelei sovetskoi muzyki v TsKVKP (b)*, (Moscow, 1948), pp. 141-42.

48. A. Zamoshkin, "Novaya ekspozitsiya v Tret'iakovskoi galleree," *Sovetskoe iskusstvo*, March 2, 1945.

49. The tasks of the Academy were more fully elaborated at its first session, held in November 1947. Akademiya khudozhestv SSSR, *Pervaya i vtoraya sessii* (Moscow, 1949), pp. 13-35.

50. A. Gerasimov, "Ob itogakh perestroiki i dal'neishikh zadachakh khudozhestvennogo obrazovaniya" (1950), *Za sotsialisticheskii realizm* (Moscow, 1952), pp. 270-89. See also his "Perestroit' sistemu vospitaniya molodykh khudozhnikov," *Sovetskoe iskusstvo*, July 31, 1948; and the 2nd session of the Academy, held in May, 1948, on the problems of art education: Akademiya khudozhestv SSSR, *Pervaya i vtoraya sessii*, pp. 51-276.

51. "Osnovnye zadachi khudozhestvennogo obrazovaniya," *Iskusstvo*, no. 4 (1948), p. 74.

52. A. Mikhailov, "Repin i peredvizhniki," *I. E. Repin. Sbornik dokladov* (Moscow, 1947), pp. 36-78; A. Gerasimov, "Luchshie traditsii russkoi zhivopisi," *Sovetskoe iskusstvo*, May 30, 1947. Abram Efros, who for a brief moment after 1945 tried to prevent the canonization of all the Peredvizhniki, was first denounced and then was no longer published. See the bibliography of Efros' works appended to his *Dva veka russkogo iskusstva* (Moscow, 1969), pp. 300-02.

53. "Velikoe nasledstvo," *Iskusstvo*, no. 4 (1947), pp. 17-22.

54. *Ibid.*, p. 9.

55. V. Prytkov, E. Poleshchuk, "Sokrovishcha russkogo iskusstva," *Sovetskoe iskusstvo*, December 18, 1948.

56. I Matsa, ed., *Sovetskoe iskusstvo za 15 let* (Moscow, 1933); V. Lobanov; *Khudozhestvennye gruppirovki za poslednie 25 let* (Moscow, 1930).

57. Lenin's plan for monumental propaganda was utilized to prove this contention: M. Neiman, "Lenin i monumental'noe iskusstvo, *Sovetskoe iskusstvo*, April 25, 1947; P. I. Lebedev, "Iz istorii sovetskogo iskusstva," *Iskusstvo*, no. 1 (1949), pp. 62-70; P. I. Lebedev, *Sovetskoe iskusstvo v period voennoi interventsii i grazhdanskoi voiny* (Moscow, 1949). On AKhRR see M. Neiman, "Tridsatiletnii put'," *Sovetskoe iskusstvo*, December 4, 1948; P. Lebedev, "Iz istorii sovetskogo iskusstva," *Iskusstvo*, no. 4 (1953),

pp. 37-50.

58. *Perepiska s P. M. Tret'iakovym. 1873-1898* (Moscow-Leningrad, 1946); *I. E. Repin i I. N. Kramskoy. Perepiska. 1873-1885* (Moscow-Leningrad, 1949); *I. E. Repin i V. V. Stasov. Perepiska,* 3 vols. (Moscow-Leningrad 1948-1950). Smaller selections of his correspondence with Leo Tolstoy and similarly "concerned" writers and painters were also published.

59. "Iskusstvo na sluzhbu naroda," *Iskusstvo,* no. 2 (1948), p. 6. Grabar's equally meticulous biography of Serov was ready for publication in 1952, but did not appear until 1965.

60. N. M. Shchekotov, ed., *Pis'ma Van Goga* (Moscow, 1937). "Dolg sovetskikh iskusstvovedov," *Iskusstvo,* no. 5 (1950), pp. 3-6.

61. "Khudozhnik–borets peredovoi linii ideologicheskogo fronta," *ibid.,* no. 6 (1948), p. 121.

62. The most extreme example of this trend was a book consisting of tendentiously selected quotations from Repin, Kramskoy, Stasov and others, all critical of the superficial brilliance and the absence of political commitment among Western artists. It was aptly entitled: *The Degenerate Art of the West before the Judgment of Russian Realists* [*Upadochnoe iskusstvo Zapada pered sudom russkikh khudozhnikov-realistov* (Moscow-Leningrad, 1949)] and was written by S. Varshavsky.

63. *Soveshchanie deyatelei sovetskoi muzyki v TsKVKP (b),* p. 139. A. Gerasimov, "Stasov i izobrazitel'noe iskusstvo" (1949), *Za sotsialisticheskii realizm,* pp. 67-69.

64. A. Kamensky, "Razmyshleniya u poloten sovetskikh khudozhnikov," *Novyi mir,* no. 7 (1956), pp. 190-203. A. Lebedev, "Slovo s preds'ezdovskoi tribuny," *Iskusstvo,* no. 6 (1956), pp. 7-10.

65. Text in *Materialy pervogo vsesoyuznogo s'ezda sovetskikh khudozhnikov* (Moscow, 1958), pp. 331-39. Though a voluntary body, the Union is an institution whose services and benefits few Soviet artists can afford, or are willing, to forego. It plays a major role in awarding the generous government commissions (between 1969 and 1972, they amounted to more than 15 million rubles). It holds more than 2,000 art exhibits each year from the local to the all-union levels and confers upon the painters one of the four grades of "honored" or "people's" artists of the national republic or the USSR (and climbing up this exhibits ladder, which in turn leads to the acquisition of honorific titles, is the tangible sign of success for Soviet painters, just as progressing through the Academic ranks had been in Tsarist times). The Union allocates art studios and sends artists abroad; it builds housing and manages extensive medical care and resort facilities for its more than 15,000 members. See "Novye formy organizatsii tvorcheskoi zhizni khudozhnikov," *Iskusstvo,* no. 9 (1967), pp. 2-4.

66. See the opening address by Boris Yoganson, the new President of the Academy in *Iskusstvo,* no. 3 (1957), pp. 5-8, and the report on the activities of the Academy for the years 1954-58 by Petr Sysoev, its Scientific Secretary. Akademiya khudozhestv SSSR, *Sessii. Odinadtsataya i dvenadtsataya* (Moscow, 1959), pp. 7-42.

67. John Berger, *Art and Revolution. Ernst Neizvestny and the Role of Artists in the USSR* (London, 1969), pp. 81-85.

68. A. Ginevsky, "Nakanune s'ezda," *Iskusstvo,* no. 3 (1956), pp. 21-25; "Traditsii i novatorstvo," *ibid.,* no. 2 (1956), pp. 17-22; D. Sarabianov, "Itogi i perspektivy v sovremennon sovetskom izobrazitel'nom iskusstve," *Vestnik istorii mirovoi kul'tury,* no. 5 (1957), pp. 132-43; R. Kaufman, "Vazhneishaya zadacha iskusstvoznaniya," *Moskovskii khudozhnik,* no. 10 (1962), p. 2; D. Sarabianov, "Sozdat' ob'ektivnuyu istoriyu sovetskogo iskusstva," *ibid.,* no. 11 (1962), p. 2; A. N. Tikhomirov's statement at the 11th session of the Academy (1958), Akademiya Khudozhestv SSSR, *Sessii. Odinadtsataya i dvenadtsataya,* pp. 88-90.

69. Quoted from his "Pis'ma ob iskusstve" (1893), by A. Ginevsky, "Nakanune s'ezda," p. 23. A. Lebedev, "Slovo s preds'ezdovskoi tribuny," p. 7

70. Consult the Party decree on literary and artistic criticism: "O literaturno-khudozhestvennoi kritike," *Pravda,* January 25, 1972, and Brezhnev's call for deeper "printsipial'nost' " to assure more significant progress in literature and art, made at the 24th Party Congress in 1972. *XXIV S'ezd Kommunisticheskoi partii Sovetskogo Soyuza. Stenograficheskii otchet* (Moscow, 1972), v. 1, p. 113.

71. For example, art colleges *(khudozhestvennye uchilishcha)* that train secondary school teachers offer courses in the history of Russian art in which 20 hours out of 100 are devoted to the Peredvizhniki.

72. Similar selective censorship existed in Tsarist Russia during the waning days of the Empire. For example, Ge's excruciatingly vivid pictures of the crucifixion, found objectionable by the Church, could not be reproduced as cheap post-cards or in the newspapers, but they could appear in expensive art albums. TsGIA, Fond 777, op. 5, no. 27 (1903), p. 1.

73. A. D. Alekseev et al., eds., *Russkaya khudozhestvennaya kul'tura kontsa XIX i nachala XX veka,* 2 vols. (Moscow, 1968-69); N. I. Sokolova, V. V. Vanslov, eds., *Puti razvitiya russkogo iskusstva kontsa XIX-nachala XX veka* (Moscow, 1972); D. V. Sarabianov, *Russkaya zhivopis' kontsa 1900-kh–nachala 1910-kh godov* (Moscow, 1971). Though some recent general histories of Russian and Soviet art contain reproductions of non-figurative art, the commentary accompanying these illustrations is far from objective. See I. E. Grabar, ed., *Istoriya russkogo iskusstva* (Moscow, 1969), v. 10, pt. 2; B. Veimarn et al., eds., *Istoriya sovetskogo iskusstva* (Moscow, 1965), v. 1. G. Yu. Sternin, *Khudozhestvennaya zhizn' Rossii na rubezhe XIX-XX vekov* (Moscow, 1970). E. Gomberg-Verzhbinskaya, ed., *Vrubel'. Perepiska, vospominaniya o khudozhnike* (Leningrad, 1963); M. Kopshitser, *Savva Mamontov* (Moscow, 1972). D. Sarabianov, *P. A. Fedotov i russkaya khudozhestvennaya kul'tura 40-kh godov XIX veka* (Moscow, 1973).

74. M. Alpatov, *Etiudy po istorii russkogo iskusstva,* 2 vols. (Moscow, 1967). N. Kalitina, "Peredvizhniki i frantsuskie khudozhniki," *Iskusstvo,* no. 5 (1972), pp. 56-63; D. Sarabianov, "Russkaya realisticheskaya zhivopis' vtoroi poloviny XIX veka sredi evropeiskikh shkol," *Vestnik moskovskogo universiteta* (Istoriya), no. 1 (1974), pp. 54-73.

75. D. Sarabianov, *Narodno-osvoboditel'nye idei russkoi zhivopisi vtoroi poloviny XIX veka* (Moscow, 1955). I. A. Brodsky, ed., *I. E. Repin. Izbrannye pis'ma,* 2 vols. (Moscow, 1969). E. Gomberg-Verzhbinskaya *Peredvizhniki* (Leningrad, 1970), pp. 42-43.

76. B. V. Asafev, *Russkaya zhivopis'. Mysli i dumy* (Moscow-Leningrad, 1966), pp. 41-43. Yu. Keldysh, M. Yankovsky, eds., *V. V. Stasov, Pis'ma k rodnym* (Moscow, 1958), v. 2, p. 23. M. Alpatov stated at the First Congress of Artists that not all of Stasov's judgments have withstood the test of time, *Iskusstvo,* no. 3 (1957), p. 11. A similar opinion is expressed in V. N. Volkova, *Iz istorii russkoi khudozhestvennoi kritiki, 70--80-e gody XIX veka* (unpublished dissertation for the degree of *Kandidat,* Institute of the History of Arts, Ministry of Culture, Moscow, 1972).

77. "Iz literaturnogo naslediya A. V. Lunacharskogo," *Novyi mir,* no. 9 (1966), pp. 240-44. E. Shchedrin, "Vzgliady Lunacharskogo na stankovuyu kartinu," *Iskusstvo,* no. 5 (1973), pp. 47-50; A. Kamensky, "Revoliutsiya i problemy khudozhestvennogo naslediya" (1970), *Vernisazhi* (Moscow, 1974), pp. 123-48.

78. E. Gomberg-Verzhbinskaya, *Russkoe iskusstvo i revoliutsiya 1905 goda* (Leningrad, 1960); Z. I. Krapivin, "Iz zhizni i tvorchestva I. E. Repina v Parizhe," *Novoe o Repine* (Moscow, 1969), pp. 380-84. A. K. Lebedev, A. V. Solodovnikov, *V. V. Stasov, Zhizn' i tvorchestvo* (Moscow, 1966); K. A. Sitnik, "Stasov, khudozhestvennyi kritik," *Voprosy teorii sovetskogo izobrazitel'nogo iskusstva* (Moscow, 1960), pp. 260-314. *Stanovlenie sotsialisticheskogo realizma v sovetskom izobrazitel'nom iskusstve* (Moscow,

1960); I. M. Gronsky, V. N. Perelman, eds., *Assotsiatsiya khudozhnikov revoliutsionnoi Rossii* (Moscow, 1973).

79. V. Vishniakov, "Tvorcheskii podvig peredvizhnikov," *Kommunist,* no. 2 (1972), pp. 82-83; N. Tomsky, "Vechno zhivye traditsii," *Pravda,* December 13, 1971; Yur. Nekhoroshev, "Vek realizma," *Izvestiya,* December 11, 1971.

80. V. Volkova, "Znachenie peredvizhnikov," *Iskusstvo,* no. 11 (1971), pp. 57-63; A. A. Fedorov-Davydov, "Chemu uchit'sia u peredvizhnikov," *Tvorchestvo,* no. 11 (1971), pp. 14-15, G. Yu. Sternin, "Peredvizhniki," *Ibid.,* no. 10 (1971), pp. 14-18.

THE FOUNDING MEMBERS OF THE ARTEL

Dmitriev-Orenburgsky, Nikolai Dmitrievich, 1838-98
Grigorev, Alexander Konstantinovich, 1837-86
Korzukhin, Alexei Ivanovich, 1835-94
Kramskoy, Ivan Nikolaevich, 1837-87
Lemokh, Karl Vikentevich, 1841-1910
Litovchenko, Alexander Dmitrievich, 1835-90
Makovsky, Konstantin Egorovich, 1839-1915
Morozov, Alexander Ivanovich, 1835-1904
Peskov, Mikhail Ivanovich, 1834-64
Petrov, Nikolai Petrovich, 1834-76
Shustov, Nikolai Semenovich, 1834-68
Venig, Bogdan Bogdanovich, 1837-72
Zhuravlev, Firs Sergeevich, 1836-1901

THE ASSOCIATION OF TRAVELING ART EXHIBITS

The Founding Members, 1870

Ge, Nikolai Nikolaevich, 1831-94
Kamenev, Lev Lvovich, 1833-86
Klodt, Mikhail Konstantinovich, 1832-1902
Klodt, Mikhail Petrovich, 1835-1914
Korzukhin, Alexei Ivanovich, 1835-94
Kramskoy, Ivan Nikolaevich, 1837-87
Lemokh, Karl Vikentevich, 1841-1910
Makovsky, Konstantin Egorovich, 1839-1915
Makovsky, Vladimir Egorovich, 1846-1920
Miasoedov, Grigori Grigorevich, 1834-1911
Perov, Vasili Grigorevich, 1833-82
Prianishnikov, Illarion Mikhailovich, 1840-94
Savrasov, Alexei Kondratevich, 1830-97
Shishkin, Ivan Ivanovich, 1832-98
Yakobi, Valeri Ivanovich, 1834-1902

The Better-Known Subsequent Members

1872	Maksimov, Vasili Maksimovich, 1844-1911
1874	Savitsky, Konstantin Apollonovich, 1844-1905
1875	Kuindzhi, Arkhip Ivanovich, 1842-1910
1876	Yaroshenko, Nikolai Alexandrovich, 1846-98
1878	Polenov, Vasili Dmitrievich, 1844-1927
	Repin, Ilya Efimovich, 1844-1930
	Vasnetsov, Viktor Mikhailovich, 1848-1926
1881	Surikov, Vasili Ivanovich, 1848-1916

DRAFT STATUTES OF THE ASSOCIATION OF TRAVELING EXHIBIT*

Aim

The founding of the Association of Traveling Exhibit has as its aim: to provide the inhabitants of the provinces with the opportunity to keep up with the achievements of Russian art. In this way, the Association endeavors to broaden the circle of art-lovers, thereby opening up new opportunities for marketing works of art.

Rights

The Association has the right to organize exhibits of works of art in all the cities of the Russian Empire.

Composition

Only full-time artists may be members of the Association; all members of the Association must be active members.

Membership

Every artist who has some reputation in the world of art may become a member of the Association if he so wishes. Persons unknown to the Association present their works to the annual General Meeting and upon acceptance of their pictures for exhibit, they are enrolled as members of the Association.

Responsibilities

Each member of the Association pledges to present a canvas for exhibit by a definite deadline.

Paintings intended for exhibit must be painted for that exhibit (that is, they must be unknown to the public.) (Exceptions can be made for works above average in quality.)

At its discretion, the Association may make exceptions for the benefit of society.

*"Proekt ustava Tovarishchestva podvizhnoi vystavki," G.G. Miasoedov, *Pis'ma, dokumenty, vospominaniya,* pp. 50-54.

Rules of Administration

All matters pertaining to a traveling exhibit are decided either by the General Meeting or by the Executive Board of the exhibit, by majority vote according to secret ballot.

The General Meeting

It convenes once a year. This annual meeting reviews the actions of the Executive Board for the past year, examines the account books, elects new members of the Executive Board, accepts as members of the Association those persons wishing to join whom it deems capable of making a contribution, fixes the date for the next exhibit, and distributes the sums available for distribution in accordance with the valuation of the paintings that have been exhibited during the past year.

The Executive Board

The Executive Board consists of those persons elected at the General Meeting to manage matters pertaining to the exhibit. The number of members of the Executive Board is determined by the General Meeting in keeping with the interests of the exhibit.

The Executive Board is divided into two sections for the management of the exhibit in both capitals.

All matters are decided by majority vote, decisions thus arrived at are made by both sections constituting one body. Those unable to appear in person may give written power of attorney or express their thoughts in writing.

The capital in which a majority of the members of the Executive Board is present is designated as the seat of the Executive Board. Financial and all others matters are conducted there.

The following matters are subject to the jurisdiction of the Executive Board:

Determining the itinerary of the exhibit. Finding a location for the exhibit.

Election of a person to accompany it.

Valuation of paintings, to serve as a basis for apportioning the proceeds of the exhibit among members.

Acquisition of items necessary for the exhibit.

Determining who will receive loans and disbursing them.

The following matters are subject to decision by each of the sections:

Acceptance of paintings submitted for exhibit (in case of refusal, the dissatisfied party may appeal either to the other section or to the General Meeting).

Determining who is to receive loans.

Receipts

The Executive Board fixes the extrance fee at its discretion.

The entrance fee, as well as the five percent fee from the items sold at the exhibit, constitute the income from the exhibit.

Capital necessary for the operating expenses of the exhibit is set aside from the receipts of the exhibit. Its amount is determined by the General Meeting.

On accumulation of this capital [i.e., operating expenses], all receipts, with the exception of the five percent fee, are subject to distribution among the members of the Association in accordance with the valuation of their works, determined by the Executive Board of the exhibit.

The sum which is accumulated from the five percent fee is earmarked for loans to those members of the Association who, for lack of funds, would not be able to complete paintings intended for exhibit, as well as for the purchase of frames, which remain the property of the exhibit, and in case of the sale of a painting the cost of the frame is deducted from the sum received for the painting.

The money of the Association is kept in a treasury at the Executive Board which is empowered to elect a treasurer from among its members.

Traveling Exhibit

An exhibit opens in one of the capitals; if the results of the exhibit are financially satisfactory and the money collected amounts to a sum sufficient to cover the expenses of transportation, then the Association's exhibit will be sent from the capitals to those cities in provincial Russia which will be selected by the Executive Board.

En route, the paintings are insured to the value determined by their creators. The exhibit is accompanied by one of the members of the Association at the Association's expense. When necessary, an assistant is provided.

The Association compiles albums of the exhibit, produced by means it deems best for their sale at the exhibit.

Albums and drawings are delivered to the buyer immediately. Paintings are delivered after the exhibit returns to its place of origin, the buyer having made a down-payment on part of the price in return for a receipt signed by the Association. The sold paintings are shipped at the expense of the painter. The price of a painting offered for sale is determined by its creator.

The person who accompanies the exhibit is given the itinerary, a book listing the paintings, their content and value, and a book for keeping income and expenses.

WORKS DISPLAYED AT THE FIRST
PEREDVIZHNIK EXHIBIT IN ST. PETERSBURG*

V. Perov : "Hunters at Rest"
"Fisherman"
Portraits of A. Ostrovsky, Stepanov, Mrs. Timashev

A. Bogoliubov: "Morning after the Storm" (drawing)
"Ayu-dag in the Crimea" (drawing)
"A View of Odessa"
"Fishing for Sturgeon in the Don"
"A View of Arnheim in Holland"

I. Shishkin: "Evening"
"Forest" (copper engraving)
"Pine Forest" (ink drawing)

G. Miasoedov: "Berry Picking"
"Grandfather of the Russian Navy"

N. Ge: "Peter I Questions Tsarevich Alexis in Peterhoff"
Portraits of T.P. Kostomarov, I.S. Turgenev, Mr. Shif

L. Kemenev: "Summer Night"
"Fall"

V. Maksimov: "A Hamlet in Chernigov Province" (drawing)
"A Hut in Kiev Province" (drawing)
"A Hut in Chernigov Province"

S. Ammosov: "Fall"

I. Prianishnikov: "A Convoy of Empty Sleds"
"Burned-out Family"

M.K. Klodt: "Noon"
"View of Kiev from Mr. Muravev's Garden"

*I. M. Grigoreva, "K 85-letiyu pervoi peredvizhnoi vystavki Tovarishchestva khu-dozhestvennykh vystavok," GTG, *Materialy,* v. 1, pp. 136-37.

K. Gun: "View of a Village in Normandy"
"Bust of an Old Man in a Helmet"
"Portal of the Chartres Cathedral in France" (watercolor)
"Interior of the Dieppe Cathedral in France" (watercolor)
"A View of the Pyrenées" (drawing)

M.P. Klodt: "A Monk Sewing" (watercolor)

A. Savrasov: "The Rooks Have Come"
"Forest Road"

I. Kramskoy: "Ready to Shoot"
"May Night"
"Sketch from Nature"
Portraits of Graf F. Litke, F. Vasilev, M.K. Klodt,
 M. Antokolsky

V. Ammon: "An Alley"
"A Landscape"

F. Kamensky: "After Gathering Mushrooms" (sculpture)

BIBLIOGRAPHY

This is not a full, systematic bibliography; what follows is a listing of the bulk of published primary sources and secondary works cited in the text and consulted. (Archival materials are cited in the footnotes.) If some monographs and other writings are not listed, this does not necessarily mean that they have not been of value to me in the preparation of this book. Those readers who seek more extensive bibliographies may wish to consult the following reference works:

Akademiya khudozhestv SSSR, Nauchnaya biblioteka. *Raboty i materialy,* Vol. 5. *Materialy k bibliografii po istorii Akademii khudozhestv, 1757-1957.* L. 1957.

Burova, G., Gaponova, O., Rumiantseva, V. *Tovarishchestvo peredvizhnykh khudozhestvennykh vystavok.* 2 vols. M. 1959.

Ostroy, O.S. *Russkie spravochnye izdaniya po izobrazitel'nomu i prikladnomu iskusstvu.* M. 1972.

* * *

Akademiya khudozhestv SSSR. *Sessii.* M. 1949-.

Akhsharumov, N.D. "Zadachi zhivopisi v period obrazovaniya russkoi narodnoi shkoly." *Vestnik iziashchnykh iskusstv,* II, 2 & 3 (1884): 143-68, 171-93.

Alekseeva, T.V. "A.G. Venetsianov i razvitie bytovogo zhanra." *Istoriya russkogo iskusstva,* VIII, 1. Ed. I.E. Grabar. M. 1963.

Alpatov, M. *Etiudy po istorii russkogo iskusstva.* 2 vols. M. 1967.

Altaev, M. "Khudozhnik narodnik." *Golos minuvshego,* II, 6 (June 1914): 59-69.

Altaeva, A. *Pamiatnye vstrechi.* M. 1946.

Ambler, E. *Russian Journalism and Politics: 1861-1888. The Career of Aleksei S. Suvorin.* Detroit, 1972.

Anichkov, I. *Opisanie kartinnoi gallerei Tainogo Sovetnika Fedora Ivanovicha Prianishnikova.* SPb. 1853.

Antokolsky, M. "Zametki ob iskusstve." *Vestnik Evropy,* XXXII, 2 (March 1897): 524-66.

Antokolsky, M. "Iz avtobiografii." *Vestnik Evropy, XXII, 9* (September 1887): 68-108.

Asafev, B. *Russkaya zhivopis'. Mysli i dumy.* M.-L. 1966.

Assotsiatsiya khudozhnikov revoliutsionnoi Rossii. Sbornik vospominanii, statei, dokumentov. Ed. I.M. Gronsky, V.N. Perelman. M. 1973.

Avdaev, A. "Vystavka Imperatorskoi Akademii khudozhestv v S. Peterburge." *Russkii vestnik,* VIII, 2 (1857): 143-62.

Benois, A. *Istoriya russkoi zhivopisi v XIX veke.* SPb. 1901-02.

Berlin, P.A. *Russkaya burzhuaziya v staroe i novoe vremia.* M. 1927.

Besançon, A. "The Dissidence in Russian Painting (1860-1922)." *The Structure of Russian History.* Ed. M. Cherniavsky. New York, 1970.

Bialyi, A. *V.M. Garshin i literaturnaya bor'ba vosmidesiatykh godov.* M. 1937.

Bogoliubov, A.P. *Vospominaniya o v Boge pochivshem Imperatore Alexandre III.* SPb. 1895.

Bor'ba za realizm v izobrazitel'nom iskusstve 20-kh godov. Materialy, dokumenty, vospominaniya. Ed. V.N. Perelman. M. 1962.

Botkina, A.P. *P.M. Tret'iakov v zhizni i iskusstve.* M. 1960.

Bowlt, J.E. "Early Soviet Art," *Art and Artists,* November 1975: 34-43.

Bowlt, J.E. "Soviet Art in the 1970s." *The Soviet Union: The Seventies and Beyond.* Ed. B.W. Eissenstadt. Lexington, Mass., 1975.

Bowlt, J.E. , ed. *Russian Art of the Avant-Garde: Theory and Criticism, 1902-1934.* New York, 1976.

Bowlt, J.E. "The Virtues of Soviet Realism." *Art in America,* Nov.-Dec. 1972: 100-07.

Brodsky, I.A. *Isaak Izrailevich Brodsky.* M. 1973.

Brower, D.R. *Training the Nihilists. Education and Radicalism in Tsarist Russia.* Ithaca, NY, 1975.

Buryshkin, P.A. *Moskva kupecheskaya.* New York, 1954.

Buslaev, F. *Moi dosugi.* 2 vols. M. 1886.

Buslaev, F. "Zadachi sovremennoi esteticheskoi kritiki." *Russkii vestnik,* Vol. 77 (1868): 273-336.

Chekhov, A. "Dom s mezoninom. Rasskaz khudozhnika" (1896). *Izbrannye sochineniya,* Vol. 2. M. 1962.

Chen, J. *Soviet Art and Artists.* London, 1944.

Cherniavsky, M. "Old Believers and New Religion." *The Structure of Russian History.* Ed. M. Cherniavsky. New York, 1970.

Chernyshevsky, N.G. "The Aesthetic Relation of Art to Reality" (1853). *Selected Philosophical Essays.* M. 1953.

Chernyshevsky, N.G. "Polemicheskie krasoty. Kollektsiya vtoraya" (1861), *Polnoe sobranie sochinenii,* Vol. 7. M. 1950.

Chernyshevsky, N.G. "Zametki po povodu predydushchei stat'i" (1858). *Polnoe sobranie sochinenii,* Vol. 5. M. 1950.

4 goda AkhRR. 1922-1926. Sbornik. Ed. A. V. Grigorev et al. M. 1926.

Chicherin, B. *Vospominaniya,* Vol. 3. M. 1934.

Cox, W.A. "The Art World and *Mir Iskusstva.* Studies in the Development of Russian Art. 1890-1905." Ph.D. dissertation, University of Michigan, 1970.

Curran, M.W. "Vladimir Stasov and the Development of Russian National Art: 1850-1906." Ph.D. dissertation, University of Wisconsin, 1965.

Dintses, L. *Neopublikovannye karikatury "Iskry" i "Gudka." 1861-1862 gody.*

M.-L. 1939.

Dintses, L. *Realizm 60-80 gg.* L. 1931.

Dmitriev, I. "Rassharkivayushcheesia iskusstvo." *Iskra,* No. 38 (October 4, 1863): 521-30.

Dmitrieva, N.A. *Moskovskoe uchilishche zhivopisi, vayaniya i zodchestva.* M. 1951.

Dmitrieva, N.A. "Iz istorii russkoi khudozhestvennoi kritiki." *Iskusstvo,* No. 2 (1950): 85-91.

Dobroliubov, N. "Russkaya satira v vek Ekateriny" (1859). *Sobranie sochinenii,* Vol. 5. M.-L. 1962.

Dostoevsky, F.M. "A propos of the Exhibition" (1873). *The Diary of a Writer.* Ed. B. Brasol. New York, 1954.

25 let russkogo iskusstva. Illiustrirovannyi katalog khudozhestvennogo otdela vserossiiskoi vystavki v Moskve 1882 g. SPb. 1882.

Easton, M. *Artists and Writers in Paris. The Bohemian Idea, 1803-1867.* London, 1964.

Efros, A. *Dva veka russkogo iskusstva.* M. 1969.

Efros, A. "Vchera, segodnia, zavtra," *Iskusstvo,* No. 6 (1933): 15-64.

Fedorov-Davydov, A. *V.G. Perov.* M. 1934.

Fedorov-Davydov, A. *Realizm v russkoi zhivopisi XIX veka.* M.-L. 1933.

Fedorov-Davydov, A. *Russkoe iskusstvo promyshlennogo kapitalizma.* M. 1929.

Fitzpatrick, S. *The Commissariat of Enlightenment. Soviet Organization of Education and the Arts under Lunacharsky.* Cambridge, 1970.

Friche, V., ed. *Russkaya zhivopis' XIX veka.* M. 1929.

Galkina, N. "Materialy k istorii Moskovskogo obshchestva liubitelei khudozhestv." Gosudarstvennaya Tret'iakovskaya galereya. *Materialy i issledovaniya,* Vol. 2. M. 1958.

Garshin, V. "Chetyre dnia" (1877); "Denshchik i ofitser" (1880); "Khudozhniki" (1879); "Konkurs na postoyannoi vystavke khudozhestvennykh proizvedenii" (1877); "Pis'mo k I.N. Kramskomu" (1878); "Zametki o khudozhestvennykh vystavkakh" (1877). *Polnoe sobranie sochinenii.* SPb. 1910.

Ge, N. "Vstrechi." *Severnyi vestnik,* IX, 3, 1 (March 1894): 233-40.

Ge, N. "Zhizn' khudozhnika shestidesiatykh godov." *Severnyi vestnik,* VIII, 3, 1 (March 1893): 266-87.

Gerasimov, A. *Za sotsialisticheskii realizm.* M. 1952.

Gerasimov, A. *Zhizn' khudozhnika.* M. 1963.

Gerts, K. "Novyi ustav Akademii khudozhestv." *Russkii vestnik,* XXVIII, 2 (1860): 149-57.

Ginzburg, I. "Iz predistorii peredvizhnichestva." *Iskusstvo,* No. 2 (1938): 103-108.

Ginzburg, I. "Russkaya akademicheskaya zhivopis' 1870-80 gg." *Iskusstvo,* No. 5 (1934): 95-127.

Glagol, S. "V.I. Surikov. Iz vstrech s nim i besed." *Nasha starina,* No. 2 (1917): 58-78.

Goldshtein, S.N. *Ivan Nikolaevich Kramskoy. Zhizn' i tvorchestvo.* M. 1965.

Goldshtein, S.N. "Iz istorii sozdaniya proizvedeniya I.N. Kramskogo 'Nekrasov v period poslednikh pesen'." Gosudarstvennaya Tret'iakovskaya galereya. *Materialy i issledovaniya,* Vol. 2. M. 1958.

Goldshtein, S.N. *Kommentarii k izbrannym sochineniyam V.V. Stasova.* M. 1938.

Gomberg-Verzhbinskaya, E. *Peredvizhniki.* L. 1970.

Gomberg-Verzhbinskaya, E. *Russkoe iskusstvo i revoliutsiya 1905 goda.* L. 1960.

Gorkin, M. "The Interrelation of Painting and Literature in Russia." *Slavonic and East European Review,* Vol. 25 (1946-47): 134-49.

Grabar, I.E., ed. *Istoriya russkogo iskusstva,* VIII, 1 & 2; IX, 1 & 2; X, 1 & 2. M. 1963-69.

Grabar, I.E. *Repin.* 2 vols. M. 1963-64.

Grabar, I.E. *The Russian Art Exhibition.* New York, 1924.

Grabar, I.E. "Upadok ili vozrozhdenie." *Niva,* No. 1 (1897): 38-74; No. 2 (1897): 298-314.

Graham, L. *The Soviet Academy of Sciences and the Communist Party, 1927-1932.* Princeton, NJ, 1967.

Grana, C. *Bohemian versus Bourgeois. French Society and the French Men of Letters in the Nineteenth Century.* New York-London, 1964.

Gray, C. "The Genesis of Socialist Realist Painting." *Survey,* No. 27 (1959): 32-39.

Gray, C. *The Russian Experiment in Art. 1863-1922.* London, 1970.

Grigoreva, M. "K 85-letiyu pervoi vystavki Tovarishchestva peredvizhnykh khudozhestvennykh vystavok." Gosudarstvennaya tret'iakovskaya galereya. *Materialy i issledovaniya,* Vol. 1. M. 1956.

Hamilton, G.H. *The Art and Architecture of Russia.* Baltimore, 1954.

Hamilton, G.H. *Manet and His Critics.* New Haven, Conn., 1954.

Harcave, S. *The First Blood.* New York, 1964.

Herzen, A. "A.A. Ivanov." *Kolokol,* No. 22 (September 1, 1858): 177-78.

Herzen, A. "N.G. Chernyshevsky." *Kolokol,* No. 186 (June 15, 1864): 1525.

"Imperator Nikolai Petrovich i russkie khudozhniki v 1839 g." *Russkaya starina,* Vol. 21 (1878): 347-56.

International Exhibition, 1862. *Official Catalogue of the Fine Art Department.* London, 1862.

"Iz pisem K.A. Ukhtomskogo k N.A. Ramazanovu, 1852-1865." *Russkii arkhiv,* XLV, 4 (1907): 523-69.

Isakov, S.K. *Akademiya khudozhestv.* L.-M. 1940.

Jelagin, J. *Taming of the Arts.* New York, 1951.

Kamensky, A. "Razmyshleniya u poloten sovetskikh khudozhnikov," *Novyi*

mir, No. 7 (1956): 190-203.

Kamensky, A. *Vernisazhi*. M. 1974.

Katsman, E. "Kak sozdavalas' AKhRR." *4 goda AKhRR*. M. 1926.

Kavelin, K. "Istoricheskii zhanr na XV vystavke Tovarishchestva peredvizhnykh vystavok." *Istoricheskii vestnik*, Vol. 28 (April-June 1887): 243-48.

Kemenov, V. *Istoricheskaya zhivopis' Surikova*. M. 1963.

Kemenov, V. "Protiv formalizma i naturalizma v zhivopisi." *Pravda*, March 6, 26, 1936.

Kemenov, V. *Stat'i ob iskusstve*. M. 1956.

Kiselev, A. "Etiudy po voprosam iskusstva." *Artist*, No. 28 (March 1893): 120-25; No. 29 (April 1893): 43-51; No. 30 (October 1893): 63-70; No. 31 (November 1893): 48-53.

Klimoff, E. "Russian Architecture, 1880-1910." *Apollo*, No. 142 (December 1973): 436-47.

Kniazeva, V. *AKhRR. Assotsiatsiya khudozhnikov revoliutsionnoi Rossii*. L. 1967.

Kommunisticheskaya Akademiya. *Iskusstvo v SSSR i zadachi khudozhnikov. Disput*. M. 1928.

Kondakov, S.N. *Yubileinyi spravochnik Imperatorskoi Akademii khudozhestv, 1764-1914*. 2 vols. SPb. 1914.

Konenkov, S. *Moi vek.* M. 1972.

Koni, A.F. "Pamiati Konstantina Dmitrievicha Kavelina." *Sobranie sochinenii K.D. Kavelina*, Vol 3. SPb. 1899.

Kopshitser, M. *Savva Mamontov*. M. 1972.

Kopshitser, M. *Valentin Serov*. M. 1967.

Korkunov, N.M. *Russkoe gosudarstvennoe pravo*, Vol. 1. SPb. 1909.

Kornilov, A. *Obshchestvennoe dvizhenie pri Alexandre II*. Paris, 1905.

Korolenko, V.G. "Dve Kartiny" (1887). *Sobranie sochinenii*, Vol. 8. M. 1955.

Korolenko, V.G. *The Story of My Contemporary*. London, 1972.

Koshelov, A. *Zapiski, 1812-1883 gody*. Berlin, 1884.

Kostin, V.I. *K.S. Petrov-Vodkin*. M. 1965.

Kovalenskaya, N.N. "Russkii zhanr nakanune peredvizhnichestva. Khudozhestvennye i sotsial'nye osobennosti Moskvy." *Russkaya zhivopis' XIX veka*. Ed. V. Friche. M. 1929.

Kovalevsky, P.M. "O khudozhestvakh i khudozhnikakh v Rossii." *Sovremennik*, LXXXIII, 3 (September-October 1860): 363-82.

Kovalevsky, P.M. "O nashikh khudozhestvakh i khudozhnikakh." *Otechestvennye zapiski*, CLXXVII, 2 (1868): 25-31.

Kovtun, E. "Zabytyi kritik-shestidesiatnik." *Iskusstvo*, No. 6 (1955): 66-69.

Kramskoy, I.N. *Ivan Nikolaevich Kramskoy. Pis'ma. Stat'i*. 2 vols. Ed. S.N. Goldshtein. M. 1965-66.

Kramskoy, I.N. *Katalog vystavki k stoletiyu so dnia rozhdeniya*. M.-L. 1937.

Kramskoy, I.N. *Perepiska I.N. Kramskogo*, Vol. 1. (*I.N. Kramskoy i P.M.*

Tret'iakov). Ed. S.N. Goldshtein. M. 1953. Vol. 2 (*Perepiska s khudozhnikami*). Ed. E.G. Levenfish. M. 1954.

Kuzminsky, K.S. *Russkaya realisticheskaya illiustratsiya XVIII i XIX vekov.* M. 1937.

Lapshin, V. "Khudozhestvannaya zhizn' 1871 goda i pervaya peredvizhnaya vystavka." *Iskusstvo,* No. 12 (1971): 55-62.

Lapshin, V. *Soyuz russkikh khudozhnikov.* L. 1974.

Lapshin, V. "Stranitsy khudozhestvennoi zhizni Moskvy i Petrograda v 1917 godu." *Iskusstvo,* No. 4 (1969): 32-42.

Lebedev, A.K. "Iz sekretnykh arkhivov samoderzhaviya." *Iskusstvo,* No. 4 (1965): 65-68.

Lebedev, A.K., Burova, G. *Tvorcheskoe sodruzhestvo. M.M. Antokol'sky i V. V. Stasov.* L. 1968.

Lebedev, A.K., Melikadze, E., Mikhailov, A., Sysoev, P. "Zhurnal 'Iskusstvo' i zadachi khudozhestvennoi kritiki." *Novyi mir,* No. 3 (1935): 247-73.

Lebedev, A.K., Melikadze, E., Mikhailov, A., Sysoev, P. "Eshche raz o zhurnale 'Iskusstvo'." *Novyi mir,* No. 7 (1935): 242-52.

Lebedev, A.K., Melikadze, E., Mikhailov, A., Sysoev, P. "Gogolevskaya khivria v roli teoretika iskusstva." *Novyi mir,* No. 11 (1935): 269-86.

Lebedev, A.K., Solodovnikov, A. *V.V. Stasov. Zhizn' i tvorchestvo.* M. 1966.

Leikina-Svirskaya, V.R. *Intelligentsiya v Rossii vo vtoroi polovine XIX veka.* M. 1971.

Lenin o kul'ture i iskusstve. Ed. N.I. Krutikova. M. 1956.

Leonov, A.I. *V.M. Maksimov.* M. 1951.

Leonov, A.I., ed. *Russkoe iskusstvo. Ocherki o zhizni i tvorchestve khudozhnikov. Seredina deviatnadsatogo veka.* M. 1958.

Leonov, A.I. *Russkoe iskusstvo. Ocherki o zhizni i tvorchestve khudozhnikov. Vtoraya polovina deviatnadtsatogo veka,* Vol. 1. M. 1962.

Levenfish, E.G. *Konstantin Apollonovich Savitsky.* L.-M. 1959.

I.I. Levitan. *Katalog vystavki.* M.-L. 1938.

Liaskovskaya, O. "Proizvedenie I.E. Repina, 'Ne Zhdali,' i problema kartiny v russkoi zhivopisi vtoroi poloviny XIX veka." Gosudarstvennaya Tret'iakovskaya galereya. *Materialy i issledovaniya,* Vol. 2. M. 1958.

Lobanov, V. *God 1905 v zhivopisi.* M. 1922.

Lobanov, V. *Khudozhestvennye gruppirovki za poslednie 25 let.* M. 1925.

London, K. *The Seven Soviet Arts.* New Haven, 1938.

Lvov, F.F. "Akademiya khudozhestv v gody eya vozrozhdeniya." *Russkaya starina,* Vol. 29 (1880): 385-416.

Lvov, F.F. "Obshchestvo pooshchreniya khudozhestv." *Russkaya starina,* Vol. 31 (1881): 641-52.

Lunacharsky, A.V. *Ob izobrazitel'nom iskusstve.* 2 vols. Ed I.A. Sats. M. 1967.

Maksimov, V.M. "Avtobiograficheskie zapiski." *Golos minuvshego,* No. 4 (April 1913): 145-83; No. 5 (May 1913): 90-116; No. 6 (June 1913):

161-98; No. 7 (July 1913): 86-112.

Mandelstam, N. *Hope Abandoned.* New York, 1973.

Mandelstam, N. *Hope Against Hope.* New York, 1970.

Manin, V. *Iz istorii khudozhestvennykh ob'edinenii Moskvy i Leningrada (1921-1932 gg.).* Kandidat dissertation, University of Moscow, 1973.

Manin, V. "Pervye peredvizhnye gosudarstvennye vystavki." *Iskusstvo,* No. 9 (1967): 52-53.

Martov, L. "Obshchestvennye i umstvennye techeniya 70-kh godov." *Istoriya russkoi literatury XIX veka,* Vol. 4. Ed. D.N. Ovsianiko-Kulikovsky. M. 1909.

Mashkovtsev, N.G., ed. *Istoriya russkogo iskusstva.* 2 vols. M. 1960.

Materialy pervogo vsesoyuznogo s'ezda sovetskikh khudozhnikov. M. 1958.

Matsa, I., ed. *Sovetskoe iskusstvo za 15 let.* L.-M. 1933.

Miasoedov, G.G. *Pis'ma, dokumenty, vospominaniya.* Ed. V.S. Ogolovets. M. 1972.

Mikeshin, M.O. "Malen'kaya serebrianaya." *Pchela,* No. 17 (May 28, 1876): 11-15; No. 18 (June 2, 1876): 10-13; No. 19 (June 6, 1876): 8-11; No. 20 (June 6, 1876): 10-14.

Mikhailov, A. "Repin i peredvizhniki," *I.E. Repin. Sbornik dokladov.* M. 1947.

Mikhailov, A. *V.I. Surikov.* L. 1935.

Mikhailov, A. "Zametki o razvitii burzhuaznoi zhivopisi v Rossii." *Russkaya zhivopis' XIX veka.* Ed. V. Friche. M. 1929.

Mikhailov, M.I. "Khudozhestvennaya vystavka v Peterburge." *Sovremennik,* LXXVI, 2 (July-August 1859): 105-15.

Minchenkov, Ya. D. *Vospominaniya o peredvizhnikakh.* L. 1963.

Mneniya lits sproshennykh po povodu peresmotra ustava Imperatorskoi Akademii khudozhstv. SPb. 1891.

Moleva, N., Beliutin, E. *Russkaya khudozhestvennaya shkola vtoroi poloviny XIX v.-nachala XX v.* M. 1967.

Monas, S. *The Third Section: Police and Society under Nicholas I.* Cambridge, Mass., 1961.

Morgunov, N., Morgunova-Rudnitskaya, N. *V.M. Vasnetsov. Zhizn' i tvorchestvo.* M. 1962.

Mudrogel, N. "58 let v Tret'iakovskoi galleree." *Novyi mir,* No. 7 (1940): 137-81.

Mudrogel, N. *Piat'desiat vosem' let v Tret'iakovskoi galeree. Vospominaniya.* L. 1966.

Murashko, N. *Vospominaniya starogo uchetelia.* Kiev, 1907.

Naidenov, N. *Vospominaniya o vidennom, slyshannom i ispytannom.* 2 vols. SPb. 1903.

Nesterov, M.V. *Davnie dni.* M.-L. 1959.

Nesterov, M.V. *Iz pisem.* Ed. A. Rusakova. L. 1968.

Nevedomsky, N.P., Repin, I.E. *Kuindzhi.* SPb. 1913.

Nikitenko, A. *Dnevnik,* Vol. 3. M. 1959.

Nochlin, L., ed. *Realism and Tradition in Art, 1848-1900.* Englewood Cliffs, NJ, 1966.

Novitsky, A. *Istoriya russkogo iskusstva s drevneishikh vremen.* 2 vols. M. 1903.

Novitsky, A. *Peredvizhniki i vliyanie ikh na russkoe iskusstvo.* M. 1897.

Novouspensky, N. *Alexei Kondrat'evich Savrasov.* M.-L. 1967.

Obshchestvo liubitelei khudozhestv. *Pervyi otchet komiteta.* M. 1862.

Ocherki tret'ei peredvizhnoi vystavki. Kiev, 1875.

Ogarev, N.P. "Pamiati khudozhnika." *Poliarnaya zvezda,* Vol. 5 (1859): 238-52.

Pavlov, I.N. *Zhizn' russkogo gravera.* M. 1940.

Perelman, V. "Ot peredvizhnichestva k geroicheskomu realizmu." *4 goda AKhRR.* M. 1926.

Perov, V. "General Samsonov." *Khudozhestvennyi zhurnal,* I, 3 (March 1881): 147-60.

V.G. Perov. K stoletiyu so dnia rozhdeniya. M. 1934.

Pervyi vsesoyuznyi s'ezd sovetskikh pisatelei. Stenograficheskii otchet. M. 1934.

Petrov, P.N., ed. *Sbornik materialov dlia istorii Imperatorskoi Akademii Khudozhestv za sto let eya sushchestvovaniya.* 3 vols. SPb. 1864-66.

Pevsner, N. *Academies of Art, Past and Present.* Cambridge, England, 1940.

Piat'desiat kratkikh biografii masterov russkogo iskusstva. L. 1971.

Pikulev, I. *I.I. Shishkin.* M. 1955.

Pobedonostsev, K. *Pis'ma Pobedonostseva Alexandru III,* 2 vols. Ed. M.N. Pokrovsky. M. 1925.

Polenov, V.D. *Vasili Dmitrievich Polenov. Elena Dmitrievna Polenova. Khronika sem'i khudozhnikov.* Ed. E.V. Sakharova. M. 1964.

Polievktov, M. *Nikolai I.* M. 1918.

Prakhov, A.V. "Chetvertaya peredvizhnaya vystavka." *Pchela,* No. 10 (March 16, 1875): 121-26.

Prakhov, A.V. "Imperator Alexandr III kak deyatel' russkogo khudozhestvennogo prosveshcheniya." *Khudozhestvennye sokrovishcha Rossii,* Vol. 3 (1903): 125-81.

Prakhov, A.V. "Khudozhestvennye vystavki v Peterburge." *Pchela,* No. 11 (April 27, 1876): 7-8.

Prakhov, A.V. "Vystavka v Akademii khudozhestv." *Pchela,* No. 11 (March 12, 1878): 170-75; No. 12 (March 19, 1878): 190-91; No. 13 (March 26, 1878): 203-07.

Prakhov, N.A. "Repin v 1860-1890 gg." *Khudozhestvennoe nasledstvo. Repin,* Vol. 2. M.-L. 1948.

"Professor zhivopisi F.G. Solntsev v ego popecheniyakh o khudozhnikakh iz krest'ianskogo sosloviya." *Russkaya starina,* Vol. 57 (1888): 555-59.

Protiv formalizma i naturalizma v iskusstve. M. 1937.

Punin, N. "Proletarskoe iskusstvo." *Iskusstvo kommuny*, No. 19 (April 13, 1919): 1.

Punina, I.N. *Peterburgskaya artel' khudozhnikov*. L. 1966.

Punina, I.N. "Peterburgskaya artel' khudozhnikov." *Kandidat* dissertation, University of Leningrad, 1971.

Putivoditel' po khudozhenstvennomu otdelu vserossiiskoi vystavki 1882 goda v Moskve. M. 1882.

Ramazanov, N.A. *Materialy dlia istorii khudozhestv v Rossii*. M. 1863.

Repin, I.E. *Dalekoe blizkoe*. M. 1937.

Repin, I.E. *Izbrannye pis'ma*. 2 vols. Ed. I.A. Brodsky. M. 1969.

Repin, I.E. *Katalog vystavki proizvedenii*. M. 1936.

Repin, I.E. *Pis'ma I.E. Repina. I.E. Repin i V.V. Stasov. Perepiska*. 3 vols. Ed. A.K. Lebedev. M.-L. 1948-50.

Repin, I.E. "V zashchitu novoi Akademii khudozhestv" (1897). *Vospominaniya, stat'i i pis'ma iz zagranitsy*. SPb. 1901.

Roginskaya, F.S. "O predistorii i organizatsii Tovarishchestva peredvizhnykh khudozhestvennykh vystavok." Institut istorii iskusstv. *Ezhegodnik, 1954*. M. 1954.

Roginskaya, F.S. "Peredvizhniki v 1900-1910-kh godakh." Institut istorii iskusstv. *Ezhegodnik. 1956*. M. 1957.

Roginskaya, F., Bystrova, T. *Antireligioznaya ekskursiya po Tret'iakovskoi galleree*. M. 1933.

Rusakov, Yu. *Petrov-Vodkin*. L. 1975.

Rylov, A. *Vospominaniya*. L. 1960.

Saltykov-Shchedrin, M. "Kartina Ge" (1863). *Sobranie sochinenii*, Vol. 6. M. 1968.

Saltykov-Shchedrin, M. "Na dosuge." *Otechestvennye zapiski*, No. 9 (1877): 167-98.

Saltykov-Shchedrin, M. "Pervaya russkaya peredvizhnaya khudozhestvennaya vystavka" (1871). *Sobranie sochinenii*, Vol. 10. M. 1970.

Saltykov-Shchedrin, M. "Triapichkiny-ochevidtsy." *Otechestvennye zapiski*, No. 8 (1877): 533-70.

Sarabianov, D.V. *Narodno-osvoboditel'nye idei russkoi zhivopisi vtoroi poloviny XIX veka*. M. 1955.

Sarabianov, D.V. "V.G. Perov i bytovoi zhanr 1860-kh godov." *Istoriya russkogo iskusstva*, IX, 1. Ed. I.E. Grabar. M. 1965.

Savinov, A. "Akademiya khudozhestv i Tovarishchestvo peredvizhnykh khudozhestvennykh vystavok." *Problemy razvitiya russkogo iskusstva*, Vol. 2. L. 1972.

Savinov, A. "Zametki o kartinakh Repina." *Khudozhestvennoe nasledstvo. Repin*, Vol. 2. M.-L. 1948.

Savinov, A. "Alexandr Benua v 1905 godu." *Problemy razvitiya russkogo iskusstva*, Vol. 4. L. 1972.

Schapiro, M. "Courbet and popular imagery: an essay on realism and naiveté." *Journal of the Warburg and Courtauld Institutes,* IV, 6-7 (1941): 164-91.

Shchekotov, N.M. "Sovetskie zhivopistsy. Vystavka 'Khudozhniki RSFSR za 15 let'," *Iskusstvo,* No. 4 (1933): 51-142.

Shchekotov, N. M. *Stat'i, vystupleniya, rechi, zametki.* Ed. N. M. Grigoreva, Zh. E. Kaganskaya. M. 1963.

Shcherbatov, S. *Khudozhnik v ushedshei Rossii.* New York, 1956.

Shelgunov, N. V. et al. *Vospominaniya,* Vol. 1. M. 1967.

Shterenberg, D. "Otchet deyatel'nosti Otdela Izobrazitel'nykh Iskusstv Narkomprosa." *Izobrazitel'noe iskusstvo,* No. 1 (1919): 69-70.

Shuvalova, I.N. *Miasoedov.* L. 1971.

Sobko, N.P. "V.G. Perov, ego zhizn' i proizvedeniya." *Vestnik iziashchnykh iskusstv,* I, 1 and 2 (1883): 129-82, 306-25.

Sobko, N.P. *Slovar' russkikh khudozhnikov.* 3 vols. M. 1893-99.

Sloane, J. *French Painting Between the Past and the Present: Artists, Critics and Tradition from 1848 to 1870.* Princeton, New Jersey, 1951.

Stanovlenie sotsialisticheskogo realizma v sovetskom izobrazitel'nom iskusstve. Sbornik statei. M. 1960.

Stasov, V.V. *Izbrannoe. Zhivopis', skul'ptura, grafika.* 2 vols. Ed. P.T. Shchipunov. M. 1950.

Stasov, V.V. *Izbrannye sochineniya.* 3 vols. Ed. P.T. Shchipunov. M. 1952.

Stasov, V.V. *Materialy k bibliografii, opisanie rukopisei.* Ed. E.N. Veiner, et al. M. 1956.

Stasov, V.V. "Pavel Tret'iakov i ego kartinnaya gallereya." *Russkaya starina,* Vol. 80 (1893): 569-608.

Stasov, V.V. *Perepiska V.V. Vereshchagina i V.V. Stasova,* vol. 2. Ed. A. Lebedev, G. Burova. M. 1950-51.

Stasov, V.V. *Pis'ma k deyateliam russkoi kul'tury,* Vol. 2. Ed. N.D. Chernikova. M. 1967.

Stasov, V.V. *Pis'ma k rodnym.* 2 vols. Ed. Yu. Keldysh, M. Yankovsky. M. 1958.

Stasov, V.V. *Selected Essays on Music.* Ed. F. Jonas. New York, 1968.

Stasov, V.V. *Sobranie sochinenii.* 3 vols. SPb. 1894.

Stasov, V.V. *Stat'i i zametki ne voshedshie v sobranie sochinenii.* 2 vols. Ed. O. Gaponova, A. Shchekotova. M. 1954.

Stasova, E.D. *Vospominaniya.* M. 1969.

Sternin, G. Yu. *Khudozhestvennaya zhizn' Rossii na rubezhe XIX-XX vekov.* M. 1970.

Sternin, G. Yu. "Peredvizhniki." *Tvorchestvo,* No. 10 (1971): 14-18.

Sysoev, P. "I.E. Repin kak predstavitel' revoliutsionnogo narodnichestva." *Novyi mir,* No. 10 (1934): 245-72.

Sysoev, P. "Tvorchestvo V.G. Perova." *V.G. Perov. K stoletiyu so dnia*

rozhdeniya. M. 1934.

Sysoev, P., Melikadze, E. "Il'ya Repin." *Novyi mir,* No. 8 (1936): 276-300.

Tolstoy, V. *A.I. Korzukhin.* M. 1960.

Tovarishchestvo peredvizhnykh khudozhestvennykh vystavok. *Illiustrirovannyi katalog XVII-i peredvizhnoi vystavki.* (Prilozhenie: Ukazateli i katalogi pervykh 15-ti peredvizhnykh vystavok, 1871-1888 gg.). SPb. 1889.

Tovarishchestvo peredvizhnykh khudozhestvennykh vystavok. *Katalog 47-oi peredvizhnoi vystavki.* M. 1922.

Tugendhold, Ya. *Iskusstvo Oktiabr'skoi revoliutsii.* M.-L. 1930.

Ukazatel' russkogo otdela Venskoi vsemirnoi vystavki. SPb. 1873.

Urusov, G.G. *Polnyi obzor tret'ei khudozhestvennoi vystavki Tovarishchestva peredvizhnykh vystavok v Rossii.* M. 1875.

Uspensky, G. "Po povodu odnoi kartinki" (1883). *Polnoe sobranie sochinenii,* Vol. 8. L. 1949.

Varshavsky, L. *Peredvizhniki, ikh proiskhozhdenie i znachenie v russkom iskusstve.* M. 1937.

Varshavsky, S. *Upadochnoe iskusstvo zapada pered sudom russkikh khudozhnikov-realistov.* M.-L. 1949.

Vasilevsky, I. "Nabroski i nedomolvki." *Molva,* No. 61 (March 4, 1879).

Vasilevsky, I. "Dve vystavki." *Russkie vedomosti,* No. 67 (March 10, 1886).

Vasilevsky, I. "XXV peredvizhnaya i akademicheskaya vystavki." *Russkie vedomosti,* No. 67 (March 9, 1897).

Venturi, F. *Roots of Revolution.* New York, 1960.

Vishniakov, V. "Tvorcheskii podvig peredvizhnikov." *Kommunist,* No. 2 (1972): 82-83.

Voloshin, M. "Surikov. Materialy dlia biografii." *Apollon,* No. 6-7 (1916): 40-63.

Vserossiiskii s'ezd khudozhnikov. *Trudy.* 3 vols. SPb. 1912.

Vse togozhe. "Kul'turnye idealy i pochva." *Delo,* X, 2 (July 1876): 41-61.

Woehrlin, W.F. *Chernyshevskii. The Man and the Journalist.* Cambridge, Mass., 1971.

Wortman, R. *Crisis in Russian Populism.* Cambridge, Mass., 1967.

Yaroslavskaya, N.V. "Akademiya khudozhestv i khodozhestvennoe obrazovanie v Rossii v XIX v." Akademiya khudozhestv SSSR. *Sessii. Diesiataya.* M. 1959.

Yovleva, L.I. *Tovarishchestvo peredvyzhnykh khudozhestvennykh vystavok.* L. 1971.

Zhemchuzhnikov, L.M. *Moi vospominaniya.* M. 1926.

Zhemchuzhnikov, L.M. "Neskol'ko zamechanii po povodu poslednei vystavki v Akademii khudozhestv." *Osnova,* Feb. 1861: 136-56.

Zhuravleva, E. "K voprosu o portrete-kartine v russkoi zhivopisi kontsa XIX, nachala XX stoletii." Gosudarstvennaya Tret'iakovskaya galereya,

Materialy i issledovaniya, Vol. 2. M. 1958.

Zilbershtein, I. "Iz istorii sozdaniya kartiny 'Arest propagandista'." *Khudozhestvennoe nasledstvo. Repin,* Vol. 2. M.-L. 1948.

Zilbershtein, I. *Repin i Turgenev.* M.-L. 1945.

Ziloti, V.P. *V dome Tret'iakovykh.* New York, 1954.

Zonova, Z. "Istoriya sozdaniya kartiny K.A. Savitskogo 'Remontnye raboty'." Gosudarstvennaya Tret'iakovskaya galereya. *Materialy i issledovaniya,* Vol. 2. M. 1958.

Zotov, A.I. *Akademiya khudozhestv.* M. 1960.

Abramtsevo: 128, 207n

Academic art: 4, 18, 19, 44, 118-19, 123-24, 200n; level of: 52-53, 127

Academy of Fine Arts, French: 3

Academy of Arts, Imperial: 3, 18, 64, 73; and Alexander II: 9-10; and Alexander III: 132-34; and the Artel: 36-37, 39; criticism of, after 1893: 140-41, 188; after the February Revolution: 142-43; liquidation (1918): 145; medals: 5-9, 12-13, 18, 33, 40, 196n; and Nicholas I: 4-10, 182; pensioners: 5, 38, 196n; the secession of 1863: 4, 10, 18, 33-34, 38, 62, 73, 115, 118, 202n; 1764 Statutes: 3-4; 1859 Statutes: 9-10, 18; 1893 Statutes: 132-34, 140; and Tovarishchestvo: 40, 41-43, 47, 115, 118-19, 120, 132-34, 137, 140-43

Academy of Arts, Soviet: 3, 145, 158; post-1932: 167, 173, 182; post-1945: 182-83, 185; post-1953: 187-88

Academy of Sciences, Imperial: 139

AKhRR — see Association of Artists of Revolutionary Russia

Akhsharumov, N.D. (1819-93): 126

Aksakov, I.S. (1823-86): 66

Alexander I (1777-1825): 4

Alexander II (1818-81): 9, 18, 68, 83, 90, 124

Alexander III (1845-94): 58; and national art: 3, 123-27; and Peredvizhniki: 125-27, 132-34

Alpatov, M.V. (1902-): 96, 190

Altaeva, A. 123

Antokolsky, M. M. (1843-1902): 36, 53, 71, 182; and Alexander III: 124: and Stasov: 61

"Christ": 124

"Ivan the Terrible": 83, 203n

"Peter I": 83, 124

Architecture, Slavic revival: 124

Arkhipov, A. E. (1862-1930): 159, 174

Art groups and organizations:

Association of Artists (Tovarishchestvo khudozhnikov), Moscow: 131

Association of Moscow Painters (OMKh): 148

Association of Easel Painters (OST): 148

Federation of Soviet Artists' Associations (FOSKh): 156

Four Arts (Chetire iskusstva): 148

Freedom to Art (Svoboda iskusstvu): 143

Knave of Diamonds (Bubnovyi valet): 170

Life (Byte): 148

New Society of Painters (NOZh): 148

Makovets: 148

Russian Association of Proletarian Artists (RAPKh): 159

Society of Art Exhibits (Obshchestvo vystavok khudozhestvennykh proizvedenii): 42

Society of Artists (Obshchestvo khudozhnikov), St. Petersburg: 131

Union of Russian Artists (Soyuz russkikh khudozhnikov): 138, 183

World of Art (Mir iskusstva): 132, 138, 141, 153, 202n; Soviet assessment of: 170, 183

—See also Artel, AKhRR, Association of Traveling Art Exhibits, Union of Soviet Artists

Art history, pre-1917, nationalist: 126, 178, 202n — See also Prakhov, A., Stasov, V.; Soviet: 184; Marxist: 89, 123, 157, 168, 169-70, 171, 202n; post-1932: 169-71; post-1935: 173-79; post 1945: 181-86; post-1953: 186-92

Artel: 11, 17, 34-37, 39, 90, 95, 121

Artistic policies: Catherine II (1762-96): 3-4, 8; Nicholas I (1825-55): 3, 4-10, 52, 123-24, 140; Alexander II (1855-81): 9, 10, 18, 123; Alexander III (1881-94): 3, 123-27, 132-34; Provisional Government (1917): 142-43; War Communism (1918-21): 143-48, 184, 191; NEP (1921-28): 148, 150-51, 187, 189, 191; First Five Year Plan (1928-32): 148, 156-57, 159; 1932-35: 3, 165ff., 180; 1936-41: 165, 172ff., 180; 1945-53: 165-66, 180ff.; 1953-: 166, 186ff., 215n

Artistic training: in Tsarist Russia: 4, 5, 9-10, 14, 95, 118-19, 133, 140; schools: 7-8, 13, 36, 38, 47-48, 65, 118, 121, 123, 128, 129, 141, 197n,

204n – See also Academy of Arts, Imperial; in Soviet Russia: 145, 148, 158, 167, 215n, 222n – See also Academy of Arts, Soviet

Arvatov, B. I. (1896-1940): 155

Association of Artists of Revolutionary Russia (AKhRR): 137, 149-59; after 1932: 166, 183, 184-85, 189, 190

Association of Traveling Art Exhibits: 4, 8, 11, 134; and the Academy: 40, 41-43, 47, 115, 118-19, 120, 132-34, 137, 140-43; and Alexander III: 125-27, 132; founding: 37-40; membership: 39, 119-20, 130-31, 137, 201n; and the 1905 Revolution: 138-40; after the October Revolution: 146, 149; Statutes (1870): 39, App.; Statutes (1890): 42, 130-31 – See also Exhibits, Peredvizhnik; *Peredvizhnichestvo*; Peredvizhniki

Balakirev, M. A. (1837-1910): 38

Balkan Slavs, liberation of, and Russian support: 66, 68-73, 83

Barbizon school: 53

Bastien-Lepage, J. 129, 130

Belinsky, V. G. (1811-48): 10-11, 58, 61, 67, 80; Soviet assessment of: 176, 184, 191

Benois, A. N. (1870-1960): 132, 139, 140, 141, 142, 144, 151, 188

Biedermeyer genre: 53

Bodarevsky, N. K. (1850-1921): 130

Bogdanov-Belsky, N. P. (1868-1945): 89, 123, 155, 213n

Bogorodsky, F. S. (1895-1959): 150

Bonch-Bruevich, V. (1873-1955): 93

Botkin, D. P. (1829-89): 63

Botkin, M. P. (1839-1914): 201n

Bouguereau, W. 125

Breton, J. 129

Briullov, K. P. (1799-1852): 19, 65, 181

Brodsky, I. I. (1884-1939): 150, 158-59, 167, 180
"Opening of the II Congress of the Comintern": 158

Bubnov, A. S. (1883-1940): 159, 167

Bukharin, N. I. (1888-1938): 150-51

Burliuk, D. D. (1882-1967): 142

Burliuk, N. D. (1890-1920): 142

Buslaev, F. I. (1818-97): 203n

Campanella, T. 147

Careers, official: 3; in Tsarist Russia: 4-10, 20-21, 36-37, 132-33, 139-41, 221n; in Soviet Russia: 150-51, 156, 179-80, 220n, 221n

Catherine II (1729-96): 3-4, 8

Censorship, Tsarist: 22, 34, 35, 43, 89, 208n, 222n; Soviet, 122-23, 173-77, 181, 189, 205n, 216n

Cézanne, P. 168, 170, 171, 172, 177, 186, 214n

Chekhov, A. P. (1860-1904): 96, 206n

Cheptsov, E. M. (1874-1950): 150

Chernyshevsky, N. G. (1828-89): 10-11, 15, 16-17, 19, 22, 34, 58, 89, 90, 198n, 199n; Soviet assessment of: 169, 171, 174, 176, 184, 190, 191

Chertkova, A. K. (1859-1927): 94

Chicherin, B. (1828-1904): 63

Committee on Arts (KDI): 173-77, 178, 181, 187

Communist Party statements: 156-57, 165, 180-81, 222n; December 1918: 214n; May 1925: 150; March 1931: 159, 216n; April 1932: 159, 165, 166, 172; May 1934: 170-71; March 1936: 218n; August 1946: 181; 1972: 189, 222n

Congress of Russian Artists (1912): 141, 188

Congress of Soviet Artists: First (1957): 187; Second (1963): 187, 188

Criticism, art: 45, 46, 96, 119, 142, 204n; conservative: 19, 59, 72, 91, 126; 1860s: 18-21, 22-23, 35, 89; historical painting: 82-83, 84-85; landscape: 78-79; nationalist: 72-73, 95, 125-26 – See also Prakhov, A., Stasov, V.; portraits: 80-81; in the provinces: 46-47; Soviet, pre-1932: 149, 152, 154-55, 157; Soviet post-1932 – see Art history, Soviet. See also Public opinion

Corot, J. B. C. 53

Courbet, G. 53, 54, 89, 118, 122, 170, 185, 186, 214n

Cultural background, artists': 4; mid-19th century: 9-10, 13-16, 21-22, 54-55; late 19th century: 129

Cultural status, artists' – see Intelligensia and painters

244

Dagnan-Bouveret, P. 129
Degas, E. 185
Delacroix, E. 53, 170
Delaroche, P. 54
Department of Fine Arts (IZO): 144, 145-46
Dmitriev, I. I. (1840-67): 20-21, 23, 33
Dobroliubov, N. A. (1836-61): 22, 35, 63, 80, 198n; Soviet assessment of, 169, 176, 184, 190, 191
Dobrynin, P. 139
Dobuzhinsky, M. V. (1875-1957): 139, 140, 142
Dostoevsky, F. M. (1821-81): 59, 66, 72, 79; Perov's portrait of: 80-81
Dubovskoy, N. N. (1859-1918): 141
Düsseldorf school: 53

Efros, A. M. (1888-1954): 169, 220n
Ermak, T. (d. 1584): Surikov's painting of: 86, 177, 211n
Esthetics, 1860s: materialist: 10-11, 15-17, 56, 169, 198n; radical: 19-22, 35, 89, 198n — See also Criticism, art
Exhibits, Academic: 8, 40; in 1860s: 18-19, 76, 90, 119; in 1870s: 45, 86-87; in 1880s: 127; in 1890s: 134, 212n; in the provinces: 42
Exhibits, International: London (1862): 57, 64; London (1873): 41; Paris (1878): 44, 66; Vienna (1873): 78, 210n
Exhibits, Peredvizhnik: 8, 134, 141, 201n; first (1871): 40, 43-44, 78, 82, 83, App.; fourth (1875): 82; 12th (1884): 91; 14th (1886): 127; 26th (1898): 134; 47th (1922): 149; 48th (1923): 149; in the provinces: 45-47; selection for: 39, 130-31
Exhibits, Soviet: 188, 221n; AKhRR: 149-50, 151-52; centenary of the *Tovarishchestvo* (1971): 191-92; during NEP: 151; during War Communism: 145-46; 15-year retrospective (1933): 166-68; Ge (1969): 190; Grand Central Palace (1924): 151; Kramskoy (1937): 176; Levitan (1938): 177-78; official French (1956): 187; Perov (1934): 170, 171; Repin (1936): 175-76, 179; Socialist industry (1939): 179-80; Surikov (1937): 176-77; 30-year retrospective (1962):

188
Exhibits in Tsarist Russia: 8, 42, 45-46, 53, 131-32, 141, 212n; Nizhni Novgorod fair (1865): 36; Moscow, All-Russian (1882): 41, 44-45; Repin (1891): 131; of Western art: 53, 129, 187, 211n

Fedorov-Davydov, A. A. (1900-69): 155, 169-70
Fedotov, P.A. (1815-52): 18, 126, 190, 197n
Figner, V. N. (1852-1942): 92
Filonov, P. N. (1883-1941): 167
Five Year Plan, first (1928-32): 148, 149, 155-59
Fortuny, M., 54, 129, 130
Free Art Studios (Svomas): 145, 148, 158
Friche, V. M. (1870-1929): 217n
Frunze, M. V. (1885-1925): 152
Futurists, pre-1917: 141-42, 143; post-1917: 144-46, 147, 148, 152, 167

Gabo, N. (1890-): 144
Garshin, V. M. (1855-88): 71, 77, 84-85
"The Artists": 88
Gauguin, P. 186
Ge, N. N. (1831-94): 41, 118, 122, 130; and the Academy: 38, 41; Soviet assessment of: 185, 190; and *Tovarishchestvo*: 38, 39; views: 38, 66, 116
"Last Supper": 22-23, 38, 80
"Peter and Alexis": 43-44, 82, 83, 185
Gentry: 16, 63, 121, 122, 197n; legal status: 12, 37; patronage: 8, 63
Gerasimov, A. M. (1881-1963): 174-75, 181ff, 187
Gérôme, J. 54
Gerts, K. K. (1820-83): 52, 53, 77-78, 197n
Gogol, N. V. (1809-52): 93, 174
Goldshtein, S. N. 178
Golovin, F. F. 142
Gorky, M. (1868-1936): 220n
Grabar, I. E. (1871-1960): 142, 144, 151, 159, 166, 178, 190
Grekov, M. B. (1882-1934): 150
Gronsky, I. M. 169, 171

Hegel, G. 176

Hermitage – see Museums, Tsarist Russia
Herzen, A. I. (1812-70): 19-20, 22, 38, 66, 89; Soviet assessment of: 171, 184
Historical painting: 82-86; Soviet assessment of: 82, 176-77, 207n

Impressionism: 59, 117, 119, 177-78, 185, 204n
Institute of the Theory and History of Art: 182
Intelligentsia: 11, 15-16, 40, 68, 197; and painters: 10, 14-17, 19ff, 35-36, 68-73, 90, 123, 129; and the West: 52, 55-58, 72-73, 82, 83, 210n; – See also Populism, Slavophilism
Iseev, P. F. (1831-?): 41, 42, 43, 125, 132
Ivan the Terrible (1530-84): Antokolsky's statue: 83, 203n; Repin's painting: 141-42, 208n, 211n
Ivanov, A. A. (1806-58): 15, 20, 22, 147, 196n
Ivanov, S. V. (1864-1910): 130
"A Resettler's Death": 95

Journals and newspapers:
 The Alarm Clock (Budil'nik): 20
 Apollo (Apollon): 79, 174
 Art (Iskusstvo): 169, 170, 172, 174, 181, 192
 Art to the Masses (Iskusstvo v massy): 158
 The Bee (Pchela): 43, 60, 72-73
 The Bell (Kolokol): 19-20, 22
 Bugbear (Zhupel): 139
 Cause (Delo): 40, 72, 77
 The Citizen (Grazhdanin): 59, 91
 The Contemporary (Sovremennik): 19, 20, 22
 Creation (Tvorchestvo): 192
 Foundation (Osnova): 20
 Golden Fleece (Zolotoe runo): 140, 174
 Hellish Post (Adskaya pochta): 139
 Izvestiya: 176
 The Messenger of Europe (Vestnik Evropy): 62, 91, 204n
 Messenger of Fine Arts (Vestnik iziashchnykh iskusstv): 125
 Moscow News (Moskovskie vedomosti), 77, 91

 New Times (Novoe vremia): 43, 60, 61, 71
 New World (Novyi mir): 171, 172, 191
 Notes of the Fatherland (Otechestvennye zapiski): 40, 71 204n
 Pravda: 171, 174, 176
 Russian Antiquity (Russkaya starina): 62
 Soviet Art (Sovetskoe iskusstvo): 171-72, 173, 181
 The Spark (Iskra): 20-21, 23, 33

Kalinin, M. I. (1875-1946): 177
Kamenev, L. L. (1833-86): 38, 77
Kandinsky, V.V. (1866-1944): 144
Kasatkin, N. A. (1859-1930): 153, 184
 "Miners": 95
Katkov, M. N. (1818-87): 66-67, 91
Katsman, E. A. (1890-): 149, 150, 153
Kavelin, K. D. (1818-85): 83
Kerzhentsev, P. M. (1881-1940): 174, 177
Khliudov, G.I. (1821-85): 64
Khrushchev, N. S. (1894-1971): 180, 187, 188, 215n
Kiev: art school: 47-48; museum: 48, 65; St. Vladimir's Cathedral: 124
Kiprensky, O. A. (1782-1836): 147
Kliun, I. V. (1870-1942): 167
Klodt, M. K. (1832-1902): 77, 78, 119-20
Knaus, L. 54
Kokorev, V. A. (1817-89): 64, 124
Kollwitz, K. 155
Korin, P. D. (1892-1967): 220n
Korolenko, V. G. (1853-1921): 46, 69
Korovin, K.A. (1861-1939): 128, 129, 130
Korzhukhin, A. I. (1835-94): 18
Kosciuszko, T. 90
Kosolap, P. S. (1834-c.1910): 18
Kotov, P.I. (1889-1953): 150
Kovalevsky, P. M. (1823-1907): 80
Kramskoy, I. N. (1837-87): 121, 178, 180: and the Academy: 36-37, 41, 43, 61, 118, 178, 204n; and Alexander III: 126, 127; and the Artel: 34-35, 37; and the 1863 secession: 33-34, 115; and Nesterov: 85, 128; political views: 66; and Repin: 59-60, 81, 117-18, 119, 122; social back-

ground: 11, 14; Soviet assessment of: 176, 185; and Stasov: 59, 61-62, 70, 178; and *Tovarishchestvo*: 11, 39; and Tretiakov: 66, 67; and Vasilev: 13, 121; views on art: 16, 61-62, 78-79, 82, 85, 86, 93ff, 115-19, 204n; and the West: 53, 54, 61-62, 117-18, 202n, 203n
"Christ in the Desert": 92, 113, 117
"Derisive Laughter": 117
"Forester": 87, 107
"May Night": 93
"Nekrasov": 80, 101
Kuindzhi, A. I. (1842-1910): 40, 119-20, 132, 134, 145, 182
Kushelev-Bezborodko, N. A. (1834-62): 53, 54

Lanceray, E.E. (1875-1946): 140, 142
Landscapes: 13, 67, 76-79, 119; Soviet assessment of: 168, 177-78
Legal status, artists': 5-6, 196n; mid-19th century: 11-13, 37; late 19th century: 129
Leman, Yu. Ya. 130
Lenin, V. I. (1870-1924): 173; views on art: 147-48, 159, 169, 191
Levitan, I. I. (1860-1900): 78, 79, 128, 129; Soviet assessment of: 177-78
L'Hermitte, L. 129
Life style, artists': Artel: 34-37, 121; late 19th century: 120-23, 132-33; Soviet: 179-80
Lubok: 122
Lunacharsky, A. V. (1875-1933): 143-44, 147, 150, 155, 159, 169, 191
Lvov, F. F. (1820-95): 9, 12, 13-14, 38

Makart, H. 130
Makovsky, K. E. (1839-1915): 71
Makovsky, V. E. (1846-1920): 95, 130, 132, 141, 146; Soviet assessment of: 182, 183-84, 190
"Bank Failure": 95
"Evening Gathering": 92, 114
"Dispersal of a Demonstration": 139
"Prisoner": 92
"Sentenced": 208n
Maksimov, V. M. (1844-1911): 40, 120, 122; legal status: 12-13; peasant themes: 87-88; views: 21-22, 55, 66
"All in the Past": 95, 114

"The Arrival of the Sorcerer at the Peasant Wedding": 87-88
"Family Division": 88, 108
Malevich, K.S. (1878-1935): 144, 167
Mamontov, S. I. (1844-1909): 85, 128, 185
Marx, K. 147, 169
Mandelstam, O. E. (1892-1938): 143
Maria Nikolaeva, Grand Duchess (1819-76): 7, 8
Maria Pavlovna, Grand Duchess (1854-1923): 140
Mayakovsky, V.V. (1893-1930): 142, 152
Medals, Academic: 5-9, 12-13, 18, 33, 40, 196n
Melikadze, E. S. (1905-?): 171, 186
Mendeleev, D. I. (1834-1907): 66, 79
Miasoedov, G. G. (1834-1911): 47, 132, 182; and *Tovarishchestvo*: 38-39; views: 77, 85, 94, 115-16, 130
"Grandfather of the Russian Navy": 83
"Reading of the Emancipation Manifesto": 94, 149
"Zemstvo at Lunch": 89 109
Mickiewicz, A. 80
Middle class: 63, 64, 204n; legal status: 11, 13; patronage: 44-45, 62-68, 73, 126; social status: 62-63
Mikhailov, M. I. (1829-65): 22, 198n
Mikhailovsky, N. K. (1842-1904): 72
Ministry of Culture (Soviet): 187, 188, 189
Ministry of the Imperial Household: 7, 10, 42, 43, 134, 142
Mir iskusstva — see Art groups and organizations: World of Art
Monumental Propaganda project: 147-48
Morozov, A. I. (1834-1904): 18
Morozov, I. A. (1871-1921): 154, 174, 185
Moscow School of Painting, Sculpture and Architecture: 7-8, 38, 128, 174
Moscow Society of the Lovers of Art: 38, 53, 63
Mudrogel, N. A. 168
Murashko, N. I. (1844-1908): 47-48
Museums: in Tsarist Russia: 65, 123, 140, 141, 142; of Alexander III: 125, 127, 210n, 211n; Hermitage; 65, 125; Kiev: 48, 65; Moscow: 63-64 — See also Tretiakov Gallery

247

Museums, Soviet: 144, 146, 150, 158, 163; of Artistic Culture: 146; of Labor: 151; of Modern Western Art: 154, 185; of the Revolution: 215n; Russian: 97, 175 — See also Tretiakov Gallery

Musorgsky, M. P. (1839-81): 147; Repin's portrait of: 81

Narkompros — see People's Commissariat of Instruction

National art: and Alexander III: 123-27; and Prakhov: 70, 72-73, 82-83, 96, 124, 210-11n; and the pre-1914 vanguard: 141-42; and Stasov: 19, 56-62, 65, 81, 117-18, 125, 126; and Tretiakov: 64-68

National tradition: and conservatives: 56, 66, 72-73, 82-86, 125; and liberals: 44, 55-58, 72, 82, 83, 210n; and radicals: 55-56, 58, 82; Soviet assessment of: pre-1932: 145, 147, 150, 152ff; post-1932: 165, 166ff; post-1945: 180ff; post-1953: 186ff.

Neizvestny, E. (1926-): 188

Nekrasov, N. A. (1821-78): 66, 79, 174; Kramskoy's portrait of: 80

Nesterov, M. V. (1862-1942): 97, 128, 129, 168, 174
 "Petitioners Coming to the Sovereign": 85
 "Young Bartholomew's Vision": 130

New Economic Policy (NEP) (1921-28): 148

Nicholas I (1796-1855): 3, 4-10, 17, 52, 123-24, 140

Nicholas II (1868-1918): 211n

Nietzsche, F. 174

Nikitenko, A. V. (1804-77): 34

Novikov, N. I. (1744-1818): 72

Ogarev, N. P. (1813-77): 19-20, 198n

Ostrovsky, A. N. (1823-86): 63, 79, 126

Patronage: in Tsarist Russia: 8-9, 34, 38, 141, 174, 202n; Alexander II: 42, 126; Alexander III: 123-25, 127, 210n; Nicholas I: 4ff, 123, 125; nobility: 8, 63; middle class: 44-45, 62-68, 73, 126; in Soviet Russia: 146, 151, 153, 156, 175, 179-80, 188, 221n; Red Army: 151-53

Peasants: legal status: 11, 12-13; painters: 8, 12, 87, 88; as theme in Peredvizhnik art: 86-89

People's Commissariat of Instruction: 144, 150, 151, 156, 159, 170, 171, 173

Peredvizhnichestvo: 76, 119-20; appeal of, in Tsarist Russia: 40, 43ff, 68ff, 76ff, 93-97, 128; civic-minded ethos: 4, 22-23, 40, 43-44, 52, 66, 68, 72, 82, 85, 88-89, 115-18; conservative national phase: 52, 65, 85-86, 95, 115, 120, 123, 126-27, 131, 134, 137-43, 180; liberal-national phase: 68-73, 123; moral ethos: 18, 21, 23, 66, 85, 116-17 — See also National art; Soviet period: and AKhRR: 150, 152-55, 157, 158; assessment, pre-1932: 137, 143ff; post-1932: 96, 137, 165, 166ff, 180, 201n; post-1935: 172ff, 180; post-1945: 180ff; post-1953: 186ff; and Lenin: 147-48; public response: 78, 79, 80-81, 96-97, 146, 168, 218n

Peredvizhniki: and younger artists: 119-20, 128-31, 141-43, 149; political views: 17-23, 35, 66, 68, 80 — See also Political themes; during War Communism: 143-48; and the West: 52-56, 59-62, 94, 117-18, 129-30, 140, 202n, 203n — See also Association of Traveling Art Exhibits; Exhibits, Peredvizhnik; *Peredvizhnichestvo*

Perelman, V. N. (1894-): 149, 153-54

Perov, V. G. (1833-82): 11, 122, 126, 128, 196n; social background: 11; Soviet assessment of: 170, 171, 183, 184; and *Tovarishchestvo*: 11, 38, 39; and the West: 54
 "The Arrival of a Rural Police Inspector": 19, 35, 64
 "Bird Catcher": 68, 86, 96
 "Dostoevsky": 80-81, 100
 "Fomushka-sych": 86, 87
 "Last Tavern at City Gates": 77, 98
 "Nikita Pustosviat": 68
 "A Petty Clerk's Son": 18
 "A Village Sermon": 18

Perovskaya, S. I. (1853-81): 92

Peskov, M. I. (1834-64): 90

Peter I (1672-1725): Ge's painting of, 43-44, 82, 83, 185; as liberal symbol:

82ff; Miasoedov's painting of: 83
Petrov, N.P. (1843-76): 18
Petrov-Vodkin, K. S. (1878-1939): 172
Pisarev, D. I. (1840-68): 22, 69, 142,
 191, 198n, 199n
Pobedonostsev, K. P. (1827-1907): 124,
 211n
Pokrovsky, M. N. (1868-1932): 171,
 217n
Police surveillance of artists: 34, 208n
Polenov, N. D. (1844-1927): 71, 129,
 138, 182; and the Academy: 132,
 133, 134; and *Tovarishchestvo*: 40,
 130, 131, 211n
Political themes: 17, 19ff, 35, 89-93; So-
 viet assessment of: pre-1932: 89, 147-
 48; post-1932: 165, 169ff, 201n;
 post-1935: 173ff; post-1945: 183ff;
 post-1953: 189-92
Populism: 68-70, 72, 83, 86, 87, 89,
 203n, 204n
Portraits: 79-81, 94; of peasants: 86-89;
 Soviet assessment of: 79, 80, 81; in
 Tretiakov Gallery: 65, 66-67, 79
Prakhov, A. V. (1846-1916): 43, 44; and
 national art: 70, 72-73, 82-83, 96,
 124, 207n, 210-11n; and Repin: 60-
 61, 185, 199n
Prianishnikov, F. I. (1793-1867): 64,
 205n
Prianishnikov, I. M. (1840-94): 38
Prices, art: 42, 68, 201n, 210n, 211n,
 213n
Proletkult: 147, 150, 214n
Proudhon, P. J. (1809-65): 36, 54-55,
 199n
Provinces, Tsarist Russia: 42-48, 123
Provisional Government: 142-43
Public opinion: 44, 68, 76, 82, 137ff —
 See also Criticism, art; radical: 17,
 19-22, 64, 92-93, 123; liberal: 1860s:
 17-19, 22-23, 35, 68; 1870s: 40, 43-
 44, 82, 123 — See also Populism, Sla-
 vophilism
Publications, art: 211n; Soviet: 182-83,
 185-86
Pugachev, E. (1742-75): 61
Pukirev, V. V. (1832-90): 23
Punin, N. N. (1888-1953): 143, 145,
 146
Punina, I. N. 22
Pushkin, A. S. (1799-1837): 76, 176

Radimov, P. A. (1887-1967): 149
Ranks, system of: 5-6, 9, 12, 37, 133,
 196n
Raphael: 16, 19, 145, 169
Razin, S. (d. 1671): 147
Raznochintsy: 15-16
Realism: in 1860s: 18-23, 35, 76-77, 78,
 86, 90, 95, 122, 198n; as national
 art after 1860s — see *Peredvizhni-*
 chestvo; and folk art: 122; demise af-
 ter 1917: 143-48; revival in 1920s:
 148-55 — See also Socialist Realism
Red Army: 151-53, 159, 168, 219n
Religious themes: 44-45, 67-68, 93, 116-
 17, 128, 178, 190
Repin, I. E. (1844-1930): 13, 23, 122,
 130, 132, 178, 180; and AKhRR:
 153; and the Artel: 35; and Balkan
 wars: 71-72, 73; and Kramskoy: 59-
 60, 81, 117-18, 119, 122; and nation-
 al art: 59-61, 62; peasant themes: 87-
 88; on Peter I: 83-84; political views:
 66, 90ff, 138, 139; and pre-1914 van-
 guard: 141-42; revolutionary themes:
 89, 90-92; social background: 11, 14;
 and Stasov: 58-61, 81, 117-18; and
 Tovarishchestvo: 11, 40, 130, 131;
 and Tretiakov: 66-67; views on art:
 59-60, 93-94, 189; and the West: 55,
 59-61, 117-18; Soviet assessment of:
 208n; post-1932: 139, 169-71; post-
 1935: 175, 177, 179; post-1945:
 181ff; post-1953: 189, 190, 191
 "Alexander III": 126-27
 "The Boat Haulers": 46, 59, 60, 86,
 88
 "He Returned": 71
 "The Hero of the Last War": 72
 "Ivan the Terrible": 141-42, 208n,
 211n
 "Meeting of the Revolutionaries": 92
 "Musorgsky": 81
 "October Manifesto": 139
 "On a Turf Bench": 117
 "Paris Cafe": 59, 60-61, 117
 "Peasant with an Evil Eye": 87, 107
 "Procession of the Cross in the Kursk
 Province": 128
 "The Propagandist's Arrest": 91
 "Protodiakon": 44-45, 81, 102, 118
 "The Recruit's Farewell": 88

"Refusal of Confession": 89, 92, 112
"The Resurrection of Jairus' Daughter": 58
"Sadko": 59, 60-61
"Stasov": 44
"They Did Not Await Him": 67, 91-92, 110-11, 170
"Timid Peasant": 87
Revolutions: 1905: 138-40, 184; October 1917: 143, 184; February 1917: 142-43
Revolutionaries: in Peredvizhnik art: 80, 89-93; their views on Peredvizhnik art: 64, 92-93, 123
Revolutionary movement: 17, 69, 90, 92-93
Riazhsky, G. G. (1895-1952): 150
Rodchenko, A. M. (1891-1956): 144
Roerikh, N. K. (1874-1947): 142
Roginskaya, F.S. (1898-1963): 154
Rublev, A. (c. 1370-c. 1430): 147
Rylov, A. A. (1870-1939): 145, 168

St. Petersburg Society for the Promotion of Art: 8, 13, 121, 205n
Saltykov-Shchedrin, M. E. (1826-89): 22-23, 35, 43-44, 82
Sarabianov, D. V. 190
Savitsky, K. A. (1844-1905): 40, 44, 132
 "Repairing the Railroad": 46, 95
 "To the War": 71
Savrasov, A. K. (1832-97): 38, 77-78
 "The Rooks Have Come": 77, 78, 99
Semiradsky, G. I. (1843-1902): 200n
Serfs: 8, 12
Serov, V. A. (1865-1911): 128, 129, 130; and 1905 Revolution: 138, 139; Soviet assessment of: 179, 185, 190
 "Girl in Sunlight": 130
Shchekotov, N. M. (1884-1945): 154, 167, 170, 177, 179-80
Shchukin, S. I. (c. 1854-1936): 154, 174, 185
Shelgunov, N. V. (1824-91): 33
Shilder, N. G. (1828-98): 64
Shishkin, I. I. (1832-98): 13, 36, 66, 77, 78, 121, 132, 180
Shostakovich, D. D. (1906-75): 174
Shterenberg, D. P. (1881-1948): 144, 166
Shvarts, V. G. (1838-69): 82, 103

Slavophilism: 66, 68, 70-73, 85
Sobko, N. P. (1852-1902): 201n
Social background, artists': 4; mid-19th century: 11-17, 37, 68-70, 121; late 19th century: 129
Socialist realism: 3, 137, 180, 182; in landscape: 168, 177-78; and Soviet painters: 165, 172, 179-80, 217n, 219-20n; definitions of: during 1932-35: 165, 166-72, 180; 1936-41: 165, 172-80; 1945-53: 165-66, 180-86; after 1953: 166, 186-92; Zhdanov's: 166
Soldatenkov, K. T. (1818-1901): 64
Solovev, V. S. (1853-1900): 147
Somov, K. A. (1869-1939): 140
Stalin, I. V. (1879-1953): 159, 165, 169, 173, 176, 189, 207n
Stasiulevich, M. M. (1826-1911): 62
Stasov, V. V. (1824-1906): 11, 19, 35, 47; and the Academy: 56-58, 132, 178, 212n; and Antokolsky: 58, 61; on historical painting: 84-85; and Kramskoy: 59, 61-62, 70, 178; on landscape: 77; and national art: 19, 56-62, 65, 81, 117-18, 125, 126; and Peredvizhniki: 36, 56, 58-62, 65, 94, 125, 132, 212n; and populism: 58, 70; on portraits: 80; and Repin: 58-61, 81, 117-18; Soviet assessment of: 56, 171, 175, 176, 178, 185, 186, 189, 191, 203n
Surikov, V. I. (1848-1916): 40, 129, 140, 207n; historical paintings: 82, 84-85, 86; Soviet assessment of: 176-77, 179, 181, 183, 190, 207n, 214n
 "Ermak": 86, 177, 211n
 "Lady Morozova": 84, 92, 104-05
 "Menshikov in Exile": 84
 "Morning of the Streltsy Execution": 84
 "Suvorov": 86, 177, 211n
Suvorin, A. S. (1834-1912): 70-71
Suvorov, A. V. (1729-1800): Surikov's painting of: 86, 177, 211n
Sysoev, P. M. (1906-): 170, 171, 221n

Tatlin, V. E. (1885-1953): 144
Tereshchenko, F. A. (1819-1903): 48, 65
Tereshchenko, I. N. (1854-1903): 48, 65
Titles, Academic: 5-9, 12-13, 34, 36-37,

133, 141, 221n; Soviet: 153, 188, 221n

Tolstoy, I. I. (1858-1916): 132

Tolstoy, I. N. (1828-1910): 66, 79

Tovarishchestvo peredvizhnykh khudozhestvennykh vystavok — see Association of Traveling Art Exhibits

Tretiakov Gallery: 64-65, 66, 93, 97; post-1917 reorganizations: 167-68, 181-82, 217n; post-1932 role: 168-69, 170, 175-77, 192, 218n; after 1945: 181, 182

Tretiakov, P. M. (1832-98): 63; patronage: 35, 42, 63-68; and Peredvizhniki: 65-68, 79, 118, 127, 130; and Repin: 66-67, 91; Soviet assessment of: 184, 185; and Vasilev: 57, 121; views: 64, 66-68, 79, 91

Tretiakov, S. M. (1834-92): 63, 64, 204n

Tugendhold, Ya. A. (1872-1928): 142, 154

Turgenev, I. S. (1818-83): 56, 87

Union of Soviet Artists: 159, 166, 187-88, 189, 217n, 221n; Moscow: 168-69, 170, 174, 181, 217n; Organizational Committe: 181, 217n

Union of Soviet Writers: 166, 217n

University education: 13-16, 69; students: 14, 21-22, 69, 121

Uspensky, G. I. (1843-1902): 94, 147, 206n

Varshavsky, L. V. (1891-?): 178, 179

Vasilev, F. A. (1850-73): 13, 67, 77, 78, 86, 121, 182

Vasilevsky, I. F. (1850-?): 45, 132-33, 134

Vasnetsov, A. M. (1856-1938): 201n

Vasnetsov, V. M. (1848-1916): 40, 181, 208n; historical paintings: 82, 84-85
"After Igor's Battle with the Polovtsy": 85
"Battle Between Russian and Scythians": 85-86, 106

Velasquez, D. 59

Venetsianov, A. G. (1780-1847): 196-97n

Vereshchagin, V. V. (1842-1904): 37, 181, 182
"All Is Quiet at Shipka": 71

Vladimir Alexandrovich, Grand Duke

(1847-1909): 41, 42, 43, 44, 134, 140

Volkov, A. M. (1827-74): 18

Volkov, E. E. (1844-1920): 130

Voloshin, M. A. (1877-1932): 142, 207n

Volter, A. A. (1889-1974): 166, 170, 174

Vorontakov, K. E. (1881-1969): 152, 153, 159, 219n

Vrubel, M. A. (1856-1910): 128, 129, 130, 141; Soviet assessment of: 147-48, 183, 214n

War Communism (1918-21): 155

Western art, exhibits of: 53, 129, 187, 211n; Peredvizhnik views on: 52-56, 59-62, 94, 117-18, 129-30, 140, 202n, 203n; in Russian collections: 53, 54, 65, 125, 154, 174, 185, 202n; Soviet attitudes toward: pre-1932: 150, 152-55, 157, 214n; post-1932: 165, 168, 169, 170, 172; post-1935: 173, 175, 177-78, 192; post-1945: 180-86, 192; post-1953: 187, 190

Wilde, O. 174

World War II: 176-78, 207n

Yakobi, V. I. (1834-1902)
"Prisoner's Stop-over": 90, 93

Yaroshenko, N. A. (1846-98): 40, 95, 134, 141, 208n; Soviet assessment of: 182, 183, 190; views: 66, 77, 85, 90, 115-16, 131
"At the Litovsky Fortress": 92, 208n
"Conflict between Generations": 95
"[Girl] Student": 67, 91, 92, 94
"Kochegar": 88
"Prisoner": 92
"Student": 92

Yuon, K. F. (1875-1958): 159

Zemstva: 70, 89, 138-39

Zhdanov, A. A. (1896-1948): 165, 166, 181, 186

Zhdanovshchina: 165-66, 180-86

Zhemchuzhnikov, L. M. (1828-1912): 53, 55